Also by Jamie James

NONFICTION

*The Music of the Spheres: Music, Science,
and the Natural Order of the Universe*

Pop Art

*The Snake Charmer:
A Life and Death in Pursuit of Knowledge*

Rimbaud in Java: The Lost Voyage

FICTION

Andrew and Joey

The Java Man

The Glamour
of Strangeness

The Glamour of Strangeness

ARTISTS AND THE LAST AGE

OF THE EXOTIC

Jamie James

FARRAR, STRAUS AND GIROUX NEW YORK

Farrar, Straus and Giroux
18 West 18th Street, New York 10011

Grateful acknowledgment is made for permission to reprint lines from
"To Walter Spies," by Noël Coward, © NC Aventales AG. Reprinted
by permission of Alan Brodie Representation Ltd., www.alanbrodie.com.

Library of Congress Cataloging-in-Publication Data
Names: James, Jamie, 1951– author.
Title: The glamour of strangeness : artists and the last age of the exotic /
 Jamie James.
Description: First edition. | New York : Farrar, Straus and Giroux, 2016. |
 Includes bibliographical references and index.
Identifiers: LCCN 2015041555| ISBN 9780374163358 (hardback) |
 ISBN 9780374711320 (e-book)
Subjects: LCSH: Artists—Psychology. | Artists—Biography. | Alienation
 (Social psychology) | Identity (Psychology) | BISAC: TRAVEL /
 Special Interest / Literary. | BIOGRAPHY & AUTOBIOGRAPHY /
 Artists, Architects, Photographers. | ART / History / Modern
 (late 19th Century to 1945).
Classification: LCC NX165 .J36 2016 | DDC 700.1/9—dc23
LC record available at http://lccn.loc.gov/2015041555

Designed by Jonathan D. Lippincott

www.fsgbooks.com
www.twitter.com/fsgbooks • www.facebook.com/fsgbooks

For Nancy Doyne
first, best writer pal

Contents

List of Illustrations

To the Reader

This book began as a dual study of Raden Saleh, the Javanese painter who enjoyed a season of fame in Europe, and Walter Spies, the dreamy German artist in Bali, who between them traversed the full spectrum of exoticism, moving in opposite directions. As the book progressed, other, similar cases presented themselves that seemed too good to leave out, and soon the book's scope expanded to a global survey of artists and writers who discovered a new homeland far from their place of birth. Paul Bowles usefully delineated the difference between tourists and travelers in *The Sheltering Sky*: "Whereas the tourist generally hurries back home at the end of a few weeks or months, the traveler, belonging no more to one place than to the next, moves slowly, over periods of years, from one part of the earth to another." I have attempted here to describe a third species, those who roam the world in search of the home they never had in the place that made them.

From the start, the challenge was to prevent the book from becoming an encyclopedia of rolling stones; the question was always whom to leave out, not whom to include. Readers of this book at different points in its composition have proposed fine alternative subjects and raised reasonable objections to my own choices. A similar book could be written with a different cast of characters. My research turned up dozens of remarkable subjects I intended to include in one way or another who dropped by the wayside. Until the final round of revisions, I had pages devoted to Leonora Carrington, Charles Montagu Doughty, W. H. Hudson,

the Turkish painter Osman Hamdi Bey, and Fearless Nadia, the athletic blond stunt rider from Australia who became a Bollywood star: interesting work and fabulous lives. However, the book was expanding at an alarming pace, and the need to reduce the total population to a manageable mob became imperative.

The first criterion for inclusion was the interest of the work; whether the life was an ideal fit to my theme was a subsidiary concern. My intention has been to write a natural history of exoticism, not a theory of evolution—a critical survey of the manifestations of the impulse to acquire a new cultural identity rather than a grand philosophical scheme to explain why so many fine artists have done so. The problem with theories is that the more case histories they adduce, the more vague and insubstantial they must become in order to accommodate them all. Anything that tends to undermine the theory is discarded, which creates strange gaps in the narrative. The biographer's attempt to extract a truthful portrait of a life from the record is difficult enough without trying to whittle it into shape to fit a factitious hypothesis. To put it another way, the differences among artists are usually more revealing than their similarities. My hope is that as the voyage progresses, the profile of the transcultural will shimmer into focus.

Emphatically, this book was never intended to be a study of travelers and explorers. I don't hate them, as Claude Lévi-Strauss claimed to do, but people who go to exotic places for the sake of going there and then write a book about the experience rarely hold my interest, at least insofar as they claim to explain the destination. Why would anyone turn to another foreigner, just passing through, to learn about a faraway place? The writer who can explain home, how we know when we have found it, has a better story to tell, and that is what I have attempted to do here.

J.J.
Batu Bolong, Lombok

An Invitation

Tu connais cette maladie fiévreuse qui s'empare de nous dans les froides misères, cette nostalgie du pays qu'on ignore, cette angoisse de la curiosité?
—Charles Baudelaire, "L'invitation au voyage"

You know that feverish sickness that seizes you with shivering sorrow, that nostalgia for a place you've never been, that anguish of curiosity?
—"Invitation to the Voyage"

The first nonfiction book that captured my imagination was *Richard Halliburton's Complete Book of Marvels.* Halliburton was a Marco Polo for the Jazz Age, one of the last traveling writers to set himself the goal of seeing the whole wide world. He was already a quaint figure by the time I discovered his book in my grandmother's library in Oxford, Mississippi, and he is nearly forgotten now, but in Halliburton's heyday his thrilling narratives of voyages to exotic places made him a celebrity and bestselling author to rival Hemingway. There were pictures on nearly every page, many of them photographs of the dashing author in flawless khaki, posing with sultans and mystics. Halliburton swam the Panama Canal, crossed the Alps on an elephant, flew loop-the-loops around the peak of Mount Everest.

The Barnumesque feats of derring-do weren't what attracted me, it was the glamorous places he visited. Halliburton voyaged to the lost cities of the world, from Machu Picchu to Petra to Angkor.

Some of his most renowned exploits took place during an eighteen-month aerial circumnavigation of the globe, which began on Christmas Day 1930 aboard a two-seater biplane called the *Flying Carpet*, piloted by his sidekick, Moye Stephens. After a dazzling performance of stunts at an air show in Fez, the pair flew across the Sahara to Timbuktu, byword of exoticism and fabulous wealth, which had been closed for centuries to infidels: the city at the end of the world. There he met Père Yakouba, born Auguste Dupuis, a Frenchman who had come to Timbuktu as a Catholic mission-ary, a vocation he renounced. Yakouba told his biographer, William Seabrook, "I quit the Church because I didn't want to leave Timbuktu and didn't want to give up women," specifically his wife, Salama. Seabrook (whom *Time* called "the Richard Halliburton of the occult," because of his investigative books about voo-doo and cannibalism) described Salama as a "magnificently strong, clean, healthy, full-grown negress with character and brains," who bore Yakouba a dozen children.

It would get my narrative off to a neat start if I said that *Richard Halliburton's Complete Book of Marvels* inspired me at the age of eleven to resolve that I would follow in the author's footsteps and see the world. Growing up in suburban Houston, I didn't dream of seeing the world, exactly; somehow I just knew that I would. Halliburton introduced me to the concept of the world as a finite place in which one could move about at will. The only dif-ference between driving to the beach for the weekend and a jour-ney to Timbuktu was the force of will required to make it happen, that and the money. If you want to go somewhere, anywhere, you can find a way to get there.

After I graduated from college, I moved to New York, an ad-venture of a different sort. I arrived in the great metropolis with a trunkful of dreams. (There was actually a trunk, a footlocker from the army-navy store in Houston, which my mother had filled with woollies when I left for my freshman year of college in Mas-sachusetts.) In New York, I devoted what pluck I possessed to making a career as a freelance writer. I was curious about almost everything, which expanded my markets to the editorial horizon but made for an odd collection of clips. On my first overseas re-

porting trip, to Buenos Aires, I had two assignments: a profile of a polo player for *Sports Illustrated* and an interview with Jorge Luis Borges for *Connoisseur*. I wrote a sports column for *Andy Warhol's Interview*, profiled rock stars for *Rolling Stone* and *Life*, interviewed orchestra conductors and opera singers for *The New York Times* and *Vanity Fair*—anything to avoid getting a job, especially if it came with an invitation to a voyage.

In 1986, I visited my first lost city. I had an assignment to write about the opera in Santiago de Chile, a revolutionary *Rigoletto* that has long since been forgotten. I routed my return through Lima, and from there booked a flight to Cuzco and the train to Machu Picchu. The night before I left on the trip, the Shining Path guerrillas bombed the train to the ruins, killing seven tourists. My mother called me up and begged me not to go, but it was too late. I had managed to get a reservation at the only hotel at the ruins, which had just twelve rooms, and I wasn't about to give it up. At that time most tourists to Machu Picchu took the train up for a day trip; no more than twenty-four visitors could tour the ruins by moonlight and see the sun rise behind the mountains. I would be among them.

My previous foreign travels had followed the path of most postcollegiate wanderers, to London and Paris, Tuscany and Rome; this would be my first visit to a truly exotic place. At Machu Picchu, I learned my first lesson in how fragile the romance can be. The hotel was clean and comfortable, but it had the thereless feeling of a motel on the interstate. Dinner was included; there was nowhere else to eat. I was seated with a couple from New York, jolly socialists of the City College variety, a species now nearly extinct. Comparing notes over mystery meat and mashed potatoes, we soon discovered that we were near neighbors in Greenwich Village. Very near: my rear apartment on Morton Street looked out on the same courtyard as their place on Commerce Street, just opposite. We feigned delight at the coincidence, but I think they were as disappointed as I was. The fantasy of a pilgrimage to Machu Picchu doesn't include meeting your back-fence neighbors. We resolved to resume our friendship in New York with a hallo from one fire escape to the other, but when I got home, I kept the curtains drawn.

A year later, I wrote a magazine profile of David Soren, an archaeologist who was directing an excavation of a Roman city in Cyprus that had been buried by an earthquake. He asked me to co-author a book about his dig. It was my first book, *Kourion: The Search for a Lost Roman City*. My toehold of an archaeological niche became more secure after *Kourion* was published, when my agent arranged an introduction to a paleoanthropologist named Russell Ciochon. Ciochon and his colleague the archaeologist John Olsen had been invited by the Institute of Archaeology in Hanoi to collaborate on a dig in Vietnam, on the border with Laos. It was the first joint program of field research carried out by scientists from the two countries since the end of the war, twelve years before. I got a contract to write a book about it.

Hanoi itself was something of a lost city in those days. We stayed at the Hoa Binh hotel in the Old Quarter, the only part of the city that was continuously electrified, at least in theory. At night, the city's residents sat on the sidewalk, smoking cigarettes and playing dominoes by lamplight. It was a quiet place, scarcely like a city at all. You rarely heard music, and television almost never. The only traffic noise was the whirr of bicycles. In 1988, there were no more than a few dozen passenger automobiles on the streets of Hanoi, and all of them belonged to party officials or foreign ambassadors. There were no tourists. We were admitted to the country on humanitarian visas, which entailed bringing in cases of vaccines from Thailand. The three of us were the only guests at the Hoa Binh apart from some lugubrious Bulgarian electricians and an Iraqi "diplomat," who was a fixture at the hotel bar. He plied us with questions about what we were doing, where we were going, who was paying for the expedition, but he was better company than the electricians.

On our first day in the city, after lunch at the hotel (bamboo rat, which tasted nothing like chicken, stuffed with white rice), we saw the city's sights: Ho Chi Minh's house, Ho Chi Minh's mausoleum, the Hanoi Hilton, and the Museum of the Vietnamese Revolution. We found the only private restaurant in the city that catered to foreigners, a small cadre of marooned journalists and burned-out philanthropists, which served a reasonable facsimile of

French bistro food. The specialty of the house was duck *à l'orange*, which savored of Tang.

The expedition in Thanh Hoa was a success, and my book was published the following year. It got a good review in *The New York Times*, which seemed like the most important thing in the world at the time. Yet in retrospect the most significant event of the trip came at the end, on the eve of our departure from Hanoi. Russ Ciochon and I were wandering through the Old Quarter and came upon a trim bamboo house flying the flag of the People's Republic of Kampuchea, the puppet government installed by the Vietnamese after they invaded Cambodia in 1979, ending the disastrous, bloody regime of the Khmer Rouge. We were greeted by a remarkably cheerful man named Bun Sambo, who appeared to be the only person there. He made tea for us, the necessary preliminary to any conversation, and then asked what he could do for us. It was an easy question. I replied, "We want to go to Angkor."

When we first met, Ciochon and I bonded over our shared life-long passion for the ruins of Angkor in central Cambodia, the classic model of a lost city in the jungle. We had collected nearly identical Angkor libraries, starting with the April 1960 issue of *National Geographic*, which featured the article "Angkor, Jewel of the Jungle," by W. Robert Moore. The story was accompanied by a series of lurid paintings, alternately sexy and gory, that depicted life in Angkor at the zenith of the Khmer Empire. Ciochon and I had both read the old French archaeological studies and a madly overwritten memoir of an Angkor pilgrimage by the French travel writer Pierre Loti. Loti's rapturous descriptions of the ruins promised an experience that fell somewhere between a religious vision and an orgasm.

Mr. Bun smiled and said, "You want to go to Angkor? I can arrange that for you."

And so he did. Six months later, Ciochon and I flew to Siem Reap, the town near the ruins, and checked into the Grand Hotel d'Angkor. In its decaying art deco magnificence, the hotel looked like an exile from the Riviera, condemned to molder in the jungle. The lobby ceiling soared twenty feet overhead, making the sagging rattan furniture look dwarfish. The room reeked of the signature

fragrance of the tropics, a heady mélange of mildew, fermented fish paste, and bug spray. Spiders had colonized a Parisian-style cage elevator, a former marvel of modernity that hadn't ascended in decades. After we checked in, Ciochon, sick with the usual complaint, ran to the room. I sent up four bottles of cold lemonade and returned to the waiting car.

I had promised Ciochon that I would save Angkor Wat, the largest and most famous temple, for him and told the driver to take me to Angkor Thom. The capital of the ancient empire, Angkor Thom occupies six square miles of cleared tropical forest, crowded with ornately carved stone temples and palaces. When the French naturalist Henri Mouhot came here in 1860, he found the place completely overgrown by jungle vegetation. In a burst of enthusiasm, he declared that the ruins of Angkor were "grander than anything left to us by Greece or Rome." When he asked the people living among the monuments who had built them, they answered: "It is the work of the King of the Angels"; "It is the work of giants"; even, "They built themselves."

I knew the layout of Angkor Thom by heart from a guidebook by the archaeologist Henri Marchal, published in 1928. The city is walled and moated, accessible by five monumental stone gateways surmounted by towers with four identical faces at the cardinal directions, smiling serenely into the jungle. The identity of the Angkor face, which is found everywhere in the ruins, remains a mystery. It has been variously identified with the Hindu god Brahma, the popular bodhisattva Lokesvara, and Jayavarman VII, the twelfth-century king who built many of the principal temples. The image could have served all three cults at once.

At the center of Angkor Thom rises the Bayon, an eccentric labyrinth of corridors and courtyards described by Loti as "this basilisk phantom, a bridge to ancient times, constructed with cyclopean blocks." Literally a labyrinth: wandering around the Bayon, one easily gets lost or comes to a dead end. The walls are covered with fine bas-reliefs depicting scenes of war and domestic life, interspersed with hundreds of images of elegant *apsara*, usually translated as "celestial nymphs." The upper level is crowded with four-faced towers like those on the city gates. Even authori-

tative sources disagree as to how many towers there are: most say fifty-four, while one scholar goes as low as thirty-seven surviving of the original forty-nine. I tried to count them, but no matter how methodically I went about it, I kept losing track, just as the driver had warned me I would. I returned to the hotel for lunch, where I was attended by a dozen adolescent boys wearing dirty white shirts missing buttons and skinny black ties.

As the afternoon sun declined, Ciochon had recovered sufficiently to accompany me to Angkor Wat. Called the largest stone monument and the largest religious building in the world, it occupies a square mile, constructed from pale gray fine-grained sandstone carved with a delicacy that exceeds the other ruins of Angkor. The central tower takes the shape of a colossal lotus bud, rising to a height of two hundred feet, lording over the forest for miles around. We roamed the grounds of the temple guided by a demented old man with a stiff brush of white hair named My Huy, who said he had been trained by French archaeologists. He told me that he had survived the Khmer Rouge era by lying awake in bed for hours every night, continually gripping and turning a rough stick in his hands, which raised calluses that enabled him to pass for a peasant and avoid summary execution as an "intellectual." A pair of cowherds, boys no older than ten, drove their charges at a discreet distance behind us, the *thok-thok* of wooden cowbells setting a gentle, strolling pace.

Ciochon and I were the only guests at the Grand Hotel d'Angkor. At dawn, when I opened the door to our room, I found the waiters seated cross-legged on the floor in the corridor, peering up at me hopefully, like a class waiting for the teacher. In fact, that was exactly what they had in mind. Their ostensible purpose was to practice English conversation, but what they really wanted was to bask in my splendid blond otherness.

The waiters' attempts at speaking English were mostly a waste of time, for few of them possessed sufficient vocabulary to construct simple sentences. However, the headwaiter's English was amazingly good. His name was Munny, which means "clever" in Khmer; it might have been a nickname, because he was. After the boys escorted Ciochon and me to the dining room for American

breakfast (latex fried eggs and a single Vienna sausage, served with asbestos toast), Munny started up a conversation. He said he had learned English by listening to the BBC and the news in Special English on VOA. Munny knew nothing but was curious about everything. Is it true that American people went to the moon, or was it a trick? If America is the richest country, then why is your money not worth as much as British money? What is a Jew? He kept creeping closer, with the other waiters just behind him, until their elbows were on the table. Ciochon, less interested in these simple country lads than I was, suddenly brandished a fork at them and yelled, "Scram!" They scattered, shrieking with laughter.

Ciochon and I set out to see every stone of Angkor. In 1989, the Khmer Rouge still controlled much of the district, so if we wanted to venture beyond the walled confines of Angkor Wat or Angkor Thom, or go anywhere after dark, we had to be escorted by soldiers, more silly adolescents, loaded into a jeep with Kalashnikovs. The reason the country's workforce seemed to be almost entirely in its teens was that so many young men had died during the brutal four-year regime of the Khmer Rouge. The soldiers detailed to guard us, like the waiters at our hotel, were young enough to have escaped the roaming execution squads that decimated the country. My Huy told us that many of them were government soldiers during the day and KR by night.

I wanted to visit a minor temple called Baksei Chamkrong, which dates to the early tenth century, making it one of the earliest sites in the Angkor district. It bears a curious resemblance to early lowland Maya pyramids, an interesting case of cultural convergence. Baksei Chamkrong was just off the main road to Angkor Thom, but because it was outside the ancient city walls, we were required to bring the soldiers with us. It was midday and the forest was thin, so the chances of encountering the Khmer Rouge appeared to be nil, but having a military escort made it more of an adventure. As a pair of soldiers led the way down the short path to the temple, I saw a lizard dart in the underbrush and chased after it. My Huy became hysterical. He shrieked, "No! No, no, *no*! You must never leave the path! You must always stay on the path. You must put your foot where the soldier puts his foot."

Then I realized that he was afraid I might step on a land mine. There were thousands of unexploded mines in the fields and forests of Cambodia; in the market in Siem Reap, we often saw beggars missing one or both legs, farmers who had stepped on a mine and survived. I contritely returned to the path. My Huy repeated, "You must always put your foot where the soldier puts his foot."

I answered, "But if the soldier steps on a mine, he may die."

"Pfeh." The old man shook his head impatiently. "No problem if the soldier dies, he is Khmer person. Big problem if American guest dies."

The site that Ciochon and I most wanted to visit was Banteay Srei, an exquisite Angkorean temple constructed from rose-colored sandstone carved in an ornate style unique to itself, sixteen miles northeast of the main group of ruins. However, at that time Banteay Srei was a full-time Khmer Rouge encampment and firmly off-limits to all visitors. Ciochon, the scientist, tested this assertion by frequently displaying an American hundred-dollar bill to the police in Siem Reap and requesting an escort to Banteay Srei, which elicited not even a flicker of interest. Weary of his entreaties, the constabulary finally offered as a consolation to take us to Preah Khan, a major temple just beyond the north wall of Angkor Thom, which had been closed for decades. A force of forty soldiers was mustered, armed with bazookas and rocket launchers in addition to the usual Kalashnikovs; forty more infantrymen were stationed around the perimeter.

The soldiers also carried *phkok*, the local machete, which they used to clear away the dense vegetation so we could make our way inside. Before we entered the temple precincts, they hacked away masses of vines to reveal a deep-relief wall sculpture of Garuda, the Hindu bird-god, mount of Vishnu. It was fearsomely hot, and the soldiers were tormented by fire ants and big black flies as they chopped away at the tapestry of vegetation that covered the entrance. Then one of them screamed: a krait on a vine overhead had fallen on his neck. He killed the serpent before it bit him, which saved his life, for the venom of the krait kills very quickly, and the hospital in Siem Reap was a bamboo shed with a dirt floor.

That night, I added superb romance to my perfect jungle adventure. I was intrigued by this passage in Marchal, in his description of the Bayon: "At whatever hour one walks around it, and particularly by moonlight on a clear evening, one feels as if one were visiting a temple in another world, built by an alien people whose conceptions are entirely unfamiliar." After we left Preah Khan, a thundershower swept across the plain of Angkor, leaving the sky sparkling clear, and I knew that that night there would be a full moon, or near it; so Ciochon and I returned to the Bayon after dinner to tour it by moonlight. I could embroider on Marchal's description of the experience, but basically he got it right. The moonlight was extraordinarily bright: I read the guidebook to Ciochon without using my flashlight, just to prove that I could. I felt a shiver when the faces on the towers looming overhead melted into view, here and there and far in the distance, then receded into the gloom when a puff of cloud passed over the moon. Periodically, the metallic buzz of the insects rose to a roar and then quickly fell quiet, so you could hear the breeze in the pine trees surrounding the temple. Even the soldiers spoke in whispers.

On the morning of our departure, I gave tips to the staff of the Grand Hotel, two one-dollar bills for each of them. (I had brought a stack of singles, knowing it would be impossible to get change for big bills here.) The lads were astounded to receive such a treasure; they knew they hadn't done anything to earn a tip except follow me around. They were crisp new notes, obviously worth a great deal more than Cambodian money, the filthy stuff we bought in pulpy bricks on the black market. It took millions of riel to buy anything at all. Munny studied the bills carefully. Pointing at George Washington with obvious disdain, he asked, "This is your king? He looks like a lady."

After I got home, I came to the realization that the power Angkor exerted over my imagination derived only in part from its geographic remoteness from Texas and Greenwich Village. Even more potent was the romantic allure of a place that had escaped time. A lost city is a fragment of the past, immured from change

and thus insulated from the persistent sense of loss in the dynamic life of a modern city. Victor Segalen, a Breton naval doctor who traveled extensively in Polynesia and China from 1903 to 1917 and wrote novels, poetry, and essays based on his experiences, was at work on a comprehensive theory about this subject at the time of his death in 1919. Segalen's working title was *Essay on Exoticism: An Aesthetics of Diversity.*

In his earliest surviving sketch of the essay, written "within sight of Java" in October 1904, he noted, "Argument: Parallelism between stepping back in time (Historicism) and moving out in space (Exoticism)." Four years later, he set as his first goal in the essay to "throw overboard everything misused or rancid contained in the word 'exoticism.' Strip off all its rags: palm tree and camel; colonial helmet; black skins and yellow sun." He liberated the concept from its exclusively geographic meaning: "Exoticism does not only exist in space but is equally a function of time." Thus Angkor is more closely related to Machu Picchu than to the villages of modern Cambodia, and people who reenact Civil War battles inhabit a more exotic space than those who go to Singapore and shop at the luxury malls on Orchard Road.

For Segalen, exoticism "is nothing other than the notion of difference, the perception of Diversity, the knowledge that something is other than oneself." He postulated an elite group of travelers who seek to immerse themselves in otherness, whom he called "exotes," in contradistinction to the "impressionistic tourist," a contemptible creature epitomized by Pierre Loti, whom Segalen condemned as a "pimp of the exotic." Exotes, he wrote, are travelers who "recognize, beneath the cold and dry veneer of words and phrases, those unforgettable transports which arise from the kind of moments I have been speaking of: the moment of Exoticism." For me, the unforgettable transport came not when the soldiers hacked away the jungle vines so I could enter the ancient temple of Preah Khan, or when I toured the Bayon by moonlight, but when Munny asked if George Washington was my king. This Cambodian farmer's son had stopped me cold. I looked into Munny's smooth, unformed face and could no more read it than if it were a text in a lost language, an inscription on a fallen stone

pillar in the jungle. He was a living connection with another world, an alien people whose conceptions were entirely unfamiliar to me.

After our trip to Angkor, Russ Ciochon and I traveled to the other major archaeological sites of Southeast Asia. He got us little grants here and there to pay expenses on the ground, and I sold stories to *Natural History* and *Archaeology* magazines to cover my airfare. We saw the two thousand pagodas of Pagan, Burma; we visited Luang Prabang, the ancient royal capital of Laos, and the Plain of Jars, a megalithic enigma that has not yet been solved; working from a sixty-year-old French monograph, we made our way to all the recorded ruins of the kingdom of Champa, dispersed along the coast of Vietnam from Ho Chi Minh north to Hué, the imperial capital of the Nguyen Empire, a scaled-down knockoff of the Forbidden City. In the early 1990s, all these places were still fairly isolated and visited by very few tourists, but I was never able to replicate the template experience at Angkor.

As Ciochon and I ran out of lost cities in Southeast Asia, I looked farther afield, and my freelance career flowed into the mainstream of travel writing. India, source of the religious traditions that inspired the empire builders of Southeast Asia, was the logical next stage. I toured the earliest shrines of Buddhism in Sanchi, Bhimbetka, and Udayagiri; I celebrated Diwali, the Hindu festival of lights, at the palace of the maharaja of Bhopal, where the garden was lit by hundreds of tiny, fragrant oil lamps. The Taj Mahal, of course. In Kathmandu, I saw men washing the corpses of their fathers on the ghats along the Bagmati River, preparing them for cremation. I made the pilgrimage to see the Great Buddha of Kamakura. Voyaging ever further back in time, I toured the pyramids of Giza and the Sphinx, the rock-cut city of Petra, the ruins of Ephesus and the Mausoleum at Halicarnassus, the fallen stones of the Pharos in the harbor of Alexandria, the monastery of St. Catherine in the Sinai. The Athenian acropolis, of course.

The risk of a career as a travel journalist is that you may become a traveler more than a writer. I began to seek assignments that would take me to the places I wanted to go rather than to those where I would find the best stories. I frequently toured in a high style of

luxury—not because I had a weakness for champagne and foie gras, or wanted rose petals strewn in my marble bathtub, but because traveling as a journalist was the easiest way to see the world. Being an invited guest does entail a certain ethical dilemma, which is often overestimated: I was no more likely to give a hotel or even the destination itself a good write-up because I wasn't paying the bill than a theater critic is to publish a positive review of a bad play because the tickets are on the house. Nonetheless, the editorial brief was always, at least in part, to make the destination attractive (otherwise known as pimping the exotic). It wasn't a question of publishing untruths so much as verbal airbrushing, smoothing away the unflattering features.

Yet, after all, you learn a lot by seeing the world. One lesson I learned is that where you call home doesn't matter nearly as much when you're about to head off to a legendary place you've always dreamed of visiting. Like most domestic immigrants in New York, I was an enthusiastic believer in the city's supremacy, but as I spent more time abroad chasing the moment of exoticism than I did in New York, I found myself growing less susceptible to feeling homesick. A perfect bowl of rice is just as satisfying as a perfect bagel, and a shadow-puppet drama performed by torchlight in a Javanese village is more exciting than most nights at the Met. If you want urban buzz, Hong Kong and Tokyo leave the West behind.

The insoluble problem with travel as a way of life is that it becomes an end in itself. You never arrive. In the mid-1990s, I discovered cruising, an efficient way to visit a string of destinations without having to pack and unpack. On a Crusades-themed cruise to the Levant, I met a lady of a certain age from Santa Monica named Inez who belonged to the Travelers' Century Club. The only qualification for membership, she said, is to have traveled to a hundred countries. Inez admitted that the list of countries was rigged: Hawaii and Alaska counted as countries, and in the days of the U.S.S.R., if your ship docked at Leningrad, you got credit for all fifteen Soviet republics. The Travelers' Century Club seemed to have even less point to it than the Mile High Club. Traveling with the object of ticking countries off a list robs the very concept of novelty of its novelty.

I never pursued such an acquisitive approach to travel, but some-times the destinations blurred together. Every now and then, jet lag would awaken me before dawn in a hotel room, and for a moment I would forget where I was. The surroundings were familiar: the room temperature was perfect, the supersoft bedsheets were combed Egyptian cotton with a desirably high thread count (what-ever that was), the fragrant toiletries in the bathroom were from Floris or Hermès, or better yet some desperately chic *parfumerie* du jour. I was in Luxury Land, and it was as distant from the Grand Hotel d'Angkor, vintage 1989, as my apartment on Morton Street.

My career as a world traveler effectively ended with that Cru-sades cruise. The last shore call was a day trip to Jerusalem that managed to squeeze a complete pilgrimage into twelve brisk hours. Bus departs Haifa harbor at six o'clock for the two-hour drive, first stop Manger Square in Bethlehem. There we had a parking place by the entrance so we could jump the queue and file past the birth-place of Jesus, which was marked by a brass plate in an alcove hung with a sequined lavender curtain, like the stage of a marionette theater. Once in the city, we power walked the Via Dolorosa, back on the bus for a quick swing by the Mount of Olives, kosher set lunch at the King David Hotel, the Israel Museum (straight to the Dead Sea Scrolls, optional detour to see the Rembrandt), then the Wailing Wall, Dome of the Rock, Al-Aqsa Mosque, and finally the Church of the Holy Sepulchre.

The holiest place in Christendom at closing time was packed solid, like the mosh pit at a Nirvana concert, with a distinct air of hysteria. Every few minutes there was another shrill polyglot an-nouncement about lost children. I had buddied up with Inez, who panicked in the crush outside the narrow entrance to the sepulcher itself. She squealed, "My feet are not touching the floor!" I disengaged her from the pious mob and ferried her to safety, but when we got back on the bus, she was disconsolate because she hadn't persevered and entered the sanctum sanctorum. The cruise director handed out pink certificates proclaiming that the bearer had completed a pilgrimage to the Holy City of Jerusalem, listing all the places we had visited. Inez, a devout Catholic, tearfully refused to take hers.

As the coach sped down the dark motorway back to the port, I thought about what I would write in my journal. My journal was supposed to be, at a minimum, a record of places seen and people met, all spelled correctly and with enough detail to allow me to reconstitute a narrative later if need be, but I had my detailed certificate of pilgrimage, and we had moved too fast to meet anyone. I settled on a passage I had read in a memoir of a pilgrimage in 1480 by Santo Brasca, a noble minion of the Sforzas in Milan. He admonished, "Let no man go to the Holy Land just to see the world, or simply to boast 'I have been there' and 'I have seen that,' and so win the admiration of his friends."

The last lesson I learned is that home can be a choice. I found my stopping place in Bali, where I went to live in 1999. Indonesia came late in my travels, as I was becoming aware of the limits of the traveler's life. In 1995, I flew to Jakarta to profile the novelist Pramoedya Ananta Toer, and by the end of the week I had fallen in love twice, with Indonesia and with my partner, Rendy. My interest in other destinations fell off drastically, and I returned to Jakarta as often and for as long at a stretch as I could manage. I made friends with a circle of American and British expatriates my age who had come to Indonesia after college and settled there. It took me no time at all to envision myself living their lives, with a housekeeper and a driver to take care of me. I would have a garden, bigger than the ones kept by millionaires in Manhattan brownstones.

I was in Jakarta in May 1998, when the country's dictator, Suharto, was brought down by mass demonstrations. I sat up until the wee hours with friends and strangers of all ages who were exhilarated by their nation's rebirth as a democracy. They were hopeful and idealistic and excited in a way I hadn't seen since I participated in antiwar rallies when I was a college student—with the huge difference that this was for real. For Indonesians, "Smash the state" wasn't an empty slogan: they did it! When I returned to the United States at the end of that year, the country's business came to a halt for the impeachment and trial of Bill Clinton. I was transfixed with disgust. So when Rendy sent me a fax proposing that we find a house in Bali, where he intended to open a restaurant, I said yes in a New York minute.

I made my move to Indonesia on April 1, 1999. My initial escape was planned as a completely reversible decision. I got a year's leave from my job as an art reviewer at *The New Yorker*, I found a nice British couple to sublet my apartment, and I booked a ticket: it was easy. There was no going-away party, because my friends thought it was an April Fools' Day prank and I would be back at the end of the year. I didn't make any promises, but I didn't think I would be coming back.

I spent my last night as a New Yorker alone, happily packing. Clothes were simple; you can wear shorts, T-shirts, and sandals anywhere in Bali. I filled the venerable collegiate footlocker with books, which required more thought: they are one necessity in scant supply in the tropics. *Richard Halliburton's Complete Book of Marvels* wasn't a candidate for export, but I took it off the shelf and leafed through it again. My grandmother's book was now an antique. It opened in my hands at the photograph of the weird mud-brick mosque of Timbuktu, and I felt a keen twinge of desire to see it in this life. Then it occurred to me that the real hero of the book wasn't Halliburton but Père Yakouba, who repudiated a sacred vow to stay in the place he called home.

The Studio of the Tropics

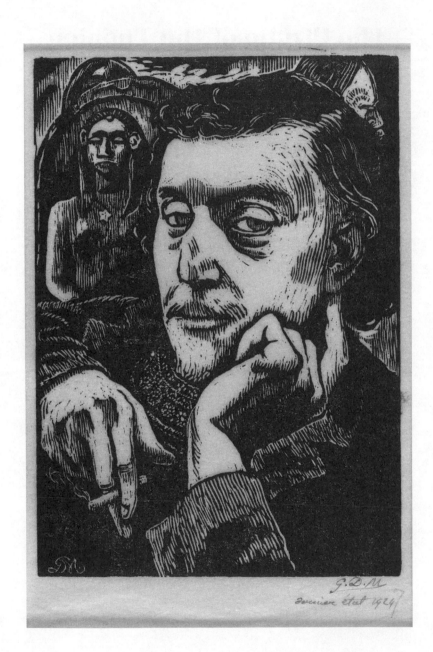

G.D.M
dernier état 1924

When Paul Gauguin announced his intention to leave Paris for Tahiti in 1891, he was feted and toasted like a general on the eve of his departure for the front line. The elite of the avant-garde hailed him as a bold adventurer who was bursting the bonds of corrupt, decadent civilization to return to a pristine state of nature, where he would forge a new artistic vision. Gauguin had begun his career as an artist exceptionally late in life, in his mid-thirties. After he resigned a lucrative position at the stock exchange, he tried his hand at a succession of commercial jobs, including a stint as a tarpaulin salesman in Copenhagen, though he could not speak a word of Danish, and he failed at all of them. Improbably, he took up painting to make money. First he followed the impressionists,

under the kindly tutelage of Camille Pissarro, a Creole artist from the Danish West Indies who began his career in Venezuela before moving to France when he was twenty-five. After the brilliant success of the pointillists Georges Seurat and Paul Signac in the late 1880s, Gauguin searched for an equally novel, eye-catching style.

He hitched his wagon to Symbolism, the Next Big Thing in literature. Symbolism had the advantage of being a philosophy or theory more than a style; no one knew exactly what it meant in the visual arts beyond the general requirement that sex and death be present in plenty, preferably conjoined in dreamlike settings spiked with spooky allusions to Edgar Allan Poe, a Symbolist idol. The movement had its presiding genius in Stéphane Mallarmé, whose landmark poem "L'après-midi d'un faune" defined the new sensibility. With his symphonic setting of Mallarmé's poem, *Prélude à l'après-midi d'un faune*, Claude Debussy established his claim to the mantle of Wagner, the movement's musical god, but no visual artist had yet gained ascendancy. Odilon Redon's paintings and pastels were full of puzzling, Poe-ish images—an eyeball floating in the sky like a balloon, a spider with a human face—but his vision was too idiosyncratic to attract disciples. Gustave Moreau's extravagant mythological scenes, set in Gothic interiors gleaming with brilliant puddles of jewel-like impasto, were closer in spirit to Jules Massenet's archaistic grand operas about doomed pagan queens than to the ongoing revolution in painting.

An urgent need was felt for a new artistic vision for the future, and Gauguin was determined to fill it. He already had a coterie of disciples, notably Vincent van Gogh, who idolized him with a schoolboy crush. For a few disastrous months in 1888, the two painters shared a house in Arles, where they conceived the dream of the Studio of the Tropics. They proposed to arrive at a new artistic vision not by developing a gimmicky stylistic innovation like pointillism but with a new world of imagery, by abandoning Europe for an exotic culture. Arthur Rimbaud had set the paradigm with his definitive move to Africa in 1880, after a feint to Java, posing as a mercenary soldier.

It is unlikely that Rimbaud's name came up at the going-away parties for Gauguin, but the older celebrants remembered him, the

impossibly pretty sixteen-year-old schoolboy who ran away from his mother's house in Charleville, in the Ardennes, and showed up on Paul Verlaine's doorstep in 1871, with his astonishingly original poetry clutched in his hot little hand. Verlaine, ten years his elder, fell headlong into a demented, lustful passion. Verlaine dragged his marvelous boy into the inner circle of avant-garde Paris, where he enjoyed the Belle Époque equivalent of his fifteen minutes of fame, but Rimbaud, who was initially likened to the child Jesus teaching the elders in the temple, soon revealed himself to be a sociopath, intent on picking quarrels with the artistic poseurs of Paris, which by his reckoning included everyone except himself and, when he was feeling sentimental, Verlaine. Two years later, driven to the tipping point of madness, Verlaine shot him in the arm during a screaming fight in Brussels. After a scandalous trial, which exposed intimate details of their relationship (including the results of a detailed proctologic examination), Verlaine was sentenced to two years in prison.

In Paris, the establishment sided with Verlaine, one of their own, and ostracized Rimbaud, whose poetry was simply too puzzling for the literati of the Parnassian generation. In the twentieth century, readers and critics reversed the poets' roles: Verlaine's exquisitely crafted lyrics came to be seen as pleasant pastels, while Rimbaud's heartless, godless mysticism made him a modernist icon. Rimbaud's contemporary reputation is grounded in what came to be known as the *Lettres du voyant* (Seer letters), written when he was sixteen, in which he expounded his aesthetic philosophy. In a letter to his teacher and friend Georges Izambard, he announced his vocation as a poet: "I hardly know how to explain it to you. The point is to arrive at the unknown through the disordering of *all the senses*. The sufferings are enormous, but one must be strong, to be born a poet, and I have discovered myself to be a poet." He continues with his often-quoted motto: "*I* is someone else." After Izambard published the letter in 1928, Rimbaud's apotheosis as a master of the modern was complete.

Yet in 1873 he was a penniless provincial guttersnipe who had published almost nothing and alienated everyone who was in a position to help him. With his beloved mentor ruined and rotting

in prison, Rimbaud responded as he did to every crisis: he ran away. After his abortive jaunt to Java, he exiled himself to the desolate wasteland of Harar, Abyssinia, a move he had prophesied in *A Season in Hell*: "My day is done; I'm leaving Europe. The sea air will burn my lungs; lost climes will tan my skin. To swim, to trample the grass, to hunt, above all to smoke; to drink liquors strong as boiling metal—as my cherished ancestors did around their bonfires. . . . Now I am cursed, I loathe my country. The best thing for me is a good drunken sleep on the beach."

It is uncertain whether Gauguin knew *A Season in Hell*, but it is likely. He was close friends with Verlaine, who had started a campaign to revive interest in the poetry of his vanished demon lover. Regardless, the passage serves uncannily well as a predictor of Gauguin's future life too. The concept of the Studio of the Tropics had been on the painter's mind for years, even before he met Van Gogh. In 1887, chasing yet another will-o'-the-wisp to make money without working too hard, he had sailed to Panama to assist his Peruvian brother-in-law in a misconceived plan to dig a sea-level shipping canal across the isthmus. He wrote to his wife, "I am going to Panama to live like a savage. . . . I will take my colors and brushes and I will rebaptize myself far from humankind." The Panama scheme was a bust, but on the way he stopped in Martinique for six months, where he produced his first manifestly original work, paintings that are recognizable to the modern eye as Gauguin's.

The choice of Tahiti was somewhat arbitrary; he and Van Gogh had also considered Madagascar, Tonkin, and Java, where Rimbaud had trampled the grass. The point was to quit Europe for a place untainted by "civilization," the bête noire of Enlightenment philosophers. Gauguin tipped toward Tahiti after Van Gogh lent him a trashy, titillating novel, *The Marriage of Loti*. (Julien Viaud, its author, adopted Pierre Loti as his pen name after the success of this, his second book.) The novel is almost plotless, little more than a series of vignettes about the erotic adventures of a French sailor in Tahiti, couched in coy innuendo. Since the early accounts

of the European voyages of discovery in the South Pacific, particularly Louis de Bougainville's *Voyage Round the World*, published in 1771, Tahiti was notorious as a place where free love flourished, where women and young girls never covered their bosoms and enthusiastically offered themselves for sex to all visitors.

Bougainville claimed the island for France and called it New Cythera, after the birthplace of Aphrodite. His ship's naturalist, Philibert Commerçon, an ardent student of Jean-Jacques Rousseau's philosophy, established the broad outlines of the myth of Tahiti, the tropical paradise: "Born under the most beautiful of skies, fed on the fruits of a land that is fertile and requires no cultivation, ruled by the fathers of families rather than by kings, [Tahitians] know no other Gods than Love. Every day is dedicated to it, the entire island is its temple, every woman is its altar, every man its priest." While the expedition was anchored in Tahiti, Commerçon's valet, Jean, was revealed to be a Jeanne, his lover, anticipating the plots of myriad comic operas and swashbuckling romances. Although Jeanne Baré had deceived the sailors for months with her male impersonation, the Tahitians divined her sex immediately, which was taken as a proof of their superior proficiency in the art of love.

According to the myth, Tahiti was also a land of easy living, where every necessity of life was provided by nature, thereby releasing its people from both want and debt, for there was no money. However, the God of Love soon fell sick with syphilis and other diseases brought by European sailors, who also sullied the island's purity by introducing commerce. When HMS *Dolphin*, a British frigate commanded by Samuel Wallis, stopped in Tahiti in June 1767 (preceding Bougainville by less than a year), Tahitian women discovered that they could demand payment for their sexual services, in the form of an iron nail. Soon the *Dolphin*'s timbers were shivering for want of nails. Wallis, when he saw that his ship was on the verge of falling to pieces, canceled all shore leaves and threatened to flog any man who broke the order, but some sailors vowed that they would rather be flogged than give up their amorous revels.

Rousseau began his treatise *The Social Contract* with the

rousing declaration "Man is born free, and everywhere he is in chains," but Wallis and Bougainville proved him wrong by discovering a country that Rousseau himself could have invented, where humankind exulted in freedom throughout life. It was a veritable land of Cockaigne—and furthermore it was a French colony. In 1890, Gauguin wrote to Odilon Redon, who had admired his recent paintings, "I want to go to Tahiti and finish my existence there. I believe that the art which you like so much today is only the germ of what will be created down there, as I cultivate in myself a state of primitiveness and savagery." The Studio of the Tropics offered strong existential enticements as well as the promise of artistic inspiration. To Gauguin, sexually frustrated and perpetually in debt, Tahiti sounded like just the place to start a new life, which would be supported by the artworks he would create there for the Paris market.

The key to winning the patronage of the Symbolists was to make a conquest of Mallarmé, and to this end Gauguin befriended a minor writer named Charles Morice, who idolized him as Van Gogh had done. Morice secured an invitation for Gauguin to attend Mallarmé's legendary salon, held every Tuesday at his tiny flat in the rue de Rome. Gauguin cut a dash at his debut at the Symbolists' headquarters, wearing a floor-length scarlet cape and brightly painted sabots, and wielding a walking stick with the image of a reclining female nude carved on the knob. He looked like a pirate or wizard from *The Arabian Nights* among the bourgeois poets and painters and their hangers-on, dressed in buttoned-up suits. Gauguin himself was a living symbol ready-made for the Symbolists, who like all Frenchmen of their era were steeped in the literature of noble savagery and primed to see a hero in flamboyant Gauguin.

They organized a series of farewell banquets and fund-raisers in his honor, starting with an auction of his paintings at a hotel in Montmartre. Morice persuaded Mallarmé to recruit Octave Mirbeau, a critic for *Le Figaro* and the author of a scandalous pornographic novel, *The Torture Garden*, to publicize the auction by writing a puff of the artist. In a letter to Mirbeau, Mallarmé wrote that Gauguin "feels the need to be able to concentrate in isolation

and virtual savagery. He wants to set off for Tahiti, to build a hut and live amongst what he has left of himself over there, to work afresh and become truly himself." Getting down to business, Mallarmé explained that Gauguin needed six thousand francs to carry out his experiment, and the "successful sale of his current works can provide him that sum. . . . We are not talking about anything commercial. Just something to draw attention to the strange case of this refugee from civilization." With Mallarmé's active support, the auction brought in 9,680 francs for thirty canvases.

A week before Gauguin's departure for Tahiti, a triumphal banquet was held at the Café Voltaire, the Symbolists' public club-house. Mallarmé proposed a toast: "We drink to the return of Paul Gauguin, with admiration for this superb mind, which, in the brilliance of its talent, seeks exile in order to be washed new, in faraway lands and within himself." Mallarmé's celebrated translation of Edgar Allan Poe's poem "The Raven" was recited, as it was two months later, at another fund-raiser. Held at the Théâtre d'Art, it was an evening of theater headlined by Maurice Maeterlinck's play *L'intruse*, which made his career, paired with Charles Morice's first play, *Chérubin*, a disaster that destroyed his. At a third event, a "Symbolist banquet," Jean Moréas, who had published a manifesto for the movement five years before, pronounced Gauguin to be the leader of the new school of painting.

It would be overstating the case to say that Gauguin saw Tahiti as a gimmick that would make his work more marketable, but it would also be a mistake to accept his fervent restatements of Enlightenment ideals and his announced intention to embrace a primitive life as his principal motive. In his ruthless pursuit of sales as much as by his stylistic innovations, Gauguin anticipated what would come to be known as the art world. Susceptible to flattery but almost incapable of bestowing praise, he had little to say at these lionizing galas. Yet he showed his gratitude to Mallarmé by presenting him with a fine portrait, an etching of the poet looking young and resolute, with his signature raven peeking over his shoulder. Pissarro, sloughed aside after Gauguin embraced Symbolism, bitterly wrote to his son that Gauguin was trying to "get

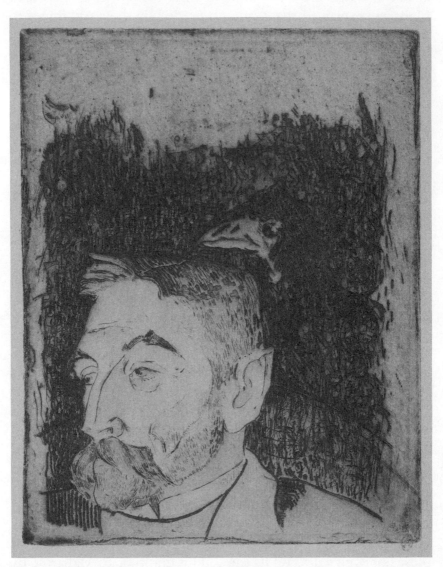

Portrait of Stéphane Mallarmé, etching by Paul Gauguin, 1891

himself elected (that is the word) man of genius, and how skillfully he went about it!"

If Gauguin was cynical in his quest for patronage, he had good reason to be. In his journal, he wrote this brutal report of the Symbolist banquet:

> Stéphane Mallarmé presides; opposite is Jean Moréas, the symbolist. The guests are symbolists. Perhaps they are lackeys, too. . . . We are dining; there are toasts. The president begins; Moréas replies. Clovis Lugnes, ruddy, long-haired, exuberant, makes a long speech, naturally in verse.
>
> [Maurice] Barrès, tall and slender, clean-shaven, quotes Baudelaire in a dry fashion, in prose. We listen. The marble is cold.
>
> My neighbor, who is very young but stout (superb diamond studs glitter on his many-pleated shirt), asks me in a low voice, "Is Monsieur Baudelaire with us tonight?"
>
> I scratch my knee and answer, "Yes, he is here, down there among the poets. Barrès is talking with him."
>
> He: "Oh! I should so much like to be introduced to him!"

Gauguin himself viewed his exile in Tahiti not as a brave, idealistic experiment so much as an escape from the smug stupidity that plagued the artistic milieu in Paris, which had harried Baudelaire to his grave (and even, as we see, thirty-three years after he was laid in it). Gauguin's biographers have at their disposal a wide choice of quotations from the artist extolling the imagined bliss of life in the tropics, borrowed opinions with a pedigree that begins with Philibert Commerçon and continues without interruption to *The Marriage of Loti*. Gauguin wrote to his wife, "There, in Tahiti, in the silence of the lovely tropical night, I can listen to the sweet murmuring of the music of my heart, beating in amorous harmony with the mysterious beings of my environment. Free at last, with no money troubles, and able to love, to sing, and to die."

He was obviously trying to convince himself (and annoy his wife). These naïve rhapsodies should be balanced by Charles

Morice's account of Gauguin breaking down in tears after the decision became irrevocable. Gauguin told Morice that he had never been able to support his family and pursue his art in France, "and now that I can hope for the future, I feel more terribly than I have ever felt the horror of the sacrifice I have made, which is utterly irreparable." On April 1, 1891, Gauguin embarked on the *Océanien*, ship of the line of Messageries Maritimes, dressed as a cowboy, wearing a hat he had bought at Buffalo Bill Cody's show in Paris. Packed with the paints and brushes in his luggage were the gifts he had received on his farewell tour: a shotgun for hunting game in the wilderness and a French horn, guitar, and two mandolins for *soirées musicales* with the rhythmical natives.

The reality of Tahiti, of course, quickly proved to be vastly different from his voluptuous fantasy. Gauguin had let his hair grow long on the voyage, so by the time he arrived in Papeete, it hung to his shoulders in a mass. The Tahitians had never seen a Frenchman who looked like that, which must have been his intention, but they assumed him to be the equivalent of their own *mahu*, effeminate men who lived as women, and teased him with good-natured raillery. Gauguin was unprepared to see the Tahitian women completely covered up in long, dowdy muumuus called Mother Hubbards, which had been introduced by puritanical Christian missionaries intent on suppressing native licentiousness.

His dream of Tahiti revived two days after his arrival, when he was invited to meet the island's royal family, which he hoped would result in lucrative commissions. Pomare V, the last king of Tahiti, had abdicated ten years before and was now scarcely even a figurehead, having surrendered all his powers except the privilege of calling himself a king and flying the defunct Tahitian flag at his residence. On the day appointed for Gauguin's presentation at the sham court, Pomare died. He was given a Catholic state funeral, and at its conclusion the Tahitian flag was lowered at the royal residence for the last time and the French tricolor raised in its place.

Gauguin was a pioneer of a new vision of travel as a one-way proposition. It wasn't travel, exactly; his voyage to Tahiti aboard the

Océanien was nothing more than the means of relocation. He was not the first to escape, as we know; Rimbaud had preceded him by eleven years with his decision to move to Africa, a land he had never set foot on—a lived fantasy based on a personal philosophy of liberation and self-definition as an act of the intellect and will. Travel was an essential part of the process, but the point was to be there, to create a new self in a new place.

The archetype of the inquisitive world traveler was Herodotus, who traversed the Mediterranean in the fifth century B.C. to collect material for the first history of the Western world, before it knew it was Western; eighteen hundred years later, the type found its epitome in Marco Polo. Victor Segalen described him in his novel *René Leys*: "Marco Polo, citizen of Venice, who returned to his homeland after seventeen years in the Khan's service, with his pockets bulging with riches and his mouth so full of adventures and tales of remote, foreign parts that people refused to believe him, indeed could not believe him." Later imprisoned in a Genoese prison, Marco "had both the occasion and the leisure to leave us a book, the Great Bible of the Exotic, the Conquest of Elsewheres Beyond Belief, wondrous penetration of the realm of the Diverse, with the title—even finer than all it contains—*The Book of the Wonders of the World*."

Marco was a curious man and a great storyteller, but the principal motive of his travels was mercantile. In the age of empire, other travelers journeyed to the continually redefined ends of the earth to pursue scientific and humanitarian interests. Bartolomé de Las Casas arrived in Hispaniola in 1502, ten years after Columbus's first voyage, as the son of a Castilian planter, but the brutal atrocities inflicted on the slaves who worked his father's estates shocked his conscience, and he became a passionate advocate of reform. Stamford Raffles, governor of Java during the brief period of British sovereignty there, from 1811 to 1814, founded the botanical gardens at Bogor, led an archaeological expedition to the ancient Buddhist monument of Borobudur, and introduced land reforms. In 1817, he published *The History of Java*, which got almost everything wrong, but it may at least be said that the book was not intended to justify the colonial mission.

Yet Marco Polo ended his life in Venice, Las Casas in Castile, and Raffles in Mill Hill, London. With Rimbaud and Gauguin, we encounter a new paradigm, the voluntary exile who goes to distant lands in search of a new home with no intent to repatriate. In this book, I shall call these transcultural voyagers "exotes," adapting Victor Segalen's coinage to describe a slightly narrower usage than he intended. Nothing new under the sun, of course: since the earliest voyages of discovery, a few Westerners who arrived in exotic corners of the world had stayed behind and acculturated themselves. Most of them were sailors and soldiers who fell in love with local women and went AWOL or scalawags who had compelling reasons not to return home, prototypes of Joseph Conrad's outcasts of the islands, deracinated losers who leave no legacy except their genes.

Gauguin, the exote, went to Tahiti with the avowed purpose of altering his cultural identity, to correct the error of his French nationality. In 1873, when his future wife Mette-Sophie Gad announced her engagement to her family in Copenhagen, she described him as "a funny sort of Frenchman." It was a literally apt description. Gauguin spent his early childhood in Peru, in the Baroque mansion of his grand-uncle Don Pío de Tristán y Moscoso, the last viceroy of colonial Peru. His grandmother Flora Tristan, the daughter of Peruvian political refugees in France, was a pioneering socialist and feminist.

Thus Gauguin's move to Polynesia was in a sense a return to the shores of the Pacific Ocean. Shortly before his death, he wrote this final self-assessment in a letter to Charles Morice: "I *am* a savage, and the civilized feel this, for there is nothing in my work which could produce bewilderment save this savage strain in me, for which I am not responsible." He believed that by leaving Europe to live in a distant land that was alien to Western civilization, he was embarking on a course of spiritual self-discovery. At any rate, he succeeded in persuading everyone else that that was what he was doing.

After Gauguin's death, the legend of his life in Polynesia emerged fully formed; he had honed the basic elements of the narrative himself during his final years. One early, integral version of

the legend was W. Somerset Maugham's popular novel *The Moon and Sixpence*, published in 1919. It tells the story of Charles Strickland, a stockbroker in London who upends his life to become a painter. When the narrator (Maugham himself, as always) first meets Strickland, he strikes him as "a good, dull, honest, plain man." Strickland abruptly leaves his wife and children for a bohemian life in Paris and then sails for Tahiti. Strickland's story strikes parallels with the key elements of Gauguin's life, but the differences are many, starting with his being an Englishman. Gauguin was never as contented in Tahiti as Strickland is in the novel, and for the artist's prolonged, excruciating death from tertiary syphilis Maugham substitutes leprosy, an approximation that avoids mentioning the unmentionable.

The novel's principal shortcoming is Maugham's meager talent for writing about art: "From floor to ceiling the walls were covered with a strange and elaborate composition. It was indescribably wonderful and mysterious." Time and again his characters are struck dumb by Strickland's paintings, which obviates any need to describe them. Inevitably, Maugham's conception of his main character is flat. The novel clumsily mimics the fractured first-person narrative structure of Conrad's classic novels of exile such as *Lord Jim*, in which the narrator patches together Jim's story from a few personal encounters over a long period of time, supplemented by secondhand reports. Conrad's fine gift for irony endows this quasi-cubist portrait of Jim with subtlety and depth, but irony is almost absent in Maugham's book, except in the sense of ridiculous understatement, the "British sense of humor," which he never tires of.

Nonetheless, Maugham understood perfectly the impulse that drove Gauguin to abandon his sketchy claim to a middle-class life in Europe in order to start over in a place he had never seen. Toward the end of *The Moon and Sixpence*, the narrator sets forth a theory:

> I have an idea that some men are born out of their due place. Accident has cast them amid certain surroundings, but they always have a nostalgia for a home they know not. They are

strangers in their birthplace, and the leafy lanes they have known from childhood or the populous streets in which they have played, remain but a place of passage. They may spend their whole lives aliens among their kindred and remain aloof among the only scenes they have ever known. Perhaps it is this sense of strangeness that sends men far and wide in the search for something permanent, to which they may attach themselves.

Maugham goes on to elaborate his theory with the fanciful notion that such wanderers may eventually chance upon the place they belong. He tells the story of a gifted young surgeon named Abraham, who abandoned his brilliant prospects to become ship's physician on a tramp steamer cruising the Mediterranean. When the ship made its first call at Alexandria, after Abraham's first glimpse of the ancient city, "suddenly he felt an exaltation. A sense of wonderful freedom. He felt himself at home, and he made up his mind there and then, in a minute, that he would live the rest of his life in Alexandria." In a plot twist reminiscent of Poe, Abraham immediately discovered that he knew his way around the city as well as if he had lived there all his life.

Gauguin certainly did not feel anything like that when he arrived in Papeete and the idlers on the beach jeered at him, taking him for a lady-boy. Yet he might have found Maugham's description of the sensation of being an outsider in one's own country to be just. In his own writings, Gauguin expressed the sense of alienation in familiar surroundings, anticipating a major theme of modernist fiction. In *Noa Noa*, the journal of his life in Tahiti (much of it cribbed from a compendious ethnographic study by Jacques-Antoine Moerenhout, published in 1837), Gauguin writes about lying down to sleep in his house: "Between me and the sky there was nothing except the high frail roof of pandanus leaves, where the lizards have their nests. I am far, far away from the prisons that European houses are."

He makes his point again, using the terms of classical philosophy, in an anecdote about a Frenchwoman, the wife of a gendarme, who insults him and his child bride on the day they married. The

woman exclaims, "'What! You bring back with you such a hussy?' . . . I looked for a moment at the symbolic spectacle which the two women offered. On the one side a fresh blossoming, faith, and nature; on the other the season of barrenness, law, and artifice. Two races were face to face, and I was ashamed of mine. It hurt me to see it so petty and intolerant, so uncomprehending. I turned quickly to feel again the warmth and the joy coming from the glamour of the other, from this living gold which I already loved."

Gauguin was undergoing a process the French would later have a word for, after more transcultural voyagers had followed his example. In 1928, a French journalist named Albert Londres published an article about Père Yakouba, the renegade missionary of Timbuktu, titled "Yacouba le décivilisé." The word had first appeared five years before as the title of a colonial novel, *Le "décivilisé,"* by Charles Renel, but Londres's article, a more serious work than William Seabrook's sensational biography of Yakouba, *The White Monk of Timbuctoo*, made it common usage in France during the protracted demise of the colonial era. It is an approving term for "going native," the decay of one's former national identity and the adoption of the mores of the new home. In English colonial novels, "going native" meant poor grooming, lazy work habits, losing your head over a native girl, and begetting a litter of half-caste brats. For the French, it was a way of expressing doubts about the legitimacy of the nation's *mission civilisatrice*, their equivalent of the white man's burden. Londres's reporting was responsible for rising skepticism about the professed goal of colonial policy, to Christianize, Gallicize, and otherwise enlighten the benighted natives, which was used as a moral justification for the expansion of empire.

The concept of the *décivilisé* was a final, feeble manifestation of the ideal of the noble savage (the phrase is ineluctable except by elegant variation), which predates Rousseau at least to Michel de Montaigne's essay "On Cannibals," published in 1580, when the New World was still newish. Montaigne begins by telling the reader that he has a servant in his employ from Antarctic France who is a cannibal. Antarctic France was one of the earliest

experiments in colonialism in South America, founded in 1555 as a haven for Huguenots, on an island in Guanabara Bay, modern Rio de Janeiro. After the arrival of Calvinist settlers, the colony was riven by doctrinal disputes, which led to bloodshed and executions by drowning; finally, twelve years after it was founded, the colony was razed by the Portuguese, who held title to the place by papal bull. The native people of Guanabara Bay were cannibals, and it was one of them who was employed by the essayist.

Montaigne has more on his mind than his ostensible subject, the pros and cons of cannibalism. He quotes Plato's law that all things are produced by nature, fortune, or artifice, of which the greatest and most beautiful are those created by nature or fortune, the least and most imperfect by artifice. Montaigne laments that Plato had no knowledge of the Brazilian cannibals, a people untouched by artifice. Their lives, he says, surpass "all the pictures with which the poets have adorned the golden age, and all their inventions in feigning a happy state of man." It was a place without letters or numbers, with no property and no employments except those of leisure, no clothing, no agriculture, no wine, where "the very words that signify lying, treachery, dissimulation, avarice, envy" are unknown. Shakespeare lifted passages of the essay intact for Gonzalo's speech describing his ideal state, in act 2 of *The Tempest*.

Gauguin wrote in *Noa Noa* that soon after his arrival he began to envy the Tahitians. "I looked at their happy, peaceful life round about me, making no further effort than was essential for their daily needs, without the least care about money. To whom were they to sell, when the gifts of Nature were within the reach of everyone?" The passage closely follows Denis Diderot's fictional *Supplement to Bougainville's Voyage*, which was as influential as any of Rousseau's works in forming the Enlightenment concept of the moral superiority of humankind in its pristine condition over the civilized citizens of Europe. Diderot imagines a debate between a Tahitian elder and Bougainville. Here, the old man addresses the French admiral sternly: "And you, chief of the brigands who obey you, quickly push off your vessel from

our shore. We are innocent, we are happy, and you can only spoil our happiness. . . . Leave us to our customs. They are wiser and more just than yours. We have no wish to exchange what you call our ignorance for your useless knowledge. We possess all that is necessary and good for us. Do we deserve contempt because we have not known how to create for ourselves wants in superfluity?"

Enlightenment philosophers and scientists, whether they had visited Tahiti or not, viewed the island as a laboratory for testing their theories. The German naturalist and early ethnographer Georg Forster presents a unique case of a young man who came to Polynesia soon after the islands had first been visited by European navigators, when his own education was just beginning. He was seventeen years old when he joined Captain James Cook's second voyage to the South Pacific (1772–75). He accompanied his father, Johann Forster, who was appointed ship's botanist.

The contrast between father and son clearly demarcated the philosophical division wrought by the Enlightenment. Johann, a Lutheran pastor, was appalled by what he viewed as the immorality of the Polynesians, not only their sexual promiscuity but the widespread, inveterate habit of petty thievery. He complained to Cook, "None is punished for his Audaciousness & Robbing." As a solution, he proposed that if "one were shot dead, the rest would be so alarmed that no thefts would more be committed." His son found his way to a more humane view of the Polynesians, based on his direct observation of them as an apprentice scientist. When young Forster published his journal of the voyage, in 1777, it made him a famous man at the age of twenty-three and became a basic text of the Enlightenment.

In it, he wrote that when Cook arrived in Tahiti, he brought with him a young islander named Hitihiti, who had sailed to England with Cook at the conclusion of Cook's first voyage, six years earlier. After the ship anchored, two highborn compatriots of Hitihiti's came aboard. They embraced the young explorer and welcomed him home, then immediately removed their fine bark clothing and offered it to him, as custom demanded. Hitihiti

quickly changed and went ashore to see his friends. Young Forster wrote in his journal,

> It is no wonder that a native of the Society Isles should prefer the happy life, the wholesome diet, and the simple dress of his countrymen, to the constant agitation, the nauseous food, and the coarse aukward garments of a set of seafaring Europeans; when we have seen Esquimaux return with the utmost ardor to their own desolate country, to greasy seal-skins, and rancid train-oil, after having been entertained with substantial viands, the pomp of dress, and the magnificence of London.

After he was reunited with his own people, Hitihiti "found the happiness and pleasure which he had expected." It was an empirical observation: people from primitive societies returned to their native habits as soon as the opportunity presented itself; therefore the civilized nations' reputation for superiority required re-examination.

When Gauguin was thrown among real "savages," he experienced the visceral exhilaration of Segalen's exote, "the notion of difference, the perception of Diversity." Whatever his philosophical goals and artistic aspirations might have been, after he had settled in at Papeete, he made a creditable effort to cut his ties to France and immerse himself in his new home. He wrote to Georges Daniel de Monfreid, his most loyal friend from the old days in Paris, who remained steadfast to the end, "I am beginning to think that everyone in Paris is forgetting me, as I get no news and here I live very much alone, speaking only the little Tahitian that I know. Yes, my dear fellow, not a word of French." He gradually adapted himself to a way of life that was utterly strange and yet immediately congenial to his tastes. He learned for himself that Pierre Loti's rapturous evocation of Tahiti as a land of free love was one element of the novel that was not exaggerated.

The missionaries' efforts to restrain the Tahitians' remarkably uninhibited sexual customs had been only superficially successful. Gauguin found that young girls, even those at the threshold of

puberty, were easily procured and kept as concubines, and he discovered in himself a desire to make love to them that became an obsession. He fathered many children in the South Seas. He wrote to Monfreid with the news of one pregnancy: "Good heavens, I seem to sow everywhere! But here it does no harm, for children are welcome and spoken for in advance by all the relatives. . . . In Tahiti, a child is the most beautiful present one can give." In *Noa Noa*, writing for a European readership, he presents himself as a faithful husband to his thirteen-year-old wife, but in fact he maintained a robust, promiscuous sex life in Tahiti as long as his health permitted, becoming *décivilisé* in a way that Frenchmen had dreamed about since the publication of Bougainville's memoir.

The art critic Robert Hughes observed, "Everyone knows something about Gauguin." Usually, that something is the Gauguin legend, the dramatic events of the artist's personal life in Polynesia as transmitted by popular mythmakers such as Maugham. Contemporary scholarship has evaluated this familiar narrative with an opposing, almost Manichaean interpretation. Good Gauguin is the Symbolist hero, the brave individual who liberated himself from the shackles of civilization in pursuit of personal and artistic freedom, the champion of the oppressed native and nemesis of the colonial overlord. Wicked Gauguin became necessary in the era of the feminist and postcolonial critiques, which portray him as a propagandist for the empire whose concept of personal freedom was a misogynistic fantasy addressed exclusively to white men. An influential essay by Abigail Solomon-Godeau, published in 1989, discerns what she calls the darker side of the primitivist school of art that Gauguin is credited with founding, which is "implicated in fantasies of imaginary knowledge, power, and rape; and these fantasies, moreover, are sometimes underpinned by real power, by real rape."

Solomon-Godeau's denunciation of Gauguin as a sexual predator is not trumped up. Before he married Tehura, the thirteen-year-old, he says that he considered seizing her by force, which he claimed was a common practice in the islands. He asserts that all

Tahitian women "wish to be 'taken,' literally, brutally taken (*Maü*, to seize), without a single word. All have the secret desire for violence, because this act of authority on the part of the male leaves to the woman-will its full share of irresponsibility." He wonders whether this practice, "which at first sight seems so revolting," might not have "a savage sort of charm." He decided against it, he reassures the reader; nonetheless, it is idle to argue that a relationship between a worldly, middle-aged European man and an island girl just entering puberty is a meeting of equals. When Gauguin tells the reader his bride's age, he adds parenthetically that in Tahiti thirteen is "the equivalent of eighteen or twenty in Europe," a ludicrous assertion that he leaves unexplained.

It does not make his behavior acceptable to modern sensibilities to cite evolving standards, to assert that such unequal relationships were common at the time, though they were; Edgar Allan Poe's bride was thirteen. Nor does it mean, on the other hand, that Gauguin's intentions were actually evil or that the arrangement was a disadvantageous one for Tehura herself. It is not as if he robbed her of an innocent childhood, snatching her from a sheltered home before her father decided she was old enough to meet nice young gentlemen in society: the feminist critique has as much to deconstruct in the lives of adolescent girls in fin de siècle Paris as in the country's overseas departments.

Contemporary readers tend to value more highly those thinkers of the past who anticipate the beliefs and values of their own time. To modern ears, they sound like voices of progress, pointing forward to a more enlightened age—our own. Yet how much of a personal relationship need one have with artists of the past? We feel that Rembrandt was a kind, generous man and Caravaggio a reckless rakehell, but what difference does it make? Solomon-Godeau makes an effort to avoid polemic, but her contempt for Gauguin is manifest. She sneers at his faulty grasp of the Tahitian language and his preference for eating macaroni and canned foods from Europe over the local fare, presenting these facts, well established since the beginning of Gauguin studies, as though they are damning evidence of hypocrisy rather than a simple inaptitude for language and finicky eating habits.

It is a crushing irony that Flora Tristan's grandson should be condemned as a misogynist. Tristan was one of the earliest and most influential feminist thinkers. In her memoir *Peregrinations of a Pariah*, published in 1838, she wrote, "Slavery is abolished, it is said, in civilized Europe. It is true that there are no more slave auctions in the public market, yet among the most advanced countries there is not one where numerous individuals do not suffer legal oppression. The serfs in Russia, the Jews in Rome, English mariners, and women everywhere. Yes, everywhere that the cessation of mutual consent, necessary for the formation of a marriage, is insufficient to break it, there woman is in slavery."

In 2003, Mario Vargas Llosa published *El paraíso en la otra esquina* (translated into English by Natasha Wimmer as *The Way to Paradise*), a novel that alternates re-created episodes from the lives of Flora Tristan and Gauguin, seeking resonances and contrasts between their individual quests for freedom from social convention. Vargas Llosa revives Good Gauguin without ambiguity. The narrative is told from the painter's point of view, presenting his search for personal liberation in essentially the same heroic terms employed by Mallarmé. Vargas Llosa calls Gauguin "an apprentice savage, a painter who was learning all at once to paint, to make love, to obey his instincts, to accept what there was in him of nature and the devil, and to satisfy his appetites like a man in his natural state." If his appetites required that the women he desired submit to him, that too was the law of nature.

Yet Vargas Llosa has a genius for writing about art. Each of the chapters takes a single painting as its theme, using it to add mass and nuance to the emerging portrait of the artist. The novel's evocation of the scene that inspired *Nevermore*, a painting from Tahiti that alludes to both Mallarmé and Poe, and the process by which it comes to life on Gauguin's canvas is a tour de force, which in turn brings the painter to vivid life. *The Way to Paradise* is a more sophisticated and imaginative work than *The Moon and Sixpence*, but it rests upon a similar conception of cultural identity. Here, the author addresses Gauguin: "A person's birthplace was an accident; his true homeland he chose himself, body

and spirit. You had chosen Tahiti, and you would die like a savage, in that beautiful land of savages."

Another aspect of Wicked Gauguin, which feminist critics such as Solomon-Godeau tend to ignore (perhaps because it undermines their premise that Gauguin was an instrument of the colonial establishment), is his career as a political gadfly. The role suited him no better than it would Ezra Pound thirty years later, in Fascist Italy. From 1899 to 1901, Gauguin was the editor of a Catholic newspaper called *Les Guêpes* (The Wasps), which he used as a platform for attacks on the colonial authorities that were frequently scurrilous and sometimes irrational. When he suspected that a mistress he had recently dismissed was sneaking into his house at night and robbing him, he demanded that she be arrested. He alleged that other women in the village were in league with her, working as a ring of thieves. As proof of his complaint, Gauguin told the gendarme that he had wakened in the middle of the night and saw a woman sweeping his compound with a broom. After the police took no action on this grievance, which sounded very much like a dream or hallucination, Gauguin was enraged. He published a vicious attack on the island's chief magistrate, Edouard Charlier, asking how law-abiding French settlers could "continue to feel safe in this district, subject as they are to the obvious bias of native chiefs and your arbitrary and autocratic rulings." He demanded Charlier's immediate recall to France and issued a thinly veiled challenge to a duel if he did not treat Gauguin with "due respect."

By this time, Gauguin's mind was weakened by the tertiary syphilis that ravaged his body, though it is impossible to determine the precise degree to which dementia was vitiating his reason and even his spiritual health. One of Gauguin's manias was actually evil. In 1900, he became the spearhead of virulent anti-Chinese feeling in the colony. He published and posted in the streets of Papeete a broadside with the headline "Tahiti for the French," calling for a public meeting of the colonists "to decide what measures should be taken to halt the Chinese invasion." At the meeting, he delivered a rousing speech in which he claimed that the Chinese, whom he likened to the barbarian hordes of Attila the

Hun, sought to control all trade in the South Seas. With blatant hypocrisy he warned of intermarriage between Chinese and Tahitians, whose offspring would be born French citizens, "a yellow blot on our country's flag."

Anti-Chinese bigotry was well established in French Polynesia, an Asian counterpart to the genteel anti-Semitism in Europe that enabled T. S. Eliot to write "Burbank with a Baedeker: Bleistein with a Cigar" ("The rats are underneath the piles. / The Jew is underneath the lot. / Money in furs") and reached its final rottenness in Pound's diatribes about bankers. In *The Marriage of Loti*, Pierre Loti suavely asserted that "the Chinese merchants of Papeete are an object of disgust and horror for Tahitian women," and "there is no greater shame for a young woman than to be persuaded into listening to their amorous propositions," yet they are sly and rich and purchase "clandestine favors that compensate them for the public's contempt." In *The Moon and Sixpence*, the proprietor of the seediest flophouse in Papeete is a querulous, one-eyed man known only as "the Chink."

Beset on all sides by quarrels mostly of his own making, Gauguin decamped in 1901 for the Marquesas, an archipelago nine hundred miles northeast of Tahiti, infamous even among the Polynesians as a place of licentious depravity. If the institution of marriage in Tahiti placed little value on fidelity to the mate, in the Marquesas, it seemed, it was effectively discarded. In 1898, the governor of French Polynesia, Gustave Gallet, reported to the home office, "Marriages made by the missionaries and civil authorities hardly last two or three months." Marquesan women, he wrote, commonly took second husbands to ensure that there would be no hiatus in their sessions of lovemaking. Up to this point, it was an extravagant conception of female empowerment that Flora Tristan might have approved or at least appreciated.

However, Gallet reported other forms of sexual profligacy that flouted the standards of the most progressive morality. "At the age of puberty, the young daughters are generally initiated by their second fathers and then made to service all the other parents and friends in the vicinity, sometimes fifteen, twenty, or even thirty individuals." An American scholar has cast doubt on the veracity

of this report, but there is no obvious reason why the colonial governor would fabricate such a scandal. Moreover, Gallet's testimony harmonizes with that of other observers. Nine years before, Robert Louis Stevenson had visited the Marquesas and reported that the "schoolchildren of Nuka-Hiva and Ua-pu escaped in a body to the woods and lived there for a fortnight in promiscuous liberty." He withheld the shocking details but said that the young people persevered in their debauches "until energy, reason, and almost life itself [were] in abeyance."

What shocked Stevenson excited Gauguin, who adapted himself with alacrity to the local custom. He built a Maori-style house on the island of Hiva Oa and carved its name in the lintel: "Maison du Jouir." The phrase may be rendered literally as "House of Joy," but a colloquial translation would be "Orgasm House." Another inscription at the Maison du Jouir urged, "Soyez amoureuses et vous serez heureuses": Be amorous and you will be happy. Gauguin's life in the Marquesas was a devastating refutation of this primitivist maxim. He had been prodigiously amorous, and now he was miserable. Syphilis, untreatable until a decade after Gauguin's death, was the AIDS crisis for Europeans in the fin de siècle, particularly the French. Baudelaire, Flaubert, Manet, and Maupassant had died horribly, as all victims of syphilis did. Death was preceded by hideous, debilitating symptoms such as bleeding chancres, which tormented Gauguin's legs so much that by the end he was immobilized. The cruelest assault was on his eyesight; in the final months of his life, the painter was virtually blind.

Good Gauguin made a triumphant return in the Marquesas. He resumed his harassment of the colonial authorities, now on behalf of the Polynesians. In the summer of 1902, he took an active part in freeing the islands' children from virtual imprisonment in convent schools, which were established with the principal aim of saving children from the sinful influence of their parents. A secret police dossier reported, "Monsieur Gauguin, despite the difficulty he experiences walking, has not hesitated to go by himself to the beach in order to try to convince the natives to remove their children and argue that the law cannot oblige parents to send

them." Soon the schools were empty. Even more seditious, Gauguin urged the Marquesans to follow his example and refuse to pay taxes.

The artist's passionate advocacy of native rights, which verged on fomenting revolution, was a total about-face from his nationalist fervor in Tahiti, a return to the idealism of his initial impulse to move to the South Seas. Gauguin wrote an obituary of Rimbaud in *Les Guêpes* eight years after the poet's death, which articulated his own beliefs. The short piece gives only a slighting glance in the direction of Rimbaud's writings ("he was a very strange poet with high intelligence, but that was all") and reserves its praise for his activities in Africa, which Gauguin portrays as the epitome of progressive colonialism.

He plainly knew nothing about Rimbaud's life in Africa. Rimbaud was a trader in Abyssinia, one of the continent's few independent nations. He organized caravans to Shewa, a kingdom that was remote by African standards, whose inhabitants were truly savage, in that they massacred outsiders who ventured into their lands and wore their victims' testicles on a necklace as an amulet. Rimbaud in Abyssinia was in no sense a colonial; he was a white man in a black country, nothing more. Gauguin idealized him as a philanthropist, furthering the *mission civilisatrice*: "With no other resources than the gracious condescension of the superior man, he managed to make himself respect, nay even adore the savage tribes, until then the terror of travelers, and taught them industry and dignity." The main purpose of the essay was to expound Gauguin's views about colonization:

> The words "glory of country" generally take on an altogether inverted sense when we talk about colonization. To colonize means to nurture a country, to make previously uncultivated land produce things that are useful, primarily for the happiness of the people who inhabit it—a noble goal. Yet to conquer that country and plant a flag in the ground, to install a parasitical administration and maintain it at enormous expense, by and for the sole glory of a distant capital, that is barbarous insanity, that is shameful!

In his last letter to Georges Daniel de Monfreid, Gauguin hopefully wrote, "It will be said that all my life I have been fated to fall, only to pull myself up and to fall again." He added in a postscript, "All these worries are killing me." He died in his bed, more precisely with one foot on the floor. The morphine bottle on his bedside table was empty. Most reconstructions of his death conjecture that he sat up to give himself another injection of morphine and fell back on his bed when he saw that the bottle was empty. At the time of his death, Gauguin was under police surveillance as a subversive, awaiting transportation to Papeete to serve a three-month sentence for libeling a gendarme—a principled martyrdom worthy of Flora Tristan's grandson.

The last thing he saw, his eyesight clouded by syphilis, was a painting he had begun in Brittany in 1894 and brought with him on his final voyage to Polynesia. The canvas, which stood on an easel at the foot of his bed, depicts a village landscape in the snow, uncharacteristically devoid of human figures or even farm animals. Gauguin's last visitor was a sympathetic Protestant pastor named Paul Vernier, who reported that they discussed the latest news about his legal case and Flaubert's novel *Salammbô*, a major text for the Symbolists.

We have an excellent idea of the appearance of the Maison du Jouir at the time of its owner's death from a memoir by Victor Segalen. He arrived in Tahiti in January 1903 to begin his first tour of duty as a ship's doctor, aboard the transport ship *Durance*. Segalen, more passionately interested in art than in medicine, already knew about Gauguin and his life in Polynesia from cultural journals such as the *Mercure de France*. When he arrived in Tahiti, Segalen decided to go straightaway to the Marquesas to meet the Master. He would have made it there in time but for a typhoon that blew through the region, causing hundreds of deaths and injuries, which made an urgent demand on his medical services. Jack London wrote a thrilling description of this disaster in "The Heathen," a sentimental yarn in *South Sea Tales* about the friendship between a sailor and his native sidekick.

By the time Segalen got to Hiva Oa, Gauguin had been dead for less than three months. His clothing and personal effects had

been sold for pennies at an impromptu auction, and afterward his neighbors stripped the Maison du Jouir of everything they could use—everything, in other words, except his artworks. Segalen received orders to transport them to Papeete and conduct another auction to raise money for the artist's creditors. While he was in the Marquesas, he made inquiries about Gauguin's final days, seeking out his friends. Paul Vernier, sporting a green beret that the artist had worn until the end, told Segalen about their last meeting and introduced him to an old woman who was versed in the island's ancient lore. In an article published in the *Mercure de France*, "Gauguin in His Final Décor" ("décor" in the sense of a stage set), Segalen describes the house and its surroundings in luxuriant phrases and reaches for an apocalyptic conclusion:

> Reddish-brown, braided with foliage, the roof sweeps down in two long slopes over the yellow inner wall, itself plaited with mats and vegetation, and blends in perfectly with its surroundings; a crude, unsophisticated but sturdy frame fashioned from natural materials anchors it to the grassy soil. . . . In the studio is a jumble of native weapons, an asthmatic little old organ, a harp, odd bits of furniture, and only a few paintings, since the artist had just made a final dispatch. . . . In a final paradox in this land of light, the work for which the dying man reserved his ultimate brushstrokes: a chilling view of Brittany in winter—glints of snow melting on the thatched roofs under a low sky overcast with clouds and scored by thin trees. . . .
>
> The sound of water is everywhere, bursting down mountains, soaking the soil, snaking along riverbeds of worn pebbles. Everything is alive, bursting into the warm scents of summers hardly ever struck by drought, everything except the human race. They are dying, those pale slender Marquesans. Without sorrow or wailing or protest, they are wending their way to their coming doom. What's the point of abstruse diagnoses? Opium has wasted them; alcohol has rotted them with the novelty of drunkenness; tuberculosis has hollowed out their lungs; syphilis has left them sterile.

What are all these things if not the different manifestations of that other scourge: contact with the "civilized." In twenty years, they will have ceased to be "savages." When they do so, they will also have ceased to exist.

The auction was a bust for Gauguin's creditors but a bonanza for his memorialist. Segalen bought seven of the ten finished paintings, including *Breton Village in the Snow*. When it came up for sale, the auctioneer displayed the picture upside down and sarcastically called it a scene of Niagara Falls, to the delight of the audience. Segalen got the painting, which now hangs in the Musée d'Orsay, for seven francs. He also paid a pittance for Gauguin's palette, many prints and drawings, and four of the five carved panels that surrounded the doorway of the Maison du Jouir, including the injunction to be amorous. Some of the other works sold at the auction are now lost.

"Gauguin in His Final Décor" began the process of transforming the legend of the Symbolist hero into the creation myth of modernism. Again, Rimbaud had set the paradigm. After his escape to Africa, he severed every connection with the homeland apart from his correspondence with his mother and sister. The poet's vanishing act created a nimbus of mystery around him. In 1887, a newspaper reporter named Paul Bourde, a childhood classmate of Rimbaud's in Charleville, met the poet's present employer, Alfred Bardey, aboard a steamship out of Marseilles. Bardey, who had known Rimbaud for seven years, knew nothing about his previous life as a litterateur. Bourde subsequently wrote to Rimbaud, "Living so far from us, you probably do not know that, in Paris, for a very small group of writers, you have become a sort of legendary figure—one of those figures whose death has been announced but in whose existence a faithful few continue to believe and whose return they obstinately wait. . . . Not knowing what has become of you, the little group that calls you its leader is hoping that you will come back one day to rescue it from its obscurity." An odd bit of flotsam from the great sea of Rimbaud legend is the tale that one night in Abyssinia he improvised a new ending for his masterpiece, *The Drunken Boat*, which featured bare-breasted,

honey-colored Tahitian girls. It is a purely apocryphal resonance with Gauguin, probably a case of convergence arising from the general French fascination with Tahiti.

Once launched, the Gauguin legend soared on an upward trajectory that closely followed the growing appreciation of his art and the prices it fetched. The legend is useful for what it tells us about those, like Segalen, who accepted it as gospel truth, as well as those who have scorned it, but it is of no use at all in looking at his art. Those who view the paintings through the lens of the myth are looking into a dull, hazy mirror. For devotees like Segalen, the Maison du Jouir represented a seductive, glamorous promise of personal liberation. Abigail Solomon-Godeau, on the other hand, sees in Gauguin's depictions of Polynesian women "nature's plenitude reflected in the desirability and compliance of 'savage women.'" She cites "alluring and compliant female bodies" as an attribute of the mythic paradise presented in Gauguin's paintings.

Gauguin's Tahitian female nudes carry an erotic charge, of course, but their salient attribute to my eye is their earthy realism. They are not juiced-up sex objects; they look like Tahitians. They have big feet, thick ankles, fleshy little bellies, and broad shoulders; their faces are beautiful, but with the blunt features of real island beauties and none of the pallid, soft-focus charms of odalisques by academic Orientalist pornographers such as Jean-Léon Gérôme. Gauguin's models exhibit no discernible air of alluring compliancy; the female body is glamorized only in the sense that it is nude, most commonplace of artistic conventions. Sometimes the figure stares straight at the viewer with a candid, challenging expression of curiosity, as if she were trying to understand the artist as much as he her. More often, as in *Nevermore*, the model is lost in a daydream, disengaged from her surroundings.

Gauguin wrote to Monfreid that in *Nevermore* he "wished to suggest by means of a simple nude a certain long-lost barbaric luxury." Yet Gauguin discovers this lost world peering through a Symbolist lens, specifically that of Poe's incantatory poem in Mallarmé's prose translation. "The Raven" was virtually the movement's anthem, epitomizing the fusion of mood and meaning that the Symbolists prized. Simply by invoking it, Gauguin infused his

image with a quality of timeless mystery, which contemporary French viewers would have felt at once. He sets his painting in a domestic interior observed from life, in Tahiti in 1897, but the human subjects, the bemused nude and the women gossiping behind her, dwell in the glamorous Tahiti of his dreams. This process of cultural overlay, interpenetrating the artist's idealized vision of the new homeland, formed in prospect, and the real world he found when he arrived, is a distinguishing characteristic, almost a defining quality of the art of the exote.

Gauguin's decision to leave Europe and refresh his artistic vision in an alien place was more than a defiant gesture, but he wasn't out to prove anyone's theory; he was simply living a life of his own devising. Gauguin was much more interested in making money than in becoming a legend, which he cannily saw as a means to that end, but the impulse to reinvent the self was genuine. It was an experiment that succeeded simply by being undertaken.

In 1904 the *Durance* was recalled to France, sailing via the Red Sea and the Suez Canal. When the ship reached Djibouti, in the heart of the region where Rimbaud had lived almost to the end of his life fourteen years before, Segalen disembarked to search for any traces the poet might have left behind. He met the Righas brothers, Athanase and Constantin, business colleagues and good friends of Rimbaud's during the last ten years of his life. Segalen wrote that his interview with them enabled him "to sketch a plausible silhouette of the second Rimbaud." One of the brothers, unnamed, or perhaps the two of them merged by journalistic convention, described Rimbaud thus:

> A tall, thin man, even skinny, and a great walker. Oh! he was an amazing walker. With his coat open and a little fez on his head, he was on the go, always on the go. He was a man of astonishing conversation. He could make you laugh, I mean really laugh. . . . He was extraordinary, our man Rimbaud. He spoke English, German, Spanish, Arabic, and Galla. He

was very sober, never drank alcohol, only coffee *à la turque*, as it is served in the countryside.

Segalen asked if Rimbaud ever talked about his friends in France: "No, never, he loved no one in France except his sister." Then he asked, Did you know that he had been a writer? "Oh, yes, his reports for the Geographical Society were beautiful things." After his expedition to Shewa in 1888, Rimbaud wrote a dry, factual account of his journey that was published by the Société de Géographie in Paris and sister organizations in Britain, Germany, Austria, and Italy.

Segalen's essay "The Double Rimbaud" was the earliest report of the total self-transformation that the poet accomplished in Africa. Segalen describes this process in fanciful terms that could have been taken from an eerie tale of a doppelgänger by Poe: "Between the author of the *Illuminations* and the merchant selling gun cartridges in Harar there exists a wall," which could not have been more complete "if instead of being the second aspect of the same man, the explorer had been born the enemy-brother of the poet: if instead of the double Rimbaud, we had two Rimbauds." Segalen offers an explanation of what he calls the poet's "definitive mutism" that is based on some newfangled psychological theories, which need not detain us. As far as I am aware, Segalen never explicitly pointed out the parallels between the lives of Rimbaud and Gauguin, but setting aside their obvious dissimilarities in temperament and the opposition posed by their homelands of choice, we can say they plotted congruent courses. Both men were compelled to begin a new life more by a disgust with the homeland than by an informed attraction to the new home; they lived as the native people did, or tried to; they were in a constant state of furious ambivalence about the decision they had made; both died painful, premature deaths and posthumously became mythic heroes.

They are even alike in their differences, in that they found different solutions to the same problems. Gauguin came to Tahiti in part to satisfy his addiction to sensual pleasure, whereas Rimbaud became ascetic to the point of masochism. Fiercely hostile to

French Catholicism, Gauguin became a sort of freelance pagan, whereas Rimbaud, driven by the same antipathy, embraced the austere life of Islam and might have converted. Both artists were sexual outlaws: Gauguin in Tahiti indulged an obsession for sex with girls at the threshold of puberty, while Rimbaud's only sustained love affair had been with a man, twenty years his elder. (In Abyssinia, Rimbaud settled down briefly with a woman in some sort of conventional ménage; precisely what sort remains ambiguous, but the record suggests that it was not a passionate relationship.) The main disparity between the two artists in exile is irreconcilable: in Africa, Rimbaud made a categorical renunciation of literature, whereas Gauguin soldiered on painting to the end, even after he was too feeble to stand.

What compelled the revolutionary prophets of modern painting and poetry to abandon Europe in search of a new life? By the end of the nineteenth century, the complexity of industrial civilization had created wants in abundant superfluity, which brought with them stressful spiritual demands. In the Renaissance, adventurers dreamed of discovering El Dorado, the legendary city in the New World encrusted with gold, where even the king's body was covered in gold dust; as the age of empire approached its summit, London, Paris, and Amsterdam were modern El Dorados, gilded by the extracted wealth of the colonies, which paid for a life of fabulous luxury for the elite. Rimbaud's and Gauguin's dream was to escape the factitious needs of civilization for a simple life in nature, an island paradise or an elemental wasteland where they might be unencumbered by useless knowledge and the hypocritical morality of established Christianity.

After Victor Segalen got home from his voyage, he married and wrote his first book, *Les immémoriaux*, an ambitious novel portraying the life of Polynesia from a Polynesian point of view. The book's title is equivalent to English "immemorial," meaning that or those so ancient as to precede human memory, but it also suggests the unremembered and those who do not remember. Segalen wrote that the book describes a people "forgetful of their customs,

their knowledge, their familiar gods, and all the forces that protected their unique past."

The book is in three parts. Part 1 is set in Tahiti soon after the arrival of the first foreign visitors but before the introduction of Christianity. Térii, the hero, is a young *haèré-po*, a priest entrusted with memorizing and reciting the annals of the tribe, "the unremitting repetition, without omitting a word, of the beautiful original phrases, which comprised, so the elders promised, the blossoming of worlds, the birth of stars, the making of men, the rutting and monstrous labors of the Maori gods." When Térii forgets a passage in the text at a public recitation, he not only brings disgrace upon himself but strikes a mortal blow at the foundation of the state, and he is violently cast out.

In the short second section, Térii and an elder priest named Paofaï undertake an epic sea voyage modeled on *The Odyssey* throughout the vast oceanic realm of Polynesia. In the last part, twenty years later, Térii regains his home, but his Penelope, Tahiti, has surrendered to the Western suitors. When he lands his boat, he sees many little white houses built on the shore. He hears people inside chanting words that sound like the mythic genealogies recited since time immemorial by the *haèré-po*, but he does not recognize the names of the gods: "The sons of Iakoba were twelve in number: from the wife Lia, the first-born Reubena, and Simeona, and Levi, and Isakara, Iosefa, and Beniamina." The book ends with a long, sorrowful diminuendo as Térii surrenders to the inevitable and converts.

Les immémoriaux is ambitious and polished in composition, but it falls painfully flat. Segalen never called his book a novel; long stretches of it are unvarnished ethnography. It bears a relationship to most novels published in the first decade of the twentieth century analogous to that of a cantata to opera, dignified and uniformly serious in tone. As original as his book is, Segalen acknowledged two primary sources of inspiration that overwhelmed his own imagination. First was Gauguin, whom he revered not for the heroism of his abandonment of Western civilization, as the Symbolists had done, but for what Segalen perceived as his enlightened mission to lead the Polynesians away from puritanical

modern Christianity and restore their ancient cult. Henry Bouillier, Segalen's biographer, observed that Segalen celebrated Gauguin as "a Julian the Apostate of the Pacific."

Segalen had a sensitive engagement with modern art and deeply felt the brilliancy of Gauguin's vision, his triumph as an artist. In a letter to Georges Daniel de Monfreid, Gauguin's faithful friend, he confided, "I have tried to 'write' the Tahitian people in a manner approximating that with which Gauguin saw them in his painting: their very selves, inside and out. It is not the least of my admiration for him that this brilliant insight into an entire race spreads throughout all his work." Perhaps seeking to form a posthumous friendship by proxy with his idol, Segalen became a close friend of Monfreid's. Monfreid painted a fine portrait of him seated at a desk, with a picture by Gauguin hanging on the wall behind him, a watercolor from Hiva Oa depicting a ship in a rough sea.

Segalen's other source was literary, a work by a writer whose reputation as a master was on its rise to supremacy: Flaubert's *Salammbô*. Segalen wrote, "As for the influence of *Salammbô*, it is undeniable! I have been under Flaubert's influence with too much fatality to attempt to defend or excuse myself." It was a complicated influence to be under. *Salammbô* is unlike anything else in Flaubert's oeuvre: his second novel to be published, between *Madame Bovary* and *Sentimental Education*, this lurid novel of ancient Carthage has never been admired with anything like the veneration inspired by the other two novels, for the excellent reason that it is not nearly as good a book. Contemporary critics tend to overlook it, perhaps intentionally, as something of an embarrassment. Replete with sex and graphic violence, the novel was a bestseller when it was published but finds few readers today.

The story is set in the third century B.C. after the First Punic War, when Carthage is under siege by its own barbarian mercenaries, who have not been paid for their services. Matho, one of their leaders, is possessed by an overwhelming desire for Salammbô, a priestess of the goddess Tanit and the daughter of Hamilcar, commander of Carthage's army. In order to have his way with her, Matho sneaks into the temple of Tanit and steals the empire's

sacred palladium, the *zaïmph*, a magical veil sparkling with gems that covers the idol of the goddess. Salammbô overcomes her fear of the barbarian and brazenly enters the mercenaries' camp in disguise. She demands to be taken to Matho's tent, where she seduces him (or succumbs to the brute force of his desire; Flaubert's wonted lucidity is absent) and retrieves the *zaïmph*. Carthage triumphs over the barbarians, and in the final pages Matho is tortured to death at a triumphant public spectacle, his heart ripped from his chest and offered to the sun on a golden spoon.

Readers seeking anything that resembles Flaubert's dissection of Emma Bovary's inner life through the exquisitely nuanced observation of its surfaces have always been disappointed in *Salammbô*. The novel is by a different writer, *le double Flaubert*. In place of the ascetic Flaubert, the obsessively meticulous researcher and "martyr of style," is Flaubert the Orientalist, the uninhibited sex tourist who recorded his erotic revels in Egypt in letters and diaries (brilliantly collected and translated by Francis Steegmuller as *Flaubert in Egypt*). Flaubert's preparation for *Salammbô* was as thorough as that for all his books, but the result was amplitude, not depth. Flaubert finds a place in the book for every species of barbarous cruelty known to classical scholarship and elaborates them all with nauseating fullness.

Salammbô might be considered the first novel of exoticism; at any rate, it is the first by a well-known writer, usually taken to be a great one. In the eighteenth century, there was a minor vogue for philosophical Oriental tales, such as Samuel Johnson's *Rasselas, Prince of Abissinia* and Voltaire's *Zadig*, in which the exotic setting is Europe thinly disguised for the purpose of satire. The singular exception is *Vathek*, written in French by William Beckford, at the age of twenty-one. Beckford was heir to a fortune reputed to be the greatest in England, which had been created by his father, a Jamaica sugar millionaire and lord mayor of London. Published in 1786, *Vathek* is just as sensational and cruel as *Salammbô*, and stranger.

It is the tale of a Faust-like caliph who thirsts for "the talismans which subdue the world," which is complicated by the author's pederastic inclination. A Mephistophelian giaour demands as the

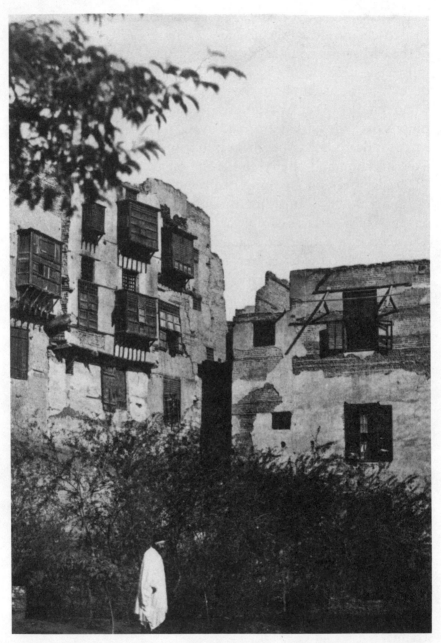

Gustave Flaubert in the garden of the Hôtel du Nil, Cairo, photograph by Maxime Du Camp dated January 9, 1850. "I would never allow anyone to photograph me," wrote Flaubert. "Max did it once, but I was in Nubian costume, standing, and seen from a considerable distance, in a garden."

price for this forbidden knowledge the blood of fifty boys, to assuage his demonic thirst. Vathek asks the nobles of his realm to send their sons to him for a day of revels. After an idyllic interlude in which the boys chase butterflies and pick flowers, the caliph announces a series of footraces. "The fifty boys hastily undressed and displayed to the admiring multitude the pleasing contours of their delicate limbs." The racecourse ends at a chasm, with Vathek standing at the edge, promising to strip off his jewelry and gorgeous raiment piece by piece as prizes. The multitude applauds "the generosity of a prince who would strip himself naked to amuse his subjects and encourage the young." One by one, the boys race toward the caliph, who throws each in his turn into the waiting jaws of the giaour, concealed at the bottom of the chasm. The scene anticipates, in a fantastically inverted tone, the infamous scene in *Salammbô* of the immolation of the children of Carthage, thrown into the fiery maw of the god Moloch to ensure victory against the mercenaries.

Beckford was a dilettante in the best sense. He had studied Arabic since he was a precocious child and was steeped in Oriental lore, particularly *The Arabian Nights*, but he spun *Vathek* directly from his feverish, postadolescent imagination. There's nothing in European literature quite like it, a series of Orientalist tableaux like the one described above, full of furious action but with almost nothing in the way of a story. Not surprisingly, Beckford's bizarre fantasy attracted few readers and no imitators—particularly after the author was accused of having an affair with his sixteen-year-old cousin, William "Kitty" Courtenay, and went into a Continental exile. The mass-market taste for the exotic in the arts was created later by Lord Byron (a Beckford admirer, who called him "the great Apostle of Pederasty"), with Oriental verse tales such as *The Bride of Abydos* and *The Corsair*, which reek of sex and danger.

In *Salammbô*, Flaubert unsuccessfully attempts to combine the titillating thrills of a Byronic burnoose ripper with the serious scholarship of a dignified historical novel. His exposition of politics in ancient Carthage and detailed battle scenes grow tedious, mere filler between the "good parts," which are as juicy as a nineteenth-century French reader could have wished. When

Salammbô arrives in Matho's tent to reclaim the *zaïmph*, the soldier is almost incapacitated by lust. He surveys her loveliness with Flaubertian precision: "The two clasps of her tunic raised her breasts a bit, pressing them together, and he lost himself in thought in the narrow space between them, where an emerald medallion dangled on a thread, visible below beneath the violet gauze." Salammbô for her part was quite as fascinated by Matho's pectoral charms: "Sweat flowed down his chest between his four-square muscles; and his panting breath shook his sides and the bronze belt trimmed with leather straps that hung down to his knees, firmer than marble. Salammbô, accustomed to eunuchs, found herself astonished by the power of this man." There are several such unintentionally ludicrous passages, camp before it had a name, which, taken with the gruesome descriptions of torture, give *Salammbô* the feel of a pulp genre novel, anticipating *Conan the Barbarian* more than *Memoirs of Hadrian*.

What makes the novel exotic, in addition to its setting in the ancient past, Segalen's exoticism "dependent on time," is that it is imaginatively told from the Carthaginian point of view. Almost everything known about Carthage is found in the histories written by its Roman conquerors. Educated Frenchmen of Flaubert's generation had read Livy, who portrayed the Carthaginians as bloodthirsty monsters. Yet almost nothing survives of Punic literature; we have no record of what they thought about themselves. Their voices are irretrievably lost, swallowed up by oblivion—*immémoriaux*.

If Flaubert's novel suffers from an excess of sensationalism, Segalen's could have benefited from a dose of juice. Perhaps trying too hard to distinguish himself from his nemesis Loti, the pimp of the exotic, Segalen took a pseudoscientific tone and suppressed his own ecstatic sensations in Tahiti, leaving his novel curiously inert and emotionally arid. Eight years after he finished it, he wrote to his friend Henry Manceron, "During the two years I spent in Polynesia, I could hardly sleep for joy. I would awaken and weep with euphoria at the break of day." And the reason for his joy? "The entire island came to me like a woman. Indeed from the women there I had such gifts as no country bestows any longer."

In his Loti-like pursuit of sexual adventure, Segalen took a "classic Maori wife, whose skin is sweet and fresh, whose hair is sleek, whose mouth is muscular," but she was not first among the island's gifts. He confided that "the young girl, the virgin, is for me the true lover." He claimed the right "after twenty years of uninterrupted tastings" to express frankly his amorous inclination: "The young girl is at the most extreme distance from us, and thus incomparably precious to all enthusiasts of the Diverse."

Segalen's research turned up ample testimony to the Tahitians' sexual licentiousness and certain practices that can only be described as barbaric, such as the ritual sacrifice of male firstborn babies, which was still being performed at the time of contact. Yet he adored the Tahitians, and in his proselytical zeal he excluded anything that might detract from his idealized conception of their pristine state. No objective standard exists by which to judge the historical accuracy of *Les immémoriaux*, for the ancient oral tradition, as the novel predicted, is extinct. The only useful opinions would be those of Tahitian readers, yet the islands' modern inhabitants are scarcely more bookish than their ancestors, and what modern literature there is is written in French. Gilles Manceron, grandnephew of Segalen's friend and confidant, and Jean-Jo Scemla, an overseas French resident of Tahiti, wrote in *Tahiti* magazine in 1992 that "*Les immémoriaux* is not only the first ethnographic novel in history, still unequaled, but also for the Tahitians the only foreign novel they accept, exceptionally, as an integral part of their heritage."

Manceron and Scemla may be right, but it might also be true that linguistic fluency is required to represent an exotic culture truthfully. Of course Segalen's real goal wasn't truth. His conscious intention might have been to write an authentic portrayal of the ancient Tahitian culture, but what he was really expressing, whether he knew it or not, was his own dream of Tahiti. Two years after *Les immémoriaux* was published, he arrived in China, where he became proficient in the language and read widely in its classical literature. He traveled deep into the countryside for months at a time on archaeological expeditions and lived in Peking long enough to form intimate connections at the imperial court, which

was then on the verge of collapse. In China, Segalen's familiar ease in an exotic landscape enabled him to use it as the setting for his own, highly original literary experiments, which anticipated some of the most interesting directions of high modernism while the movement was still gestating.

Prince of Java

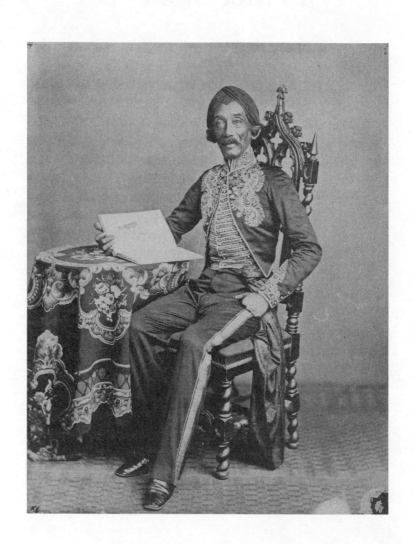

Iphigenie. Kann uns zum Vaterland die Fremde werden?
Arkas. Und dir ist fremd das Vaterland geworden.
Iphigenie. Das ist's, warum mein blutend Herz nicht heilt.
 —Johann Wolfgang von Goethe, *Iphigenie auf Tauris*

Iphigenia. Can what is alien to us become our homeland?
Arkas. And your homeland has become alien to you.
Iphigenia. That's why my bleeding heart never heals.
 —*Iphigenia in Tauris*

The story of the Javanese painter Raden Saleh is a tragedy, which begins, as the saddest tragedies do, in triumph. In 1829, at the age of eighteen, he started a new life by undertaking the long, dangerous voyage from Java to Holland. He made the journey as a protégé of Jean Baptiste de Linge, a colonial administrator of the Dutch East Indies who had been summoned home. Raden Saleh's principal obligation was to tutor him in Javanese and Malay during the voyage; de Linge was entrusted with delivering the lad to the Netherlands for an education. After his father's early death, Raden Saleh Syarif Bustaman bin Yahya was raised in the court of Semarang, a provincial capital on Java's north coast, by his uncle Sura-adimanggala, the *bupati*. Before the Dutch consolidated their control of Java, the *bupati* was a sort of prince, but in the colonial era he was a puppet, tasked with enforcing

the laws of the foreign overlord and collecting King Willem's taxes.

The record of Raden Saleh's early life is spotted with lacunae, like the pages of an old book in the tropics tenanted by bookworms. A child prodigy, he was apprenticed at the age of eight to an expatriate Belgian painter named Antoine Payen. The likely scenario is that when the governor-general of the Indies, Godert van der Capellen, visited Semarang in 1819, accompanied by a German botanist named Caspar Reinwardt, they met the *bupati*'s nephew, recognized his precocious gifts as a draftsman, and arranged the apprenticeship for him. At the age of nine, after one year of study with Payen, Raden Saleh wrote to Reinwardt to tell him that he was busily producing botanical drawings and that his master, Payen, was pleased with his progress. Raden Saleh's earliest surviving works are precisely observed watercolors of farming implements and country folk in traditional dress, faultless exemplars of the sorts of ethnographic drawings that Payen created for home consumption. From the beginning, Raden Saleh viewed his native land as if through the eyes of foreigners.

His voyage aboard the sailing ship *Raymond* ended at Antwerp, in Flanders, which at the time was a province of the Netherlands on the verge of rebellion. Antwerp was the cultural antipodes to Semarang, a place as alien to everything he had known before as Semarang would be to Rimbaud when he arrived there forty-three years later, after a journey in the opposite direction. Rimbaud's route from Holland via the recently opened Suez Canal was shorter and much safer aboard a steam-powered ship; Raden Saleh sailed under canvas around the perilous Cape of Good Hope. Like a knight-errant in *The Arabian Nights* he had journeyed to a far-away land to seek his fortune, yet in this case the brave new world was straitlaced Holland, where treasure was kept in the ledgers of colonial trading companies rather than in enchanted caves.

Soon after his arrival in Antwerp, Raden Saleh obtained a scholarship from the Crown to pay for advanced studies in art, a generous two thousand guilders a year—an unprecedented honor. The stipend was secured for him by an administrator named Jean Chrétien Baud, who had met the boy on a tour of Java. Baud later

became governor-general of the Indies and would remain an affectionate, fatherly mentor to the artist throughout his twenty-two-year residency in Europe. In 1830, shortly before the Belgian Revolution liberated Flanders from Dutch rule, Raden Saleh moved to The Hague, a city as peaceful and dull as any place in Europe, where Baud could keep an eye on him. Baud arranged for him to study with two of the most prominent artists of the day, Cornelis Kruseman, a portraitist and painter of historical scenes, and the landscape artist Andries Schelfhout. The fees Baud paid for Raden Saleh's tuition were exorbitant, coming to four hundred guilders a year, twice the amount Dutch students paid.

Raden Saleh studied hard and learned quickly, producing copies of paintings by Rembrandt, Van Dyck, and Paulus Potter that met with Kruseman's "utter satisfaction." The ambitious young Javanese set about Europeanizing himself as quickly as he could, though his dark face framed by long, curly locks of black hair, with intense, slightly bulging eyes and sensual lips, would always make him an exotic interloper among the tall, pale lowlanders. At Schelfhout's atelier, he fell in with the boisterous young artists studying there, who imitated the style of bohemian Paris: they grew their hair long, wore flashy clothes, and caroused in cafés. Under their influence, Raden Saleh joined the Freemason lodge Eendracht Maakt Macht (Unity Makes Strength) in 1836, becoming the first Mason from the East Indies.

Within a few years, he had established a promising career as a professional painter. He was awarded commissions from the Crown for official portraits and took in students of his own. In 1839, he left Holland to begin a progress across Europe that would make him a celebrity. He was the intimate friend of princes and dukes, who invited him to lavish routs at their palaces, where he moved freely in the company of the most distinguished artists and writers of Europe.

Raden Saleh is a rare example of the East-to-West exote, an Asian who found a place for himself in Europe; yet we know almost nothing about his motives or state of mind when he made the momentous decision that propelled him into his new life. The only direct testimony we have is a fragment of a memoir he wrote in

1849 in Maxen, a village near Dresden in the kingdom of Saxony, a summation of his life after twenty years in Europe. It was never published, and the manuscript was lost in the chaos of Soviet-controlled Germany after the end of World War II, but the first page survives:

> Two poles diametrically opposed to each other, both bright and friendly, exert a powerful spell on my soul. There, the paradise of my childhood in the hot sunshine, where the Hindustan Ocean breaks against the shores, where my loved ones live and where the ashes of my ancestors rest; and here, Europe's happy countries, luminous in the diamond jewels of art, science, and high education, where the longings of my youth drew me, where I found so much more than even in my wildest dreams, where I was so happy amongst the noblest of friends, who replaced my father, mother, brothers, and sisters—between these two poles my heart is divided.

We can only surmise what form these longings of his youth had taken and what education and experiences had stimulated them. His uncle the *bupati* was a learned man. He had assisted Raffles in the research for his *History of Java*. John Crawfurd, the British resident at the court of the sultan of Yogyakarta, wrote that Sura-adimanggala was "far superior to all [his] countrymen," and his sphere of ideas "extended far beyond what is common among Javanese of the high quality." Raden Saleh grew up in a home where the ideals of the Enlightenment in Europe were studied and respected. At his uncle's court, he had access to some of the literature that embodied the new foreign ideas, so contrary to the principles that governed the strict hierarchical society of Java. The most obvious difference between Raden Saleh and West-to-East exotes such as Rimbaud and Gauguin is that he maintained an affectionate allegiance to his homeland while he lived abroad. Rimbaud loathed his country; Gauguin called himself a savage and never felt that he belonged in France, like those displaced men postulated by Maugham, who are refugees at birth and live as aliens among their own kind; but Raden Saleh described his child-

hood home in Java as a paradise, a bright, happy place that continued to exert a powerful spell on his soul twenty years after he left it.

Raden Saleh's decision to leave Java was remarkably bold and brave. His position was altogether different from that of "savages" kidnapped in distant lands by early European explorers and brought back to the sovereign's court as human souvenirs. Raden Saleh undertook his voyage to the mysterious West by his own volition. A thousand years before, navigators from the Indonesian archipelago had sailed across the Indian Ocean to East Africa on the "cinnamon route." Some of them settled down overseas to operate trading posts: the linguistic and genetic footprint of Indonesia in Madagascar has been amply proved. It is even possible that Malay ships sailed into the South Atlantic as far north as modern Ghana. Yet these early mariners were explorers, Asian precursors of Columbus and Magellan, whereas Raden Saleh was drawn to Europe by his childhood dreams and found there a congenial civilization and a sense of family.

I have said that Raden Saleh was eighteen years old at the time of his voyage to Europe, but he might have been younger. In 1865, he wrote a letter to Willem III, king of the Netherlands, in which he claimed that he was sixteen when he left Java for Europe; if that were true, he would have been just six years old when he was apprenticed to Payen, which strains credulity. A more probable chronology, which I have followed, may be found in an inscription that Raden Saleh wrote on a portrait of himself by the Dutch painter Carl Vogel von Vogelstein in 1839, in which he stated that he was born in Semarang in May 1811.

Raden Saleh was an enthusiast who fervently idealized Europe and European ways, conforming to the pattern of Western travelers freshly arrived in the Orient with stars in their eyes. In 1832, at the age of twenty-one (or nineteen), he set up his own household on Hoogstraat, near the royal palaces. In his authoritative monograph on Raden Saleh, the German art historian Werner Kraus writes, "He had his lunch brought to his room by a chef and wore white trousers, a yellow cashmere waistcoat, a particularly fine green Russian winter coat, and English shirts." He ran up bills at

the city's best merchants in the flamboyant, freewheeling style of an aristocratic dandy.

A fabulist, Raden Saleh adapted his self-presentation to suit his ambitions. From a rational, Western point of view, the stories he told about himself in Europe could be viewed as self-aggrandizing lies, but it might be more useful to view them as self-romancing in the venerable Eastern tradition. For all his patrician airs, Raden Saleh was a poor, dark-skinned Muslim traveling in affluent Christian lands. He made his way in Europe by virtue of his personal charm and his talent, which eventually made him a successful artist. He was a sensitive young man with a passionate temperament, a character prized by Europeans raised on Rousseau and *The Sorrows of Young Werther*. However, not all the people Raden Saleh met in his travels were educated, open-minded followers of the Enlightenment; he must have been subjected to racist taunts, particularly in his early days in Antwerp and The Hague, when he was a gauche islander in the mother country, desperately trying to fit in.

In order to raise himself in a society that was almost as rigidly stratified as that of Java, Raden Saleh burnished his life story by greatly exaggerating his social position at home. By the time he arrived at the court of Saxe-Coburg-Gotha, where he became the particular friend of the grand duke, Raden Saleh styled himself the prince of Java, a ridiculous title, self-evidently meaningless, which would have provoked only jeers at home. His actual status in Java was closer to that of a lord mayor's nephew than a prince. As he climbed higher socially in Europe, Raden Saleh's self-confidence grew and his flamboyance burned ever brighter. He confected fanciful court costumes for himself, pastel satin tunics with a bejeweled kris thrust in the sash and a turban set with a fluffy aigrette and a diamond crescent.

In fact his family background was distinguished more by its revolutionary zeal than by its aristocratic lineage. In 1825, Sura-adimanggala, the *bupati* of Semarang, was arrested for treason after his son joined the Javanese resistance movement led by Pangeran (Prince) Diponegoro. Diponegoro was the eldest son of the sultan of Yogyakarta, but when his father died in 1814, he was

passed over, and his younger brother was set on the throne. After the premature death of the new sultan, his infant son succeeded to the title, and Diponegoro was again passed over, for the post of regent. Pangeran Diponegoro was an intensely devout Muslim, a visionary who believed he had a mandate from heaven to expel the Dutch infidels from Java. His followers hailed him as the Ratu Adil, the "Just King," a national messiah who would lead the Javanese to greatness, as predicted by the *Pralembang Joyoboyo*. This twelfth-century corpus of prophecies consists of long epic poems believed to have been written by Joyoboyo, a legendary ruler of Java who was revered as a demigod. His prophecies were mostly vague and enigmatic, but they made a few specific predictions about the Ratu Adil. One oracular verse stipulated that his name "must contain at least one syllable of the Javanese *notonogoro*": Diponegoro had two.

Yet his rebellion was no more successful than most military adventures predicated on divine intervention. The Dutch forces led by General Hendrik de Kock outnumbered the rebels and subdued them handily. In 1830, de Kock captured Diponegoro with the deceitful ruse of inviting him to a peace parley and then arresting him. Much later, after his return to Java, Raden Saleh painted the scene in his most famous picture, *The Capture of Diponegoro*, a patriotic icon that occupies a position in Indonesian history analogous to that of Eugène Delacroix's *Liberty Leading the People* or Emanuel Leutze's *Washington Crossing the Delaware*.

In 1831, Raden Saleh was entrusted with a sensitive task. The director of the Royal Cabinet of Rarities in The Hague asked him to identify a golden kris that de Kock had confiscated in Java after the collapse of Diponegoro's rebellion. Raden Saleh confirmed that it was indeed the kris of Pangeran Diponegoro. In Java, the kris is the emblem of divine authority, like the scepter of a European king; for the Javanese people, Diponegoro's kris was a national treasure that possessed supernatural power. Raden Saleh wrote this dry description of the golden dagger, which was called *Kyai Nogo Siloeman*: "*Kyai* means lord. Everything that belongs to a prince bears this name. *Nogo* is a legendary snake that wears a crown on its head. *Siloeman* is a name that is associated with

extraordinary gifts, such as the ability to make oneself invisible. . . . The name of the kris, *Kyai Nogo Siloeman*, thus means 'magic king of the snakes,' to the extent that it is possible at all to translate such a ceremonial name." The fact that this holy relic was in enemy hands was a profound humiliation for the Javanese. History added the insult that the Dutch later lost it: the national museums show no record of the kris of Diponegoro, and today its whereabouts are unknown.

It is impossible, of course, to know what was going through Raden Saleh's mind as he handled the kris. Did he sympathize with the vanquished royal rebel, as his uncle's family in Semarang had done? Or did he feel the first intimation of the gulf between himself and the magic world of his native land, which would grow wider during his residency in Europe? The incident might be viewed as the first manifestation of the cultural schizophrenia of a young man whose heart was divided between two diametrically opposed poles.

Displaced royals with divided loyalties turned up in Europe from many distant colonies in the post-Napoleonic period. One of the most important state commissions Raden Saleh received in Holland was a portrait of Kwasi Boachi and Kwame Poku, two princes of the Ashanti kingdom in the Gold Coast, a Dutch colony in West Africa, modern Ghana. First cousins, at the age of ten they were sent to Holland by their father and uncle the Asantehene, king of the Ashanti, as an incidental part of a scheme to conscript soldiers from Africa for the Dutch army in exchange for guns. The official report of the Dutch mission to Kumasi, capital of the Ashanti Empire, describes a collision of cultures that were utterly incomprehensible to each another.

When the Dutch entered Kumasi, the military band played the rousing Hunter's Chorus from *Der Freischütz*, the opera by Carl Maria von Weber. Major General Jan Verveer, the expedition's commander, told the Asantehene that it was the "Anthem of the King of Ashanti," which had been composed in his honor. The Asantehene adored the piece and asked that it be played over and

over. A ritual exchange of gifts took days. The Dutch gave the monarch a box of gunpowder, Chinese fans, champagne and pickled fruits, a porcelain tea set, a camera obscura, mirrors, a mantel clock, a silk banner of the royal arms, and a large statue of Psyche, which the Asantehene particularly admired. In return, he gave the Dutch gold dust wrapped in silk, an ox, a pig, sheep, and chickens; more than a thousand slaves brought panniers full of bananas, sugarcane, pineapples, yams, nuts, and palm wine. At a banquet on their last night in Kumasi, the Dutch staged a spectacle. They erected a prefabricated Greek temple made of wood painted *faux marbre*, with the statue of Psyche, brilliantly lit by mirrors, at its center. The camera obscura projected a swirling light show on the scene. In the finale, urns of Bengal fire erupted, gunpowder boomed, and the band played Weber. Then, as if on cue, a rainstorm blew through and destroyed the temple.

The Asantehene might have appeared to the Dutch as an ignorant savage potentate, but the deal he negotiated with them proved to be quite favorable to him. In exchange for an unenforceable commitment to provide "volunteer" soldiers to the Dutch, the king received two thousand rifles and more than eight hundred ounces of gold dust. Verveer also undertook to bring Kwasi Boachi and Kwame Poku to Holland to be educated. The boys were plucked up and carried off to Holland like exotic orchids.

The cousins were enrolled in an academy in Delft. Kwasi Boachi was one of the most brilliant students in his class, a tabula rasa who soaked up classical learning and Christian doctrine as fast as it could be poured over him. Kwame Poku fared less well: he never recovered from homesickness and took more interest in his piano and painting lessons than in classics, the principal subject of the curriculum. On holidays, the royal court in The Hague made pets of the boys, treating them in every way like princes of the blood, as indeed they were. Their playmates were the crown prince, the future king Willem III, and his sister, Princess Sophie, later married to the Grand Duke of Saxe-Weimar-Eisenach.

In 1838, the Ministry of Colonies commissioned Raden Saleh to paint a portrait of Kwasi Boachi and Kwame Poku as a gift for the Asantehene, to reassure him that his kinsmen were being well

looked after and also as a "personal reminder" of his agreement with the Dutch, "which, notwithstanding the great expense incurred by the government, still remains fully to be honored." Raden Saleh was paid the princely sum of nine hundred guilders. He posed the two boys with General Verveer, who stood beside them as a fatherly guardian. After the finished work was shipped to the Gold Coast, Verveer wrote to the Asantehene, asking that "the greatest care be taken of the envoy in charge of the beautiful painting, and that the carriers will be accompanied by some soldiers." Furthermore, it was "urgently necessary" that a good path be made around the mountain that intervened between the Dutch port of Elmina and Kumasi, because "it would be impossible to carry the painting over the mountain." None of this was done. After a halfhearted attempt to deliver Raden Saleh's portrait to Kumasi, it was returned to Elmina, where it was consumed by ants and rotted on the dank walls of the Dutch fort.

In adolescence, the Ashanti princes followed very different paths: Kwasi Boachi, a distinguished scholar, adopted European ways readily and became, to all appearances, fully assimilated, while Kwame Poku was a noncommissioned officer in the Dutch army whose aspirations as an artist and musician were thwarted. Pining keenly for home, he requested and was granted leave to return to the Gold Coast. As soon as his ship arrived, he wrote the Asantehene a letter in Dutch stating his readiness to serve him; in response, his uncle sent him two ounces of gold dust, a pittance, and refused him permission to enter the kingdom until he had mastered Twi, the language of his people. Virtually a prisoner in a place where no one spoke the language, Kwame Poku grew despondent and committed suicide with a gunshot to the head, at the approximate age of twenty-two.

Kwasi Boachi trained as a mining engineer, with the original aim of returning to his homeland to aid in the extraction of its gold, which financed the Dutch state and in particular its incessant wars to suppress rebellions in the East Indies. To this end, in 1846 the Crown sent him to Freiberg, Saxony, to study mining with Bernhard von Cotta, a famous geologist. There Kwasi Boachi was reunited with his childhood playmate the former princess Sophie,

now duchess of the realm, and received as an equal by the royal family. Like Raden Saleh, he developed a dangerous taste for the luxurious life of the upper crust and formed a lifelong affection for Germany. At the conclusion of his studies in Freiberg, when the time came for his repatriation to the Gold Coast, Kwasi Boachi wrote to King Willem that the prospect aroused in him a feeling of "abomination and horror." Kwasi Boachi had a strong motive to resist, for the reports from the mines in the Gold Coast that would have employed him revealed conditions that were truly abominable and horrifying: four years after the mines in the Gold Coast opened, twenty-one of the twenty-six employees dispatched to work in them had died, including the director of operations and three engineers, while the mines' total yield was four ounces of gold.

The principal reason for Kwasi Boachi's turn away from his native land might have been religious. He was now a devout congregant of the Dutch Reformed Church, and the widespread Ashanti practice of human sacrifice and trafficking in slavery revolted him. In his letter to King Willem, he said that he dreaded returning to "people whose mores, customs, habits, and religion . . . have not only become alien to me, but for which I have the greatest aversion." He could not find a position in the Netherlands that would have enabled him to remain there, for the obvious reason that there were no mines in the country, so he sought a job in the Indies.

He was sent to Java in 1850 as an "extraordinary engineer," a title created especially for him, he was told, because as "a political child of the Dutch government" he was entitled to exceptional privileges. It was a lie: the real meaning of the designation was to ensure that he never advanced to a leadership post—a distinct possibility, given his outstanding record. In a confidential memorandum, the governor-general of the Indies stated that if the African prince were ever put in a position of authority over Hollanders, "the principle of *la noblesse de peau* [nobility of skin] and of the moral and intellectual superiority of the white race above the brown, upon which our domination in the Indies rests, would receive a severe blow."

There was another, clandestine reason that Kwasi Boachi's career in the colonial service was stymied. In 1847, he ran into Raden Saleh at a house party in Maxen. The painter struck up a conversation with him and asserted that the Asantehene owed the Crown a large sum of money from the contract he had signed. Kwasi Boachi defended his father and laid the blame for any malfeasance on the Dutch. Raden Saleh wrote a confidential report to the Ministry of Colonies about this meeting, denouncing Kwasi Boachi as an ingrate. This tattletale letter might have contributed materially to the troubles that dogged Kwasi Boachi for the next twenty years. The incident casts an unflattering light on Raden Saleh, but he was more likely motivated by pride than malice. He was vain of his social position in Dresden and wanted to put the African upstart in his place. Many years later, when the two men met again in Java, they became friends.

In his travels throughout the Indies, Kwasi Boachi was humiliated by his immediate superior, a former classmate named Cornelius de Groot, who disobeyed orders by treating him as a manservant. De Groot made the Ashanti prince eat and sleep with the household servants and beat him frequently. Once Kwasi Boachi realized that he would never be able to take a place among the educated class of the Indies, he wrote to the governor-general complaining about the discriminatory treatment he had received and requested that he be reassigned. In 1862, after several long delays, he was granted a small pension and a freehold in Madiun, East Java, where he lived for forty-two years, cultivating tea and coffee. After his farm failed, he retired to a village outside Buitenzorg, modern Bogor. When he died, in 1904, he left the largest private library in Java.

In 1839, Raden Saleh began a grand tour of the capitals of Europe, which might have been intended to keep this dangerously westernized scion of a family with a history of treason out of Java as much as to finish his artistic education. He began in Germany. In brief stays in Düsseldorf, Frankfurt, and Berlin, followed by a long sojourn in Dresden, he saw for himself how old-fashioned the

style Kruseman and Schelfhout taught him had become. Romanticism, specifically narrative paintings of high drama and sublime wilderness landscapes, misty and moonlit, ruled. Caspar David Friedrich, based in Dresden, was the influential leader of the new sensibility in Germany. He painted solitary figures or loitering pairs in extremes of nature, dizzying heights and blasted forests. In his quintessentially Romantic painting *Wanderer Above the Sea of Fog* (1818), a young man surveys a mountain landscape obscured by luminous mist. The figure's back is to the viewer, which emphasizes his solitude and also conceals any clue to his emotional response to his precarious position. Ernst Ferdinand Oehme, a native Dresdener, built his career around eerie processions of cowled monks amid misty Gothic ruins, creating an atmosphere of historicist exoticism, Segalen's "stepping back in time."

In France, Romantic artists, notably Delacroix, exploited the fascination with Eastern subjects, creating the Orientalist genre in the visual arts. The use of the terms "Orient" and "Far East" to describe Asia has fallen from favor, for the logical reason that it depends on where the speaker stands: in California, China and Japan are the Far West. ("Western" is scarcely more useful as a descriptor of cultural identity: Finns and Cubans, in the West, have no more in common than do Bedouins and Koreans in the East.) In the Romantic age, "Orient" did not even refer to Asia; it was virtually a synonym for the Islamic world. French travelers used the word to locate Turkey, the Levant, Arabia, and North Africa; in *Salammbô*, Flaubert describes the people of Carthage as "oriental," yet Carthage is, in fact, west of Rome.

There were a few precursors, notably Gentile Bellini's superb portrait of the Turkish sultan Mehmed II, but Orientalism in European painting began in earnest with Delacroix's Algerian harem scenes, painted after he was sent on a mission to North Africa in 1832. Many of his narrative paintings were based on scenes from Byron's Oriental verse tales and dramas, which were also used by the prominent opera composers of the day, such as Donizetti and the young Verdi. Among Delacroix's earliest large-scale works in the genre is *The Death of Sardanapalus* (1827), based on Byron's tragedy *Sardanapalus*, which takes the ahistorical conceit

that the Assyrian tyrant had his concubines put to the sword before he himself committed suicide in the face of imminent defeat. The composition is a colorful, swirling mass of muscular male limbs and plump female breasts and buttocks, enacted upon and around a broad divan ornamented with golden elephants' heads at the corners. Berlioz wrote a cantata inspired by Byron's verse drama; Liszt left unfinished an opera based on it.

The main object of Orientalist paintings, like the poems that inspired them, was to stimulate sensation: unforgettable transports that arose from the moment of exoticism. The fascination with the lascivious, infidel Other in barbarous lands where (it was supposed) submissive maidens could be carried off and locked up for the private delectation of the bold began as a fad. In *Beppo*, Byron admits as much with his usual flippant candor. "Oh that I had the art of easy writing," he wrote, inviting the reader to protest that that was precisely the talent he possessed more abundantly than any poet of his age,

> How quickly would I print (the world delighting)
> A Grecian, Syrian, or Assyrian tale;
> And sell you, mix'd with western sentimentalism,
> Some samples of the finest Orientalism!

Byron, Delacroix, and the Orientalist opera composers created emotional excitement with graphic presentations of sex and violence. Modern museumgoers and opera audiences are challenged to keep in mind that in the age before photography and mechanical color printing, the oversized canvases of Delacroix and other Salon artists, painted in a brilliant palette with technical virtuosity, were in their time the sharpest, most colorful images ever created. Before the invention of sound recording and amplification, the orchestra was the loudest musical noise in the city, and the stages of opera houses the brightest places in the urban night. The spectacular Orientalist operas by Meyerbeer, Saint-Saëns, and Massenet, staged at the Paris Opéra using hydraulic machinery and lit by 960 gas jets, performed by an enlarged orchestra and troupes of dancers whose glittery, diaphanous costumes exposed

as much flesh as the censors allowed (particularly in scenes of barbaric orgies), were horripilating sensory assaults.

Even before his mission to North Africa, Delacroix had painted visual thrills with images of tigers, such as a well-known painting of a tiger cub playing with its mother, from 1830. Like most Europeans, he saw the great cats for the first time in public spectacles. Henri Martin, an animal trainer from Marseilles (who later founded the Rotterdam Zoo), became the first celebrity lion tamer when he entered the cages of his tigers and lions at a performance at a Dutch fairground, in 1819. The widely attested explanation of Martin's success was that he made the beasts docile by masturbating them immediately before the show.

Raden Saleh caught Henri Martin's act in The Hague shortly before he left for Germany. Tigers were plentiful in Java at the time; the Java tiger did not become extinct until the late twentieth century. However, he had never before seen a lion. At this time, Martin was staging fully produced melodramas that used lions in the action of the story. Raden Saleh saw *The Lions of Mysore*, which starred Martin's lordly lion Nero. He painted three portraits of the animal, which are among the best, liveliest works he produced in the Netherlands. He also painted an excellent portrait of Martin, an animated likeness that captures the humaneness of the lion tamer who eschewed the whip for gentler measures to subdue the great cats.

In a passage that has survived from his lost autobiography, Raden Saleh revealed a marked preference for Dresden. He found acceptance in aristocratic society in Germany more fully than he had in Holland. He wrote to his benefactor Baud that he had rented a "pleasant flat" and copied Van Dyck and Rubens "with tireless diligence." In Dresden, Raden Saleh discovered his style, and what a strange artistic phenomenon it was. He specialized in Orientalist scenes, particularly tiger and lion hunts, under the influence of Delacroix and especially Horace Vernet, a popular artist in Paris. Raden Saleh was following the market, apparently unaware of the irony that he, a Javanese artist, was painting subjects he was familiar with, specifically tiger hunts, as though they were exotic narratives, sensational glimpses of a mysterious, faraway

land. He played the role to the hilt, making himself a living arti-
fact of Orientalism.

His contribution to European art history, admittedly minor,
was to introduce Orientalism to German painting. It never caught
on as it did in France and England, for the same reason that the
quaint, diminutive aristocrat from Semarang was treated as a
social equal there: disunified, inward-looking Germany had no
colonial interests in the Orient, and thus no expensive wars of
conquest. The French interest in the Islamic world was a conse-
quence of France's invasion and occupation of Algeria in 1830;
later, when the French gained control of Cambodia, they almost
convinced themselves that Angkor was a French creation. In Dres-
den, Raden Saleh was lionized, feted as a visiting dignitary at the
most exclusive functions. His fame extended at least as far as Mu-
nich. A Dresden correspondent for the *Political Times* newspaper
reported that

> Raden Saleh, the chieftain's son or Prince of the island of
> Java, still remains here; the longer he stays the better he likes
> it here; just as he, as one becomes better acquainted with
> him, also becomes increasingly likable. A few days ago the
> Prince had the honor of being presented to the King by the
> Russian envoy. On this occasion he was clothed in his na-
> tional dress, which is very colorful, adorned with much
> goldwork and somewhat theatrical. He even had a dagger in
> his belt.

Raden Saleh was adopted as a protégé and social ornament by
one of the city's most prominent families. Friedrich Serre made his
fortune by operating the lime kilns that produced the raw materi-
als for the city's gas-lighting system and spent much of the money
on philanthropic causes. He was an early proponent of protecting
animals from cruel treatment and founded a society dedicated to
the new cause. Raden Saleh designed the logo for its journal, a vi-
gnette of the classical folktale of Androcles, a fugitive Roman
slave who sought shelter in the den of a lion, which befriended him
after he plucked a thorn from its paw. Serre also created philan-

thropies in aid of humans; he established the Tiedge Foundation, which provided financial assistance for poor artists.

Serre's wife, Friederike Amalie, was the charismatic hostess of a flourishing salon. Raden Saleh moved from the pleasant flat to live in their house and spent the summers at their estate in Maxen, ten miles south of the city. The Serre circle comprised some of Europe's most famous creative geniuses. Writers included Hans Christian Andersen, whose fairy tales were an international publishing phenomenon, and Ludwig Tieck, an influential Romantic poet. Franz Liszt and Robert and Clara Schumann played at the Serres' gatherings, and Jenny Lind sang with them. Ernst Ferdinand Oehme was a frequent caller, as was Carl Gustav Carus, a painter who had studied with Caspar David Friedrich and was one of the first psychologists. Carus described the unconscious in *Psyche*, a book published in 1846, fifty-four years before *The Interpretation of Dreams*.

Raden Saleh became attached to the Norwegian painter Johan Christian Dahl, best known for his moonlit harbor scenes; he also painted a spectacular view of Vesuvius erupting. Dahl fulfilled the role of master to Raden Saleh, so important to him throughout his European tour. Dahl's son Siegwald, also an artist, became a comrade and drew a series of sensitive portraits of his exotic friend. Scientists, too, frequented the Serres' salon, including the geologist Cotta, an enthusiastic fossil hunter in the early days of paleontology. It was at the Serres' Christmas party in 1847 that Cotta's pupil Kwasi Boachi had his unfortunate run-in with Raden Saleh. Liszt was there; he composed a transcription of a traditional Ashanti tune based on Kwasi Boachi's memory of it. He prepared his brief score, titled "Folk Anthem of the Ashanti," for publication in a learned journal that went out of business before it could appear.

Raden Saleh was one of the most popular habitués of the Serres' salon; he also managed to get a lot of painting done between the teas and balls and *soirées musicales*. He ignored the itinerary that the colonial authorities had prepared for his tour and stayed on in Dresden as long as he could get away with it, and then some. In 1840, long after he was supposed to have arrived in Vienna, the

"Folk Anthem of the Ashanti," transcription for piano by Franz Liszt

Dutch ran him to earth and ordered him to move on. He wrote to his benefactor Baud to explain himself and seek yet a further extension of his visit:

> Certainly Your Excellency will be surprised by this and may even be annoyed that I am still in Dresden, and I wish to explain this to Your Excellency. One reason is that I have friends here who attest that I have a talent for composition. I have firstly painted a lion hunt here, secondly a battle between Bedouins and Arabs (caravan), thirdly a storm at sea, fourthly two beggars. All the people here, even the professors, confirm that I have a good mastery of animal and human fights and of storms at sea. Europeans are less well able to depict fights and battles because they have a different temperament. It is therefore fortunate that I am Asian.

The respectful tone befitted his filial relationship with Baud, but his list of works sounds like a mixed lot in an auction catalog. Raden Saleh was always totting up how many paintings he had done, usually without a word about their artistic qualities beyond other people's praise. He had won the approval of the "professors," which was his principal concern. Most extraordinary was his assumption that being Asian was a fortunate accident for his career. The phrase about Europeans being temperamentally less apt at painting battles and hunts sounds like a parroted comment from "professors" who subscribed to the canard that Asians are cruel and violent by nature. In addition to the pleasure he took in dressing as a prince, Raden Saleh used his gaudy, exotic attire to draw attention to his fortunate Asianness. Ida von Düringsfeld, a visitor to Dresden in 1841, quoted this remark by him: "Feelings are so Oriental."

Maxen today looks very much as it did in the Serres' time: the church and the castle, a cluster of old houses, and not much else besides, set amid gently rolling fields bounded by country lanes barely wide enough for two-way traffic. In 2013, I drove down

from Dresden to visit a new friend, Jutta Tronicke, who keeps the key to the local history museum. The Heimatmuseum is located in an old rooming house at the main crossroads of the village. One of its three neatly kept rooms is devoted to the Serres and their circle, with a marble bust of Friedrich, a medallion of Hans Christian Andersen, and a purplish reproduction of Carl Vogel von Vogelstein's portrait of Raden Saleh.

The museum's main exhibit is a diorama with tin soldiers depicting the Battle of Maxen, a crushing defeat for the Prussians in the Seven Years' War. On November 20, 1759, a Prussian army of fourteen thousand troops led by General Friedrich Finck went behind Austrian lines on a mission to cut off their communication with command in Bohemia. The Austrians surrounded and overwhelmed the Prussians at a ridge known ever after as the Finckenfang, a contemptuous euphony that means something like Finck's Fall. The men of Maxen enact the Battle of Finckenfang from time to time, followed by what appears from the photographs at the Heimatmuseum to be a high-spirited picnic.

Jutta Tronicke is a short, stout, formidable-looking Saxon with blond bangs. One can easily imagine her running Prussian stragglers off her farmyard with a pitchfork, but she was raised in the Cold War, relatively peaceful times, and her furious energy has been channeled into the historical society and gardening. Our tour of the town proceeds quickly. The only points of interest are the Gasthof, an eighteenth-century inn that still serves good schnitzel and beer, and the church, which is closed. Business is slow at churches in Germany, particularly in the former German Democratic Republic.

We find the current master of Schloss Maxen at the top of a ladder, repairing a brick wall. *Schloss* is usually translated "castle" or "palace," but in Maxen it describes a compact, three-story manor house. Peter Flache bought the place in 2004 and is restoring it on a shoestring, with what in America would be called sweat equity. He descends the ladder, shakes my hand, and shows me his domain. The Doric pediment of the main entrance has an inscription, which informs the visitor that what is now the main house was built by a certain Schönberg in 1726. The interior is

empty; the only relic of the Serres' time is a grand, gilt-framed mirror, five feet tall. Flache says, "There were still many paintings here until World War II, but they were burned as fuel during the terrible winter of 1946." Jutta Tronicke believes that the lost manuscript of Raden Saleh's autobiography, which he wrote here, might have been immolated for the same purpose.

The small parlor where Liszt and the Schumanns played for the Serres and their guests has been hung with reproductions of paintings by Raden Saleh. Folding chairs lean against the walls. Flache's original intention was to restore Schloss Maxen for the purpose of presenting chamber music recitals to the public, part of a grand scheme to make Maxen a weekend holiday destination for Dresdeners, but it has been a disappointment. "The drive is a little too long," he explains, "and if it rains, no one comes."

We exit through a side door from the musical parlor to a small herb garden with a bronze sundial and walk around the house. Flache sketches a map of the floor plan for me. At the rear corner is a squat, square annex, built on the site of a tall tower that was part of the original house, which dates to 1510. Friedrich Serre took the medieval roof off the tower and added Gothic turrets in 1839. Fifty-five years later, the entire structure collapsed. The rear of the original house overlooks a steep, wooded decline toward a pond drooped over by a magnificent willow tree, which was there in the Serres' time. In the G.D.R. era, the old house was faced with asbestos and converted to granny flats.

Next Jutta takes me to the Lindenmuseum Clara Schumann, built beside a genuinely amazing linden tree, thirty-six feet in circumference and eighty feet tall. The museum is a former firehouse, six by ten feet; if it isn't the smallest museum in Europe, it can't be off by more than inches. On a stone pillar next to it is a bronze bust of Clara, looking up solemnly to admire the tree's boughs.

We drive through an arch in a high stone wall, quitting the village, and commence the short journey to our main destination, the so-called Blue Mosque of Raden Saleh. The road leads past a ceramic factory built by Serre, now converted to an artists' collective, and then turns into a dirt lane shaded by cherry trees. Halfway

there, Jutta pauses so I can take in the view of the village. She asks me if I will want tea or coffee and drives off, leaving me to stroll down, as the Serres' guests would have done. The road peters out in a thicket of pine trees. When I emerge from the woods, I see, topping a gentle knoll, Raden Saleh's contribution to the architecture of Saxony, a pale ocher cube about ten feet in each dimension, crowned by a silvery onion dome with a crescent finial, like hundreds I have seen in Java.

It is too small to have been a mosque of any kind; more likely it was conceived as a *langgar*, a place informally devoted to private prayer. It might have served no other purpose than to remind its builder of home. Germans call it Das blaue Häusel, the Blue Cottage, which is exactly what it is (except that it's yellow). The facade is finished in echt Javanese style; a scrolled tablet over the entrance has an inscription in classical script that says, "Honor God and love mankind." Inside is a small Maxenian shrine, with a copy of Hans Christian Andersen's fairy tales in German and postcards of Raden Saleh's paintings; a collection of Schumann CDs is piled by a little boom box.

Jutta has brewed our afternoon tea, served with homemade cookies. She introduces me to her husband, Georg, a retired engineer, who waves shyly from the garden. She explains that they bought the place in 1995, when it was in a state of complete ruin. Now they keep it as a sort of dacha with a bunk for Georg, who, she says with a smile, prefers it to home. "Georg has always been a worker. I knew he would never be content without work to do." Jutta reminisces fondly about her visit to Indonesia on a group tour in 2011. We lapse into a companionable silence, basking in the lilac-scented sunshine until it is time to drive me back to the village to collect my car and return to Dresden.

I ask Jutta about conditions in Maxen in the G.D.R. era: Was life harder under the Communist regime?

She hunches over the steering wheel and purses her lips. Finally, she says slowly, "Yes, it was hard sometimes." She looks around warily, as if there might be a Stasi officer in the backseat. "Everyone was not so rich. Everyone did not have beautiful cars and too much food to eat, but we were happy." A sidelong glance reassures

her that I am a sympathetic listener, and she confesses boldly, "In my heart, I am still a socialist."

In the spring of 1844, Raden Saleh moved to Coburg at the invitation of Ernest II, Duke of Saxe-Coburg-Gotha, whom he had met four years earlier in Dresden. Ernest, the elder brother of Albert, prince consort to Queen Victoria, had succeeded to his title less than two months before, on the death of his father the duke. The haste of the invitation during a time of mourning suggests that the old man might not have approved of an artistic Javanese dandy taking up residence in his castle, even if he posed as a prince. Middle European royalty was entering its final, confoundingly complex decadence, when duchies and dukedoms were shuffled and swapped about like properties in a game of Monopoly. Ernest's father started his ducal career as Ernest III, Duke of Saxe-Coburg-Saalfeld, but after the death of his wife's uncle, Frederick IV, the last Duke of Saxe-Gotha-Altenburg, he became Ernest I, Duke of Saxe-Coburg-Gotha, the royal house that ruled Great Britain until 1917, at the height of World War I, when George V changed its name to the house of Windsor.

Seven years younger than his guest, Ernest was an amateur painter and composer who strove to be a modern, enlightened sovereign to his poly-hyphenated dominion. The two young men formed a close friendship, which endured until Raden Saleh's death. They alternated painting days in the studio with hunts in the ducal forests and dined together every evening. A few days after Raden Saleh was installed in Ehrenburg Castle, the duchy's seat in Coburg town, Prince Albert arrived for a short visit, and Raden Saleh dined with them as a fellow royal. In Coburg, Raden Saleh embellished his royal pedigree with fanciful fabrications. He told Ernest's cousin the Count of Mensdorff-Pouilly, that his father was "the formerly independent prince of Yogyakarta . . . among those who resisted Dutch encroachment the longest," a tale with no factual basis (unless you count the fact that his uncle, the *bupati* of Semarang, had been arrested for treason). In the summertime, the court moved to Callenberg, a smaller castle

superbly sited on a wooded hilltop, where Ernest gave Raden Saleh a room for himself as a studio. Dating to the twelfth century, Callenberg, with its lofty towers and crenellated turrets, possessed an intensely romantic air, evocative of a tale of chivalry by Walter Scott (though such an association would have been lost on Raden Saleh, who appears to have read no imaginative literature whatsoever).

One of Raden Saleh's most impressive paintings from his German period is an affectionate portrait of Ernest and his wife, Alexandrine, an après-hunt conversation piece set on a castle terrace beneath a turreted tower. Ernest proudly exhibits a dead pheasant to his admiring wife. A huntsman kneels before them, displaying the rest of the day's kill, ducks and a doe, while a dog grips a hare in its muzzle. A groom in a top hat is leading away the duke's chestnut mount at left. In the middle distance at right stands the picture's most intriguing character, a black footman in livery holding Ernest's scarlet riding coat. His name was Maximilian Wilhelm Phillips, thirty years old at the time of the painting. He had come to Coburg three years before with a traveling animal show like that of Henri Martin; indeed it might have been Martin's own troupe. Ernest I hired him as a servant, and Phillips remained in Coburg to the end of his life. He was a popular and well-respected member of Coburg society: Ernest II stood as godfather for his son, and when Phillips died, at sixty-five, he was mourned by thousands in a public funeral.

Raden Saleh's residence in Coburg was the happiest period of his life, satisfying his aristocratic vanity and providing him with a surrogate family and ideal working conditions. Later in his European progress, he looked back on his time there fondly, recalling the "peaceful silence and domesticity of the familiar Callenberg" and "the affectionate circles who are so kind to me." Duchess Alexandrine was just as fond of Raden Saleh as her husband. In her unpublished memoir, she recalled,

> When in the first years after our marriage Saleh became a most welcome guest in our house, often for months at a time, he felt at home with us and was as close to us as a

family member; for he displayed the most sensitive tact and was never annoying or disturbing. He worked the whole day at his easel, and when in the evenings he came to eat, he was able with his comical ideas and stories in his broken Dutch German to set our laughter muscles in motion. Often he would also disappear for several days with his sketchbook to do studies or to fish, sleeping in some peasant's hut or another. He was known throughout the region as "the black prince," and everyone liked him for his simple affability.

Raden Saleh achieved the loftiest peak of his career as a social climber after he had moved to Paris, in 1845, when Ernest invited him to return to Coburg during his sister-in-law Queen Victoria's summer sojourn there. The English were not as kindly disposed to the black prince as the Saxons were. Lady Charlotte Canning, the queen's lady-in-waiting and later the first vicereine of India, wrote, "In the Grand Duke of Baden's room I saw one of the works of the Java Prince Ali, who lives at Coburg like a tame monkey about the house. [British foreign minister] Lord Aberdeen was so taken aback the first day to see this black in his Turkish dress instead of handing us coffee, quietly take some to drink himself." Yet she conceded, "When others are not in uniform he sheds his turban & gold & silver & becomes a regular German Dandy with most prussian manners."

Ernest was a merry monarch, beloved of his people, generous and high living, who fathered several illegitimate children. He led a corps of soldiers against Denmark in a little war over Schleswig-Holstein, greatly vexing Victoria, who was pressing for a royal match between Bertie, the Prince of Wales, and a Danish princess. After Raden Saleh left Coburg, Ernest professed music over painting. His opera *Diana von Solange* inspired Liszt's "Festival March on a Theme by E. H. z. S.-C.-G. [Ernest Herzog of Saxe-Coburg-Gotha]." When the opera was revived by the Metropolitan Opera in 1891, thirty-three years after its premiere, the piece was despised so bitterly by the public that a petition circulated demanding that the third performance be canceled, and it was. The Met's general manager, Edmund Stanton, was sacked after the debacle. The

rumor among Mrs. Astor's Four Hundred was that Stanton had been motivated to stage the long-forgotten piece because the elderly composer was notoriously liberal in the dispensation of orders and decorations; Stanton received one, but he was too embarrassed to wear it in public.

Ernest was also an avid supporter of scientific exploration. In 1862, he led an expedition up the Nile to Abyssinia with the zoologist Alfred Brehm, the first director of the Hamburg Zoo, and Friedrich Gerstäcker, a famous world traveler, a German prototype of Richard Halliburton. Gerstäcker published adventure novels and travelogues about the American frontier, revolutionary South America, and Polynesia that were among the most popular books in nineteenth-century Germany. By the time of his death, in 1893, Ernest had a reputation as an eccentric who wore frock coats several sizes too small, with lemon-colored gloves and a rosebud in his lapel. After he published an anonymous pamphlet attacking the British royal family, Queen Victoria wrote to her eldest daughter, the principal target of the libel, "Dear Uncle Ernest does us all a great deal of harm by his odd ways and uncontrollable tongue."

In Paris, Raden Saleh found his greatest triumph as a fashionable artist. He met his idol, the Orientalist painter Horace Vernet, a favorite of King Louis-Philippe. He wrote to Ernest, "Upon my arrival I had occasion to make the acquaintance of Horace Vernet, a contact that is extremely important to me. I visited him at his huge studio in Versailles and was given the most amicable reception and the friendly and obliging invitation to view his studio as my own." Raden Saleh did not take up Vernet's invitation, preferring to work at his own atelier, off the Champs-Élysées. There he labored over a vast canvas (more than eleven feet long and nearly eight feet high) of a stag hunt in the island of Java, which was exhibited in the Salon of 1847. The painting received exceptional reviews—"one of the greatest artworks of the last exposition," according to a Viennese critic—and was purchased by the king. As always mindful of the opinion of his mentors, Raden Saleh triumphantly wrote to Ernest to report that Vernet himself judged the painting "to be entirely successful. I am very pleased

and thank God that my tireless diligence has been crowned with glory."

Yet gay, glittering Paris was never as congenial to Raden Saleh's soul as sober Saxony. He moved in exalted company in Paris and was presented to the king, but he did not find a sympathetic circle of friends there as he had done in Dresden and Coburg. A letter to Baud written soon after his arrival revealed that the pious, discreet Javanese courtier survived beneath his gold-embroidered raiment: "Paris is a garden at the center of the universe, full of fragrant and delicious flowers and fruits. Everyone wants to plant more than the rest; but in the gardens there are serpents hiding amid the flowers and fruit-trees, who lurk in places where there are narrow, crooked pathways. O Allah! O My God!" One can only conjecture what inspired the striking image of serpents in crooked pathways: Was his heart broken by a cruel courtesan? Was he fleeced by a confidence trickster?

Yet for all his maidenly shock at the wicked ways of Paris, Raden Saleh adored being the cynosure of a stylish rout. He had developed a thirst for fame that would never be quenched. His zenith of social éclat in Paris occurred at a mid-Lenten ball in 1845. The correspondent for the *Ladies' Little Courier* reported,

All eyes were on a handsome young Indian, dressed in the most magnificent costume: his turban was surmounted by an aigrette and a crescent of diamonds; he wore a light green tunic worked with gold embroidery, and his belt and weapons were adorned with all sorts of precious stones. . . . His name is Raden-Salek-Sarif Bastaman. He was born in Java of an Arabic Mahometan family that counts many ruling princes among its members. The young prince declared early on his very pronounced taste for European civilization, and often left his uncle's palace to frequent the society of Semarang. . . .

He is now a man of Europe, who no longer has anything Javanese about him but his complexion. . . . Prince Salek is now thirty-two years old; his manners are noble, easy, and exhale a perfume of *bon ton* and good company; his tastes

are simple and modest; he appears to have no other passions than the study of science and painting. He comes to Paris, where he expects to make a stay of two years, to learn the French language and study the compositions of the great masters contained in our museums.

There is little profit in critiquing the credulous effusions of an anonymous journalist, but he or she got one thing right: Raden Saleh had become a man of Europe. One of the most curious phrases in the report is the observation that Raden Saleh now had nothing Javanese about him but his complexion ("n'a plus de java-nais que le teint"). It is a silly remark, for such a complete cultural reassignment is impossible, yet it inadvertently hit the mark, for it was precisely the tint of his skin that would later cause mischief for him. An incident dating to his arrival in Paris revealed how thoroughly Raden Saleh regarded himself a European, and was seen as one by his friends, and predicted the inevitable outcome of such a misapprehension. As a parting gift, Ernest provided him with a manservant to accompany him to France. Karl Cobelli was a Lombard, the son of a soldier in Napoleon's army who had settled in Coburg in peacetime and married there. Young Cobelli was a clever fellow, fluent in German, Italian, French, and English, who made it clear from the start that he had no interest in serving as a domestic in the household of a Javanese.

It was a doomed experiment in postcolonial egalitarianism at the height of the colonial period, which more than anything else revealed how advanced in his thinking Ernest was. Such an arrangement would have been unthinkable in Holland or England, and had a very peculiar appearance in France. When Raden Saleh discharged him, he wrote to Ernest, "The servant Cobellie [sic], whom I took with me from Coburg, has failed to meet the hopes invested in him to such an extent that I now feel forced, after having given him several warnings in vain, to dismiss him. He is neither orderly nor loyal nor honest, and above all so disobedient that neither kind nor angry words can induce him to perform his duties." As black a character as Raden Saleh painted of Cobelli, it did not hurt his standing in Coburg; after his dismissal in Paris,

Cobelli subsequently served in the entourage of Queen Victoria. In 1850, he immigrated to America and became a schoolteacher in Ohio.

We have a detailed portrait of Raden Saleh in Paris from the life by Charles de Spoelberch de Lovenjoul, bosom friend of Théophile Gautier, the author of macabre tales in the style of Poe a decade before Baudelaire's translations of Poe were published. Gautier was also an influential art critic and frequent visitor at the royal salon, where he and Lovenjoul probably met Raden Saleh. Lovenjoul begins his account of their visit with a fine Parisian indifference to geography by describing Raden Saleh as "well-built, like an Ethiopian Antinous. He has the brow, the hooked nose, the full curve of a very pure profile, for he is descended from an Arab race. The whites of his eyes are veined with golden filaments, which give his glance the various reflections of a gentle, radiant forest animal." The painter's hair was wavy, his "dark complexion set off by high cheekbones the color of copper, which shine like a bronze figurine that has been polished by rubbing." Raden Saleh wore amaranth-colored cashmere pantaloons, cinched at the ankles, and a charcoal-gray Javanese jacket lined in red, "which showed off his figure *à merveille*."

In 1851, Raden Saleh's Dutch patrons returned him more or less forcibly to Java. King Willem appointed him painter to the king, and the cabinet approved a generous travel allowance of three thousand guilders, but his request simply for the right to seek permission to return to the Netherlands at some point in the future was refused. The Crown had evidently decided that whether it had succeeded or not, the experiment of subsidizing the footloose wandering of a colonial subject across Europe had come to an end. Thus Raden Saleh, who styled himself the prince of Java, boarded the steamer *Makassar* bound for Batavia, twenty-two years after he had arrived in Antwerp as a passionately curious adolescent.

Raden Saleh was embarking on a new quest, as treacherous as the first. Now the poles were reversed: he was leaving Europe, where he was happy among the noblest of friends, to return to the paradise of his childhood in the hot sunshine. He would soon discover the perils that await the returning exote: not only has he

been changed by his experiences, but the former homeland too has changed, as every human habitation must, making him a stranger in a familiar land.

The business of colonial Java was always colonial business, with a single-minded concentration on the extraction of resources and little or no concern for the health and education of the native population. The gulf between Dutch and Javanese interests began to widen dangerously in 1830, the year after Raden Saleh's voyage west, when the Dutch instituted the Culture System (*Cultuurstelsel*, better translated as "Cultivation System"), which required farmers to raise export crops such as sugar, coffee, and indigo in fields formerly devoted to rice and other food staples for domestic consumption. The system was a brilliant success for the Dutch; by some calculations, the Dutch East Indies were the most profitable colony in history. In 1850, income from the Indies, principally Java, accounted for 19 percent of the wealth of Holland; at its peak, the colony's contribution to the national income exceeded 34 percent. The money was used to finance Dutch military campaigns and domestic public works such as rail and waterway networks.

However, it was a disaster for the Javanese. As a direct result of the Culture System, Central Java was devastated by famines. The scheme depended upon a large, virtually unpaid workforce, peasants who were treated as inferior brutes by a social structure that ensured that they remained brutes. The wretchedness of the lives of the mass of Javanese people had motivated support for Pangeran Diponegoro, and by the time of Raden Saleh's homecoming hunger was creating conditions ripe for revolt. The Dutch responded as colonial powers always did, with stricter and more severe repression of the rebellious subjects. In Europe, Raden Saleh had been able to play the operetta role of the prince of Java for an audience of enlightened aristocrats; in Java, he was an educated native, which made him potentially a dangerous man in the eyes of colonial authorities, benighted bureaucrats who left the operettas to their wives.

Therese von Lützow, a friend of Raden Saleh's from the idyllic days at Schloss Maxen, met him soon after his return. The author of society novels and editor of a volume of Humboldt's letters, she had come to the Indies with her second husband, the military commander of East Java. She wrote, "All Malays who undergo a process of Europeanization are unsuitable for Java and are kept at a distance on account of their free-thinking ideas. This is why the empire is closed to Raden Saleh, for a thinking man is an object of horror for the Dutch, who require blind obedience."

One of the principal difficulties he had to confront on his repatriation was the question of dress and decorum. He faced the humiliating prospect of having to dress at court in his "native costume," a sarong without a shirt or other vestment to cover his torso, and worst of all the requirement that he kowtow in the presence of sultans. He wrote a passionate letter to King Willem III (the one in which he stated his age as sixteen at the time of his arrival in the Netherlands), begging to be exempted from this requirement. He requested permission to wear a Western uniform, like the Javanese who served as officers in the Dutch army, who were excused from the requirement to prostrate themselves before the local sovereign.

It is a long, exquisitely convoluted letter, phrased in pathetic terms similar to Kwasi Boachi's letter to the same monarch when his return to the Gold Coast was mooted. Writing about himself in the third person, Raden Saleh tells the king that "he wishes to emphasize that his position in the country of his birth, as a Javanese, is quite unparalleled" and that "on account of his European education, his long stay in the country of education, his dealings with Europeans, the studies he has pursued, and the art which he creates, he is not able to place himself on the same level as the great majority of his less developed compatriots despite the fact that they are also his brothers." He is particularly alarmed by the prospect of being required to appear at court wearing a sarong "with naked upper body" (phrase underscored), which "his decency forbids." He cleverly posed as the most serious objection to baring his chest that it would prevent him from wearing the medal of a knight of the Oak Crown, which the king had awarded him in 1845. The

solution he proposed to this dilemma was for the king to allow him to wear the uniform of a defunct regiment, the Batavia civil defense cavalry, "which is worn neither by the Dutch nor by the Dutch Indian military, and is thus tantamount to a fantasy uniform."

It would be pleasant to attribute this stiff-necked refusal to humble himself before sultans to his belief in the Enlightenment ideal of equality, but he was more likely motivated by pride. After having sat at his ease in the royal drawing rooms of Europe, he felt himself an equal to the sovereigns of Java. The insoluble inconsistency between swearing brotherhood with the Javanese and his insistence that he nonetheless cannot place himself on the same level as them is precisely the inconsistency of his existence in Java as an educated native, a creature that could not exist in colonial society. A fantasy uniform was the only escape from the quandary created by the conflict between the fantasy identity he had spun for himself in Europe and the strict social hierarchy of the Dutch Indies.

Raden Saleh began his new life in Java with high hopes. Upon his arrival, as painter to the king he stayed at the palace of the governor-general in Buitenzorg ("Beyond Care"), a privileged enclave in the cool highlands south of Batavia. Then he visited his mother in Semarang and made a series of calls on uncles and cousins in Central Java, the *bupati* of minor regencies and districts. He settled for a while in a village a few miles outside Salatiga, the army town where Rimbaud would be posted after his arrival in Java, twenty-three years later.

In the mid-1850s, Raden Saleh moved to Batavia with a commission to restore portraits of the governors-general of the Indies, which had suffered damage from rot and insect infestation, the nemeses of oil paintings in the tropics. While he was there, he met and took to wife a rich white woman, the most subversive affront possible against the social orthodoxy of the Indies. In Holland, aristocratic society held advanced views about the place of people of color, at least the wellborn, such as Raden Saleh and Kwasi Boachi; but in the Indies the wealth of the nation was at stake. The imperative need to maintain racial purity (or the illusion of

it) was one of the foundations of the empire, just as it was in British India.

The racist code was tarted up with religious and pseudoscientific rationales, but it was fundamentally a question of property law. European men in the Indies could keep native women as mistresses; indeed the practice was encouraged in the early years of the empire, when there were few respectable single white women in the Indies and the daughters of Dutchmen born in the colonies were sent home as soon as they were old enough to travel. Such extramarital unions were harmless, for their illegitimate issue had no expectation of inheritance (never mind that they were condemned to lead wretched lives as outcasts). However, the marriage of a white woman to a native man of any class was anathema. Apart from the unspeakable horror of a dark-skinned infidel possessing the body of a white woman, any issue of such a union posed a threat to the integrity of the nation's wealth. The land belonged to the Dutch, so the procreation of a legal Eurasian heir was an assault against all white men.

Thus it might have been said that Raden Saleh had married well, if it were not a catastrophe. Constancia von Mansfeldt was born in Semarang of German ancestry in 1826. At the age of fourteen, she was married to one of the richest landowners in Central Java, Christoffel Nicolaas Winckelhaagen, also German; when he died in 1850, his young widow took sole possession of one of the largest, richest plantations in Java, more than eight thousand acres of well-irrigated agricultural land tilled by some six thousand dependents, virtually serfs. The estate was a river of wealth to its owner. Constancia's inheritance also brought a batik workshop, a perfumery, and a gold-smithing factory that employed thirty craftsmen.

It is probable that she and Raden Saleh entered into a common-law marriage in 1855 or 1856. It must have been a love match, for Constancia could hardly have been unaware of the risks. In short, Raden Saleh's life turned into the plot of a colonial melodrama about forbidden interracial love. With his wife's money, he built a stone mansion in Batavia in the neo-Gothic style, which was modeled on Schloss Callenberg—an architectural quotation

from Germany to match the Javanese souvenir of the Blue Mosque in Maxen. Raden Saleh's house was a showplace of the Indies. Ludovic, comte de Beauvoir, wrote a vivid account of his visit there in his bestselling *Voyage Round the World*, published in 1870:

> We alighted at the house, which was painted and ornamented by Raden-Saleh, the artist who passed many years in European courts, heaping adventure on adventure. . . . He was his own architect, and has colored his house a pale pink; it is shaded with tamarind and tulip trees, and looks into the enclosures of the botanical gardens, where black panthers and royal tigers are sporting: he uses them as models for his pictures, in which he succeeds in representing the more brilliant effects of tropical nature. He spoke French a little, and German very well. "Ah," he said to us in that language, "I think of nothing but Europe; one is so dazzled there that there is no time to think of death." It was a singular contrast to hear this man of color, in a green vest and red turban, with a kris at his side, and a palette in his hand, speaking, in Goethe's tongue, of French art, English beauties, and the curious recollections of European life.

The American biologist Albert Bickmore, later a founder of the American Museum of Natural History, called it "the most magnificent residence that a native prince owns in all of the East Indian archipelago." The house was conceived as a salon, a center of learning and the arts like that of the Serres at Schloss Maxen, yet this palace of enlightenment for the tropics was shunned by colonial society and received as its only guests curious foreign travelers like the marquis de Beauvoir and Bickmore. The house survives today as part of Cikini Hospital in Jakarta, on Jalan Raden Saleh.

In his memoir Raden Saleh described Europe's "diamond jewels" as three: art, science, and high education. He had returned to Java with an explicit, self-appointed mission to preach not only the techniques of modern art but also the latest discoveries of science, acquired by sporadic reading and conversations with other

Raden Saleh's house in Batavia, circa 1860

guests chez Serre and at the court of Ernest II. In his statement about the two diametrically opposed poles that exerted a spell on his soul, he vowed that when he returned to Java, he would paint for his people "a picture of the wonders of Europe and of the majestic dignity of human intellect."

Raden Saleh was an intellectual only in the loosest sense of the word: he had no ideas of his own, and most of his education took place at balls and house parties. Yet in the context of the Indies, he was a Promethean revolutionary. In his youth, there was really no such thing as Javanese science, unless one admits herbal cures and astrology, an important adjunct to court ritual. What learned inquiry there was was carried out by colonial amateurs such as Johan Maurits Mohr, a Dutch-German clergyman who toiled at translations of the Bible into Malay and Portuguese until a second marriage to a wealthy widow gave him the means to indulge his passion for astronomy. In 1765, Mohr built a grand Palladian observatory set in a green park in exurban Batavia, equipped with the best scientific instruments from Leiden, at a cost of two hundred thousand guilders, twice the budget for the governor-general's mansion. Mohr's observation of the transit of Venus in 1769 was among the most accurate made anywhere in the world. When Captain Cook stopped at Batavia for repairs, he called on Mohr, who gave him a copy of his report on the transit of Venus and that of Mercury later the same year, which Cook delivered to the Royal Society.

Raden Saleh's research in Java concentrated on the earth sciences, probably the result of having met Bernhard von Cotta in Maxen. In 1865, he painted a series of canvases of an eruption of Mount Merapi, the volcano near Yogyakarta, both in daylight and by night, which he had observed from a near vantage point. The paintings are vivid and precisely observed, with an intent scientific as much as artistic; they were used to illustrate geology textbooks until the early twentieth century, when good photographs of the phenomenon became available. In the same year, Raden Saleh led field expeditions in Java to collect fossils, one of the most popular pastimes of amateur scientists in the nineteenth century. He had most likely picked up the basics from Cotta when they met in Maxen.

A decade before the great excavations of fossil dinosaurs began in the western United States, Raden Saleh mounted an expedition near Yogyakarta after hearing reports from local farmers that they had found large bones buried in their fields. He sent the chairman of the Batavian Society of Arts and Sciences a detailed explanation of his finds, which included the fossilized bones of a twenty-foot-long prehistoric shark, which he identified as *Carcharodon megalodon*. Two months later, while exploring in a teak forest, he discovered the fossil remains of a mastodon. In his report to the Batavian Society, he wrote, "I thought I saw a piece of wood protruding from the ground in a small gorge. When I came closer I noticed that it was not wood at all, but a bone. I had it excavated and found it was some nine feet long. I saw other bones lying next to it, the largest of which was about ten thumbs in diameter." The letter was accompanied by precise drawings of his finds. The society, more enlightened in its views than the planters and bureaucrats who ran the colony, was impressed: after his return to Batavia with his specimens, it inducted Raden Saleh as an honorary member, the only native so honored besides two Javanese princes (real ones).

Yet there is no doubt that Raden Saleh's major achievement was to bring modern painting to tropical Asia. "Modern" may seem a curious description of his art, given its style and subject matter. By the time of his return to Java, Romanticism was a movement in decline. At the Paris Salon of 1850–51, the last that Raden Saleh saw before his return to Java, the triumph belonged to Gustave Courbet's panoramic painting *A Burial at Ornans* (at twenty-two feet in length, twice the size of Raden Saleh's *Stag Hunt*), a detailed, realistic document of a country funeral the artist had attended. Courbet himself boldly proclaimed, *"Burial at Ornans* was in reality the burial of romanticism." Fifteen years later, Manet's *Olympia* upended European painting once and for all, opening the way to modernism (thanks in good measure to the artistic vision of Gauguin, who was obsessed by Manet's enigmatic painting). Exciting narratives like those Raden Saleh had painted were gradually transforming into the sick fancies of academic Orientalism.

Werner Kraus makes an ingenious argument that despite Raden Saleh's appropriation of the subjects and pictorial style of the late French Romantic painters, he himself was not a Romantic artist. Fundamentally, Romanticism was a feeling or attitude of the mind. Delacroix and others set out to capture the sensory and intellectual stimulation they experienced contemplating the alien world of the Orient, conjuring the visceral thrill of a tiger hunt and the strange race of men who were on the chase. A part of the excitement, indeed essential to it, was the sense of revolutionary freedom that the Romantic artists felt at overturning the tyrannical canons of classicism that had ruled the art that preceded them. In Kraus's view, the aims and achievement of Romanticism, as Raden Saleh discovered it, are "impossible to understand without a knowledge of the German idealism and German classicism that preceded it." In 1830, the critic Ludwig Börne wrote about the Romantic movement in music in terms that apply just as well to art: "It is a joy to see how the industrious Romantics light a match to everything and tear it down, and push great wheelbarrowfuls of rules and Classical rubbish away from the scene of the conflagration."

This intellectual background meant nothing to Raden Saleh. Indeed, writes Kraus, it was "extremely alien to him. All that he experienced and saw in the Netherlands, Dresden, Coburg, and Paris was projected onto a different background, the background of a Javanese." Delacroix's paintings of tiger hunts were grounded in his perception of the exotic, but there was nothing strange about such a scene for a Javanese man who had hunted in the tropical jungle in his boyhood. In the case of the Javanese painter in Europe, the process of cultural overlay is inverted and purely conceptual: Raden Saleh painted scenes he was familiar with in a style that was alien to him, one that required him to feign wonderment at the commonplace.

Raden Saleh painted these exciting Orientalist scenes for reasons that were not really artistic. In the first place, he was catering to the market that was available to him. He was also influenced by the cockeyed notion that as an Asian he was temperamentally better suited to painting scenes of violent gore than a European artist was. Raden Saleh was observing and imitating the Roman-

tic feeling, just as he had observed and imitated the works of Dutch Baroque masters in The Hague during his apprenticeship.

What *was* alien to Raden Saleh, the novelty he found in European art, was simply the notion of painting scenes from life as the artist perceived them, without following an established pattern or serving an ulterior purpose. The poorly developed pictorial tradition of Java existed primarily as an adjunct to the religious experience, with rare excursions into naturalistic imagery borrowed from the narratives of the *wayang*, Indonesia's classical puppet theater. Based on stories from the Mahabharata and the Ramayana, the *wayang* is Java's principal artistic contribution to the world, which has exerted an overpowering influence over the other arts of the island. Painting was a decorative art, which required the faithful execution of narrowly prescribed patterns and gave the artist little scope for individual expression.

Raden Saleh took a craftsman's satisfaction at having successfully performed an allotted task, but the notion that the work was supposed to be an expression of his own imagination might have puzzled him. In his letters, he frequently writes about his "compositions": a good composition was one that his teachers approved because it followed the canons of the Dutch masters or later those that skillfully imitated Romantic painters who had found success at the Salon. If Raden Saleh had been born a hundred years earlier, he might have devoted himself with the same diligence to scenes of blushing Venus and muscular Mars. There is an emptiness at the core of Raden Saleh's European work. The Oriental hunt scenes he is best known for were not expressions of his imagination so much as variations on the imaginative vision of other artists.

After his return to Java, Raden Saleh found the confidence and skill to approach scenes familiar to him from childhood with a creative attitude of detachment, acquired by living as a stranger in an alien culture that prized creativity. A painting of 1863, *Drinking Tiger*, takes as its principal subject the awesome power of the tropical forest, reminiscent of contemporaneous landscapes of the Andes by the American painter Frederic Edwin Church. The small figure of the tiger, at the extreme lower edge of the canvas, has

become a conventional ornament, as if added for scale, like a piping shepherd in the middle distance of an Arcadia by Claude Lorrain. The beast laps at a gentle stream, peaceable as a tabby cat, dwarfed by the primordial majesty of the land. Before Raden Saleh, no Indonesian artist had ever painted a picture with the forest as its principal subject; if it was depicted at all, it was the background to a scene from the *wayang*. In the context of Javanese art, *Drinking Tiger* is as revolutionary as *Olympia*.

Among Raden Saleh's best work in Java are the many portraits he painted after his return. It is interesting work because it interested him; one feels that he is reckoning not only with the subject seated before him but with what it means to be Javanese. A portrait of Raden Ayu Muning Kasari, sister of the last court poet of the sultanate of Surakarta, seats the subject by a small marble-top table with her arm resting on it, beside a teacup, a wooden box, and a small spittoon. Her traditional costume is meticulously observed, every fine, spidery line of her batik sarong rendered with a precision reminiscent of a Dutch Baroque genre scene. The composition is conventional, focusing the eye on the subject's face, which is observed with emotional complexity. The old woman peers at the viewer with heavy-lidded eyes and a mouth pursed shut: Is it sadness or resignation? Weariness with life? One feels the artist's sympathy with the subject even as he respects her isolation. A portrait of Hamengkubuwono VI, sultan of Yogyakarta, in Javanese court dress is rigorously frontal and stiffly posed, yet the face is animated with perceptible human warmth; a depth of intelligent feeling shines forth from the dark, placid eyes. The subject of the painting is the man, not his office. Like *Drinking Tiger*, in the context of Javanese art these portraits are modern paintings.

By 1869, Raden Saleh's life had attained a certain stability. He never found a congenial place in the sparse intellectual life of colonial Java, which was compelled by its white supremacist ideology to marginalize him; yet he was nonetheless able to pursue the scientific studies that interested him, and he even found a measure of acceptance as an honorary member of the Batavia Society (though it is unclear to what extent that "honorary" qualification limited his participation in the society's activities). He had pros-

pered professionally, receiving many lucrative public and private commissions. Most important, he was happily remarried. His marriage with Constancia von Mansfeldt had ended in divorce under terms that have not survived, though they left him in possession of the house in Cikini. He adored his new wife, Raden Ayu Danudirejo, an aristocrat's daughter who had been raised in the privileged confines of the *kraton*, the palace of the sultan of Yogyakarta. He moved from the mansion in Batavia, the showcase for modern art and science that never was, to a modest house in Buitenzorg, where he lived quietly with Raden Ayu and her adopted niece, a child named Sarinah.

Then disaster struck. In April 1869, a violent insurrection against colonial rule broke out in Bekasi, West Java. Such rebellions had become frequent since the time of Diponegoro, as Dutch control over the economy of Java intensified and the Culture System played grievous havoc with life in rural villages. The disgruntled peasants of Bekasi, desperate and hungry, put their confidence in a demented visionary who claimed that Raden Saleh had endowed him with magical powers. The insurgents believed that Raden Saleh, a Javanese who had traveled to the distant, almost mythical land of Europe and who (in their eyes) moved easily among the Dutch as an equal and received distinguished foreign guests, must be a wizard of some sort.

Like all such rebellions, the Bekasi uprising was quickly suppressed by the Dutch. One of the mutineers arrested by the police had in his possession a letter with the signature "Raden Saleh." The authorities sent soldiers to Buitenzorg to seize the artist and brought him to the regent of Batavia, who interrogated him with severity. Raden Saleh knew nothing about the events in Bekasi. How could he? The police ransacked his house and found no corroborating evidence, but the resident insisted that Raden Saleh be transported to the jail where the conspirators were confined to participate in a lineup, to see if the arrested men could identify him. They could not, of course: they had never seen him before. The gang's leader confessed that he had appropriated the artist's name as a talisman to endow the insurrection with magical power, and the letter was exposed as a crude forgery.

Despite the incontrovertible evidence of Raden Saleh's innocence, the resident put him under surveillance for months. Imagine his chagrin: he, painter to the king, knight of the Oak Crown, who had supped with Queen Victoria and counted princes and dukes among his intimate friends, was treated as a common criminal based on the flimsiest evidence, which had already been discredited as a fanatic's fantasy. Raden Ayu was not in purdah, but she had spent her entire life sheltered in the *kraton* and her husband's home, and the rough treatment she received was an insult to her position as a highborn Javanese matron. Raden Saleh experienced a crushing disillusionment, which engendered a corrosive bitterness that robbed him of his peace of mind for the rest of his life.

Three years later, still smarting from the humiliation, he decided to return to Europe to live. He wrote a series of letters to Ernest, more than twenty years since they had last seen each other, seeking a renewal of his aid and protection. In March 1873, candidly confessing the depth of his cultural confusion, he wrote, "I yearn terribly for Germany, where people are united by so much more intellectual intercourse and educational community. Having departed for Europe a Javanese, I returned in spirit a true German and hope soon to see my new homeland once again." Ernest took the hint and invited his old friend for a visit. Raden Saleh sold all his possessions to raise funds for the trip, and in May he took his family and two Javanese servants aboard a steamer bound for Marseilles.

The European tour, which he hoped would lead to a permanent residence, began in Paris. The city was almost unrecognizable as the place he had lived twenty-five years before. It had been rebuilt and transformed into a model of a modern bourgeois city, following the plans of Baron Haussmann; moreover, it was still recovering from the depredations of the Prussian occupation and subsequent chaos of the Commune four years before. Yet most disappointing of all was his discovery that as an artist he had become a provincial antique. The Romantic style he had followed was now in its final decline. Raden Saleh soon abandoned his naïve hope of reclaiming his position as a fashionable artist in order to

support himself after he exhausted the meager funds raised by the sale of his household goods.

The world had shrunk in a quarter century. The opening of the Suez Canal and the rise of global telegraphy had made the cities of Europe much more cosmopolitan. Travel periodicals such as *Le Tour du Monde*, a French forerunner of *National Geographic* illustrated with fine engravings, had begun publication, sapping the mysterious East of its mystery. Raden Saleh might well have felt ridiculous wandering the new boulevards of Paris in his "fantasy uniform" with his childlike wife. He cut short his stay and left for The Hague, where he had to wait two months for an audience with King Willem III, his knighthood notwithstanding.

Coburg, too, proved to be a disappointment. Germany's fairy-tale fiefdoms had coalesced into a new empire, which strove to "out-modern" Victoria's industrialized England and the newly established Third Republic in France. Ernest received his old friend hospitably, but the intimacy was strained. No longer was he held as close as a family member who set them all laughing with his comical ideas. In her memoir, Duchess Alexandrine wrote this cruel description of Raden Saleh after a separation of twenty-five years:

> He had become an old man, and it was not only his external appearance that showed the traces of old age, his intellect had also become weak and shallow due to the long period of estrangement from European culture. He still painted, yet his pictures lacked all the poetry and all the truth of the tones. It was painful to observe a former artistic master decline and decay to such an extent. One could not praise what was not beautiful, and one did not wish to offend him by expressing the naked truth, for he was very sensitive, and as a result of bitter persecution by the Dutch government in Java had become highly distrustful and suspicious.

The passage is perhaps more revealing about the closing of the duchess's mind since the days when she seated her Javanese friend at a dinner table with the queen of England than about the quality of Raden Saleh's art, though there's no doubt that the years had

vitiated his creative powers. The duchess's attempts at tact in her relations with the proud artist must have fallen flat; surely he felt the coolness. Ernest put him up in a castle outside town with a German maid but invited him less and less often to dine with the family at the ducal seat.

In an affectionate bread-and-butter letter to Ernest and Alexandrine written after his final return to Java, which would be his last communication with the friends he steadfastly adored, Raden Saleh described his triumphant homecoming. He wrote that when he arrived in Batavia, he was received by the governor-general, who told him, " 'Think no more, Raden Saleh, about that affair with the brigands! Forget the injustice that was done to you! You are entirely free of any suspicion!' And his Excellency said the same to my wife: 'Reassure your husband completely!' " One may wonder whether the governor-general was really so emphatic in his reassurances, or indeed if they were wholly invented by Raden Saleh; yet even if his report was accurate, the comforting words came too late. Elsewhere in the letter, Raden Saleh clearly spoke from his heart, for so long divided by diametrically opposed poles: "Believe me, Your Highnesses, when I say that only our bodies are in Java but our spirit and our thoughts are in Europe."

Raden Saleh lived on in his house in Buitenzorg, unfurnished since the sale of its contents, for less than a year after his return. He died of a brain hemorrhage at the age of sixty-eight. His death was reported to the governor-general by his neighbor in Buitenzorg, none other than his old rival Kwasi Boachi, whom he had painted when he was a princeling newly arrived from the Gold Coast and he himself was an ambitious young artist set on making his name in Europe's happy countries, where the longings of his youth had drawn him.

Insanely Gorgeous

Where should we be today?
Is it right to be watching strangers in a play
in this strangest of theatres?
What childishness is it that while there's a breath of life
in our bodies, we are determined to rush
to see the sun the other way around?
The tiniest green hummingbird in the world?
 —Elizabeth Bishop, "Questions of Travel"

When the German artist Walter Spies embarked on his voyage to Java in August 1923, he must have felt that he would never return. Two months before his departure, he wrote to Hedwig Woermann, a shipping heiress and sculptor, "It's only when you're really clear of Germany that you realize how terrible it is to live there, what a terrible place it is, what ghastly people are there, how arid and unfeeling they are, and how you become the same in their midst." He declared his independence: "I'd rather go away from the lot of them and try to find myself a new home." Like Rimbaud when he abandoned the country he loathed, Spies had no fixed destination; he was sailing away from, not toward, a particular place. He told Frau Woermann that he was considering "Australia, the South Sea islands or East Asia, India or South Africa; if it turns out that way even America, South America, or the Gulf of Mexico": in other words, anywhere that wasn't

Europe. The point was to start over in "eine neue Heimat," a new home.

Again following the pattern of Rimbaud, Spies made his resolution to leave Europe just as his artistic career there was beginning to find success. His vividly colored, theatrically lit paintings of village life, often with a naïve feeling reminiscent of Henri Rousseau, *le Douanier*, had been hung in major exhibitions in Berlin and Amsterdam. He had an ideal living situation as the lover and protégé of F. W. Murnau, one of Germany's first great film directors, who introduced him to many of the best-known artists of the day and set him up in a studio and private apartment in his luxurious villa in Grunewald, on the outskirts of Berlin. It was all much too comfortable and secure for a lively dreamer of twenty-seven.

The main purpose of the letter to Frau Woermann, whom Spies had not seen in four years, when she took him under her wing while he was living in Dresden, was to beg a job aboard one of her family's ocean liners, which could transport him to his new home. A month later, he shipped out aboard the SS *Hamburg*, bound for Java, posing as a sailor. He went AWOL in Batavia and spent the next four years wandering the island in a daze of delight, with a long sojourn at the palace of the sultan of Yogyakarta, who had appointed him conductor of the court orchestra. In 1927, Spies moved to Bali at the invitation of Tjokorde Gde Rake Soekawati, in the highland village of Ubud. The Tjokorde, equivalent to a duke or prince, gave him a plot of land at the auspicious confluence of two rivers, which became his *neue Heimat*.

Heimat is a central concept of German identity, much as "freedom" is to Americans, which has evolved over centuries to reflect the aspirations of the country's people. The basic meaning is "home," but it is fraught with a sense of destiny and dominion, in the sense of the British legal proverb that a man's home is his castle. In Bali, Spies created what amounted to a tiny aesthetic state, democratic and multicultural, with himself as *arbiter elegantiae* and philosopher-raja.

In Germany today, Walter Spies is almost entirely forgotten. His hasty flight to Asia at the onset of his artistic maturity effec-

tively obliterated him from the history of European art. The Dutch colonial authorities despised him for his intimate familiarity with the native inhabitants, but the people of Bali adored him, and there his legend endures. Any modern visitor to the island who takes a serious interest in its art and culture soon learns about Walter Spies, but outside Indonesia his name has been almost entirely effaced. His artistic legacy is divided among many media and riddled with gaps. As a painter, he was a slow worker and lazy to start new projects without a commission; many of his best works have been destroyed or lost, and virtually all that survive are in private hands.

The life of Walter Spies presents a perfect pattern of the exote artist. I have said that he was German, and he was; Spies loathed bourgeois German society as only a German intellectual can. Yet like Gauguin, who spent his early childhood in Peru with his mother's patrician colonial family, Spies had a cosmopolitan pedigree. His paternal grandfather was a German merchant who immigrated to Russia and subsequently became a Russian citizen; his son Léon, Walter's father, was born in Russia. Walter's German mother, Martha von Mohl, was of Scottish descent on her mother's side and met Léon Spies in St. Petersburg.

Walter, the third of five children, grew up amid wealth and culture in a grim, imposing neoclassical mansion in Moscow with a staff of twenty servants. A bluestocking cousin held regular musical soirées, where the child Walter met Gorky, Rachmaninoff, and Scriabin, whom he idolized. He heard Feodor Chaliapin sing in her parlor. The family passed the summer holidays at a lakeside dacha swimming, cycling, rowing, and playing tennis; by the age of eight, Walter was shooting fowl with the men. When Russia went to war against Germany in 1914, opening the eastern front in World War I, the lavish life of the Spieses disintegrated. Léon Spies, who served as German consul, was taken into custody under suspicion of espionage; eventually, the family business was seized, and the dacha was burned. Martha was able to escape to Germany with her two youngest children, but Walter, who had just turned twenty, was arrested and interned in the foothills of the Urals.

His three years at Sterlitamak proved to be an idyllic interlude, confirming Spies in the adolescent conviction that he had been blessed with a charmed life. His internment might also have instilled in him the principle that *Heimat* was a portable concept. His living conditions were far from harsh, more like the family dacha than a prison camp. He stayed with a Tatar family who gave him a private room with a piano; with the addition of local carpets and embroidered pillows, he lived in far greater comfort than his family did in Berlin. Internees at Sterlitamak were given extraordinary freedom to pursue leisure activities. Spies reported that "a dancing tea" (his English) was held on the tennis court daily. He had his fox terrier Gipsy with him; two of his cousins were quartered nearby and accompanied him on long walking tours in the mountains.

Spies did a few drawings in the outdoors, but he devoted most of his time to music. He met a talented violinist named Müller, with whom he played Grieg's sonatas and "things by Bach," yet his consuming enthusiasm was the folk music of the Tatar and Bashkir peoples of the Urals. He endeared himself to his hosts by performing a concert of their own music, featuring his transcriptions of traditional songs for piano. In addition to learning the local languages, he studied Arabic and Persian with a linguist who was interned there and commenced a translation of *The Arabian Nights*. Another scholarly prisoner lectured about Edgar Allan Poe.

Sterlitamak, as Spies described it in his letters, was a tranquil retreat devoted to learning and creativity to a degree that invites incredulity. His letters to his mother no doubt suppressed any unpleasantness and embellished the pleasures of his life in confinement, but he had already mastered the knack of believing his own fantasies. He was also endowed with a prodigious talent for self-knowledge, which partook of prophecy. Just before his twenty-second birthday, near the end of the war, he wrote to Martha, "One thing I've got out of it, never again in life will I think 'what will become of you.' What will be will be. I shall never live for the future, just enjoy the present, be that what it may. You can always find something good in it. What is the future to me, when to-

morrow I may not even exist? This way I'll always feel good, espe-
cially as I have the quality of fitting into my surroundings like a
chameleon."

Spies was released at the end of the war and returned to
Moscow. There, through a recommendation from Maxim Gorky,
he received a commission from the Moscow Opera to design the
décors for a production of Donizetti's *Don Pasquale*, a remarkable
assignment for an artist of twenty-three with no résumé. Condi-
tions in Moscow were wretched, and he soon made his way to
Berlin, where he was reunited with his family. Although they were
penniless now, all the children except the eldest, Bruno, who went
into business in Finland and later immigrated to America, pursued
careers in the arts: Walter's elder sister, Ira, as a singer, Leo as a
composer of symphonies, and Daisy, the baby, who had a success-
ful career as a dancer. Spies left almost immediately for Dresden,
where he made a point of not enrolling in classes at the Art Acad-
emy; nonetheless, he befriended Otto Dix, Oskar Kokoschka, and
other painters who pursued humanistic ideals in the aftermath of
the catastrophic war.

Lucky as he would always be in his choice of living situations,
Spies found a place at Hellerau, a creative commune twenty min-
utes by train from the center of Dresden. It was a utopia in the
strictest sense, a model city built to foster the theories of Émile
Jaques-Dalcroze, in particular eurythmics, his system of music ed-
ucation based on rhythmic gymnastics, which had the ultimate
goal of transforming life into a continuous, fraternal harmony.
Hellerau attracted many brilliant artists and writers, including Paul
Claudel, Sergei Diaghilev, Rainer Maria Rilke, and George Bernard
Shaw. An aspiring twenty-three-year-old architect named Charles-
Édouard Jeanneret, who as Le Corbusier would become the great
idealist of modernist architecture, visited his brother at Hellerau
and wrote to their parents that "everything is new . . . the new
painting, the new sounds, the new literary form."

In 1920, Spies made another venture into theater with designs
for Knut Hamsun's play *The Game of Life* (*Spiel des Lebens*) at the
State Theater of Saxony. The production was a hit, and the critics
singled out Spies's décor for praise. His paintings from this period

are mostly faux-naïf forest scenes evoking his years in the Urals, disclosing potent influences from Marc Chagall and especially the paintings of Rousseau, whom he had recently discovered in a private collection in Moscow. Spies was enchanted by Rousseau's flat, frontal depiction of the figure, childlike perspective, and obsessive detail. He would later say of his first encounter with Rousseau's work, "I was totally carried away! It was like a revelation and a confirmation. At last something that seemed to me to be totally frank, honest, and straightforward."

Among Spies's most complex and accomplished paintings from his early period is *The Farewell* (*Die Abschied*), painted in 1921, a theatrical scene of leave-taking that comically invokes scenes from *Romeo and Juliet* and *Cyrano de Bergerac*. The setting is a farmhouse beside a lake, the space defined by fences twisting into a helix, with the lake appearing to rise into the sky. The woman being taken leave of sits on a balcony, fluttering the requisite handkerchief at her buffoonish lover, who lifts his hat in a reciprocal cliché. The painting has an antic, sarcastic tone, like a parody of a bad play. A major canvas painted in Berlin the following year, *The Merry-Go-Round* (*Das Karussell*), shows Spies at his most lighthearted in a scene of a Russian village fair, complete with puppets, an "American boxing" match, and, at the center, the vertiginous carousel. Daisy would later recall that Spies danced while he was painting it, to prove to her the affinity between their fields.

At Hellerau, Spies formed a strong romantic attachment with a pianist and composer his age named Hans Jürgen von der Wense. Wense's career was off to a brilliant start. Critics compared his music favorably to that of Prokofiev, Stravinsky, Bartók, and Schönberg; Hans Heinz Stuckenschmidt ventured that Wense was "perhaps the most future-looking among them." The musical genius fell hard for graceful, golden-haired Spies. In his diary, Wense described Spies as a "Futurist wild child like Rimbaud." Wense created a phantom lover from his romantic daydreams about Spies by the same process, at the same time, that Proust was composing a fantasy lover in the character of Albertine in his novel. Wense evidently had a poor understanding of Rimbaud: he himself, a gloomy introvert prone to strange obsessions, was much more like

Rimbaud than indomitable, sunny-natured Spies. A portrait of Wense in his military school uniform holding a pet dachshund reveals a gentle young man with a plain face, sensitive to excess. He was dazzled and intimidated by the close-knit Spieses, who were something of a German counterpart to the Mitfords. Wense wrote in his diary, "The family has a language and a sense of humor all their own. They are constantly making private allusions that they enjoy enormously. They live entirely as they please, without any discipline; not like me but quite spontaneous."

The youths' friendship became physical when Wense moved in with Spies at Hedwig Woermann's house in Dresden. She played a kindly, indulgent mother hen to the brilliant young men from Hellerau. She could see the emotional perils for high-strung Wense and warned him not to expect a stable relationship with the impulsive Spies, who loved everybody and wanted to belong to no one. Inevitably, Wense came out of the relationship with a wounded heart and moved to Berlin. Around the time of his liaison with Wense, Spies experimented with heterosexual love, with Bianca Segantini, the daughter of Giovanni Segantini, an Italian Symbolist painter of Alpine landscapes. She was the first in a line of married women who found themselves charmed by Spies a shade too much. She described him at this time as having "hair the color of ripe corn and eyes as blue as the sky." Spies's extraordinary good looks were affirmed by everyone who knew him, but his beauty was not photogenic: pictures of him from the same period sometimes look like photographs of different people.

The experiment failed. By 1920, Spies too had moved to Berlin, the center of gay life in Germany. Wense introduced him to the Erdmanns, Eduard, a composer and pianist who gave the first performances of compositions by Wense and the Spies brothers, and his wife, Irene. Eduard was reputed to be a jealous husband but raised no objection to Irene going out on the town with Walter. Once when they were dancing, Irene commented on the dashing good looks of another man on the dance floor, and Spies replied that it was nice that they could share the same tastes.

Another homosexual intellectual in Spies's circle was a polymathic linguist named Kostja Behrens, who had also been interned

at Sterlitamak, though the two men seem to have had no contact there. Under his influence, Spies undertook a study of ancient Egyptian hieroglyphics and the Coptic language at the University of Berlin. He was fascinated by the iconoclastic pharaoh Akhenaten and his queen, Nefertiti. The pharaoh's writings, including the philosophical *Great Hymn to Aten*, the most complex and profound work of pre-Homeric literature known then, had been published for the first time twenty-five years before, by James Henry Breasted, an American Egyptologist in Berlin.

Spies dabbled in the occult but never joined a mystic lodge. Like Faust and his famulus Wagner, Behrens and Spies pored over enigmatic hieroglyphic manuscripts late into the night, but there is no evidence that their friendship was anything but platonic. However, the intensely romantic, perpetually disappointed Wense fell in love with Behrens and suffered a nervous breakdown after the relationship ended. Spies, the life bringer, talked him out of suicide and proposed a visit to Behrens in Heidelberg, where he was studying, to restore his friends' peace of mind. From there, they voyaged down the Rhine to southern Germany and concluded the tour in Munich, where they met several artists, including Paul Klee, whose works would later be exhibited with Spies's.

The conventional wisdom about life in Berlin during the Weimar Republic is based more on Christopher Isherwood's writings and particularly the Isherwood-derived Broadway musical *Cabaret* than a knowledge of its actual history. Berlin deserved its reputation as an open city where all tastes and inclinations were tolerated—to a point. The gay underground was indeed active during the Weimar Republic, although homosexual acts were strictly outlawed by the notorious Paragraph 175 of the criminal code. The abuse directed against gay men was sometimes vicious. Throughout his life, part of Spies's attractiveness, to his heterosexual friends as well as to his lovers, was his utter insouciance about his sexual inclination. His sexual experiences began in high school and continued at Sterlitamak, and he never concealed his gay identity from anyone: it was inconceivable to him that anything he did could be wrong. However, for a repressed young man like

Hans Jürgen von der Wense, the feelings of guilt arising from il-
licit sexual activities were intense.

Hans Rhodius was a Spies enthusiast from the Netherlands
who devoted his life to the study of the artist's life and work. He
tracked down and preserved Spies's letters and published them in
1964, supplemented by testimonies he had solicited from Spies's
surviving friends, in a beautiful big book, *The Beauty and Riches
of Life*, which remains the principal source for all Spiesian inves-
tigators. In it, Rhodius poignantly describes his meeting with
Hans Jürgen von der Wense in 1955, thirteen years after Spies's
death. The composer who at twenty-eight had been called more
forward-looking than Stravinsky and Schönberg was, at sixty,
living in a single room in Göttingen that was just large enough
to accommodate a bed, desk, sofa, and bookcases. Rhodius pon-
ders how to explain Wense's current researches, which included
philosophy, philology, geology, and astrology, and concludes that
the best way to understand him is to refer to the opening lines
of *Faust*. In Goethe's drama, the aged magus, in a "narrow Gothic
chamber," laments that his mastery of human learning has left
him unsatisfied: "And here, poor fool! with all my lore I stand, no
wiser than before."

> Then he passes me a photo: Walter and Hans Jürgen. On
> the back is written, "The two friends, Stuttgart 1920." The
> faces look as if they were lifted from a Roman coin. Full
> of force and confidence, they look forward into the future.
> You sense the way in which the two friends, being of
> roughly the same age, set each other aflame, how they were
> strong enough together to defy a bourgeois world, and how
> they retained an unforgettable, lifelong memory of those
> years.

The insecure position of homosexuals in German society was a
subject under wide discussion during the Weimar Republic. The
most influential early crusader for equality was Magnus Hirschfeld,
who in 1897 founded the Scientific Humanitarian Committee
to campaign for the repeal of Paragraph 175. He appeared in an

influential film directed by Richard Oswald, *Different from the Others* (*Anders als die Andern*), released in 1919, which was a cinematic manifesto for gay rights. It tells the story of a violinist, played by the elegant Conrad Veidt, one of the first matinee idols of European cinema, who falls in love with a male student. Driven to despair by blackmailers, Veidt's character kills himself. Hirschfeld appears in the film as himself, delivering his basic lecture about the rational, medical case for equal rights for homosexuals.

When the Nazis came to power, they stormed Hirschfeld's Institute for Sexual Research and burned his library. In exile, he went on a research tour of the world, which brought him to Bali in the early 1930s, where he met Walter Spies. Conrad Veidt, meanwhile, created a movie studio in partnership with F. W. Murnau, who became Spies's lover, the only man who was ever able to domesticate him.

Born Friedrich Wilhelm Plumpe, Murnau changed his name for his stage debut in 1909, with Max Reinhardt's Deutsches Theater; there he met Veidt, another actor in the troupe. (His family name sounded as silly in German as it did in English, particularly because he was abnormally tall: in German *plump* means awkward and ungainly.) In 1919, under the auspices of the newly formed Murnau Veidt Filmgesellschaft, Murnau made his first feature, *The Boy in Blue* (*Der Knabe in Blau*), a gothic melodrama about an impoverished aristocrat obsessed with Thomas Gainsborough's painting of a young cavalier. In a dream, the Blue Boy steps out of the painting and reveals the location of a large emerald hidden in the dreamer's ancestral castle, which comes with a curse. Like the six films that followed, it is now lost. Murnau's third film, *The Hunchback and the Dancer* (*Der Bucklige und die Tänzerin*), is a bizarre tale even by Murnau's standards, and weirdly prophetic: the hunchback discovers a diamond mine in Java and returns to Germany, where he woos a beautiful dancer, who rejects him, with tragic results.

When he met Spies, Murnau was already a major figure in the

emerging German film industry. He was still mourning the death of his lover, a poet named Hans Ehrenbaum-Degele, a Jewish banker's son who died in action on the Russian front. The two men had been deeply in love, and their union was accepted by the family to a remarkable degree: after the war, Hans's mother not only invited Murnau to come live at the family's villa in Grunewald but bequeathed it to him in her will. It was there that Spies came to make a home with Murnau, at the family estate of his predecessor, a situation that could have been taken from a Victorian potboiler or indeed the scenario of one of Murnau's films. Spies painted a sprightly mural in the style of Persian miniatures for his lover's study.

Precisely when they met is a vexed issue. The earliest positive evidence of their relationship dates to April 1920, in a letter from Conrad Veidt to Murnau in which he sends "greetings to your wife," which must refer to Spies. Wense, who was something of a yenta, hinted that Veidt himself carried a torch for Spies. Veidt was married three times, but he had many homosexual friends and participated in the effort to repeal Paragraph 175. In 1920, Murnau made a film called *Desire* (*Sehnsucht*), which starred Veidt as a Russian dancer, a character that appears to be modeled on Spies. Spies was supporting himself at this time in part by dancing professionally on the ballroom circuit; in 1921, he won the silver medal in a national competition.

By the time Veidt wrote him that cheeky letter, Murnau was evidently as much besotted with Spies as he had been with Hans Ehrenbaum-Degele. The record is nearly a void, for after Murnau's death his family suppressed any evidence of his homosexuality; indefatigable Rhodius never found Spies's letters to Murnau, presumably because they were destroyed. In 1921, Murnau invited Spies to assist him in what would prove to be his most famous film, *Nosferatu*, one of the earliest screen adaptations of Bram Stoker's *Dracula*. It is difficult to ascertain what contribution Spies made to the film, but Murnau thought enough of it to give him an official position as artistic adviser. Spies was on location with him when the film was shot in Lübeck and Wismar and then in Czechoslovakia. After a holiday in Prague, the company went on

F. W. Murnau in his study in Grunewald, with murals painted by Walter Spies, circa 1920

walking tours in search of ruined castles for the film's scenes set in Transylvania.

In August, Spies sailed with Murnau aboard his yacht to the island of Sylt, in the North Sea, where the film's beach scenes were shot. Spies wrote to his mother from Sylt, revealing for the first time his intention to travel to exotic places, with his usual vagueness about the destination: "I'm off to God knows where, to Guatemala or Sumatra! I have the urge to do a great deal." He had recruited Murnau into his pipe dream and facetiously proposed that she come along for the ride: "Murnau plans to buy himself a big yacht that we can go there and live in. I'll take you with me to the Cape of Good Hope. Oh yes, Mama, God knows what will become of us all! Anyway, it'll be great, won't it?" He sketches a verbal cartoon of them lazing under banana trees in Java and diving in Honolulu.

The scenario of *Nosferatu*, by Henrik Galeen, is faithful to *Dracula* in spirit more than by strict adherence to plot points. Dracula is renamed Graf Orlok, because the production did not have the permission of the Stoker estate to film the novel. The Baltic port city of Wismar is substituted for London, where Orlok moves with an ample supply of his native soil to prey on the innocent young wife of Hutter (Jonathan Harker in the novel), a real-estate agent who journeys to Transylvania to sell him the spooky, ramshackle mansion that will serve as the headquarters for his bloody reign of terror. The film lives up to its subtitle, "A Symphony of Horror": Orlok's stealthy massacre of the ship's crew still produces a creeping chill of dread. The scenes shot on the windy, desolate beach at Sylt, where Hutter's wife keeps a vigil for her husband, evoke the metaphysical disquiet of Caspar David Friedrich's seascapes. The film is Germanized not only in its setting but also by the overlay of elements of Enlightenment-age philosophy, in scenes with a Faustian scientist named Bulwer, who demonstrates the deadly power of nature in documentary footage of spiders and a Venus flytrap wreaking mayhem.

In August 1922, after the release of *Nosferatu*, Murnau had an operation for the removal of kidney stones and went to recuperate in a sanitarium in the Black Forest. Spies accompanied him and

met Georgette Schoonderbeek-Vreedenberg, the wife of a well-known Bach conductor who was there to recover from a heart attack. A bright, sociable woman of fifty-five, she was the perfect audience for Spies's high-spirited line of chat and latched onto him. When their spouses recovered a few weeks later, they parted ways, both assuming that it had been nothing more than another pleasant, fleeting encounter. However, as she told her story to Rhodius, soon after the Schoonderbeeks got home, chance intervened. They had tickets for the annual Bachfest in Breslau, but two days before it began, her husband received an unexpected invitation to conduct elsewhere, and he suggested that she invite Spies to accompany her to the festival.

They had a ball in Breslau, the lively middle-aged lady and the "excessively happy young man," as she put it to Rhodius. When the festival ended, Spies invited her to come to Grunewald to visit for a few days. Schoonderbeek described how Murnau had fixed up an old wing of the mansion with a piano and painting studio for Spies. Fascinated by Spies's work, she arranged for eleven of his paintings to be exhibited at the Stedelijk Museum in Amsterdam, followed by a show at a private gallery in The Hague. The reviews were good, and he sold several canvases. After the exhibitions, Spies stayed on in Holland until Easter for a performance of Bach's *St. Matthew Passion* conducted by Maestro Schoonderbeek in Naarden, which moved him to tears of joy.

Spies's paintings of Russian scenes had recently been included in an exhibition in Berlin by the November Group, an informal movement that advocated revolutionary politics, which included Otto Dix, George Grosz, and other established artists. A critic named Franz Roh took an interest in Spies and included him in an essay that described a quality of contemporary art he discerned in painters working in disparate styles, which he called "magic realism." The phrase, borrowed from Novalis, went on to have a robust afterlife in literary criticism about the works of Gabriel García Márquez and other Latin American novelists.

Georgette Schoonderbeek reported that Spies was particularly excited about the Dutch exhibitions because the sales were paid for in guilders, a stable currency, whereas inflation in the days of the

Weimar Republic made the German mark worthless. Spies, uncharacteristically, was saving his money, but for an altogether typical reason. At precisely the moment when serious attention was being paid to his work as an artist and he was starting to earn good money from it, Spies's desire to leave Europe in search of a new home was rapidly approaching the tipping point. Schoonderbeek described his state of mind at this passage in his life: "He always seemed, or rather he was, cheerful and happy, but a wish that overtook him more and more was a longing for the Indies; he spent hours in the so-called Colonial Institute in Amsterdam, nowadays the Royal Tropical Institute. It grew into some sort of obsession to get away, away from Europe, where he felt himself hedged in, unfree and unhappy." She also expressed concern for Spies's health if he stayed in Berlin, which might have been a delicate way of saying that she feared he was becoming addicted to cocaine. Hans Jürgen von der Wense's letters reveal that Spies used the drug, which was legal and particularly fashionable in the film community.

The pressing problem was what to do about Murnau. When she stayed with the two men at the villa in Grunewald, Schoonderbeek perceived that the splenetic Murnau needed Spies's "sunny cheerfulness and indomitable vitality." He was just seven years older than Spies, yet the relationship in some ways resembled that of father and son more than a partnership of equals. Spies, for his part, loved Murnau and was devoted to him to the extent that his roaring vitality permitted. Throughout his life, Spies gladly accepted help from his friends—up to the point that he felt beholden to them, and then he ran away. The Schoonderbeeks thought that Spies would not last much longer in Europe, and they were right. In fact it was Georgette Schoonderbeek who engineered the separation so as to avoid lasting damage to their friendship.

Spies sent her a telegram: "You must help." She came to Grunewald immediately and sat up late into the night with Murnau. She told Rhodius, "I tried to get him to see that what we freely give up and let go is always there for us, whereas what you try to hold on to inevitably gets lost. Whoever renounces

something retains it; whoever clings loses it forever. And suddenly Murnau saw the truth of it, so that he could say with total conviction: Walter must be free to go. I must not try to stop him."

In the morning, Murnau kept his word. Spies left, and the two men never saw each other again. Near the end of the year, when Spies was living in Java, he complained in a letter to his mother that he had not heard a word from Murnau, but later they resumed contact. In 1927, after Spies had relocated to Bali, Murnau sent him money to buy a piano, and in the years that followed, Murnau repeatedly avowed his intention of coming to Bali to make a film with him. Again, it is impossible to assess the emotional cost of the separation for Murnau, for his family carefully scrubbed his papers of any reference to his affair with Spies.

After the departure of Murnau's complicated muse, his artistic career ascended precipitously. His last film in Germany was a fabulous *Faust*, based on the medieval source material more than on Goethe's drama. Murnau moved to Los Angeles, where he signed a contract with the pioneering motion-picture executive William Fox. His first film with Fox, *Sunrise: A Song of Two Humans*, is an extravagantly produced romantic allegory that is included on most lists of the greatest films ever made. The story is a sugary, pretentious paean to marital fidelity, told in the style of a medieval mystery play, but as filmmaking it is a work of genius. The cinematography was a breakthrough, setting a new standard for continuous tracking shots and superimposed images. The set designs, combining miniatures and elaborate full-sized constructions, were built in forced perspective, requiring a different set for every camera angle. It was also the first feature to use the Fox Movietone synchronized sound-on-film system, in this case for music and sound effects only. Murnau remained fiercely opposed to dialogue in films, a key element of his crusade to purge cinema of all influences from other media.

In 1929, Murnau abandoned Hollywood and sailed to the South Seas on his sixty-five-foot yacht, the *Bali*, which had a red heart painted on its stern. In a letter to his mother, Spies reported, "Murnau sailed off from America in his own yacht in mid-March, towards Bali (!), via Honolulu, the Solomons, Fiji, New Guinea,

Timor, Flores, Lombok. The journey will take three-quarters of a year before he gets here, if there are no mishaps on the way." In fact Murnau did not make it west of Tahiti, where he shot his final film, *Tabu*. It began as a collaboration with Robert Flaherty, the director of *Nanook of the North*, the first documentary film to have a success at the box office. *Tabu* was shot on location in 1930 in Bora-Bora, an island in the western cluster of the Tahitian archipelago, with a local cast of nonactors.

The story is altogether un-Polynesian. It begins straightforwardly: Boy (Matahi) meets Girl (Reri). They fall in love, but soon afterward an embassy arrives from the high priest of the islands, who announces that Reri has been chosen to serve the gods as a priestess on their sacred isle. Henceforward she is taboo: "Man must not touch her or cast upon her the eye of desire," on pain of death. Undaunted, Matahi carries her off in his *perahu*, and they start a new life on a distant island, where he supports them by diving for pearls. Eventually, they are tracked down by the French colonial authorities, and Reri is handed over to the priest, who transports her to assume her sacerdotal duties. Matahi swims after the ship until exhaustion overtakes him and he drowns, satisfying the punishment prescribed by the taboo.

Flaherty wanted a realistic scenario about the exploitation of pearl divers in the French South Seas possessions, but Murnau took full artistic control of the film and shaped it into a classic iteration of the myth of Tahiti, the tropical paradise. His plot depends upon the principle of the faithful devotion of lovers, an ancient storytelling convention, but if there was one aspect of Polynesian mores that was clear, it was that sexual fidelity was not prized as a virtue. In addition to the likelihood that in historic Bora-Bora veneration of the gods and awe of the taboo would have trumped romantic love, the elite votaries of the gods in precontact Polynesia were expected to have many and various lovers. Matahi in Murnau's tale behaves more like Héloïse's Abelard, defying the law out of loyalty to the beloved, than a Polynesian lover, who would simply have found himself another girl after the priest came to claim Reri.

The film's first chapter, "Paradise," is a straightforward expres-

sion of the ideal of man's natural nobility in an uncorrupted state, which had been identified with Tahiti for more than 150 years. The opening title card exaggerates conditions there in 1930: "A land of enchantment remote in the South Seas, the island of Bora-Bora, still untouched by the hand of civilization." The opening scene is a delirious hymn to the male figure. A group of young men in loincloths are fishing with spears, displaying the symmetrical perfection of their bodies, which are endowed with all the grace of ancient Greek sculpture. This cliché to describe a handsome, well-built young man applies literally to Murnau's vision of the Polynesians. The first image, shot from ground level to emphasize the figure's monumentality, shows Matahi, wearing a circlet of cane leaves on his brow, launching a bamboo trident from a dynamic pose, legs planted far apart and arms outstretched. The pose is identical to that of the Artemision Bronze, one of the best-preserved sculptures of Greek antiquity, a slightly larger-than-life image of a god that had been discovered in the Aegean Sea four years before *Tabu* was filmed. Most contemporary scholars believe it is an image of Zeus, but at the time of its discovery it was widely thought to be trident-wielding Poseidon, god of the sea.

In the shots that follow, Matahi and his brawny comrades romp in the surf with an exuberant bonhomie that obviously owes nothing to a choreographer or acting coach. Given Murnau's sexual penchant, there has always been a suspicion that *Tabu* is beefcake with artistic pretensions. Lotte Eisner, Murnau's biographer, wrote, "Murnau offers us an apotheosis of the flesh: the feats and canoe races are only pretexts for showing those godlike young bodies. He was intoxicated by them." It is correct, as far as it goes, to discern in the film's glamorous portrayal of the male body (specifically, the bared chest, which was still taboo at the Hollywood studios) an adumbration of what would become known as the "gay sensibility," just as Abigail Solomon-Godeau's discovery of rape fantasies in Gauguin's paintings of bare-breasted young women is valid in the context of her investigation.

Yet in the case of *Tabu*, the sexual-political analysis is extraneous or at best parallel to the film's conscious aim, which is to ex-

press a universal ideal of beauty. An educated German of Murnau's generation, regardless of his sexual inclination, would have had his ideas of beauty formed in part by the works of Johann Joachim Winckelmann, who created modern art history in the service of his campaign to elevate the aesthetic standards of his times. Winckelmann wanted to stimulate the same reverence of Greek ideals in art that had long prevailed in literature. In *Reflections on the Painting and Sculpture of the Greeks*, he issued this familiar injunction to the artists of his time: "There is but one way for the moderns to become great, and perhaps unequaled; I mean, by imitating the ancients" (in Henry Fuseli's translation, published in 1765).

Winckelmann was homosexual, with a particular interest in adolescent boys, and thus his motives, like Murnau's, have been viewed with cynical distrust. Winckelmann's analysis of Greek sculpture certainly emphasized the carnal. He praised the Spartans for their strict enforcement of high standards of physical fitness. "The young Spartans," he wrote in *Reflections*, "were bound to appear every tenth day naked before the Ephori [supreme magistrates], who, when they perceived any inclinable to fatness, ordered them a scantier diet." Winckelmann approvingly notes that Alcibiades, whose beauty as an adolescent was proverbial, refused to learn to play the flute when he was a boy because he feared it might spoil the features of his face. Winckelmann tried to be evenhanded in his treatment of the sexes, but he plainly does not bring the same warmth to his subject when he praises the beauty of Greek maidens as he does when he rhapsodizes about male athletes.

Yet neither did the Greeks, for whom the superiority of men over women was axiomatic. The beauty of Aphrodite incited lust, which brought only trouble to mankind; the noble beauty of mind and spirit was exemplified in the pantheon by Apollo. Winckelmann and the Spartan ephori did not exalt the beauty of boys because they found them sexy (even if they did); they venerated the adolescent male figure because it was perfect. The symmetry and proportion of a young Greek's body, as yet unblemished by the decay of mortality, expressed the harmonious perfection of the universe and thus partook of godliness. "The forms of the Greeks," wrote Winckelmann, "prepared to beauty by the influence of the

mildest and purest sky, became perfectly elegant by their early exercises." He proposes as an example "a Spartan youth, sprung from heroes, undistorted by swaddling-cloths, whose bed, from his seventh year, was the earth, familiar with wrestling and swimming from his infancy."

The passage could be applied to the youth of Bora-Bora without altering a word. Many echoes of Winckelmann may be found in Murnau's production notes for *Tabu*. Before filming began, he cruised throughout Polynesia on the *Bali*, scouting locations and playing the part of a Spartan ephor in search of actors. In the Marquesas, he discovered a youth named Mehao, his initial choice for the male lead, in a group of dancers performing the *tapraita*—the tropical equivalent of a chorus line. "Mehao had more grace," Murnau wrote, "a finer figure, greater passion than any of the rest." He took a photograph of him and wrote this note beneath the image: "A pure-bred Polynesian, of extraordinary physical beauty, slim and strong, with simple, natural movements. The marvelous harmony of his figure makes him look like a Greek god, a model for the Olympian games, a delight of nature."

Gauguin, of course, was more interested in the marvelous harmony of the female figure, but he also appreciated the beauty of Polynesian men. A passage in *Noa Noa* describes a walk in the mountains with a good-looking youth named Totefa, portrayed in *Man with an Ax*, among Gauguin's first fine paintings in Tahiti and one of the very few with a male figure as the principal subject. Totefa leads Gauguin into the forest: "With the suppleness of an animal and the graceful litheness of an androgyne he walked a few paces in advance of me. And it seemed to me that I saw incarnated in him, palpitating and living, all the magnificent plant-life which surrounded us. From it in him, through him there became disengaged and emanated a powerful perfume of beauty." Gauguin confides that for a mad moment he contemplated initiating sex with Totefa, but the reader senses that it is an intention to be shocking more than a true confession.

While he was in the Marquesas, Murnau visited Gauguin's grave in Hiva Oa. At an atoll called Takaroa, he met Henri Matisse, who was touring Polynesia to see the light, which he described as a

"deep gold tumbler into which one looks." There is no record of their encounter apart from a photograph of the two artists in a *perahu*. One might suppose that the vibrant master of color and the tragic poet of black and white, so different in their personal habits, would have had little to talk about, but obviously that could be quite wrong.

Winckelmann is the classic case of a classical exote in time. He idealized the ancient Greeks through the lens of remote time in much the same terms that Van Gogh and Gauguin imagined far-away Polynesia, and with a similar defiance of common sense. "In Greece," wrote Winckelmann, "from their earliest youth, the happy inhabitants were devoted to mirth and pleasure, where narrow-minded formality never restrained the liberty of manners." He never troubled to explain some of the obvious lapses of logic in this pretty picture of ancient life: Who tilled the fields and reaped the harvest? Who quarried the marble that was used to make those beautiful sculptures? If Euripides is any guide, the domestic lives of the Athenians were not entirely devoted to mirth and pleasure. Yet for his passionate admirers, Winckelmann's rapturous dream of antiquity swept aside any objections to its rational shortcomings.

In a letter to his mother that closely echoes Winckelmann's fanciful notions, Murnau wrote that in Tahiti "there is no work and no worries, where the shining days go by in games and dancing, bathing and fishing." He concluded, "The night innocently brings all lovers together." In another letter to her, he wrote, "I am be-witched by this place. I have been here a year and I don't want to be anywhere else. The thought of cities and all those people is re-pulsive to me. I want to be alone, or with a few rare people." Yet after he wrapped *Tabu*, Murnau reluctantly decided that he must return to the world of work and worries, to study the new devel-opments in film: in other words, to devise a professional strategy to survive the triumph of the talkies. Murnau was a sort of anti-exote, who lived without the hope of finding a place where he belonged. His only home was the cinema, specifically silent film, a world that was dissolving around him. Amid the abundance of sensual beauty in the tropics, he only seemed to grow more mel-ancholy: "I am never 'at home' anywhere—I feel this more and

more the older I get—not in any country nor in any house nor with anybody."

Tabu proved to be the most successful film of Murnau's career. He died a week before its premiere in an automobile accident on the Pacific Coast Highway, when his rented Packard went off the road with a fourteen-year-old employee, his Filipino valet Garcia Stevenson, at the wheel. Stevenson and a third passenger survived, but Murnau was killed instantly. Spies was devastated when the news reached him in Bali. He wrote to Willem Stutterheim, a Dutch archaeologist in Java he had befriended, that Murnau was "the only person in the world who loved me and whom I could trust." The bizarre circumstances of Murnau's death gave rise to vicious rumors that have been debunked time and again, but so intense was the homosexual panic in Hollywood that only eleven people came to his funeral. One of them was Greta Garbo, another deracinated film artist who wanted to be alone. She commissioned a death mask of Murnau, which she kept on her desk to the end of her life.

Spies's voyage to Java was like the first chapter of a boys' adventure novel. His rich friends did not come through with a job for him, so he teamed up with a great strapping fellow named Heinrich Hauser, another friend of Hans Jürgen von der Wense's who had joined the circle around Murnau. Hauser was a German prototype for Jack Kerouac, a man of action with literary aspirations. Although six years younger than Spies, just twenty-one, he was clearly the hero of the story, with Spies his loyal sidekick. As a cadet at the imperial naval academy in Flensburg, Hauser had participated in a left-wing uprising; the following year he joined a right-wing military corps that defended the Weimar government against a rebellion by workers and soldiers. He had worked in the blast furnace of a steel mill and had just begun a career as a merchant seaman. To complete the profile of a perfect pal for Walter Spies, he was bisexual. The family took him in as a surrogate son, with the affectionate nickname Schneck, which is close to the German word for snail.

Hauser found them berths aboard the merchant ship *Hamburg*, bound for the Indies. Spies would pose as a Russian sailor who had lost his papers fleeing the revolution, to explain his lack of familiarity with shipboard commands. Spies boasted to his mother about the "marvelous sailor's outfits" he had had made and his new short haircut, as though he were singing in the chorus of a nautical musical comedy rather than turning his life upside down. The main purpose of his letter to his mother was to conceal his true intentions: he assured her that it was a three-month lark that would have him home by Christmas, whereas the plan from the beginning was that he would desert his post as soon as the right opportunity presented itself.

Like any boys' adventure (including Rimbaud's own escapade in Java), the scheme depended heavily on luck. It worked well enough to get them to sea, but Spies's complete innocence of all things maritime and general ineptitude led to his exposure soon after they left port. The other sailors joined in the charade and, to Hauser's annoyance, exempted Spies from any except the lightest duties. A letter to *liebe Mama* posted from Cardiff, where the ship loaded coal for Java, sounds as though he were on a pleasure cruise: "It's odd, but I can scarcely imagine that in a few weeks I shall be in Arabia and then Ceylon! I hope we won't spend too little time tied up for me to get a proper look at everything. I shall take splendid photos! and do loads of sketches!"

On the voyage, Hauser wrote affectionate letters to Daisy Spies, describing her brother's antics and his reactions to the exotic places they visited, which he too was seeing for the first time. His letters are as exuberant as Spies's, with a modernist edge and even a certain bebop feeling. The two young men were obviously close. In Ceylon, Hauser wrote to Daisy that they sneaked past the quarantine every night to wander the streets in Colombo: "And then just lights and a huge native town in the midst of a forest of palm trees and temples with dances and fantastic, unearthly music and the air is thick with smoke and a thousand smells and it drives you crazy. We're dead tired all day and sleep in the bowels of the ship among the coal in dirty rags. All we eat is fruit and are invited everywhere by the Hindus." Padang, the principal port on the

west coast of Sumatra, was fabulously beautiful, he wrote, like nothing in the world he had ever seen (in all his twenty-one years). If there was any way he could have stayed behind there he would have done so, but he had to see America and China and Japan before he put a pause to his travels.

When the *Hamburg* reached Batavia on October 24, 1923, Spies saw his chance and took it. Going AWOL from a merchant ship was a criminal act just as much as desertion from the navy, so some cunning was required. After the ship had anchored, Spies and Hauser decided that the first night in port offered the best opportunity for flight, as all hands were going ashore. The main problem was how to get Spies's luggage off the ship. As Hauser wrote to Daisy from Cirebon, Java, the ship's next port, "Sampans, the native boats, wouldn't chance it. So I grabbed a coolie and stuck Walter's suitcase in his sack, and that's how he got off the boat and past the sentry. Walja made himself very elegant and passed customs without a hitch, claiming he had to sail to Surabaya as third officer on the *Cassel*, and so all was well."

All was well as far as the shore authorities were concerned, but when Spies arrived at the train station in Batavia to make his getaway to Bandung, a city just over a hundred miles inland, he encountered the stock comic obstacle of the helpful, interfering stranger. As he wrote to Hauser afterward, "The fat man was somewhat too nice." Spies managed to shake him off, but the man's suspicions were aroused. He must have warned the authorities, for before the train left the station, it was delayed by the police, searching for a suspicious-looking European in second class bound for Bandung. They interrogated Spies and searched his luggage, but finding no grounds to detain him, they finally let the train leave.

With the departure of the *Hamburg*, Hauser sailed out of Spies's life. It was an intense friendship while it lasted. In his last letter to Daisy Spies, Hauser wrote, "I'm a lot sadder about it than I expected, for the three months we lived close together have somehow bound us one to another, even if we were not aware of it." Hauser went on to have a career as a world traveler to rival Richard Halliburton's. His second book, a novel called *Brackwasser*, published in 1928, was declared "the book of the year" by Thomas

Mann and won a prize. Translated as *Bitter Water*, it is a poignant, Hemingwayesque story of a sailor who tries to rescue a Mexican prostitute by bringing her home to Germany, where they start a farm on a desolate, windswept island in the North Sea. Hauser captures the tragic result of the exile's homecoming: "It is impossible for any man to judge his native land. It is dreadful when you see that it appears barren and cheerless to someone whom you would have know its beauties." In the end, the couple's cultural differences and a cruel winter defeat their hopes to start a new life.

Heinrich Hauser had published more than thirty books of fiction, travel, and photography when he committed suicide, at the age of fifty-three.

Spies's plans were never quite as harebrained as they seemed. He chose Bandung as his destination because he had letters of introduction to relations of the Schoonderbeeks who lived there, and Georgette Schoonderbeek was ready to wire him the funds from the sale of his paintings in Amsterdam as soon as he was settled. Yet in his last surviving letter to Hauser, Spies wrote that he was depressed by doubts as the train wended its way through the dreary exurbs of Batavia, which seemed to him as ugly as metropolitan Germany, and then across the orderly agricultural fields of West Java, flat and featureless to the horizon. He was tormented by the fear that he had made a terrible mistake. "Dead tired and nothing in my belly," he fell asleep. When he awoke, the train was climbing into the highlands, and his spirits were restored: "Mountains, mountains, mountains, right and left, and you see such fantastic shapes like in Chinese paintings, with banana groves and forests of cocoa, and it became more and more unbelievable."

In Bandung, he found the Schoonderbeeks' relatives easily enough, a "quite stupid but pretty" young woman and her father, who was small and gray. There was a piano in the parlor, and Spies soon charmed them with song and the well-honed narrative of his interesting life, glossing over his desertion from the *Hamburg* with a ridiculous story that his position with the shipping line gave him the freedom to change ships at will. Soon he found a

place of his own with a piano, a handsome houseboy, and a bicycle. He wrote to his mother that his room was big and bright, with a veranda that commanded a fantastic view of the mountains. For company he had a dear, dear monkey, a bird named Anne, and four lizards running the walls to eat the mosquitoes: "Tell me, is that not paradise?" Spies's immersion in the life of Java was exhilarating. "The people, the Sundanese and the Javanese,* are so unbelievably beautiful, so fine-limbed, brown, and aristocratic that everyone should be ashamed not to be one of them." Spies's earliest known artwork in the Indies is a finely finished pencil portrait of his adolescent Sundanese servant, Hamid, which precisely renders the youth's clean-cut features. The subject's cap is set back rakishly on his head and his large almond eyes are averted, as if he were peering into the distance, daydreaming.

In the throes of the exote's love at first sight, Spies quickly developed a deep aversion to the other foreign residents. "The Dutch here are the most unsympathetic and provincial people you can imagine, uneducated, boorish, stupid, narrow-minded, arrogant, and I can't find words to express my hatred for them." As Raden Saleh learned when he returned to Java, Dutch colonials could indeed be arrogant and narrow-minded when they felt threatened, and boorish in their treatment of their native hosts, whom they regarded as inherently inferior creatures. Yet Spies's blanket condemnation was arbitrary and unfair: of course there were kind, open-minded Dutch people in the Indies who took an interest in the arts, and Spies eventually became friends with them; but when exotes encounter one another in the *neue Heimat*, they are often wary and behave like jealous lovers meeting their rivals.

Spies found a job playing piano at a Chinese cinema, and soon the prospect for a better engagement turned up, through a chance encounter with a Russian violinist named Woskressensky, a friend

*The people of Bandung are mostly Sundanese, an ethnic group distinct from the Javanese, with its own language and culture. Sundanese Islam is more orthodox than that of the Javanese, which retains a strong measure of pre-conversion Hindu and Buddhist elements. In anthropological shorthand, Sundanese life is more village-centered than Javanese culture, which maintains a strict caste system centered on the royal courts.

of the Spies family in Moscow who recognized him when they passed each other on the street. Woskressensky had been stranded in Java while he was on a tour with a Russian opera company that was canceled. He had a gig at the city's best hotel starting in December and proposed that Spies join him. "Luck and good fortune follow me around like a fool," Spies told his mother.

Two weeks later, Spies was on the move again. He had another letter of introduction from the Schoonderbeeks, to P. H. W. Sitsen, the director of the public building authority in the sultanate of Yogyakarta, and his wife, née Maria Russer, a singer who had trained in The Hague and Berlin. Sitsen, who played the piano, met her when she came to Java on a tour. The couple had founded the Kunstkring, or arts society, of Yogyakarta, part of a colonial network of cultural institutions that presented lectures, art exhibitions, and concerts. Maria Sitsen had created a chorus of sixty voices, which Spies later conducted. The society's concerts attracted large audiences, mostly resident expatriates. It was not just another case of Spies charming people whose help he needed; he himself was charmed by the Sitsens. They began making music together on the night he arrived, and he taught them his arrangements of the Tatar and Kirghiz folk songs he loved so much. It was the beginning of a long and intimate friendship.

Yogyakarta, the ancient cultural capital of Java, was the right place for Spies, a man for whom life had little to offer except to foster art. The city was much less "Dutch" than Batavia, Bandung, and indeed the rest of the island, for Sultan Hamengkubuwono VIII retained real power, and the traditional arts continued to flourish there just as they had done before the Dutch consolidated their control of Java. Now equipped with a résumé as a pianist to the foreign community, Spies found employment with the dance orchestra at the palm court of a Dutch club, filling in for the regular pianist who was on sick leave. Yet playing dance tunes for portly Dutch imperialists in dinner jackets and their dowdy wives was irksome, even if the pay was better than he could ever have hoped to find for such work in Europe. His real employment in Yogyakarta

was his deepening engagement in the life of the island, which for him meant the absorption of its artistic culture.

His letters home became longer and more elaborate, sharing the elation he experienced at the discovery of this new world. They were addressed to his mother, but it was understood that they were intended for the whole family. Hans Rhodius did his job as editor of Spies's correspondence well and yet not well enough. He was a dedicated investigator, dogged in his efforts to track down the letters and other documents, and his book, six hundred pages long, has every appearance of being a definitive collection. However, it is far from complete: when the book was ready to go to press, Daisy and Leo threatened to withdraw permission to use any of the family letters, the heart of the book, unless Rhodius suppressed a section he had prepared about Spies's sex life. Not only were those letters omitted from *The Beauty and Riches of Life*, they have since gone missing, presumed to have been destroyed with the rest of Rhodius's research materials in a comprehensive immolation carried out by his family after he died in 1988, just as Murnau's family had destroyed his correspondence with Spies.

Moreover, Rhodius cut many of the letters substantially. It is easy to understand why: he could not have made his book longer without publishing it in two volumes. Yet he had no scholarly training and gave no indication as to where he made his excisions. His book is thus a shaped impression of the correspondence, an essentially truthful yet "improved" portrait of the artist's life that has de facto become the official version, for no other edition exists. Nor has any translation of Spies's correspondence been published. As a result, the artist's own description of his life, one of his principal creative endeavors, has not been available to non-German speakers except in snippets. A letter dated November 26, 1923, an ecstatic description of his unfolding discovery of the sultanate of Yogyakarta, is an exemplary specimen, translated here by Nigel Barley:

Dear darling Mama,
It's already the end of November and still no news from all of you, but it really couldn't be otherwise since it's cer-

tain you had no mail from me till November. It's a dreadful bore to have to wait two months for an answer.

In the meanwhile loads has happened. I'm out of Bandung and in Yogyakarta, since I've found a wonderful job here, and I hope it lasts a while. It's so silly but no one here gives a contract and you have to be ready to change jobs from one day to the next. I play piano in a little orchestra here, four times a week, two hours at a time, and earn five hundred guilders a month, isn't that a fantastically soft life? Around two hundred a month goes for lodging, food, and suchlike, anyway far too much! But if you run your own establishment you don't need more than eighty to a hundred guilders. Here servants are really cheap. For fifteen guilders a month you can have boys, girls, old men, whatever you want; all good, honest people who will go through the fire for you if you treat them nicely. Here, it's like in Moscow. Servants and cooks stay with the same house for fifteen or twenty years and get to see its children and grandchildren.

Oh, lots here reminds me of Russia, a sort of fabulous generosity and freedom and hospitality. And you always live *na datsche* [Russian, "in the country"], even in the city. And after all, what is a city here? Nothing more than a few dachas gathered together and one or two streets with shops all tricked out to be ten times as big and elegant as the biggest and most elegant shops in Europe. And a few streets with Chinese, Japanese, and Indian shops where everything is just as good, if not better, and a lot cheaper. Then the market every day. A bright, seething mass of nice- and nasty-smelling things, fruits, people, animals, and birds, such fun, so exciting. That's the city! A couple of cinemas with splendid American films.

This city of Yogyakarta is one of the most interesting in Java because it's the center of Javanese culture. Here resides the sultan with his forty wives and hundred and fifty children, a quite incredible life at court with elephants, great coaches, monkeys, and over ten thousand retainers. The total figure of everyone living behind the white walls of the

kraton and thus forming a part of the palace, including women and children, amounts to sixty thousand people! Javanese art and culture in general are so unbelievably high and fabulous that it is hard to find words to describe them. The performances of the old Javanese opera, which I'm afraid I haven't experienced yet, which are given in the palace every now and then, are said to be the most incredible of all: a sixty-man gamelan orchestra, all kinds of gongs, xylophones, instruments like bells, violins, flutes, and then singing, recitative, and the whole thing is half danced in fantastic masks and costumes. The players and female dancers are all princes and princesses, mostly the sultan's children; they learn it from childhood up, and if Daisy saw this dance, she would swoon! I at least can't begin to understand how anything so divine can exist on earth, and the music too! Compared with it, all the art in Europe is shameful trash and dung.

Because I play so little I have a lot of free time to travel around and look at everything, also to paint. Only yesterday I began to paint the portrait of a Javanese prince. The people here are so lovely that you never get tired of looking at them. They have the best figures possible, and they run about bare-chested, brown and delectable, even the women, but the latter not in the city, only in the villages. I hope the portrait will turn out well, I love doing it, and the prince is buying it for himself; once it's started I'll be able to send you so much money in one or two months that you'll choke on it!

Now, as I'm feeling my way into contact with the Javanese and their amazingly high and fabulous culture, I'm half out of my mind! You can scarcely imagine that anything so beautiful can exist. Oh, I worship them as I have never worshipped anything in my whole life!

A gust of wind just blew the whole letter out the window and up into a palm tree, from there it blew across the street into someone else's garden, now it's recaptured but my fountain pen gushed with joy, and my white trousers are

full of ultramarine spots. What's more, they're not my trousers but a pair I borrowed since my own aren't ready—the Chinese tailor works so slowly. Now I have to order a replacement pair, since I can't possibly return them like this.

Great! My servant has washed them in some secret potion and the stain has disappeared. . . .

Mama, there are birds, bright and crazy, singing coloratura like Neschdanowa [Antonina Neschdanowa (1873–1950), soprano at the Bolshoi Opera] and great lizards snapping and crying out like full-grown calves. Flying foxes among the treetops and hordes of monkeys that hurl prickly fruit at you. Best of all are the flowers. Almost every tree is in flower, completely covered in fire-red or sky-blue or some other kind of blossom; lianas and amazingly aromatic orchids in all colors and sizes cling to the huge trunks, and there are ferns as big as one of our taller trees. It's quite dark in the forest and dripping with humidity, and an incredible smell, hot and heavy, like in a greenhouse.

The people—the foreigners here—live in great style, most have two houses, one in town or a little way outside, and a smaller one somewhere up in the mountain forest, between the volcanoes. Oh, the countryside here is wonderful, still so unspoiled!! And the paddy fields look so crazy, cascading down the hillsides in terraces, completely underwater and with little waterfalls gushing from one to another, hemmed in by little earthen walls not wide enough for two people to pass. And everywhere are bamboo groves and coconut groves, and the Javanese live in them in sweet little bamboo huts, narrow and dirty, set cheek by jowl with bamboo fences and a maze of paths in between; you always get lost, and on every house hang two, three, even more cages with brightly colored birds all twittering and chattering away. . . .

I'm dreadfully sorry not to have come a month earlier, then I could have seen the opera performance they gave in the palace for the jubilee, they only put on something that

big maybe once every twenty-five years. Imagine the way they rehearse every day for three or four years! That kind of opera lasts from seven in the morning to eight at night and that's for three days on the run, and when it's over, they say, you feel really sad—it's that beautiful, so exciting that you can't get enough of it. It's said to be something so complete that you can't believe that human beings are doing the acting, singing, and dancing. The production must be something really special; everything, the smallest movement, is calculated and done with feeling. People take it so seriously and are as solemn as saints. You should just see the face of a dancer: completely still, turned in on itself and somehow lit up with divinity. And now, on the fourth day, wherever I go, bits of the opera are being put on, and I think I'll just drop dead on the spot or start to howl like a child! Oh God, what people they are! How on earth can one live in Europe!! . . .

A gecko is just creeping in the door—a big, rather spiky lizard that crawls up the walls as if they weren't there—and calls out at me like a cow. So loud! Sadly, these nice creatures are dreadfully shy and seldom come and visit. May bugs are flying around this evening, big as chickens. A hummingbird looks smaller.

I think it must be getting late and early tomorrow morning I'm going up into the mountains to visit another temple and crawl up a volcano. "For God's sake be careful, my boy, and don't fall in," I hear you say. Don't you? "Ah, in life I've so often fallen into volcanoes, once more will make no difference!" . . .

So, finally, I come to an end, the more I write, the more letters I get back, which I shouldn't mind! And the reverse! Is Kosja [Conrad Spies, a favorite cousin] still in Berlin, at 10 Cornelius Street? I've written asking him to send Javanese, Sundanese, and Malay grammars, I hope he'll be kind enough to do that. Remind him to get the money from Murnau. What's going on at Grunewald? Does it still exist? And what films is he making! So far I haven't had a single letter from him. I'm very ashamed of myself.

Like everything Spies did, it is a performance. He cares little for accuracy: his rapturous panegyric of the *wayang* ("old Javanese opera") is based entirely on secondhand reports. The description of the forest in Java is exaggerated: in fact, most trees in the tropical forest do not have colorful flowers; the overwhelming visual impact of the jungle is a wall of unrelieved green.

Yet for all its rough edges, the letter conveys emotions with an immediacy reminiscent of the eighteenth-century epistolary novels by Samuel Richardson and Choderlos de Laclos. The reader's sensation of participating in events with the letter writer, such as the slapstick tale of the runaway page and erupting fountain pen, a scene from a Harold Lloyd two-reeler, evokes passages of thrilling intimacy experienced by contemporary readers of *Clarissa*. In letter 126, written in secrecy, Clarissa apologizes to her friend for the state of the first sheet, "creased and crumpled, occasioned by putting it into my bosom on my mamma's sudden coming upon me"—as titillating a tidbit as Richardsonian morality permitted. *Clarissa* and *Les liaisons dangereuses* were both widely read in German translations, but there is no reason to suppose that Spies had seen them. On the contrary, Spies's letters are marked by a nearly complete lack of references to literature and books generally, apart from his study of exotic languages and sporadic interest in Egyptology and the occult. The only books he mentions are Gregor Krause's portfolio of photographs of Bali, which was a factor in his choice of the Indies as his destination, and Max Doerner's *Materials of the Artist*; he asked his cousin to send him grammars. Yet the artless candor of Spies's letters is itself an artful creation; he nurtured his naïveté as a condition necessary for the production of an amateur literary work spun directly from his fervid imagination.

Spies's first paintings in his new homeland occupy a deeper, more rational space than that of the European work. In *Village with View of Mount Sumbing*, sunlit treetops crowd around the high-peaked roofs of the village, with the forest landscape beyond rolling across a mist-streaked valley to the boldly incised silhouette of the volcano. His palette in Java is more vibrant, creating a dense, undulating curtain of green that encloses the viewer, reminiscent of Raden Saleh's landscapes in Java in its feeling for the verdant

mass of the jungle. Spies's characteristic attention to minute detail, articulating individual leaves and roof tiles, has lost any sense of the naïve and now evinces an affinity with old masters such as Albrecht Dürer and Adam Elsheimer, whose works he had seen in his youth. Spies might even have seen Elsheimer's fanciful drawing of the "King of Bali" and his retinue, looking very much like Greek gods on a holiday jaunt, which was published as an illustration for an account of a voyage to Southeast Asia in the newsletter (*Messrelationen*) of the Frankfurt Book Fair, an early almanac of world events, in 1598.

Luck, his constant companion, soon brought Spies into the *kraton*. Through the patronage of the Sitsens, the "little orchestra" he played with was hired to provide dance music at a grand fete in honor of a state visit by the president of the Philippines. In his report of the event, the sense of wonderment reaches a delirious climax. He begins, "I've seen and experienced so much that is insanely gorgeous that I'm still breathless." His description of the *kraton* evokes the barbaric splendor of a lost kingdom in a tale by H. Rider Haggard, narrated with the chaotic, glittering brilliancy of an opium vision:

> Is it possible that such a fabulous land as I saw there still exists in the world! The palace is something of unprecedented beauty—you enter through a huge gateway of carved wood, brightly painted with giant dragons and serpents, and then you set off down endless passages and pathways through the garden, which is actually already the palace itself, for it's all open halls and free-standing verandas under giant old banyan trees, their roots hanging down from the sky. Oh, and all the royal servants who look after you, in the wildest old Javanese costumes, with swords of gold and silver, and on every corner there are princes crouching to receive you, gentle, slim, and beautiful as gods in the most incredible costumes; so you walk and walk and arrive in the prince's main throne room—there he sits on the golden throne, fanning himself—all his wives along the walls, simple, beautiful, barefoot girls.

King of Bali, drawing by Adam Elsheimer, 1598

Spies wrote that he felt as if he had been transported to the capital of Akhenaten, "with everything like in an ancient Egyptian relief." His observation of the dance and music at the event is perhaps the most precise, detailed account of a royal Javanese dance performance that had yet been written. It is followed by a report of his own performance, with the usual lamentations about the inferiority of Western music and sarcastic swipes at the Dutch.

Yet the sultan took note of Spies and asked the Sitsens about him, and in the morning, "it happened! I couldn't believe my eyes! Carriages drew up outside my lodgings with princes and their retinues of a dozen retainers, with full ceremony, raised golden umbrellas, utensils of gold on high-borne gold trays, and the princes wanted to talk to me by order of the sultan. And what was it all about? The sultan sent to ask if I would take over the conductorship of the court dance orchestra!!!!" Here the narrative is fully appareled in the conventions of fairy tale, specifically the fantasy-fulfillment story of Cinderella, with Walter himself cast in the lead role. The lowly, impoverished servant improbably becomes the belle of the ball and wins the heart of the prince; the next morning his emissaries search the town for her, and when she is found, they carry her off to live in the royal palace. Just as the gilt finery of the anachronistic princedoms in Middle Europe seduced Raden Saleh and transformed his life, so the storybook splendor of the sultan's palace set Spies's head spinning.

He was the first foreigner ever invited to live within the walls of the *kraton*, reporting directly to the sultan. His dream had come true.

Goona–Goona in Bali

Oh, must we dream our dreams
and have them, too?

—Elizabeth Bishop, "Questions of Travel"

Spies's first assignment as the sultan's orchestra leader was to whip
the band into shape. The ensemble under his direction was not the
gamelan, the Javanese percussion ensemble that performed at the
court's traditional ceremonies, but rather a conventional Western
orchestra that played when foreigners came to visit, specifically tea
dances and balls for the Dutch colonial establishment, Spies's *bête
blanche*. His first move was to reduce the orchestra's forces from
thirty to twenty-three; he allowed those suspended from the ros-
ter to return after they had learned to play their instruments com-
petently. Within a month, the orchestra was playing well enough
to perform at the farewell banquet for the president of the Philip-
pines; after six months, it was engaged to play at the Dutch club.

The sultan showed his approval by doubling Spies's salary,
though it was still far less than he had earned with the palm-court
band. He supplemented his income by touring as an accompanist
for visiting European artists throughout Java; on a few occasions,
he was more warmly received than the headliner. Spies's main
agenda in his new job was to learn Javanese music inside out. He
befriended the director of the royal gamelan, Raden Mas Djo-
djodipoerno, who supervised the dance and musical performances
at the *kraton*. Spies was a diligent apprentice, a role he cherished,

and eventually he learned to play all the instruments in the gamelan. His goal was not to become a virtuoso performer but rather to inhabit the classical sound world and acquire its rarefied sensibility.

As soon as he had achieved a fair command of the instruments, he began transcribing gamelan music in Western notation. He enlisted the aid of a Dutch musicologist named Jaap Kunst, who had been studying music in Java since 1919 without finding a satisfactory method of notation. Spies hit upon the idea of retuning the piano to reflect the tones of the gamelan. He soon realized that it would take more than one piano to reproduce the complexity of Javanese music, and his experiments became more ambitious, requiring two pianos, then three, and culminated in a grand performance with four Javanese-tuned instruments. By the end of it, the garden surrounding the pavilion where Spies and his cohort were playing was filled with a crowd of admiring listeners, fascinated to hear their music being performed on the exotic instruments.

Kunst was delighted. After visiting Spies at the *kraton*, he wrote, "He now has complete scores of Javanese and Balinese compositions ready for the press and played me parts of them on the piano. It was just marvelous. Spies has achieved a brilliant piece of work." Kunst persuaded Spies to let him take the scores to Europe, where he would arrange for their publication by the Netherlands Academy of Arts and Sciences and music conservatories in Berlin and Vienna. Spies worked steadily on the manuscript until Kunst's departure, yet in the end the project stalled, a victim of Spies's perfectionism. Typically, his interest withered once he had solved the problem to his own satisfaction, and he never published his work. Years later, he wrote to Kunst to explain his disenchantment: "Time and again I see that we all too quickly set up a hundred false hypotheses, and then by drawing the logical conclusions come to quite incorrect results. And what's the sense of printing unprovable pseudotruths that have just popped out of a European brain, which time and again don't seem to come a jot closer to the mark?"

In June 1925, Martha Spies came to Yogyakarta to visit her fair-haired boy and stayed for more than two years. It was part of another scheme, to get all his family to come live with him in the

Indies before the economic collapse and social disintegration of Germany, which Spies believed was imminent. When Martha arrived, Walter had just returned from his first visit to Bali, at the invitation of the Tjokorde Gde Rake Soekawati of Ubud. At that time, Ubud was an insignificant village in the hill country northwest of Denpasar, the island's capital, but Tjokorde Soekawati also held an important post in the colonial administration. He had a bold vision for his little domain.

Bali had precisely the same effect on Spies that Java had had initially: he felt an instant affection for the place and saw it as his new *neue Heimat*. In 1926, in answer to a letter from Franz Roh, the art critic, who had maintained a lively interest in his work, Spies wrote, "I am still here [in the Indies] and haven't the least desire to go back to Europe." In Bali, the people live "internally with clarity, at peace, permeated with divinity, and externally so wonderfully earthy. Everything is simple, unconditional, free of despair!" Spies's love of Java and specifically the court at Yogyakarta had not diminished, but his position as orchestra leader, which in the beginning had seemed like a lark, proved to be onerous, and he had succeeded all too well at his new supplementary profession as a musicologist. The Kunstkring in Batavia had organized a series of lectures for him at seventeen sister societies throughout Java, which were lucrative and well attended, but he said they left him feeling like a missionary.

The most significant drawback to this musical busyness was that he had all but abandoned painting. On a second visit to Bali, again at Tjokorde Soekawati's invitation, Spies painted four scenic backdrops for a spectacle. Martha wrote to Leo, "The scene-drops turned out splendidly, far too beautifully executed: he had a Balinese helping him who has a great talent for drawing." It was the first glimpse of Spies's attachment to the artists of Bali, which would take up more and more of his time. Sounding very much like Gauguin before his first voyage to Tahiti, he wrote to Georgette Schoonderbeek,

I'm going to go to Bali provisionally for a year and build myself a hut in the forest, finally I'll find peace there. And

finally start painting! But I hope I'll be allowed to stay there longer. Then you must come on a visit. Mama will make you pancakes, and I'll get my gamelan to play you something. Later we'll go into the forest and run with *pas de géant* [giant steps], hanging on to the dangling roots, and tomorrow there'll be an earthquake and our temple will come crashing down.

In August 1927, when Martha Spies returned to Germany, Walter moved from the palace in Yogyakarta, after an amicable parting with the sultan, to that of the Tjokorde in Ubud. Within a few months, he occupied a house the Tjokorde had built for him near the palace, on the main street of Ubud. He soon made friends with his neighbor across the street, I Gusti Nyoman Lempad, the most distinguished and influential Balinese artist of his era, which was exceptionally long: Lempad died in 1978 at the age of approximately 116; he could not have been much younger, for he married at the time of the eruption of Krakatoa in 1883.

Spies lived in Bali for the next fifteen years with few interruptions in an experiment in a purely aesthetic life that has few modern parallels. He more or less accomplished what Gauguin had set out to do: he integrated his own life and art with that of the island. As Spies wrote to Schoonderbeek, his main motive was to return to painting. In Bali, he produced the pictures for which he is best known, particularly in Southeast Asia, where collectors regard him as a modern master. He studied all the island's traditional arts and made records of them using the latest Western technology available to him, and introduced local artists to foreign techniques and materials.*

*This book is not the place for a résumé of Balinese culture, which is fundamentally different from that of Java. However, in order to have even a rudimentary understanding of what Spies experienced by moving from Yogyakarta to Bali, it is at least necessary to know that while Java and most of Indonesia is predominantly Muslim, the Balinese follow their own version of Hinduism, heavily influenced (as indeed is the Javanese practice of Islam) by primordial animist religion. When the Muslim conversion swept eastward across the Malay Archipelago five hundred years ago, it came to a halt at the Bali Strait, leaving the island as a refuge for the remnants of the ancient Hindu kingdoms.

Spies arrived in Bali nineteen years after the greatest cataclysm in the island's history. While the Dutch had subjugated most of the archipelago to colonial rule by the mid-nineteenth century, southern Bali had been allowed to continue in a state approximating self-governance until 1906. After a Chinese schooner foundered on a reef off the coast of Sanur, on Bali's eastern shore, the rajas of Badung, the regency that encompassed Denpasar, plundered the wreck, as they were permitted to do under island law. When the colonial administration in Batavia demanded that they pay compensation to the ship's owners, they refused. The Dutch had been waiting for a pretext to establish full control over Bali since a suttee in Tabanan three years before, a royal cremation in which the prince's widows were burned alive with their husband's corpse. To end the standoff in Sanur, Batavia dispatched a large military force with the mission to carry out a swift conquest of southern Bali, starting in Badung.

When the troops landed on the beach, they encountered little resistance and marched inland to the palace in Denpasar. There, a procession of the entire court, led by the raja, carrying the kris denoting his kingship, serenely marched out to meet the invaders. At the raja's command, a priest plunged the kris into his lord's chest. The rest of the court, dressed in white cremation garments, likewise began to kill themselves and each other. When jumpy Dutch soldiers heard a stray gunshot, they opened fire on the host of royals, court officials, and priests, with their wives and children. The inhabitants of the palace continued to pour out of the gates and the Dutch kept firing, mowing down wave after wave of people armed only with ceremonial krises. Approximately a thousand civilians died in the massacre. The *puputan*, the Balinese term for a ritual of mass suicide, shocked the conscience of the West, particularly the Dutch intelligentsia, which had relied upon the illusion that colonialism was a benevolent force of cultural uplift and spiritual salvation, the Dutch equivalent of the *mission civilisatrice*.

The loss of the king, the cynosure and theoretical center of the Balinese theater-state (in Clifford Geertz's durable phrase), with his entire court and the priesthood, was nothing less than the end

of the world, a Götterdämmerung with very few parallels in history—among which may be counted the abrupt snuffing out of the ancient culture of Tahiti described in Segalen's *Les immémoriaux*. When Spies came to the island, the Balinese were attempting to save what they could of their old way of life after this holocaust of its social superstructure. Always a hospitable people, they welcomed with exceptional warmth this glamorous white man who took a serious interest in their traditional arts and was even learning to speak their language fluently, as few foreign residents had ever done.

Whether by conscious design or simply as the result of an omnivorous appetite for new art forms, Spies took up one traditional medium after another. Almost immediately, he apprenticed himself informally to a master mask carver in the village of Mas, named Ida Bagus Ngurah. Spies's earliest surviving works in Bali are a pair of exquisitely rendered portraits in pencil of Ngurah's sons. The drawing of Ida Bagus Ketut Gelodog is particularly fine, depicting a handsome youth in temple dress in a contemplative mood, his face as impassive as the masks he carved. Spies remained close to Gelodog and years later described him as "a really great artist [who] has a completely individual style, absolutely simple, smooth, and very like himself . . . quite different from anything else that has ever existed in Bali." Gelodog's brother, Ida Bagus Rai, was evidently less well-favored, presenting a rather frog-like appearance in Spies's drawing.

The drawings are still in the possession of the subjects' descendants. In 2013, I drove up to Mas to see them. Ibu Dayu, the present manager of Ida Bagus Ngurah's shop, has turned the place into a veritable museum, with grotesque masks hung chockablock on the walls behind a thicket of *wayang* puppets dangling from the ceiling. She was pleased to take me across the street to the family house to see the drawings. They are hung in shoddy wooden frames without mats in a storage room on the top floor, which is open to the damp. The drawings have deteriorated badly, riddled with tiny holes gnawed by insects. Ibu Dayu told me that a German professor came to see them a few years earlier and offered to have the drawings reframed to conserve them, but the family

refused, remaining true to a tradition that forbids the drawings ever to leave the ancestral house. She casually mentioned that she was the reincarnation of Ida Bagus Rai, and her nephew Ida Bagus Sutarja, the slender young man with a mustache whom I had met below in the compound, was the reincarnation of Ketut Gelodog.

Spies's early paintings in Bali continued the celebration of the majestic tropical landscape he had begun in Java and reintroduced the element of magic realism characteristic of his best work in Germany. Both tendencies are evident in two canvases he painted for an early, frequent visitor to Bali, Victor Baron von Plessen, which he swapped for Plessen's automobile. *Village Street* is a lush chiaroscuro landscape in a strongly vertical format (seventy-five by forty-five centimeters), composed around a winding, rising path, which creates a vertiginous effect. In the foreground, a single male figure with his sarong tied up around his waist, his head obscured by the broad straw hat used by Balinese laborers, guides his cow home. The figure is slight of build, with nothing romantic or idealized about it; like most of Spies's male figures, it depicts a body accustomed to hard work. The other painting for Plessen, *Animal Fable*, is an enigmatic landscape: in the foreground, a ferocious tiger beside a lotus pond bites a serpent, which is coiling around its body; in the background, three stags with strange, braided antlers stand guard. The painting has a naïve air, with a comical grimace on the tiger's face that has a strong Rousseau feeling.

In Bali, Spies continued his study of the gamelan, which peaked with a series of gramophone recordings, the sequel of a project he had begun in Yogyakarta for the German labels Odeon and Beka. Limited by the technology of the day to three minutes each, these recordings gave Western listeners their first opportunity to hear the music of the archipelago. When the Canadian composer Colin McPhee heard the records in New York, he and his wife, the American anthropologist Jane Belo, decided to come to Bali to hear the music for themselves. They moved into a house in Sayan, a village near Ubud, which McPhee described with lively charm in his memoir, *A House in Bali*.

Yet Spies's focus in the performing arts shifted decisively to dance. In Java, he had learned the whole repertory of movements of classical Javanese dance while he was studying with Raden Mas Djodjodipoerno, which gave him an advantage in his study of the Balinese tradition. Later Spies would serve the court in Ubud in a role similar to that of Djodjodipoerno for the sultan of Yogyakarta, supervising entertainments for the Tjokorde, notably an extravagant festival to celebrate a visit by the governor-general of the Indies in 1935. Spies described the event in a letter to his mother with his usual superabundant enthusiasm: "Gamelans, dances, games everywhere. It was the most fantastic thing ever! I can't believe that anywhere in the world anyone has been greeted with such pomp and ballyhoo."

One of the dance pieces was the largest performance yet mounted of a newly choreographed dance-drama that emerged in the 1930s, which Spies himself played a role in developing. The *kecak* is an exorcism ritual that arose from the *sanghyang dedari*, a trance dance without gamelan accompaniment performed by a chorus of men who sat in circles, swaying and rhythmically chanting the staccato syllable *cak* (pronounced *chok*), imitating the chatter of monkeys, while young female dancers enacted an elegant ballet of celestial nymphs like those on the reliefs of Angkor Thom. The *kecak* was created by a dancer named I Wayan Limbak, a close friend of Spies's who later joined him on a butterfly-hunting expedition to Sumatra. At Spies's suggestion, Limbak combined the choruses into one large group, seated in a circular mass. A visiting American dancer, Katharane Mershon, proposed the idea of having the soloists perform a scene from the Ramayana, bringing the dance more or less to its final form. It is now one of the most popular pieces in the Balinese repertory, often performed with a chorus of a hundred or more men.

Guidebooks and travel writers have exaggerated Spies's role in the evolution of the *kecak*, which infuriates scholars, but Spies himself never claimed to be its creator. In 1934, the British dancer and critic Beryl de Zoete came to Bali for a visit. She had studied eurythmics with Émile Jaques-Dalcroze at Hellerau, though she and Spies were not there at the same time. Together they carried

out a comprehensive study of the dance and drama traditions of Bali: in other words, Spies taught her everything he knew. The result, *Dance and Drama in Bali*, is a witty, gracefully written account of traditional Balinese performance, illustrated with excellent photographs by Spies. The book remains a standard reference. After a detailed description of a performance of the *kecak* in Bedulu, Limbak's home village, the authors write, "It is true that the creative effort which produced the astonishing ensemble we have attempted to describe was partly inspired by certain Europeans who felt that Limbak's great gifts as a dancer had not found their full expression . . . and urged him to make something splendid out of the *Ketjak* group of his own village. But the *Ketjak* was of purely Balinese inspiration." ("Europeans" is a polite way of saying "white people," for Katharane Mershon was from California.)

Spies's direct involvement with the *kecak* came about when he was helping Baron von Plessen shoot a feature film in Bali, *Island of Demons* (*Die Insel der Dämonen*), also known as *Black Magic*. It was Spies's second venture in filmmaking in Bali. A year after his arrival, he had assisted the American adventurer André Roosevelt (a cousin of the former president Theodore Roosevelt) in shooting a conventional script about doomed young lovers. In a letter to Martha, Spies breezily remarked, "What else—oh yes, I'm making a film with Balinese [actors] only, here in Ubud. I'm directing and doing most of it, a certain Mr. Roosevelt is the camera man. I've got a splendid, very simple story." However, the film they shot was ruined by the lab in Surabaya, and Roosevelt returned the following year to reshoot the movie without Spies. Called *Goona-Goona*, the Indonesian word for a love spell, the film had a huge success; its title became popular slang in America for "sex appeal."

For Spies, "helping" usually meant doing everything and taking none of the credit (except, of course, with *liebe Mama*). It is clear from his letters home and those of his young cousin Conrad Spies, who had come to live and work with him, that in *Island of Demons*, as in the lost first version of *Goona-Goona*, Spies was principally responsible for the film's scenario, casting and coaching of

the actors, choice of locations, music direction, costumes, and décor. One almost gets the impression that Spies told the baron where to plant his movie camera and let him crank the machine. Yet Spies was never doctrinaire or tyrannical; more likely it was a continuous collaboration, with the knowledgeable local resident taking the lead. Spies compared his vision of the film to a struggle between white and black magic: "The whole thing is like some great, lovely folk song, great and simple! The direction and photography will strongly recall Russian films: very strong, simple, and completely magic-realistic." As one might expect, a principal aim of *Island of Demons* was to present a showcase for traditional dance, the *kecak* in particular.

The finished film is not as engaging as Spies's description promises. The opening scroll succinctly tells the story, such as it is: "The people of Bali live happily bound to nature and their gods. But their happiness is often overshadowed by the doings of hostile demons, which afflict their paradise as powers of nature or even in human form. The fate of such a demon, the witch of the village of Bedulu, lies at the center of this film." The first sentence, a concise résumé of the well-worn Enlightenment concept of a tropical paradise, was nearly a factual description of Bali in 1931, which predicts every scene in the film. The first half is pure ethnography: the farmer Wajan plants his paddy, ducks and geese dabble in the flooded fields, the market bustles, women weave, there is a cockfight, children play. Wajan's mother, a witch, casts an evil spell on the village, causing the children of the town to fall sick. The priest sends Wajan into the forest to collect sacred water, and a series of purificatory dances begins, climaxing with the *kecak*, filmed in its newly elaborated choreography. The witch dies, the children recover, and the village rejoices.

Island of Demons does not glamorize its subject; indeed, it could have used a touch of glamour. What the film most conspicuously lacks is dramatic tension. The story never gets in the way of random shots of wildlife or a good-looking patch of jungle. While the village children are dying, the camera following Wajan's search for the sacred spring lingers lovingly over shots of deer, mischievous monkeys, and a pangolin. There is a faint suggestion of

a love story: Wajan is courting a village beauty named Sari, who has a stall in the market, but nothing passes between them except significant glances, and at the film's end the two remain just as they began, smiling and holding hands. The film has many beautifully photographed scenes of life in a Balinese village in 1931, of particular interest to viewers familiar with contemporary Bali, who will find that little has changed in the island's ritual, agriculture, and traditional crafts; but as drama it's a thin soup.

Murnau's ghost hovers over the project: Spies received the news of his death three months before shooting began. In several scenes, the viewer feels that Spies is aiming for an effect of the master that falls short. Yet in *Tabu*, even in blatantly ethnographic passages, Murnau keeps the viewer's attention focused on the central conflict, the emotional state of the main characters. Spies (who almost certainly could not have seen *Tabu*) did not have the patience for a sustained narrative. In *Island of Demons*, as it was edited, the camera floats like a butterfly from one strange and beautiful thing to the next, just as Spies's letters flit from one subject to another, following his fancy.

These early films set in Bali had a phenomenal success, particularly in the United States, launching a minor but long-lived boom. Creative works in many media exploited the fascination with the island, from serious literature to kitsch, lamps and saltshakers in the image of bare-breasted temple dancers. A Javanese performer named Devi Dja immigrated to America in 1939 and seized the opportunity to make a career for herself in all-singing, all-dancing exotic revues such as *A Night in Bali* and *Temptation of the Buddha*, the latter supposedly based on the sculptural reliefs of Borobudur. Devi Dja presents a singular if complicated case of a twentieth-century East-to-West exote living as a specimen of exotica, similar to Raden Saleh's calculated self-presentation in Europe a century before.

Born in East Java in 1913 or 1914, Devi Dja grew up on the streets, performing with her grandparents' *komedi stambul* ensemble, a form of itinerant theater, now extinct, that drew its

narratives from global mass culture, *The Arabian Nights* and classic European novels popularized by the early cinema, rather than indigenous tradition. When she was barely in her teens, Dja was discovered by Adolf Piëdro, the director of a major *stambul* company, who married her and made her a star. Born Willy Klimanoff in Penang, British Malaya, Piëdro was the son of Russian circus performers. After his father died in a fall during a performance of his chair-stacking act, his mother, a ballerina, took him to Java, where they entertained audiences between reels at cinemas. When he was twenty-three, Piëdro founded Dardanella, a *stambul* company specializing in elaborate spectacles based on swashbucklers such as *The Count of Monte Cristo*. Devi Dja was the headliner in the company's signature piece, a version of the tearjerker *Madame X* set in Java. It was a bravura role that required fifteen-year-old Dja to play an elderly woman in the last act.

There was nothing traditional about Devi Dja's act until 1932, when she studied Balinese dance with a classical troupe that had recently performed at the Colonial Exhibition in Paris. Piëdro created a revue for her, "a Bali temple story" based on H. Rider Haggard's adventure fantasy *She*, which billed her as an adept of the ancient dance traditions of Indonesia. In 1935, Devi Dja's Bali and Java Cultural Dancers embarked on a five-year world tour with a program drawn from throughout the tropical archipelago. They were performing in Germany in 1939, when World War II broke out and brought the tour to an abrupt end. Devi Dja, Piëdro, and the core of the company fled to America.

By 1943, they had taken up residence in Chicago, where they opened a nightclub called the Sarong Room. The company performed jazzed-up numbers from their tour program and served Indonesian food cooked by the artists. After the Sarong Room burned down, Dja divorced Adolf Piëdro and married an American Indian artist named Acee Blue Eagle. In a disastrous experiment in serial transcultural migration, she lived for a few months as his squaw on the reservation in Muskogee, Oklahoma, where she wore traditional Indian dresses and beaded moccasins. The marriage ended in divorce, primarily because of Acee's acute alcoholism.

Now on her own in Los Angeles, Devi Dja made a determined

effort to create a career in film. She choreographed exotic dance numbers for *Road to Singapore*, starring Bob Hope and Bing Crosby, and a film version of *The Moon and Sixpence*, with George Sanders as Charles Strickland, but she never got a break as an actress, because she was unable to master the comical pidgin English required of Asian actors at that time. It would be easy to lampoon Devi Dja's artistic career: a revival of *A Night in Bali* in 1940 comprised "sarong-girl numbers, sword plays, sport events, plate-juggling, vampire dramas, and jungle dances"—in a word, it was vaudeville. Hollywood press agents claimed that she was of royal Javanese descent and even a "priestess of a mystic cult." Despite the ballyhoo, she had an excellent reputation as a serious dancer and taught at Jacob's Pillow, the festival founded by Ruth St. Denis and Ted Shawn.

Her third marriage, to a younger man, an Indonesian dancer named Alli Assan, was a happy one. In 1957, soon after she gave birth to a daughter, Devi Dja became an American citizen at a mass ceremony at the Hollywood Bowl. Her choice of the United States as the place to put a halt to her peripatetic life was an easy one, to some extent made for her by the war, although she was not a political refugee; Sukarno, the first president of the Republic of Indonesia, was a fan and urged her to repatriate. Dja always considered herself a goodwill ambassador for Indonesia. In 1987, in her mid-seventies, she took a new show on a cross-country tour, billing the group as Devi Dja's Anggita National Ballet of West Java. She died after two exhausting years on the road and was buried in Los Angeles.

The first Bali boom engendered a small but enduring market for light fiction. A friend of Spies's named Cornelius Conyn, a Dutch ballet critic who stayed with him in Ubud, wrote an old-fashioned whodunit called *The Bali Ballet Murder*, in collaboration with an Australian writer named Jon C. Marten. The publisher provides an enticing synopsis on the book's first page: "Here is an exciting detective story distinguished by its authentic picture of life in a small touring company set against the unusual and exotic background of Indonesia. Who killed the ballerina's dresser, and for what reason? Had the murderer mistaken her in the dark for

the young supporting dancer, who had outraged the local priests by uncovering some sacred temple masks?" and so forth. The teaser promises "many novel twists to the plot before the killer is finally unmasked"—including the revelation that the company's director-impresario wears a pink woman's girdle under his suit. When the company arrives in Bali, they stay with a painter obviously modeled on Spies, who attempts to settle the altercation between the dancers and the Balinese after the incident with the masks. The character is underdeveloped, but the description of his estate is closely based on Spies's compound when Conyn stayed there. Apparently, the author absorbed little of his host's love for the place: in Conyn's novel, the Balinese are bloodthirsty savages.

Hollywood produced several movies exploiting the interest in Bali, the most famous title being *Road to Bali* (1952), starring Bob Hope, Bing Crosby, and Dorothy Lamour, but in the movie the trio never make their way to the island. The most interesting Bali film is the first, *Honeymoon in Bali* (also known as *My Love for Yours*), a Paramount picture released in 1939 starring Fred Mac-Murray and Madeleine Carroll. The screenplay by Virginia Van Upp, with the rumored collaboration of F. Scott Fitzgerald, is ostensibly a romantic comedy of love deferred by the usual obstacles, but it has a lot more on its mind. MacMurray plays an American businessman resident in Bali on a visit to New York, where he meets the executive manager of a Fifth Avenue department store, played by Carroll. They fall in love, but she is encumbered by a permanent suitor, a tenor at the Metropolitan Opera, and MacMurray's character is pursued by an athletic Dutch colonial heiress. The story is further complicated by an annoying child, a winsome orphan wise beyond her years who shouts her lines. In the end, true love conquers all plot devices, and they end up happily on the beach in Bali.

The film is an early Hollywood excursion into feminism, with Carroll's female executive a precursor of the plucky career women played by Katharine Hepburn and Rosalind Russell. The movie is also remarkable for making a serious and generally successful attempt at an authentic portrayal of Bali. There are only a few scenes set on the island, which were filmed in the Bahamas, but they re-

semble contemporary photographs of Bali. In a scene at the Bali-
Hoo restaurant in New York, the couple dines on turtle satay, a
classic Balinese dish (now illegal), and the uncredited floor show of
traditional dance is as reasonable an approximation of the real
thing as one could expect of a Manhattan nightclub on a Holly-
wood soundstage. The film's art directors, Hans Dreier and Ernst
Fegté, were active in the film industry in Berlin in the early 1920s,
where they must have known Murnau and could very well have
met Spies. Moreover, the comic actor Monty Woolley, who has an
uncredited bit part, had visited Bali, where he and his traveling
companion, the playwright Moss Hart, called on Spies.

Fred MacMurray, cast against type, is utterly unbelievable as a
resident of Bali, an incongruity the film plays for laughs, but his
dialogue describing life there is pitch perfect. At the Bali-Hoo, he
tries to win over Madeleine Carroll's executive to the idea of living
in Bali with this little speech: "The Balinese have the right idea—
plenty to eat and a house like their neighbor, and no better. What
more could you want? That gives them peace, and peace is tough
to find." It is a stripped-down synopsis of the essential myth of
tropical paradise, without the palm trees and colonial helmets that
exasperated Victor Segalen—a direct descendant of Diderot's pas-
sionate plea against creating wants in superfluity.

If one of Spies's motives in leaving Europe was to escape the hec-
tic hobnobbing of the Berlin film scene, as the consort of one of its
leading figures, even so he created a cosmopolitan social whirl of
his own in Bali. One of the problems presented by his life is the
question of whether he was a serious artist: his behavior in Bali
alternated erratically between that of a Garboesque recluse, par-
ticularly when he was painting, and that of a starstruck social
climber, who made himself the new best friend of every famous
visitor to the island.

His house in central Ubud collapsed a year after he moved in,
so he built a new one on a plot of land given to him by Tjokorde
Soekawati, at a place called Tjampuhan, sited on dramatic gorges
at the confluence of two rivers about a mile downhill from the

palace. He designed a handsome wood-and-thatch house in tradi-
tional open style with broad porches, which was widely admired
and has been imitated by a thousand holiday villas for rich for-
eigners. It was the birth of shabby chic. The house was soon sur-
rounded by a collection of bungalows, which became the most
desired address in Bali for well-connected visitors to the island.
Spies himself was one of the island's principal attractions, much as
Gertrude Stein in Paris, before him, and later Paul Bowles in Tan-
gier became objects of pilgrimage.

Spies's visitors in Tjampuhan were serious people. Moss Hart
and Monty Woolley were funny men but dedicated to their craft;
Colin McPhee wrote the definitive treatise *Music in Bali*, and his
wife, Jane Belo, the unconventional anthropologist from Texas,
became Spies's intimate friend, almost a platonic lover. For her first
field trip, Spies took her to a village where twins had recently been
born; the parents had been exiled and their house burned for
bringing misfortune on the community. The Balinese still believe
that male-female twins have sexual intercourse in the womb, a sin
of incest that requires an extensive purification ritual.

When they returned to New York, McPhee and Belo met Mar-
garet Mead and Gregory Bateson and told them about their visit.
After their wedding in Singapore, Bateson and Mead came on a
working honeymoon to Bali, where they conducted field research
for three years, which resulted in some of their most influential
publications. They used photography and film extensively in Bali,
creating an archive of some twenty-five thousand photographs,
with Bateson shooting and Mead cataloging. They also bought
more than eight hundred paintings by Balinese artists, most of
them commissions.

Another pair of honeymooners, Miguel and Rose (later Rosa)
Covarrubias, cruised to Bali in 1930. A native of Mexico City,
Miguel had arrived in New York six years earlier at the age of
nineteen and achieved phenomenal success as the caricaturist of
Manhattan's Smart Set in *Vanity Fair* and *The New Yorker* and as
a book illustrator and stage designer. He met Rose when she had
a star turn in the *Garrick Gaieties* revue, for which he had created
the décor. They came to Bali with a letter of introduction from

André Roosevelt, and Spies took them under his wing. Of all the foreign visitors to Bali between the world wars, none, perhaps not even Spies himself, left a more considerable legacy than Miguel Covarrubias: his book *Island of Bali*, a bestseller in 1937, remains the best single-volume reference to the arts and rituals of Bali.

Running to more than five hundred pages, abundantly illustrated with line drawings and paintings by Miguel and a portfolio of Rose's photographs, it is an encyclopedia of Balinese village life. The depth of research is astonishing and can only be explained by Spies's active participation; it would have been impossible for one person to have attended all the performances and visited all the places described in the book in the twenty months of Covarrubias's residency in Bali. Covarrubias was explicit about Spies's contribution to the book in his introduction: "In his charming devil-may-care way, Spies is familiar with every phase of Balinese life and has been the constant source of disinterested information to every archaeologist, anthropologist, musician, or artist who has come to Bali. His assistance is given generously and without expecting even the reward of credit."

Even taking Spies's participation into account, the sympathetic acuity of Covarrubias's portrayal of Balinese culture has always amazed readers, including Indonesians. How did a society caricaturist and illustrator achieve so profound an understanding of an alien way of life, so quickly? One explanation that has often been advanced is that as a Mexican he had an innate grasp of village life, but Covarrubias was a city boy, the son of a government minister, who attended an elite private school. Yet he was temperamentally well-disposed to gain the trust of the Balinese; he was a serious student of their way of life, but not too serious. He loved playing practical jokes, and when he attended practice sessions of the gamelan, he brought his guitar and played with them. Like Spies, he wanted to befriend the Balinese as much as to study them. *Island of Bali* marked a pinnacle of sorts in the literature of the island paradise, managing to merge the dream of Bali with an objective observation of the real place in a near-pristine state.

In 1932, after the triumphant success of *City Lights*, Charlie Chaplin came to Bali at the end of a long holiday with his half

brother Sydney, to ponder his future in the era of the talkies, the same existential dilemma that Murnau faced at the time of his death, the year before. Spies served as the interpreter at the predictable round of banquets held in Chaplin's honor; when the actor begged to be "kidnapped," Spies took him on forays into the countryside to see the dance and drama. Bali charmed Chaplin, whom Spies correctly described in a letter to his mother as "perhaps the best known, most popular personality in the world." Spies wrote that he had never seen anyone respond so perceptively to Balinese dance and music:

> He's an incredibly sensitive, kindly man and has such a gift for imitation that you clap your hands together over your head! For example, at my house, right after the first dance performance he saw, he began to reproduce what he had seen. He'd caught the tiniest, finest details, little twists, accents, little muted moments, the tiniest changes, the whole lot, and he reproduced it in motion with almost photographic accuracy.

The Chaplin archive in Paris has a fifty-page manuscript in which the actor and director sketched some ideas for a picture about Bali, which was to have been his first film with spoken dialogue. It was obviously written under Spies's influence; many of the scenes described in the manuscript, particularly those of farming and craft activities, are lifted from the scenario of *Island of Demons*. The story is a trenchant satire of colonialism in the tropics, told from both points of view. In one snatch of dialogue, a visiting businessman tries to persuade a Balinese prince to excavate a coal deposit in his domain: "This would mean great prosperity to your people and a contribution to the outside world."

The prince replies, "We grow rice on these fields. Why dig up coal?"

"But with your profits you could get rice elsewhere."

"Then let them get coal elsewhere, which is much simpler."

Spies played his gamelan transcriptions for Chaplin, who was sufficiently impressed to offer to arrange an American concert tour

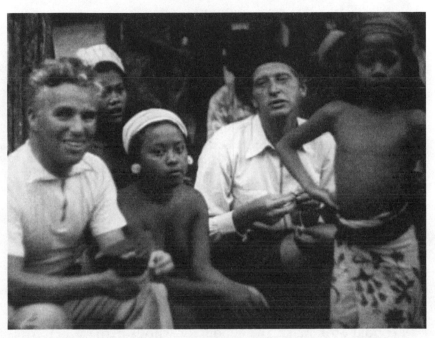

Charlie Chaplin and Walter Spies with temple dancers, still frame from Chaplin's archival film shot in Bali, 1932

for him. It might have been a serious offer, but nothing came of it. When Chaplin left, he bought a painting from Spies.

Noël Coward sailed to Bali aboard the same ship that brought Chaplin, Bateson, and Mead. He got to know Spies well during his ten-day visit, judging by the poem he wrote in the guest book, which begins,

> Oh Walter dear, oh Walter dear,
> Please don't neglect your painting.
> Neglect, dear Walter, if you must,
> Your pleasure in the natives' trust;
> Neglect, if need be, Social Grace
> And Charity and Pride of Race.
> Crush down, dear Walter, if you can
> Your passion for the Gamelan;
> Neglect your love of birds and beasts,
> Go to far fewer Temple Feasts;
> Neglect your overwhelming wish
> To gaze for hours at colored fish.
> You may delight in flowers and trees
> And talking to the Balinese,
> But they, alas, tho' gay and sweet
> Are, notwithstanding, most effete
> And not conducive to the state
> You need in order to create.

Leopold Stokowski, the conductor who is perhaps better remembered as Mickey Mouse's costar in *Fantasia* than as a champion of new music and a prolific recording artist, came to Bali and bought a painting by Spies, which is now lost. Ruth Draper, an actress who specialized in one-woman shows of humorous monologues with a bittersweet edge that were hits on Broadway, came to the island in 1938 and wrote, "I found an interesting German artist, living in a heavenly 'nook' in the mountains, and I spent a night there and swam at dawn in a pool with orchids hanging from the trees—it was lovely." Bali, for Draper, was "unique in beauty, mystery, and unsullied charm. Something to dream about

always, when striving to forget the complex and sorrowful mess of our times."

Vicki Baum, one of the bestselling German-language authors of the twentieth century, fortuitously arrived in Bali on the first day of the grand festival in honor of the governor-general in 1935. She and Walter hit it off at once and remained good friends until his death. Baum specialized in novels with big ideas and a large cast of characters thrown together by dramatic circumstances. Her first bestseller was *Grand Hotel* (*Menschen im Hotel*, 1929), filmed by MGM with an all-star cast headed by Greta Garbo. Baum returned to Bali the following year for a longer stay, during which she wrote a book based on the *puputan* called *Love and Death in Bali* (*Liebe und Tod auf Bali*, originally translated with the insipid title *A Tale from Bali*).

Her novel knits together the stories of a poor rice farmer, a temple dancer who contracts leprosy, and anxious Dutch colonial officials on the horns of a dilemma. It is a complex book, which sees conflicting points of view on both sides of the colonial divide. The scenes of village life are particularly effective, richly atmospheric without cloying, and realistic in broad concept and detail— once again, Spies's hand silently at work. Much transformed, he has a cameo turn in the book as Dr. Fabius, "an eccentric with an unrivaled knowledge of Balinese life." Baum, in her persona as the book's author, writes in a prophetic preface that Dr. Fabius was responsible for "the privilege I enjoyed of seeing the real and unspoilt Bali instead of merely the modernized and tawdry fringes which tourists skirt in comfort."

Spies's most glamorous visitor, anyway the richest, was Barbara Hutton, the Woolworth heiress. Noël Coward wrote the song "Poor Little Rich Girl" about her when she was still in her teens, a nickname that stuck to her the rest of her life. Hutton, just twenty when she came to Bali, was charmed by Spies and his romantic life in the tropical forest. Her own life would become even more storied than his, in the sense that it inspired literally countless lurid stories in the tabloids. Alcoholic, painfully thin, a collector of jewelry that had belonged to queens, she married seven husbands. Five of them were royals real or fake, most of

whom abused her and pilfered from the family treasury. The only one who was kind to her and indifferent to her millions, it seemed, was Cary Grant, in a marriage that lasted from 1942 to 1945.

Hutton and her constant companion, Jean Kennerley, the daughter of a British lord, saw *Goona-Goona* in the cinema in New York and impulsively decided to sail to Bali. Kennerley wrote, "In the village of Ubud we befriended a painter and teacher, Walter Spies, who, following Gauguin's example, had emigrated from Europe. Spies lived in one of the loveliest homes on the island. It was primitive but very elegant. You washed by pouring well water into a canvas bag and you read by kerosene lantern." At the conclusion of her visit to Bali, Hutton bought two paintings from Spies and commissioned two more.

She invited Spies to join her entourage on its onward tour of Java, Bangkok, and Angkor. In Java, Hutton became engaged to marry her first husband, Alexis Mdivani, a prince of Georgia whose family had lost its fortune after the Soviet invasion; now he was hunting a new one to support his family's lavish style of living. After Hutton accepted his proposal, Mdivani sent his sister a telegram that read: HAVE WON THE PRIZE. ANNOUNCE BETROTHAL. When he met Barbara Hutton, he was married to an Astor and carrying on a love affair with a Gabor; he divorced Louise Astor Van Alen in order to marry Hutton but continued the liaison with Zsa Zsa. The engagement was celebrated in Bangkok, where Mdivani bought every flower in the city (as Jean Kennerley told the story), hired a nightclub orchestra to play in his hotel suite, and had hundreds of baby ducks delivered to the bathtubs of all the guests.

It was Spies's first visit to Siam. Ten years of living in Asia had not dimmed his enthusiasm for new cultures. In Bangkok he wrote, "The palace and Buddhist temples are like a fairy tale. Very baroque and completely covered in ornamentation, but this luxuriance is so unexpectedly beautiful in its coloring that you forgive it. It glitters in blue, green, yellow, violet, pink, and gold. Gold in bright sunlight against the green-blue-gray sky that shimmers with heat. It's exactly the way you imagine the 1001 Nights except even

more fabulous." Later he conceded that it was "at times a bit kitsch."

The last stop, Angkor, was the high point of the tour. In his book about Angkor, published eighteen years before, Pierre Loti laid on the conventional element of jungle mystery with a heavy hand: the ruins stopped him in his tracks with a frisson, a vision "of tall, strange towers everywhere entwined by exotic verdure, the temples of mysterious Angkor." Spies, a seeker of living exoticism more than a connoisseur of lost cities, responded to Angkor with passionate hyperbole that delved no deeper than Loti:

> I got up terribly early in the morning to have a walk in the ruins! And it was fantastic: the most beautiful sculpture, and especially reliefs, that I have ever seen. Some reliefs are so unexpected in their composition and the extreme simplicity of their execution that you think, compared with them, everything else that humanity has ever done is crap. It's a bit like ancient Egypt, only with more warmth of feeling. It's incredible that nothing is known about this unexpectedly high, ancient culture. . . . There's mile after mile of ruins, all of it in the thickest jungle, smothered in vegetation; lots of stuff is still inaccessible and was only discovered using aircraft. Gateways, towers, cloisters, palaces, libraries, bathing pools, temples, a whole city.

The comparison with ancient Egypt is no more apt here than it was in his description of the *kraton* in Yogyakarta. One suspects that these places reminded him of Egypt simply because it was the only ancient civilization he had ever studied; to distinguish Angkor from Luxor by saying that it possesses more "warmth of feeling" does not reveal insight into either. Spies's lament that nothing is known about the Khmer is a lazy restatement of a journalistic cliché. In fact, by 1933 a great deal was known about the people who built Angkor. The École française d'Extrême-Orient had been studying the city since 1900 and by the time of Spies's visit had published translations of most of its major inscriptions. It had recently completed a magnificent portfolio of photographs of

the integral bas-reliefs of Angkor Wat, the most ambitious archae-
ological publication since the Napoleonic *Description de l'Égypte*.
It may not be fair to fault a letter to Mama for a lack of erudition,
but it goes to show that after his move to Indonesia, Spies's energy
and enthusiasm were not accompanied by even a passing interest in
scholarly research.

In the late 1930s, a hot wave of moralistic fervor swept across the
Dutch East Indies, fomented by journalists who presented as fact
appalling rumors of a homosexual-pedophiliac underworld in Bali.
It was, in a phrase, a witch hunt: an anonymous accusation was all
that was required to mount a prosecution, and the standard of ev-
idence was set so low as to ensure conviction. The spearhead in
Bali was the colonial resident, H.J.E. Moll, who defined "the
immoral lifestyle of certain European residents" by "alcohol abuse;
consorting with the natives in extreme fashion; 'would-be' art,
where the natural nakedness of Bali has been lowered to shameless
posing for the taking of all kinds of pictures and photographs,"
and "unbridled sensuality." The expatriate community in Bali cer-
tainly enjoyed a cocktail and indulged in many varieties of sensu-
ality, unbridled as it usually is, which sometimes involved sex with
adolescents; but the real purpose of the crackdown appears to have
been to maintain the color line, always an imperative goal of the
colonial administration in the Dutch Indies. The result for the ac-
cused, as Hans Rhodius wrote in *Walter Spies and Balinese Art*,
was "a series of suicides, dismissals, broken marriages, and ruined
careers."

The center of the alleged child-prostitution ring was Spies's
compound in Tjampuhan, which he had abandoned. By the end of
the decade, the constant stream of visitors had left him with little
time to paint; pursuing his usual strategy, he bolted. He found a
retreat in the mountains at a place called Iseh, where he did some
of his best work in years, and turned the management of the Tjam-
puhan estate over to a pair of German homosexuals who had ac-
companied Vicki Baum to Bali. They gradually transformed it into
a hotel, which acquired a shady reputation after Spies had de-

camped. Friends wrote to warn him of his perilous position, but Spies never worried. Jane Belo characterized the situation in Indonesia as "the whole European population apparently gone mad. Such whisperings and spyings and accusations behind backs as you never would have dreamed possible, even in this happy hunting ground for the gossiper." The archaeologist Willem Stutterheim, with whom Spies had worked on a number of projects, wrote him a stern, semiofficial letter. Spies answered it with his usual good cheer, addressing the rather pompous academic as "Dear Strop-piproppity." He expressed gratitude for the warning but dismissed the rumors as "a pailful of nastiness" and averred, "For the present I can reassure you on the point of my own pure, calm, and clear conscience. I will surely never do anything I would have to be ashamed of."

By the end of the year, he was in jail on charges of pederasty. Spies's trial was a cause célèbre, a tropical counterpart of Oscar Wilde's scandalous trials. The case against Spies was extremely vague: the victims of the alleged acts of pederasty were identified as boys without establishing their ages. The police detained Spies's servants for long periods and threatened to send them to prison unless they "confessed," in other words, unless they signed a statement affirming the official narrative of their employer's depraved orgies at Tjampuhan. The father of one of the youths was a witness for the defense. According to Rhodius, he expressed the perplexity of the Balinese by expostulating, when he was asked if he was angry at Spies's conduct toward his son, "Why? He is after all our best friend."

Conditions at Tjampuhan might well have degenerated to a criminal state; the dire warnings of Spies's friends must have had a factual basis. However, the record is bare. There is no evidence that Spies was involved, unless it was simply a question of knowing or suspecting what was going on. Spies was as indifferent to the private behavior of other people as he was to maintaining an appearance of propriety in his own conduct. Margaret Mead and Gregory Bateson wrote powerful character references for Spies that included a detailed consideration of the issues of age and normal sexual conduct in Bali, which flew over the heads of the colonial

judges, whose duty plainly was to convict. Mead described Spies as "a homosexual who is a man-loving man," which was a "very different picture from the type of homosexual who loves little boys." She concluded with this astute assessment: "Walter Spies has been able to do what very few gifted people . . . have been fortunate enough to do. He has found a country of the spirit, a country which is so congenial to him, that his rare gifts have been able to flower there."

The court handed down the inevitable verdict of guilty and sentenced Spies to eight months, including three months already served in detention. Mead was deeply distressed by the injustice of the verdict. The day before he was to be transported to prison in Bandung, Spies wrote her a generous letter to lift her spirits; his own were, as ever, buoyant. "It is dreadfully nice of you to have been so anxious to comfort me after the sentence came out. But really, Margrit, I think that all this happened just in time—and it had to happen, and it was very, very necessary! And it is all for the best, as everything always is in my life."

Spies's arrest and conviction raise the issue of the true nature of his relations with the young men and boys who were constantly in his company at the Tjampuhan estate. There is no doubt that Spies adored their clean-limbed beauty and high spirits, and he often romped with them as a playmate. Baron von Plessen told Rhodius about the time he and Spies slithered down a rushing brook with some local lads after a heavy rain. It is equally certain that Spies had sexual relations with Balinese men during the time he lived there, but who they were and how old must remain a matter of conjecture; as we know, his letters describing his sexual experiences were destroyed by Rhodius's family. His only serious love affair had been with a man seven years his elder. Spies obviously delighted in the company of boys, which may be interpreted as a manifestation not of a sexual fixation but rather of an immature personality, an aspect of his character that no one has ever doubted. The only evidence that Spies was a pedophile is that his name was on a secret list drawn up by Resident Moll.

After his release from prison, Spies stayed for six weeks at the botanical garden at Buitenzorg as the guest of the director. He

returned to Bali in January 1940 with a collection of exotic plants for his garden. On May 10, Germany invaded Holland. Just as in Russia in 1914, Spies was a German civilian residing in a country at war with Germany, cause for him to be detained and sent to a prison camp. In August, he was transported to Kotatjane, an Allied internment center in Sumatra. It was not as comfortable as Sterlitamak had been, but as always Spies made the most of the experience. Soon after he arrived, he gave lessons in drawing and Russian language to fellow internees and organized musical performances, including a recital of solo works by Rachmaninoff on a decrepit piano. He had art supplies sent to him and continued painting: an unusually gloomy jungle landscape with a tiny patch of sunlight; a prophetic painting, *The Vision of the Prophet Ezekiel*, which is lost; and a realistic picture of his house and garden in Bali, a poignant expression of homesickness. He produced many drawings of insects and asked for a magnifying glass from home so he could sharpen the detail even more.

One of the guards at Kotatjane was Cornelius Conyn. In a recognition scene worthy of Greek tragedy, he identified his former host at once; Spies appeared to recognize him too but did not acknowledge it openly, lest he compromise Conyn with the camp bosses. In a novel based on his experiences at Kotatjane, Conyn described their meeting, drawing the last portrait of Walter Spies from life:

> Walter sat on his own, his knees drawn up high, his long back leaning against one of the few palm trees, busy drawing. He was smoking a cigarette he had just rolled himself in quick, nervous drags. I probably first recognized him by his distinctive gestures, for in the years that had gone by since my visit to Bali he had really changed! He'd grown a beard—a thin, yellow, stubbly beard that was still in its first stage. His crumpled straw hat, the provocative red shirt that hung completely unbuttoned, but above all the striking, clear, all-seeing eyes lent his face an expression that reminded you of a Van Gogh self-portrait.
>
> It was shocking to find him, him of all people, like

that . . . like a dangerous predator in a cage or some evildoer who had abused human rights! This proud eagle of a man who had found refuge in his beloved Bali from the small-mindedness of modern life had for years been a symbol of spiritual liberty for his friends.

As the Japanese invaders rapidly swept toward Sumatra and mounted air strikes against strategic targets there, Allied command decided to evacuate the prisoners from Kotatjane to a safer place of confinement. Spies was probably among the group removed from the camp on New Year's Day 1942, which arrived at the port of Sibolga, on the west coast of Sumatra, just in time to be loaded on their ship. The *Van Imhoff* departed on January 18 with 411 civilian prisoners confined in hastily built barbed-wire cages. On the morning of the ship's second day at sea, within sight of land, it was bombed by a Japanese fighter plane. By midday, it was clear that the *Van Imhoff* was sinking, and the captain ordered the crew and military escort to abandon ship. As they boarded the lifeboats, which left with at least fifty empty seats, they deceitfully assured the prisoners that help was on the way and rowed off, leaving them to drown when the ship sank, six hours later. Luck, which had followed Spies around like a fool, had finally forsaken him.

My sketch of Walter Spies's life has neglected some important areas of his work, such as his scientific interests. Spies participated in archaeological expeditions in Java and Bali and made a few important discoveries. In the village of Selulung, in north Bali, he found some small stepped pyramids of great antiquity. When the paleoanthropologist Ralph von Koenigswald came to Bali, Spies took him to see the ruins. Von Koenigswald, famed for his excavation of fossils of *Pithecanthropus* in Sangiran, Java, confirmed that the pyramids were evidence of the advanced state of the aboriginal culture of the island, the Bali Aga.

A few months after his arrival in Bali, Spies went on a tour of the island while he awaited the completion of his house in Ubud.

He visited the remote Bali Aga village of Trunyan, on the shores of the volcanic lake of Mount Batur. In 1933, he published an article in the journal of the Royal Batavian Society about a strange fertility ritual unique to Trunyan, the *barong berutuk*, which is still performed today. In the center of the village's walled temple enclosure is a shrine that houses a thirteen-foot-tall stone sculpture of Trunyan's guardian deity, which is more than a thousand years old. No one is allowed to enter the temple except the virgin boys who are chosen to perform the *barong berutuk*. For a month preceding the event, they live together in a pavilion, wearing bushy banana-leaf tunics they make themselves. On the day of the full moon, the youths don ghoulish white masks and perform the raucous ritual dance, which includes chasing onlookers and beating them with sticks.

Spies was a dedicated amateur naturalist, as Noël Coward alluded to in his poem. From his early years at Sterlitamak, Spies had devoted a significant amount of his artistic activity to precisely observed illustrations of plants and animals he collected in the forest. In *Island of Bali*, Covarrubias wrote, "Walter loves to collect velvety dragonflies, strange spiders, and sea slugs, not in a naturalist's box but in minutely accurate drawings." When Spies was staying at the botanical garden in Buitenzorg after his release from prison, the director introduced him to M. A. Lieftinck, head of the zoological museum, who gave him an informal commission to observe insect and marine life. Lieftinck wrote of Spies, "With inexhaustible energy and hunger for adventure, he sought out nature in the coral reefs, in forest streams, and in the wild plants in his garden, diligently spending weeks doing his research."

Typically, Spies masked his serious intentions with a pose of flippancy. "I have started collecting bees!" he wrote to Lieftinck. "But oh, oh, oh! which are the wasps and which are the bees?" Spies's detailed, beautifully composed illustrations identified several species of insects previously unknown to Western science. In the brief interval between his prison term in Bandung and his internment as a prisoner of war, he went on an expedition to the island of Nusa Penida in search of a rare species of bat that has green fur, on account of parasitic algae that grow on its body. In

1934, Spies was a partner in founding an aquarium in Sanur as a tourist attraction, which supplemented tanks of live marine life with his framed collection of mounted butterflies and watercolors of starfishes, spiders, and dragonflies. He also played an active role in the creation of the Bali Museum in Denpasar, a comprehensive ethnographic collection of the island's arts. It was Bali's first museum and remains the island's principal public collection.

Yet more important to Spies than this Dutch-sponsored institution was an informal artist collective, Pita Maha, which he cofounded in 1936 with Tjokorde Soekawati, Lempad, and Rudolf Bonnet, a Dutch artist who had arrived in Ubud in 1929 and became Spies's closest friend among the foreign residents. Bonnet was a gifted portraitist, whose best works were crayon and pastel studies of young farmers in repose. Pita Maha was intended to support Balinese artists not by instruction or enforcing a theory, like a Western art movement, but by creating a marketplace for them to sell their works at a good price. Art galleries catering to the tourist trade had opened in Denpasar, which took hefty commissions and, worse, imposed on the artists what the dealer conceived to be a commercial style. Pita Maha freed the artists from such constraints.

None of Spies's creative endeavors was as dear to him as his personal relationships with Balinese artists. I have mentioned his friendships with Lempad and the wood-carver Ida Bagus Ketut Gelodog; there were many more, in particular Anak Agung Gede Soberat, a painter who worked in Spies's studio almost from childhood. There can be little doubt that Spies exerted influence on Balinese painting, but as the Australian filmmaker John Darling wrote, "The degree of Spies' influence on Balinese art is a jungle of conjecture." Traditionally, painting in Bali was not ranked among the highest art forms, on a par with dance and music; as in Java, its primary uses were as décor for ritual performances and charms in the temples, which were governed by strict rules of composition and color. Depictions of the human figure were based on the characters of the *wayang*, and the palette was severely limited.

Balinese art had already begun to evolve profoundly, led by

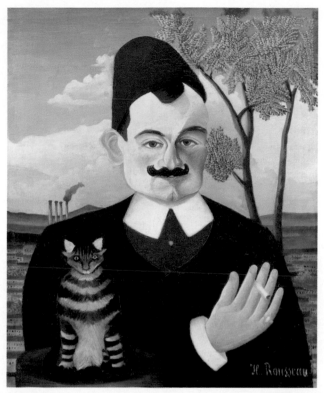

Portrait of Pierre Loti, Henri Rousseau, 1892. After he discovered Rousseau's art, Walter Spies wrote, "At last something that seemed to me totally frank, honest, and straightforward."

Nevermore, Paul Gauguin, 1897. Gauguin wanted to evoke "a certain long-lost barbaric luxury." (The Samuel Courtauld Trust, The Samuel Courtauld Gallery, London)

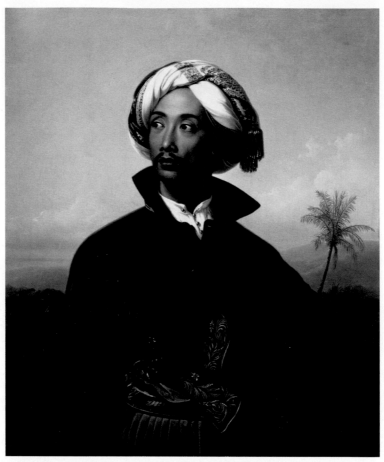

Portrait of Raden Saleh, by Johann Karl Bähr, 1841 (By kind permission of LNMA / Art Museum "Riga Bourse")

Raden Saleh, watercolor, 1847. As a boy, Raden Saleh hunted tigers in Java. (Kupferstich-Kabinett, Staatliche Kunstsammlungen Dresden, photo: Herbert Boswank)

Arab Horseman Attacked by a Lion, Raden Saleh, 1842 (Photo © Sotheby's)

Portrait of Raden Ayu Muning Kasari, attributed to Raden Saleh, ca. 1857 (Courtesy of Museum Oei Hong Djien, Magelang [Java])

Raden Saleh's "Blue Mosque," in Maxen, Saxony (Courtesy of Jutta Tronicke)

The Merry-Go-Round, Walter Spies, 1922. Spies's sister Daisy, a professional dancer, said that Walter danced as he painted the picture, to prove to her the affinity between their fields. (By kind permission of anonymous owner)

Four Young Balinese with Fighting Cocks, Walter Spies, 1929 (Hans Rhodius / John Stowell)

Animal Fable, Walter Spies, 1928 (Photo © Sotheby's)

Studies of spiders by Walter Spies, 1940
(© Naturalis Biodiversity Center, Leiden)

Portrait of Victor Segalen by Georges Daniel de Monfreid, 1909. The wood carving on the table, *Idol with a Pearl*, is one of Gauguin's earliest works in Tahiti, the seascape behind the sitter among his last. (© Jean Lepage; courtesy of Aude Pessey-Lux)

Victor Segalen's ship journal, with a watercolor of Bora-Bora, 1903 (Bibliothèque nationale de France)

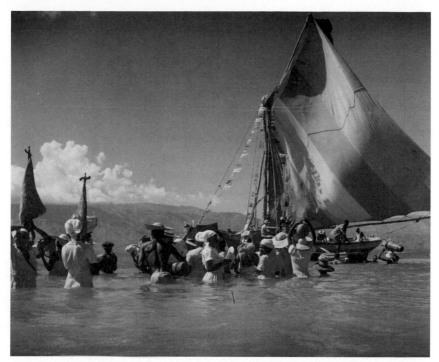

Ceremony for Agwé, Sovereign of the Seas, photograph by Maya Deren, 1949. This ritual, which was performed at Port-au-Prince bay, celebrates the wedding of Agwé to Erzulie, goddess of love. (By kind permission of Tavia Ito; photo courtesy of Howard Gotlieb Archival Research Center, Boston University)

Photograph of Maya Deren, by Alexander Hammid, ca. 1944 (By kind permission of Julia Hammid and Tino Hammid; photo courtesy of Martina Kudláček)

Emerante de Pradines Morse at her home in Port-au-Prince, 2014. "You could never tell exactly when Maya was possessed and when she wasn't. She might have been possessed all the time." (Courtesy of the author)

The author with military escort, on the road to Angkor, 1989 (Courtesy of the author)

Angkor Wat, Lunar New Year, 2013 (© Martin Westlake)

Lempad, who was charged with the design and execution of many of Ubud's principal royal buildings. Yet any objective analysis of twentieth-century Balinese art reveals a pronounced change after Spies's arrival—starting with the career of Lempad himself. When he was Lempad's neighbor, Spies gave him his first piece of paper to draw on, which would eventually become his preferred medium. The story is well attested: one day when Spies was visiting Lempad, a large procession passed by on its way to the cremation grounds. Spies ran out to the street to see what was going on, and when he returned, he made some sketches of the scene. Lempad asked to have a look and was intrigued by his new friend's use of paper. Spies gave him a sheet, and Lempad quickly knocked off some drawings of extraordinary beauty. Spies urged him to keep at it, but Lempad did not begin to draw seriously until the mid-1930s, when he produced hundreds of polished drawings of mythological scenes with a mordant, occasionally obscene satirical edge, which he sold to Spies's foreign guests for a good price, a lucrative new career in his seventies.

Spies's paintings of the forest landscape and its human inhabitants inspired local artists to look beyond the prescribed religious subjects. Classical Balinese painting was nearly monochromatic, black highlighted with vermilion, dark blue, and yellow ocher; the use of green pigment was unknown before Spies. John Darling wrote, "The debt to Spies of Anak Agung Gede Soberat and his cousin, Anak Agung Gede Meregeg, is clear and acknowledged. The suggestion of a new subject matter of landscape and daily life, the idea of perspective, and the introduction of modern materials were eagerly adopted by these young men."

The proof of these assertions is evident in the work, yet the notion that Western artists could have a beneficial effect on Indonesian artists became controversial in the postcolonial era. Indonesian and foreign scholars have either found indigenous antecedents for a stylistic innovation or discerned a corrupting influence in it. The most influential contemporary investigator into the Western myth of Bali and the impact of foreign visitors on the island is Adrian Vickers, a professor at the University of Sydney. His book *Bali: A Paradise Created*, first published in Australia in 1989, chronicles

the complicated relationship between Bali and the world from first contact to the tourist boom of the present day. Vickers's book is admirable in many ways—wide-ranging in historical erudition and often original in its analysis—but his assessment of Spies is strangely warped.

In Vickers's scenario, Spies and Bonnet came to Bali as proselytizers, to propagate the canons of Western art among the islanders, whom they viewed as primitive. Basing his theory on articles by Bonnet, which he does not quote, Vickers concludes, "The assumptions were always paternalistic: the West was already developed and artistically mature; Balinese culture was being helped by beneficent Westerners to go through the proper stages of development and maturity." Bonnet is the heavy, Spies guilty by association. Vickers concludes, "Spies probably did not share Bonnet's sense of paternalistic mission so enthusiastically, but he went along with it, and no doubt would have enjoyed the later romanticizing of himself as the 'father' of modern Balinese art. No matter that some of the Balinese artists being patronized were far more talented than either Bonnet or Spies."

Nothing in the record supports the suggestion that Spies would have enjoyed such a bogus distinction; on the contrary, he was by nature excessively self-effacing. Readers of Spies's letters will find many passages that directly contradict the assertion that he viewed Balinese art as inferior to Western art (which he habitually called *Dreck*, trash) or wished to Europeanize it. We recall his letter to Jaap Kunst explaining why he abandoned the publication of his gamelan scores: "What's the sense of printing unprovable pseudotruths that have just popped out of a European brain?" In a letter to his mother in 1938, Spies wrote, "I hope all will go well, and the Balinese will be sensible and not foolishly give way to European influence." Vickers supplants the colonial narrative of backward native artists in need of foreign guidance with what might be called the postcolonial narrative, in which arrogant, meddlesome Westerners sap the vitality of native artists, who are powerless to resist foreign influence. Vickers reveals his bias with the flat assertion that certain unnamed Balinese artists were more talented—indeed *far* more talented—than Spies. This statement is precisely

the sort of unprovable pseudotruth that Spies loathed about the European art world, which he rejoiced to find lacking in Bali.

A better informed and more judicious analysis of the impact of European artists on Bali is that in Bruce Granquist's recent history of the Batuan school of painting in Bali. Granquist points out that while Spies and Bonnet had an enormous influence on the island's artists by freeing them from the restrictive models of tradition and creating a lucrative market for their work, they

> did not after all travel to Bali as teachers; they were actually drawn to the island because of its vibrant artistic traditions. Each was actively painting during this period and each was looking for his own source of inspiration in this new tropical environment. Importantly, the style of their paintings altered significantly during their time on the island. There must have been much learning and exchange going on among both foreign and local artists, and the art they produced while working together was mutually strengthened through their association.

Adrian Vickers is far from alone in his effort to deflate Spies's reputation, tiny though it is outside Bali. A prolonged exposure to Walter Spies does make one sympathetic to the impulse to take him down a few pegs: his inexhaustible good humor and sometimes irrational optimism can become irritating. Yet the principal failure of the postcolonial narrative is not that it is unjust to the exote by predicating a motive of condescending paternalism solely on his origins (expatriates get used to that) but because it assumes that the host people lack an independent willpower. Vickers assumes that when foreigners came to impose their standards on the Balinese, the islanders docilely submitted to them. Yet the Balinese have proved time and again a rugged ability to preserve their old ways in the teeth of foreign occupation. A more plausible (and less insulting) interpretation, which is firmly supported by the record, is that artists such as Gelodog and Soberat saw Spies's work and were fascinated and inspired by it. Why would they not be? Painters living in an eternally verdant land such as Bali

who saw green pigment for the first time must have been excited by the possibilities it offered their work, without worrying over a theoretical implication of the inferiority of indigenous tradition. Once Lempad saw that finely textured Western drawing paper was the ideal ground for his ink drawings, his only concern was finding a good supply.

It is a universally received truth of art history that Picasso's discovery of African sculpture at the Palais du Trocadéro in 1907 was a turning point for modern art, reinvigorating the clapped-out European tradition with the primal vitality of tribal art. Can we not credit Balinese artists with experiencing the same excitement at the discovery of an alien artistic vision? Why assume that they imitated Spies's example in certain ways because of their innate, childlike suggestibility rather than by their own volition? Finally, who is being patronizing? The postcolonial narrative mooted by Vickers and others arises from a persistent prejudice about exote artists, that their migration to a new homeland betrays a lack of seriousness. If Spies had stayed in Germany and continued to paint phantasmagorical nighttime scenes of European village life, he probably would have maintained a respectable position in European art history, filed under the rubric of magic realism—precisely what did not interest him.

In some ways, a more interesting question than Spies's influence on the Balinese is Bali's influence on him. He absorbed some important art lessons, particularly in his experiments with multiple perspective, depicting a sequence of events simultaneously as vignettes, either stacked vertically or glimpsed amid a forest background—a standard Asian approach to composition familiar to anyone who has eaten off a Blue Willow plate. Yet the affect, the feeling of Spies's paintings from Bali is just as "German" as his work in Europe. By a process that might be described as cultural lamination, the artist fused his idealistic dream of the primeval forest, formed in Europe, with the palpable reality of the tropical jungle observed from life in Java and Bali, in much the same way that Raden Saleh viewed his homeland through Europeanized eyes. Miguel Covarrubias captured Spies's artistic vision in a single, just sentence: "He paints dreamlike landscapes in which

every branch and every leaf is carefully painted, done with the love of a Persian miniaturist, a Cranach, a Breughel, or a Douanier Rousseau."

The key word is "love." What Spies learned in Bali was how to live. Art was one activity of life among many; delighting in flowers and trees and talking to the Balinese were important too. His experiment in a purely aesthetic way of life brought him to the belief that the experience of beauty mattered more than the creation of beautiful things. This heresy at the height of the modernist era may be part of the solution to another Spies enigma, why such an interesting (at least) artist has been not undervalued or neglected so much as completely forgotten, except by a cult populated primarily by Western culture vultures who have spent time in Bali. To put it crudely, he is too Indonesian for the Germans yet not Indonesian enough for the Indonesians; and as a result no one else knows what to do with him.

There are some practical considerations, too. He was an undisciplined worker who rarely started a painting without a ready buyer except when he was in prison. A high proportion of his paintings have been lost, and virtually none of the surviving works are in public collections. Yet Spies's major disadvantage in the intellectual marketplace is that it's almost impossible to see all of him at once, to maintain a comprehensive view of him painting, making music, making films, building houses and museums, chasing butterflies and bees, digging up ruins, and all the other things he was doing more or less simultaneously. We honor the "Renaissance man" in theory, but modern exponents of the phenomenon are routinely dismissed as dabblers. Spies despised the very notion of a career: the main reason he is not a "famous artist" may be that he never sought to become one.

Spies invites the charge of dilettantism, but he was serious about everything he undertook. He was an "enthusiast," a word that is now ordinarily used to describe a hobbyist or fanatic, but the word has a deep inner life. In his essay on Winckelmann, Walter Pater argued that Winckelmann's enthusiasm was what propelled his genius: "He multiplied his intellectual force by detaching from it all flaccid interests. . . . Nothing was to enter into his life

unpenetrated by its central enthusiasm." Pater was as alert as Winckelmann to the etymology of "enthusiasm": from the Greek, naturally, its root meaning is "possessed by divinity." A god enters the enthusiast, a concept as Balinese as it is Greek. Pater describes Winckelmann in terms that are perfectly apt to Walter Spies: "This enthusiasm, dependent as it is to a great degree on bodily temperament, has a power of re-enforcing the purer emotions of the intellect with an almost physical excitement."

To the end of his life, Spies approached his work as an amateur, another word that has lost its mojo. He wanted to learn, not to teach. It would not have bothered him in the least to be called a minor artist: he had detached himself from all flaccid interests. In the twenty-first century, the tyranny of the canon, the continual threshing out of the great from the less than great, has declined not only among renegades who are interested in art for its own sake, as opposed to the data it offers the spinners of theories, but also among academics, who have come to accept the value of outliers, those left behind by the modernist master theory that art is forever being lifted into a glorious future by visionary heroes such as Gauguin and Picasso.

One of the usual yardsticks of greatness in art has always been influence on subsequent generations. Thus Spies's European paintings add luster to the greatness of Rousseau and Chagall and detract from his own, by casting him as an artist receiving rather than exerting influence. It might be argued that no other transcultural artist has had a greater impact on the new homeland than Spies did on Bali. By way of comparison, Gauguin left nothing behind him in Polynesia except children, and Raden Saleh was almost forgotten in Europe by the time of his death. Yet Spies's most enduring legacy, his formative influence on the tourist industry in Bali, was something that he came to regret bitterly by the end of his life. It was entirely incidental to what he set out to do, which was something that no one else had tried before, quite: something very like dissolving the classical boundary between art and life and merging them into a joyous whole.

The Empire of the Self

There is no ease in royal affairs, we have no comfort.
Our sorrow is bitter, but we would not return to our country.
—Ezra Pound, "Song of the Bowmen of Shu"
(after King Wen of Zhou, ca. 1100 B.C.)

In 1905, Victor Segalen returned home from his twenty-eight-month voyage around the world. After the *Durance* passed quarantine, he went directly to Paris and commenced a formal courtship of Yvonne Hébert, the daughter of a doctor from Brest. It was an odd engagement: Segalen had plainly stated on many occasions that he had no intention of marrying, and no sooner were the *fiançailles* announced than "a certain anxiety about his conjugal vocation brought on a nervous depression," in Henry Bouillier's delicate phrase. It was Segalen's second debilitating attack of nerves; in 1900, he had suffered a serious bout of neurasthenic depression. His fiancée allayed his fears, and the wedding, complete with a Catholic Mass, was celebrated on June 3. It must have been a full recovery: ten months later his son Yvon was born, the first of three children.

After his marriage, Segalen returned full-time to the literary life he had begun before his voyage, principally the completion of the manuscript of *Les immémoriaux*. He borrowed a thousand francs from his parents to pay the printer and for obscure reasons published the book under the pseudonym Max-Anély. Segalen had

high hopes that it would establish him as a writer of repute. He entered it for the Prix Goncourt and made the customary calls on the members of the Académie Goncourt, but it is difficult to believe that his eccentric, didactic book was ever in the running.

Segalen published a series of essays based on his voyage in the *Mercure de France*, including "Gauguin in His Final Décor." He went to Paris to meet Isabelle Rimbaud, the poet's sister, and a few months later published "The Double Rimbaud." After an emotional visit to the Gustave Moreau Museum, Segalen wrote a study of the painter, who had been extolled in *À rebours* (translated as *Against the Grain* and *Against Nature*), the quintessential Decadent novel, by Joris-Karl Huysmans. Huysmans was Segalen's first literary hero and one of the principal subjects of his thesis at the naval medical academy in Bordeaux, about depictions of nervous disorders in French literature after *Madame Bovary*—an unorthodox subject, to say the least.

À rebours is a nearly plotless series of tableaux from the life of Des Esseintes, a hypersensitive aesthete afflicted by terminal splenetic boredom who seeks distraction in a series of exquisitely perverse pastimes. A Faust of the senses, he cultivates a garden of poisonous plants, experiments in exotic perfumery, encrusts the carapace of his pet tortoise with rare gems, and finds fleeting sexual diversion with mannish women and girlish boys. Des Esseintes owns Moreau's painting of Salome and spends every night in rapt contemplation of its "symbolic incarnation of undying Lust, the Goddess of immortal Hysteria, the accursed Beauty exalted above all other beauties." *À rebours* is the book that Dorian Gray read, in which "the sins of the world were passing in dumb show before him."

When Segalen met Huysmans, he revealed his passionate admiration of the music of Debussy, particularly his opera *Pélleas et Mélisande*, and appealed to Huysmans to arrange a meeting with the composer. Huysmans replied that there was no need of an introduction. He advised Segalen simply to turn up on the composer's doorstep, and that's just what he did. Debussy gave Segalen a warm welcome and invited him to return the next day. In the morning, the two talked at length about Maori music; at

the composer's urging, Segalen wrote a long article on the subject with many musical examples, which was published in the journal *Le Mercure Musical*, through the composer's influence. Segalen, always more ambitious than he let on, presented Debussy with pages from a libretto he was writing about the life of the Buddha, which he had begun in Colombo when the *Durance* made a prolonged port call there.

The composer turned it down flat, saying that he could not conceive of any music "capable of penetrating this abyss," that he had no intention of attempting the impossible and indeed "the very idea frightens me." However, in the same letter he proposed that Segalen write a libretto based on the legend of Orpheus. Debussy's main motive, it seemed, was a desire to surpass Gluck's *Orfeo ed Euridice*, which he derided as "anecdotal and weepy." Segalen took the hint and wrote a first draft that Debussy liked well enough to encourage a revision. *Orpheus the King* eventually went through three drafts, the last one a few months before the author's death. Debussy ought to have given Segalen the same warning he gave Giulio Gatti-Casazza, the director of the Metropolitan Opera, when he negotiated a contract with the Met to compose an opera based on Poe's "Fall of the House of Usher" at the same time he was committed to Segalen: "I am a lazy composer [who] requires weeks to decide on one harmonious chord over another." At his death, Debussy left some gorgeous fragments of the Poe opera and not one note of *Orpheus*.

As Segalen reached the end of the material he had gathered on his voyage, he cast about for a more substantial subject. He made a good start, nearly thirty thousand words long, on a polemical novel about Gauguin in Polynesia, *Le Maître-du-Jouir* (Master of Joy), which was primarily a vehicle for Segalen to vent his hatred of Christianity. After the *Mercure de France* ran a broadside advocating the prohibition of the opium trade, Segalen composed a stirring defense of the drug, which he had smoked since he was a medical student in Bordeaux. In 1906, he was living with his in-laws in Brest and teaching at a shipboard school for naval apprentices, with a growing conviction that he was meant for better things. Whether he realized it or not, the emergent theorist of

exoticism was himself experiencing the first symptom of the exote, the inability to focus one's thoughts homeward when at home.

In May 1908, Segalen returned to Paris and took up residence on the rue de Rome, a few blocks from the tiny apartment where Stéphane Mallarmé had ruled literary Paris like a pasha until his death ten years before. Segalen had decided on the destination for his next overseas voyage: he enrolled in two intensive courses in the Chinese language. Little survives in the record to explain the choice, though it was hardly surprising for a rising young Orientalist seeking to make his name. Then as now China was the intellectual dragon of the East, and the mastery of its language the supreme challenge for Westerners.

Segalen's first exposure to the Chinese world had been in San Francisco, in 1902, at the conclusion of his train journey across the United States en route to Polynesia. His original plan had been to embark on the *Durance* in San Francisco, but upon his arrival he fell sick with typhoid and was hospitalized for three months, causing him to miss the boat. As his daughter later observed, if he had not fallen ill in San Francisco he might well have arrived in Tahiti in time to meet Gauguin in the painter's final days. However, the delay had two happy outcomes. After his release from the hospital, he had a fling with "a little Jewess of eighteen years, mixed with Mexican parentage and a touch of German. The result of this improbable cross-breeding was purely exquisite."

The monthlong wait for the next Tahiti-bound ship also gave him an opportunity to explore San Francisco, which he found delightfully picturesque, particularly Chinatown. There, he wrote to his parents, he mingled with "twenty-six thousand industrious, authentic Chinese people." He attended the Chinese opera and browsed shops that purveyed "absolutely authentic bibelots, because they were not destined for the Americans but on sale to the Celestials [Chinese people]." His most precious discovery was "an inlaid slate cup in which the Chinese scholar mixes his ink, a brush mounted in bamboo, and—joy!—extraordinary letter paper, light and silky." It was a pointed omen of his future fascination with Chinese calligraphy and fine papers.

Segalen's progress in the Chinese language was phenomenal: in

March 1909, less than a year after he had commenced his studies, he passed the examination required for a posting in China to perfect his skills. He had hatched a plan with a new friend, Auguste Gilbert de Voisins, to mount an expedition into remote parts of China in search of relics of the country's primordial civilization. In April, he embarked on the ship *Sydney* in Marseilles, bound for Tientsin (modern Tianjin), the port city of Peking. He traveled alone; his wife and their son would join him later. In his passage through the Gulf of Aden, Segalen's thoughts returned to Rimbaud, matrix of the modern exote, "a perpetual image who returns from time to time to dog my steps." He started a second essay about the poet, which he destroyed.

Soon after he arrived in China, he set off on his first expedition with Voisins, a long trek by foot, horseback, and riverboat through the country's interior. They traversed the western provinces almost to the border of Tibet, then descended the Yangtze River from Szechuan to Shanghai, visiting places that were less traveled by foreigners in 1909 than equatorial Africa. Voisins was rich and free with his money, and set them up in grand style. The two aesthetes traveled with six horses, eleven mules, a donkey, and enough servants to staff a grand château, including a steward, interpreter, cook, five muleteers, two grooms, and two "boys" (Segalen's English word) charged with setting up the tables, beds, and rugs at the encampments. In the evenings, Segalen filled notebooks and wrote long, detailed letters to his wife, suffused with wonderment at his immersion in the Chinese Other, an experience more concentrated than that previously offered by Tahiti.

In a letter to Yvonne from Peking, he wrote with the bravado of a literary conquistador: "I am fortunate that China, an immense land, is intact in French letters, for Loti scarcely touched it in *The Last Days of Peking*." With his growing mastery of the language, Segalen accomplished his transformation into the complete exote. He was grooming himself to take over the role of France's premier interpreter of the East from the contemptible Loti (who, inexplicably, had been admitted to the French Academy). In Peking, Segalen made the acquaintance of a more distinguished rival, Paul Claudel, whose collection of dreamy prose poems *Knowing*

the East (*Connaissance de l'Est*), published in 1900, would later be a model for Segalen. Claudel served as the French consul and thus might prove to be useful to Segalen and Voisins on their next expedition. After he met Claudel, Segalen noted his astonishment (which might have covered a secret satisfaction) that the great man spoke Chinese not at all.

Segalen found Peking very much to his liking. He spent as little time as possible with the city's French residents in order to accelerate the *transformation décivilisatrice*, to strip away the cultural imprint of the home country. While he waited for his wife and son to arrive, he undertook a brisk tour of Japan with Voisins, visiting Nagasaki, Kobe, Osaka, Kyoto, and Tokyo; yet after just eight months' residence in China, Segalen had become a confirmed sinophile. Japan seemed to him but a pale imitation of the Middle Kingdom. Their tour ended in Hong Kong in February 1910, where they met the ship bringing Madame Segalen and little Yvon and escorted them to the capital.

Peking at that time was a gilded mansion on the verge of collapse, its timbers rotten and consumed from within by voracious mites. It was a precarious moment: the Kuang Hsu emperor had died of poisoning two years before, after a decadelong confinement in a tiny palace in the middle of a lake just outside the walls of the Forbidden City. It was widely believed that his murder had been ordered by his aunt, the empress dowager Tz'u Hsi, who had effectively ruled the empire since 1861, after the death of her husband the Hsien-feng emperor. Tz'u Hsi herself died the day after the Kuang Hsu emperor. Now the emperor was a four-year-old boy, Pu'yi, whose father, the regent prince Chun, governed in his name. In fact, the Chinese Empire in its final decadence was a kleptocracy run by corrupt eunuchs who raked in gold from the foreign capitalists who were looting the country with riotous abandon. Two years later, the rot finally won out: the Republic of China was proclaimed, Pu'yi "abdicated," and four thousand years of imperial rule in China sputtered to an end.

Less than a year after his arrival in Peking, Segalen received the highest honor that could be accorded a foreign resident: he was granted an audience with the emperor, Son of Heaven, in the com-

pany of a French delegation. Yet the real high point of Segalen's Peking sojourn came a few months later, when he met Maurice Roy, the nineteen-year-old son of the French director of postal services in the capital. A native of the city, Roy spoke Chinese and the Pekingese dialect perfectly. Segalen hired him as his tutor, and the two became fast friends, as the much younger teacher told his pupil about his amazing life at the imperial court. Roy confided that his career as a language tutor was only a cover for his high position in the city's secret police, a post that enabled him to travel at will into the deepest recesses of the Forbidden City.

The revelations became ever more intimate, perfectly calculated to stoke Segalen's interest. When he met young Roy, he was working on a novel based on the life of the Kuang Hsu emperor, to be called *Son of Heaven* (*Le fils du ciel*), which told the story in a series of imperial edicts, composed in the stilted, ornate language of the court. Segalen was panting for the sort of inside information that the postmaster's son was peddling. Roy told him that he had first gained admission to the palace as a member of a troupe of actors hired to entertain the empress. After he met the emperor, the two became close friends and played games together. Roy claimed that he once saved the emperor's life by rescuing him after he fell into a cistern. Segalen, excited by Roy's exploits, kept a journal devoted to him called the *Secret Annals According to M.R.* As Henry Bouillier wrote, Segalen had found "a witness to the secret, bloody history of the last days of the last dynasty. He was talking with a man, a European, who at his leisure penetrated the Forbidden City, the 'Within,' the heart of China and the world."

Roy was Scheherazade as a striptease artist, who removed another veil of mystery from his story with each nocturnal meeting. Segalen, trapped in a proof of Zeno's paradox, found himself getting closer and closer to the heart of the matter but never quite arriving; there was always another veil blocking the way. Three months after they met, Roy revealed his most sensational secret yet: he told Segalen that he was the lover of the empress dowager, the widow of his friend the martyred Kuang Hsu emperor. Moreover, the regent had assigned a concubine to him, an honor unheard of for a foreigner (much less one in his teens). Roy said that

he had infiltrated the enemies of the dynasty and foiled plots against the throne, and tried to get Segalen to join him in a speculative venture to sell guns to the imperial army.

Segalen naturally had his doubts about this story, but Roy provided so many precise, verifiable details to support it that Segalen, despite himself, eventually came to believe in its essential veracity. One of the most incredible aspects of Roy's tale was how he met the emperor: How could an adolescent actor, a foreigner, become the intimate friend of the Son of Heaven? In the *Secret Annals*, Segalen debates with himself about how the youth had ingratiated himself into the favor of the palace and arrives at an alternative theory, which Roy would have had every reason to keep to himself:

> Then how? By providing him with women (not Chinese, Tartar)? Banal. European women? (There would have been one present in the palace then.) Or by surrendering himself to the emperor for "Greek games"? This is most likely. Maurice Roy is handsome, slender, very young. Dark eyes full of velvet. . . . It is likely that his entrée to the palace (where not even princes may enter unless they are summoned) was made by means of these games. . . . Now, what is he, exactly? Oh, the meanness of labels like those in Krafft-Ebing! He is young and has a pretty face. He already spoke Chinese well and doesn't like women. Does he play the same "games" with the eunuchs, yes or no? They would have initiated him and then brought him to the emperor. It certainly seems true that it's all very familiar to him.

It is a provocative scenario, which harmonizes with other accounts of life in the capital at the end of the Ch'ing dynasty. When Segalen says that the homosexual explanation is most likely, we may take it as his considered judgment, not a prurient daydream. Nothing in the record indicates that Segalen himself took part in "Greek games," though "dark eyes full of velvet" and the repeated references to Roy's youth and good looks suggest interest in the subject. It might be worthwhile to push his theory a step

further and speculate whether Roy's claim to being the lover of the empress dowager might not have been an encrypted reference to a sexual relationship with the emperor himself, a juvenile boast to an elder compatriot that he had an imperial lover, yet which concealed his homosexual inclination. It was fifteen years after the trials of Oscar Wilde: his conviction and harsh sentence had had a chilling, even terrifying effect on homosexuals in Europe, particularly in France and Germany, where investigations of the Uranian underground were also under way. The ensuing panic would have rippled out to the expatriate community in Peking.

Segalen's doubts about Roy's story rose with every new revelation. He never caught him in an out-and-out lie; he uncovered a few stretchers, but they were all minor points. In the *Secret Annals*, Segalen frequently agonizes about his informant's veracity, but the proof either way eluded his grasp. He could not bear to let go of the possibility that Roy was telling the truth, and as much as he fretted over it, one suspects that he enjoyed the tormenting ambiguity.

Segalen revised but never published *Son of Heaven*. The novel was ingeniously conceived but severely constricted in tone by the cumbersome device of casting the story in the form of imperial decrees. In 1913, he set it aside for a few months and confected a novel based on the exploits of Maurice Roy. *René Leys* was Segalen's best book, anyway the one in which readers who have not studied Chinese language and history will find the most pleasure and lasting intellectual stimulation. Mystery stories based not on the question "Who did it?" but "What happened?" would become a staple of modernism, yet at the time Segalen wrote *René Leys*, it was a radically innovative concept: a story that invites the reader to cultivate disbelief, not to suspend it.

In 1910, Segalen had written some scattered notes for a projected essay to be called "On a New Form for the Novel." Within days after he met Maurice Roy, he condensed his thoughts on the subject to this vitriolic essence: "The hateful character in every novel: the Author. It is he who knows so many improbable things

and retails them shamelessly. It is he whom one senses everywhere but who rarely has the courage to make an appearance." The diatribe concludes, "The impersonal author is a creature that ought to be killed."

In *René Leys*, Segalen set himself the task of writing a book without an author. He formally kills himself off before the curtain rises, in the book's dedication: "À sa mémoire / V.S." He solves the problem of authorial presence by composing his story in the form of a journal, an artifice that covers many faults: if there are inconsistencies in the story or inaccuracies in its picture of life in Peking, they are attributable to the foibles of the journal keeper. He is called Victor Segalen, though the name is mentioned just once; however, he is obviously not the navy doctor who wrote *Les immémoriaux* but rather a doppelgänger like the one Segalen imagined in "The Double Rimbaud."

Rimbaud himself had coined the gnomic motto "*Je* est un autre": "*I* is someone else," which is almost a plot synopsis of *René Leys*. The novel has a bit of ironic fun with the naïveté about Chinese culture of its shadow Segalen, marking a clean distinction with the living Segalen, a well-informed exote. For example, at one point the journal keeper mentions a traditional Chinese remedy that consists of "needles stuck in all over the place." The novel's Segalen rambles and repeats himself, like a lost, lonely flâneur. It is a transparent literary device; every reader will be aware that the *I* of the journal is the late V.S.—not only in the sense that the living Victor Segalen prepared the text for the typesetter but also in that the book is closely based on real events in his own life.

Another clue about the book's composition comes in the postscript, after the final curtain falls: "Written in Peking from November 1, 1913, until January 31, 1914." *René Leys* is barely a full-length novel, just over two hundred pages in translation, but even so, three months is remarkably fast writing. The explanation is simple: Segalen closely followed the *Secret Annals According to M.R.* He imported many phrases and whole scenes intact and made relatively few alterations to the "plot." He makes René Leys Belgian and his father a grocer, and introduces a few minor char-

acters, notably a prying neighbor, Jarignoux, who calls on the narrator several times to warn him of René's immoral behavior in the city's brothels. The novel's Segalen is a bachelor who is considering marriage with a Chinese woman, whereas in life Segalen's second child, his daughter, Annie, was born two months before he sat down to write the book.

The basic story imitates life closely: A literary Frenchman with an obscure official post sets up housekeeping in Peking, where he plans to write a novel based on the life of the recently deceased Kuang Hsu emperor. He becomes obsessed by a desire to penetrate the heart of the imperial palace and learn its secrets, but he runs into one blind alley after another. He hires as his Chinese tutor a European youth who seems to have firsthand knowledge of the most intimate details of life in the Forbidden City. After much obfuscation, the mysterious young man finally reveals that he was a constant companion to the emperor in his confinement, and after the emperor's death he became the lover of his widow, the empress dowager. Crucially, neither the author of *René Leys* nor the novel's narrator is able to verify or disprove the accuracy of his informant's account of events. The most significant departure from Maurice Roy's story comes in the book's ending: René Leys is poisoned and dies, whereas Roy survived the fall of the Manchu dynasty to lead a pedestrian middle-class existence. (The journal keeper's description of Leys's body in death again suggests a possible interest in Greek games: "So much strength couched in such suppleness! The perfection of symmetrical elegance. Tracing the line of his hips and thighs I could see the secret of his grip on that wild horse of his.")

René Leys inverts the detective genre by having the murder occur at the end rather than the beginning of the book. Segalen facetiously toyed with the idea of calling his novel "The Mystery of the Violet Room," in homage to Gaston Leroux's *Mystery of the Yellow Room*, a novel about an apparently insoluble murder in a locked room, which was a bestseller in 1907. Elements of the detective genre, as popular in France as it was in Britain and America, are present throughout the book in mostly superficial ways, with hidden passageways and disguises, including a scene in which slim,

handsome René Leys, with his velvety dark eyes, impersonates a Manchu princess. The menacing urban setting anticipates American noir in significant ways: most of the action takes place at night, with scenes set in unlit alleys and disreputable dives.

It is not quite accurate to say that *René Leys* has no plot; it certainly has plenty of action, even if much of it is told secondhand. The structure is vortical, a turbid cloud of clues and images that whirl round and round in a diminishing spiral until the story is finally sucked into extinction by the death of its focal point. Everything is ambiguous. In the final, ellipsis-ridden entry of his journal, "Victor Segalen" consigns the secret world he discovered through René Leys to the realm of information, in contradistinction to experience: "There remain those inexplicable moments . . . glimpses, flashes . . . insights, words no one could have made up, things no one could have fabricated . . . All his confidences really did inhabit an essential Palace built upon the most magnificent foundations . . . And the sets he conjured up . . . and that teeming ceremonial and secret Pekingese life that no truth as officially known will ever begin to suspect. . . ."

On the novel's first page, the narrator writes, "I must close, having only just opened it, this journal of which I had hoped to make a book. The book, too, will never be. (But failing the book, what a splendid posthumous title—*The Book That Never Was!*)." The text makes repeated allusion to the nonexistence of the book that the reader holds in his hands. Before Leys's death, as the narrator's doubts multiply and overwhelm his comprehension, he counsels himself, "I tell myself one should not be afraid of the miraculous side of the whole adventure. One should not turn one's back on the mysterious and the unknown. The rare moments in which the myth consents to take one by the throat."

René Leys is a milestone in the history of the European novel that never was. The decade bracketed by the composition of *René Leys*, which was begun in 1913, and the novel's publication in 1922, three years after Segalen's death, delimits the rise of modernism, from *Swann's Way* to *Ulysses*. The modernist novel that *René Leys* resembles most closely is *The Castle*: both chronicle a futile attempt to breach a grand, forbidding institution, the seat

of earthly power, which aspires to heaven. Throughout Kafka's novel, K., the land surveyor, attempts to enter the castle that towers over the village; the journal keeper in *René Leys* is possessed by the desire to gain access to the secret life of the Forbidden City. The two novels have a similar circular structure (though it is risky to assess the construction of *The Castle*, which Kafka left disordered and unfinished at his death). Both books have a somber overall tone, which is lightened by ironic humor at the expense of the quixotic quester.

If Max Brod, Kafka's friend and editor, had obeyed the writer's dying command to burn his manuscripts, and Victor Segalen had had a keen posthumous advocate like Brod, then students of modern literature might well be required to read *René Leys* and Kafka would be a nobody. It is an idle thought-experiment; the exotic setting and complicated historical background of Segalen's novel must have deterred many readers and critics in an era that still regarded China as fundamentally incomprehensible. *René Leys* remained almost unknown until modernism was already in decline, but we may still identify it as a pioneering work of the movement.

Borges, in his ingenious short essay "Kafka and His Precursors," could have included Segalen with Zeno, Kierkegaard, and the others on his list; indeed he could well have named Segalen as one of his own precursors. Borges did know Segalen's work at some point in his life, or so it would seem: in an undated, sketchily attributed, but altogether characteristic anecdote, Borges is quoted as scolding the French: "Don't they know that in Victor Segalen they have one of the most intelligent writers of our age, perhaps the only one to have made a fresh synthesis of Western and Eastern aesthetics and philosophy?" Taking the tone of a banner on a Broadway marquee, he added, "Do not live another month before you have read the entire oeuvre. You can read Segalen in less than a month, but it might take you the rest of your life to begin to understand him."

Among many puzzles associated with *René Leys*, none is more teasing than that posed by *Décadence Mandchoue*, the purported

memoir of the scandalous Edmund Backhouse, which offers striking parallels to Segalen's novel. Born in 1873 to a wealthy banking family, son of a baronet, Backhouse attended Oxford, where he had a nervous breakdown and left without a degree. Unable to pay a debt of twenty-three thousand pounds to a jeweler in Oxford, he declared bankruptcy in 1895 and fled to Peking. There he achieved a mastery of the Chinese language that was said to be unequaled by any other foreigner. He attained a high position of trust in both the British legation and the imperial palace. In 1910, Backhouse published *China Under the Empress Dowager*, a history of the empire in the era of Tz'u Hsi, co-authored with John Otway Percy Bland. The authors claimed that the book was based on the secret diary of a Manchu scholar and relative of the empress that later proved to be a forgery. Backhouse and Bland's book was the first popular history of the Ch'ing dynasty in decline and created Tz'u Hsi's reputation as a ruthless dragon lady, which has been discredited by recent scholars.

After the fall of the empire, Backhouse hatched a series of embezzlement schemes, including the sale of phantom battleships to the new republic and a fraudulent contract to print Chinese paper money in New York, in which he forged the signature of the prime minister. He remained in Peking, living the life of a hermit (as he said himself) until his death, in 1944. In Backhouse's final, impoverished years, a Swiss doctor named Reinhard Hoeppli befriended him. Hoeppli wrote that Backhouse had a profound aversion to any contact with foreigners: he would "turn around when, walking on the city wall, he saw a foreigner coming towards him, and cover his face with a handkerchief when passing a foreigner in a rickshaw." Fascinated by the old man's life story, Hoeppli commissioned him to write his autobiography. *Décadence Mandchoue*, narrating Backhouse's life in China, is the memoir of a remarkably lecherous man, which tells all, and a great deal more.

The long first chapter describes Backhouse's visit in 1898 to an elegant male brothel called, with a peculiarly Chinese irony, the Hall of Chaste Joys. The proprietor gives him a tour of the premises and explains the menu to him, running down the services on offer, with prices. He introduces Backhouse to the talent, adoles-

Edmund Backhouse in Peking, circa 1943

cent actors from the Peking opera, all of them extraordinarily handsome, like every Chinese male the author meets. The youths are presented as sexless dolls, powdered and rouged, but there is one, named Cassia Flower, "whose lovely face was innocent of cosmetics; eyes of a rare luster and an angelic smile like a cherub of Murillo, delicate tapering fingers and a slender well-knit frame, a mouth that Saint Simon's Duc de Bourgogne—'*la plus belle bouche du monde*' [the most beautiful mouth in the world]—might not have disdained, teeth whiter than ivory," and so forth, celebrating the perfection of every feature.

In Backhouse's lustful eyes, Cassia Flower was Cupid, as beautiful as the morning star or Hadrian's favorite, Antinous, transformed by the same process of idealization that inspired F. W. Murnau to see Poseidon in a fisherman from Bora-Bora. Over a light supper to fortify themselves for Greek games, "not without wines and liqueurs," Backhouse asked him "which feature in the love congress" most inflamed him with desire. First Cassia Flower mentions *pedicatio ascendante*, rising or mounted buggery, in other words with the participant being penetrated on top, sitting astride, and after that

> " 'cinnamon leaves,' by the long application of my lips *au fondement et aux parties adjacentes de mon amant* [to the anus and adjacent parts of my lover], because a perfect affinity is thus established, exalting both giver and receiver to heaven. The perfection of line gives to me a rapture like that derived from a work of art; the labial contact excites my inmost being; my lips are never sated of caresses. When I am the recipient, the gratification is more sensual but less aesthetic. Uncleanness forsooth! As if the fairest portion of the male body could be unclean. You must curb your *Yang* proclivities for tonight and let your *Yin* element be in the ascendant; so that we two can achieve an ideal union. And their four lips becoming one," said Cassia, suiting action to the word; "because I know that in your brimming veins run longings like mine own, but tonight you must let me begin, continue, and end each act in our love comedy."

Backhouse's blissful description of their love congress is minutely detailed, with obscure anatomical terminology and classical allusions in lavish excess. He brings bravura to the art of overwriting, never settling for a good English word if a Latin periphrasis or archaic French can be made to serve. To evoke the timeless, radiant splendor of his night of paid sex, Backhouse quotes Homer, Sophocles, Euripides, Horace, Ovid, Virgil, the King James Bible, Michelangelo, Shakespeare, Dryden, Herrick, Swinburne, and D'Annunzio, as well as the *Dream of the Red Chamber* and other classics of Chinese literature, all in their original languages, with only the Chinese passages translated. His diction is exquisitely nuanced and every quotation is perfectly apt, but the effect is not erudite so much as demented.

After this outrageous opening, Backhouse varies the sexual episodes with scenes that demonstrate his intimate knowledge of political intrigues in the Forbidden City. In chapter 4, he makes his most spectacular revelation. He writes that he was commanded by the empress dowager Tz'u Hsi, whom he had just met, to call on her at the Summer Palace that evening on important business. "Guessing what the 'important business' might be, I asked myself: Was I sexually adequate for Her Majesty's overflowing carnality?" When he arrived at the palace he was met by the chief eunuch, who instructed him in protocol and gave him an aphrodisiac to ensure that he would be up to the task. The eunuch confided that the Old Buddha, as she was called, took particular delight in taking the active role in anal intercourse, which she accomplished with her prodigiously large clitoris. Backhouse records many subsequent amorous encounters with the empress dowager, which continued until her death in 1908, at the age of seventy-three, with no apparent abatement in her appetite.

Now, what is the reader to make of *Décadence Mandchoue?* In a foreword, the author swears a solemn vow "that the studies I have endeavored to write for Dr. Hoeppli contain nothing but the truth, the whole truth, and the absolute truth." He repeats this juvenile-sounding oath several times in the course of the book, which has the usual effect on the reader's credulity—to diminish it. Backhouse makes it clear that he has no interest in verisimilitude.

He does not expect the reader to believe that an adolescent Chinese rent boy sprinkles his conversation with Latin and French phrases and archaic words like "forsooth." Cassia Flower speaks in the author's voice: Backhouse is talking to himself. He plays a taunting ironic game with the reader, sometimes describing phenomena that are impossible prima facie, as here: "I don't know what the explanation may be, but the catamites said that *des écoulements visqueux mensuels ou bimensuels* [viscous monthly or bimonthly flows] from their fundaments were their MENSES!!" A story about a young couple who are struck by lightning while making love on a picnic with Backhouse and the Old Buddha reads like a Renaissance romance, which commences, "Life is sad and so is this narration."

Hoeppli's account of meeting Backhouse begins with an intriguing anecdote. The first time he saw him, before they were introduced, he passed Backhouse while riding in a rickshaw. The old man was walking on the side of the road, dressed in an ankle-length robe and a skullcap set with a large red jewel. As Hoeppli drove by, his rickshaw puller, without being prompted, told him that they "were in the presence of greatness." The man they had passed, the rickshaw puller said, was Sir Edmund Backhouse, rumored to have been the lover of the late ruler of all China, the empress dowager Tz'u Hsi. Hoeppli attached a great deal of importance to this incident, and it is easy to understand why. It is far from being corroborative evidence, but the improbability of the rickshaw puller's testimony enhances his credibility: If he was going to invent a colorful story to impress a foreign fare, what were the chances he would come up with that? Backhouse's account of his date with Cassia Flower is delirious pornography, but it conforms closely to contemporary descriptions of boy bordellos in Peking and has the ring of an eyewitness account.

Hoeppli noted the parallels between *Décadence Mandchoue* and *René Leys*, stories in which a young European, a skilled linguist who deals in arms with the palace, becomes the lover of the empress dowager (albeit different empresses dowager). A more interesting similarity is that of tone, in the interpretive challenges the

books pose. *Décadence Mandchoue* puts the reader in the position of both Victor Segalens, the living one who hears Maurice Roy's narrative and the fictional one obsessed with ascertaining the veracity of René Leys's story. The unreliable narrator is a venerable device of fiction, but before Segalen it was in the hands of a reliable author, whom the reader could trust to know what was really going on in the imaginary world; Segalen polishes the irony to a higher gloss in his novel by assassinating that hateful character, the author.

However, an unreliable narrator in a memoir is a poison dart. The issue is not simply whether Backhouse is telling the truth but his own attitude toward the tale he is telling and thus toward the reader. His intensely serious tone might be read as an elaborate hoax, a sort of self-forgery in the language of rococo bathos, which exalts the carnal to a sublime spiritual plane while the author giggles up his sleeve at the reader's consternation. On the other hand, if Backhouse is as innocent as he presents himself, oblivious to the dissonance between the commonplace nature of his compulsive pursuit of sex and the lofty tropes he uses to describe it—if he really believes that Cassia Flower is a modern Antinous, unaware of the irony that the boy with the angelic smile is his own creation, just as the cultic Antinous was Hadrian's, then his book is a raunchy grand opera of camp. Consider number 23 in Susan Sontag's "Notes on 'Camp'": "In naïve, or pure, Camp, the essential element is seriousness, a seriousness that fails. Of course, not all seriousness that fails can be redeemed as Camp. Only that which has the proper mixture of the exaggerated, the fantastic, the passionate, and the naïve." In this reading, Backhouse's distraught narrator is a lonely ghost lamenting the loss of his powers.

Expressing shock at the total transformation of China's coastal cities in the twenty-first century is a cliché, but that does not allay the actual shock experienced by a traveler returning there after a long absence. My first visit to Beijing was in 1988. The democracy movement that culminated in a calamitous showdown in

Tiananmen Square a year later was invisible to my eyes, but as Victor Segalen understood, foreigners never know what's going on in China. The trip was on me, so I stayed at the Friendship Hotel. The name is a classic Orwellism that translates as "cheap." The hotel had a staff of thousands, it seemed, but few of them took an interest in helping the guests. When I complained that a lightbulb in my room (one of two) had burned out, the under-assistant day-shift floor manager told me that she would request a replacement, but if I wanted it today, I could buy a lightbulb myself at a shop down the street. The city was bleak and quiet, not decrepit like Hanoi, but the feeling was the same. You could walk around Beijing all you wanted, but there was little to see except the high walls that enclosed the life of the city.

On my second visit to Beijing, in 1997, change was stirring. I went there to interview a rising novelist for *The New Yorker*, so I stayed at the Shangri-La, one of the city's new luxury hotels. My subject came there to meet me in a stretch limousine like the ones American high-school kids rent for the prom. In the backseat with him were two leggy, fragrant young women wearing long ermine coats and, I gathered, nothing underneath them. We dined at a restaurant with a Cultural Revolution theme. Our rustic pavilion was painted with slogans, and the waiters wore ragged Red Guard uniforms with multiple Mao badges. The menu featured boiled nettles for guests who wanted to get into the spirit; we ate steaks. On the way back to the hotel, the rising novelist invited me to choose one of the prostitutes to bring back to my room, promising to arrange everything at the desk. The tactful way out of the situation, I thought, was to tell him that the magazine did not permit me to accept such a gift.

On my first visit to Beijing, I made the pilgrimage to Tiananmen Square, the parade ground where Mao organized mass demonstrations to acclaim the glory of his revolution. After a brisk march past his remains, on display in a cavernous mausoleum, I passed beneath his enigmatic, blandly serene portrait, one of the most famous images in history, through the Noon Gate and into the Forbidden City.

Like Angkor Wat, the Forbidden City inspires awe by immense

horizontal spaces rather than sublime heights. The visitor is diminished by being made to traverse vast quadrangular fields of stone. The innermost destination, the Hall of Supreme Harmony, where the Son of Heaven sat enthroned, almost seems to recede as the supplicant approaches it, like a mirage. The emperor's throne was sited at dead center of the Forbidden City, with a view due south through the courtyards of the palace, straight down the middle of the Noon Gate and beyond, surveying the empire and thus the world. The interior of the Hall of Supreme Harmony was a disappointment, with the forlorn air of the ballroom of an abandoned hotel. The throne just looked like a big chair with tattered silk banners hanging around it, décor left behind after the last banquet.

As you progress through the Forbidden City, the stone courtyards give way to a maze of paved alleys that ramify into ever smaller enclosures, as if the builders realized halfway through that they had already used up most of the space for the emperor but still had to find room for many lesser elements, residences for the myriad eunuchs and concubines, and gardens and libraries for their use. In 1988, there were few barriers. I wandered away from the proposed tourist route and found myself quite alone in a mysterious de Chirico composition, trapezoids of faded red walls, shining cobblestones, and deep shadows, razor-sharp vectors that receded to a vanishing point in rational, un-Chinese space. Rounding a corner, I came upon an old man wearing socialist black pajamas who was sweeping up clouds of dust. He cackled and said in English, "You are lost. Go back! Go back!" I thanked him and continued on my way.

When I revisited the Forbidden City in 2014, as I expected I found the security tighter and the crush of visitors much greater, but I was pleased to see that they had not made any improvements. When the Chinese restore historic monuments, the aim is to make them look brand-new. I let myself be carried along by the mob across the great fields of stone, peeping into the stately halls, until I reached the labyrinth. In one of the little courtyards there, I found a cistern, shaded by a tiny pavilion roofed with the same ocher tiles used on the palaces: it could have been the very one

where Maurice Roy rescued the Kuang Hsu emperor from drowning (if he did).

Farther along, I saw a door slightly ajar, with a bunch of keys hanging from the lock. It was an empty chamber, choked with weeds growing up in the cracks between the stones, perhaps the former abode of an inconsequential eunuch or a concubine who had lost favor. A gardener had brought a dish of rice to a mother cat who, judging from her blind, wobbly offspring, had just littered a day or two before. The gardener looked around in alarm when he heard me, perhaps fearing I was his boss. I gave him the thumbs-up, and we shared a conspiratorial smile.

I was reminded of a passage in the memoir of George Kates, an American sinophile in Beijing in the 1930s who lived the life of a Ming literatus in an old-fashioned house far from the quarter inhabited by foreigners. Kates visited the Forbidden City daily for years, with the intention of seeing every rock and cranny in the place, a project that required "a great deal of luck. After two or three years, some weed-overgrown courtyard, apparently destined to remain sealed forever with a rusty Chinese padlock, through chinks in whose rotting doorways I had long peered in vain, would one day be wide open, while unconcerned masons went about some simple task. My reward would then be great." He called his quest "an imperial hunt," like that of the narrator of *René Leys*.

In the evening, my friends took me for dinner at a swank shopping mall populated by the same tenants as its counterparts in Beverly Hills, with stunning restaurants and chic little shops purveying thousand-dollar sneakers and sequined T-shirts. We walked through the lobby of a smart hotel that re-created the feeling of SoHo in the postmodernist 1980s, with puzzling sculptures spotlighted in the gloom and willowy, epicene staff in severe black-and-white uniforms. The mall was thronged with the gilded youth of Beijing; the few foreigners wore the same guarded, slightly dazed expression that Chinese tourists in New York used to have, trying to look unintimidated.

One of my main objectives on this visit was to see the ancient observatory, a squat Ming tower near where Victor Segalen lived, in the southeastern corner of the Manchu city. From the street,

you could see enormous bronze astrolabes on the upper terrace, but there were no stars to observe because of the air pollution, unless you counted the sun, which was a glowering presence more than a visible orb. I saved the observatory for my last day in the city, which was a Tuesday. The day before was a national holiday, the mid-autumn festival. I appeared at the observatory's gate at the posted opening time and found it chained with a padlock. The employees' entrance was open, so I went in to inquire. The woman in charge crisply informed me, "Today is Monday. The museum is closed on Monday." I pointed out that today was, in fact, Tuesday.

She beamed triumphantly. "Yesterday was a holiday, so today is Monday." It was perfect socialist logic, which admitted of no debate. I slouched away in defeat yet felt almost relieved to find a fugitive trace of the bad old days surviving amid the new opulence.

The French admire Segalen as a poet more than for his prose works, and most readers rank *Stèles*, published in Peking in 1912, as his poetical masterpiece. In this collection, Segalen created a new verse form, inspired by his ongoing archaeological collaboration with Gilbert de Voisins. In an introductory essay, he defines a stele as "an upright stone tablet bearing an inscription. They embed their low foreheads in the Chinese sky." His book comprises sixty-four poems composed in long, flowing lines that sometimes expand to short, prosy paragraphs, which are printed on narrow pages that approximate the shape of ancient steles. These poems, literally lapidary, embody Segalen's understanding of Taoism, arranged to reflect Confucian ideals of order. The texts are framed by lines of rule, with Chinese ideograms running alongside the poems' French titles, in some cases simply a translation of the title, in others classical quotations that serve as the poem's starting point.

Segalen's goal was to bring the reader into contact with the Other through purely literary means. His innovation was to ground his vision not in ancient Greek and Roman classics or European literature but rather in the great philosophical and aesthetic

traditions of the East, which remained an undiscovered world to most Western readers. It was a bold experiment in pure cultural overlay, which attempted to coalesce Chinese and French sensibilities in a wholly original literary form. *Stèles* was thus a precursor of two monuments of high modernism, *The Cantos* and *Finnegans Wake*, which expanded the concept to a global scale. Like those works, *Stèles* showcases impressive intellectual virtuosity, but also like them it has inspired admiration more than it has attracted converts. For readers not literate in Chinese, the ideograms are simply incomprehensible.

Although it's doubtful that Ezra Pound ever saw *Stèles*, he used ideograms extensively in the "China Cantos" (LII–LXI), published in 1940, after he had alienated almost everyone except T. S. Eliot and James Laughlin, his publisher at New Directions, with his idol worship of Mussolini and bigoted jeremiads against banking. Yet a quarter century before the "China Cantos," Pound had published *Cathay*, the most persuasive interpretation of classical Chinese poetry for Western readers that had yet been attempted, following his maxim "Make it new." *Cathay* moved Eliot to issue his provocative proclamation that Pound was "the inventor of Chinese poetry for our time," a remark that was not intended as high praise so much as to describe the illusoriness of poetry translation in general. *Stèles* is undoubtedly more correct in its use of Chinese than Pound's collection; sinologists have complained about the mistakes in *Cathay* since it was published; but Pound succeeded brilliantly at writing fresh, gorgeous poetry out of the Chinese for his contemporaries without resorting to the rancid clichés of exoticism that Segalen despised.

Segalen's motto for *Stèles* could have been "Make it old." He might have been in the front line of the avant-garde as a craftsman, but his vision of China was deeply conservative. Segalen wrote *Stèles* when the Chinese Empire, history's longest-enduring attempt to establish a celestial order on Earth, was on the verge of collapse yet still intact. He had had an audience with the emperor, so for him the empire could never be merely a passage in history, but for his readers it can be nothing else. No one now living can remember a time when it was still possible to believe in a rational,

Confucian world order. Yet as chaotic as China was after the empire's fall, no one except terminal nostalgists wanted it to be restored.

As challenging as *Stèles* was to its readers, the physical book made an exciting first impression: published under Segalen's supervision in Peking, the first edition is a remarkable achievement in the art of bookmaking. Oversized and nobly proportioned, printed on exquisite Korean paper that was folded and bound concertina-style and tied with silk ribbons, the book went a long way toward realizing the poet's intention to transform the printed page into a facsimile of a stone stele. When Segalen was on home leave in 1913, he presented a copy of the book to Georges Crès, a publisher in Paris, who proposed that Segalen edit a series of books in the same style, to be called the Korean Collection, after the paper. It was something new, an expatriate imprint produced *à la chinoise* for Western bibliophiles. The series' second title, after *Stèles*, was a lavish production of Claudel's *Knowing the East* in a blue silk slipcase with clasps of polished bone. Claudel was ecstatic: "What paper! Where did you find it? this sort of pearlescent felt, with the transparency of algae, of women's hair or the nerves of fishes, cultures of stars or bacilli, the mist of an entire world coming into being. . . ."

The third and last title of the Korean Collection was arrant Orientalism, a sumptuous edition of *Aladdin and the Magic Lamp, from the Tales of a Thousand and One Nights*, in the popular translation by J. C. Mardrus, a Frenchman born in Cairo, with cover calligraphy in a burlesque, pseudo-Arabic style. It was a strange choice for someone who abhorred being associated with pimps of the exotic: the first French translation of *The Arabian Nights*, published by Antoine Galland beginning in 1701, was the literary genesis of European Orientalism. The book's title betrayed faulty scholarship, for the story of Aladdin is not included in any canonical manuscripts of the *Nights*. After the success of the early volumes of his translation, Galland looked around for tales to amplify the collection. His primary informant, a Maronite Christian from Aleppo, brought him *Aladdin*, which is set in an imaginary Islamic China. Versions of the Aladdin story existed in

storytelling traditions throughout the medieval world, including Greece; Galland synthesized them and introduced Arabic elements to make the story conform to his conception of the *Nights*. Thus the story Segalen published was compiled and heavily redacted by a Frenchman, if not actually written by him. In its way, it is just as much a French dream of China as *Stèles* and *Knowing the East*.

In 1914, Segalen set off on his second expedition with Gilbert de Voisins. Their first outing, lavishly equipped though it was, had been more productive of beautiful words than actual discoveries. In Segalen's journal of that expedition, he wrote that he was constructing a "vast imaginary China" that was "fashioned from echoes, faint glimmers, smells, desires, frights, and seductions"— far from the serious archaeological endeavor he had set as his goal. The second expedition was mounted with financing from the French Ministry of Education and Fine Arts and the backing of a prominent collector, Jacques Doucet (who later bought *Les demoiselles d'Avignon* from Picasso). Segalen found what he was looking for: in Shansi province, the team excavated a superb funerary sculpture of a horse from the tomb of a young Han general. In his report for the journal of a branch of the Royal Asiatic Society in China, Segalen wrote (in English) that the sculpture "can be exactly determined as dating from 117 *Before Christ*; that is to say more than two hundred years older than the most ancient stone monument in *ronde bosse* [in the round] hitherto known in the Far East."

The Lumière company, the photographic firm owned by the cinema pioneers Auguste and Louis Lumière, had supplied the expedition with a thousand glass plates to make photographs of their discoveries. Every night in camp, Segalen developed the plates he had exposed during the day. His photograph of the sculpture of the Han horseman depicts a sophisticated work of primordial Chinese art. Segalen wrote a fine description of it, which begins, "You will at once observe that this statue is striking on account of its archaic form, the rudeness and bold simplicity of its contours. You will also notice that for the first time in Chinese style of full *ronde bosse* we have to do with a group. As a matter of

fact, what you see between the legs of the horse is a man—a man thrown on his back, trampled on, conquered, yet a man still defending himself."

Segalen's plan to push on to Tibet, at that time scarcely broached by foreign travelers, had to be scrapped because of the outbreak of war in Europe. After his return to Peking, he labored intensively over a comprehensive monograph about the large sculptures of China, illustrated with his photographs. He completed the manuscript of *Chine: La grande statuaire* shortly before his death. When it was finally published, in 1972, in a handsome volume illustrated with photographs and drawings by the author, it made the author's reputation as a major historian of Chinese art, half a century after his death.

While he was on his archaeological expedition with Gilbert de Voisins, Segalen began writing *Escapade* (*Équipée*), subtitled *Travels in the Land of the Real* (*Voyage au pays du réel*), an experimental attempt to delineate the troubled frontier between imagination and experience. In addition to searching for archaeological artifacts, the expedition had received a commission to create a topographical map of uncharted regions of the country. Traveling through a pristine landscape with his mind uncontaminated by information, Segalen saw the journey as a perfect testing ground for his evolving theories about the exotic. Before he set out, he wrote to a friend, "The journey has decidedly acquired for me the value of a genuine experience: a confrontation in the field between the imaginary and the real." *Escapade* takes the superficial form of a narrative of a real journey, the expedition with Voisins, but the writer's imagination anticipates real events, and the imaginary insinuates itself into the literary world.

The book has twenty-eight numbered episodes, which are situated at different points on the imaginary-real continuum. The longest chapter, number 20, falls deep in the fanciful end. Segalen begins by setting himself a challenge: "One must look deeply into oneself, even strain a little, to find something new of one's own, the unforeseen, and the incomparable shock of the Diverse, in

places where people who write and speak the same language have lived together a long time." He compares the blank spaces on a map to an artist's primed canvas, where marvelous creatures abound in potentiality, awaiting the explorer to bring them to life.

Then he edges into his tale. The narrator, a ghostly emanation of himself like the journal keeper of *René Leys*, inadvertently discovers a village that has been isolated from the outside world for centuries. At a fork in the road, he takes the path less traveled by, abandoning the main highway for an overgrown trail, "the road to the impossible." Below him he sees a village called White Salt Wells, the last locality marked on the map; the region above him is a blank. Ancient chronicles mention that there was once a town there called Black Salt Holes, which is now *fei*, defunct. The path hugs a purple cliff, sinuous as the infinite spine of a dragon, traversing a dark wood. The traveler stumbles blindly through the dense brush until he emerges into a clearing. At first dazzled by the bright light, he hears dogs barking and then sees the smoke of hearth fires rising in the clear, sweet air. He recalls a passage from Lao-tzu describing the tranquil life of the ideal village, free from all concerns outside its own domain, translated here by D. C. Lau: "Though adjoining states are within sight of one another, and the sound of dogs barking and cocks crowing in one state can be heard in another, yet the people of one state will grow old and die without having had any dealings with those of another."

The traveler has found the lost town of Black Salt Holes, enclosed on all sides by mountains, completely cut off from the outside world. Shy villagers come forward, astonished by the appearance of their first visitor in three hundred years. They ask for news about the Grand Mings who rule the world: What is the name of the Son of Heaven now? The narrator hesitates to tell them that the Ming dynasty was deposed by barbarians. For a moment, he thinks he hears the approach of one of his muleteers and takes fright: the villagers will see the man's queue hanging down to his heels, signifying his subservience to the Manchu. "They will know that their right to live has passed, their lives are in fact out of date, their city decommissioned by imperial decree

and moreover nonexistent. Perhaps these sweet, quavering elders will crumble into dust at my feet." The traveler takes his leave, vowing never to tell anyone about his experience or the location of "this paradoxical place, perhaps imaginary."

In this tale, Segalen clearly articulates his conception of the unstable cohabitation of the real and the unreal, a stasis of interpenetration more than a conflict. The relationship is usually conceived in the West in Platonic terms, with the eternal Ideal opposed to the feeble earthly reflections of it in perceptible reality. Segalen considers the matter in Chinese terms, as two worlds seeking to achieve harmony. He accomplishes this not by imitating Chinese modes, as he had done in *Stèles*, but with an elaborate literary allusion; for *Escapade* 20 is a paraphrase of one of the most famous works of Chinese antiquity, "Peach Blossom Spring," by T'ao Yüan-ming (or T'ao Ch'ien, A.D. 365–427).

In "Peach Blossom Spring," the voyager is a river fisherman who loses his way and discovers a peach orchard in bloom. He follows the winding stream through the orchard to the foot of a mountain, where a spring feeding the stream rises in a small cave. The fisherman disembarks and enters the cave. At first, the path is so narrow that he can barely make his way, then it debouches into a sunny plain, where "austere houses were graced with fine fields and lovely ponds. Dikes and paths crossed here and there among mulberries and bamboos." As Segalen will do, T'ao Yüan-ming makes his allusion to Lao-tzu explicit, with barking dogs and crowing cocks to alert the erudite reader that the lost village is an exemplar of the ideal community, indifferent to evidence of human life outside itself, even in its immediate vicinity.

The villagers, amazed to see their visitor, offer him food and drink. They explain that they came to this secluded valley long ago to escape the ruin wrought by dynastic warfare. Like Segalen's denizens of Black Salt Holes, they ask their visitor who is ruling the empire now. After a few days' repose, the fisherman takes his leave. His hosts diffidently ask him not to reveal the location of their earthly paradise, but he disregards the request and takes careful note of landmarks on his return journey so he can find his

way back. When he gets home and reports what he has seen, a party is organized to go in search of the enchanted village, but they lose their way and finally give up the search.

Escapade 20 diverges most significantly from T'ao Yüan-ming in its ending. Segalen romanticizes the story slightly by having the interloper appreciate that the lost village is a precious place, liberated from history, and honors it by protecting its isolation. T'ao takes a realistic view of human nature, recognizing that mortals feel an irresistible urge to acquire anything that has value. The attitude of Segalen's narrator is based on the Enlightenment view of the Other that began with Diderot and was still robust in Gauguin's vision of Polynesia, motivated by a desire to conserve what he perceives to be an innocent way of life, isolated from the world of manufactured wants in superfluity. Borges's claim that Segalen's writing offers a "fresh synthesis of Western and Eastern aesthetics and philosophy" may, after all, be just.

A similar story, which predates *Escapade*, is the novella *Germelshausen*, by Friedrich Gerstäcker, the popular German author who accompanied Ernest II, Duke of Saxe-Coburg-Gotha, on his Nile expedition. Gerstäcker's tale is set in Saxony twenty years before it was published, in 1862. The traveler is a vagabond artist named Arnold, a character based on Goethe's young heroes, who wears a broad-brimmed hat atop his curly blond hair, which falls to the shoulders of his threadbare black velvet jacket. He stops to rest by an ancient stone bridge, where he meets a pretty maiden. She is shy, but charming. Arnold puts her at her ease, and soon they are chatting amiably. He asks her to sit for a portrait in pencil; when he finishes it, the girl is astonished, even frightened by the close likeness.

Gertrud, as she is called, leads him to her village, Germelshausen, where her father is the mayor. "Over the village lowered a thick mist, which Arnold had already perceived from afar, and it dimmed the bright sunshine, which fell upon the gray, old, weather-beaten roofs with a weird yellowish light." After dinner at her father's house, she takes Arnold for a stroll in the village cemetery, where her mother is buried. According to the gravestone, Gertrud's mother died in 1228. They hurry home, for there is to

be a festival, and as the mayor's daughter she must lead the dance. The atmosphere at the inn is excessively merry, almost frenzied. The two young people discover they are in love. When Arnold laments that he must leave in the morning, Gertrud says, "Don't trouble about that; we shall be together longer—longer perhaps than you like."

Just before midnight, she takes Arnold's hand and urgently leads him to the edge of town, where she points out a hill beyond its perimeter and asks him to wait there until midnight. When the church bell tolls, she says, he must hurry back to the village, where she will be waiting for him. Arnold is mystified but accedes to her request. However, at midnight a storm blows up, and Arnold can no longer distinguish the village. Repeatedly, he tries to find it but is thwarted by darkness and the boggy terrain. Germelshausen has vanished.

The next morning a forester finds him resting by the side of the road. He tells Arnold that Germelshausen is a cursed village that sank fathoms below the surface of the earth centuries ago; once in every century, it rises to the surface for twenty-four hours before sinking back into perdition. Arnold has only his drawing of Gertrud to console his broken heart, and to prove that his experience was real.

It is quite possible that Segalen read *Germelshausen* when it was published, when he was studying at the Jesuit college in Brest. The novella enjoyed an immense popular success and was much in use for teaching German. Yet even if he did, it is unlikely that it made a strong impression on him: Segalen's taste in literature was already ruled by Symbolist poetry and the unconventional novels of Huysmans. In any case, by 1914, when he wrote *Escapade* 20, Segalen's imagination was consumed by Chinese art and literature, with little use for sentimental stories of lost love.

The affinities are even more pronounced between *Germelshausen* and the Broadway musical *Brigadoon*, by Alan Jay Lerner and Frederick Loewe, which sets virtually the same story in the Scottish Highlands. The musical has a Hollywood happy ending, with the errant traveler choosing to stay with his new love in the lost village. Germelshausen's doom was decreed by a papal

anathema, while Brigadoon's escape from the world was an answer to a parson's prayer that the village be delivered from evil sorcerers who were making mischief in the Highlands, like the farmers fleeing war in "Peach Blossom Spring." Yet important details are retained; the stage directions of *Brigadoon* call for the stage to be "filled with a misty gray-yellow light" when the village sinks into the earth.

Brigadoon was a success with the public and critics when it opened on Broadway in 1947, playing for 581 performances; a production in London's West End ran even longer. There was one sour note in the play's success: the close resemblance to *Germelshausen* was not lost on the critic from *The New York Times*, George Jean Nathan, who accused Lerner of "barefaced plagiarism." Lerner stoutly denied that he knew Gerstäcker's novella until it was pointed out to him, after he had finished writing the script. We need not believe him, or care; the play was clearly not a case of plagiarism.

Other modern myths of places lost in time, such as the relict pagan kingdoms in a dozen romances by H. Rider Haggard, notably the lost city of Kôr, realm of the immortal Ayesha, "She-who-must-be-obeyed," and Shangri-La, in James Hilton's pretentious potboiler *Lost Horizon*—even Skull Island, stomping ground of King Kong in Merian C. Cooper's film—stretch Segalen's concept of exoticism in time to the limits of fantasy. They depend for their scanty measure of credibility upon the concept of uncharted lands, places unbroached by outsiders until the exote-hero discovers them. Such wilderness areas existed in 1914, when Segalen and Gilbert de Voisins were commissioned to create the first topographical maps of remote localities they visited on their expedition, and the concept was still viable in 1933, when *Lost Horizon* and *King Kong* appeared, but in the Space Age (as it was once known), satellite photography filled in all the blanks, undermining a sine qua non of exoticism.

The last of the three books Victor Segalen published in his lifetime, after *Les immémoriaux* and *Stèles*, is *Paintings*, a collection

of imaginative, frequently grotesque prose poems that describe invented classical Chinese scroll paintings. In the introduction, a master of ceremonies, taking the supercilious tone of Rimbaud's compère in *Illuminations*, admonishes the reader,

> You are there: you wait, resolved perhaps on hearing me out to the end; but destined or not to see clearly, without shame, to see everything until the end?—I do not exact promises at all: I do not wish for any other response or help from you except silence and your eyes. First, have you any idea of what is shown here and why this SPECTACLE is taking place? These are Chinese Paintings; long, dark silken paintings, laded with soot and the color of time from the earliest ages.

Segalen's imaginary paintings present one marvelous transformation after another. In one passage, a drunken artist claps his hands three times, commanding a door to appear in his painting; then he enters the scroll through the door, "and he becomes small, and then: a dot. He becomes spirit and disappears." Segalen dissects the decay of dynasties and the failure of aristocratic morality with the detachment of a medical man, promising the reader that he will see tyrants passing their final days "in feasts, music, flowers, murders, and wine; you will see them dragging down with them in their fall their friends, their favorites, mistresses sometimes paid for with the bullion of a kingdom, their families, and even their ancestors, who are disinterred and dethroned with them."

One emperor hunted peasants stripped naked and made to run through the woods, stirred into action like big game by beaters. Another emperor decreed the death of the past: he burned all the books in the empire and buried alive everyone who had read them. The empress dowager Wou, of the T'ang dynasty, was the shameless mistress of an abbot who had murdered her husband the emperor with witchcraft, by causing his head to swell until it exploded. One of the few sympathetic figures in this gallery of horrors is the emperor of the Western Han who offered to

abdicate the throne to prove his love for his male favorite. The poems are disordered and distracted, riven by extremes of beauty and filth, exquisite pleasure and pain. Like the inhabitants of the watery world of a lacquer screen, they "participate in the life of sap and essences. Their dwelling place is a limbo made shadowy by thick opiums." Indeed the intensified sensuality and hallucinatory transformations in *Paintings* mimic the opium smoker's reveries.

Rather than attempting to counterfeit a Chinese artifact, as he had done laboriously in *Son of Heaven* and more successfully in *Stèles*, he distilled his erudition and passion for China, his sensitive empathy for its classical sensibility—in a word, his rare genius for chinoiserie—into refined French poetry. Segalen spent six years composing and polishing this slender collection, in which he surrendered to his love of Symbolism and let its sickly luster flicker across his vision of decadent China. It is not exoticism per se but rather an aesthetic frontier where sensibility blends with imperceptible sfumato into history.

The infatuation with cruelty and the macabre that runs through Decadent literature has many sources, but the fountainhead was Edgar Allan Poe's tales of the extraordinary and supernatural. Baudelaire's scrupulously faithful translations of them (which are routinely pronounced to be better than the original for no apparent reason except the imperishable glamour attached to Baudelaire's name) were as decisive an influence in French literature as Byron's poetry had been a generation before. Baudelaire wrote in his introduction that Poe never received the honor he deserved in his home country, a pathetic prediction of Baudelaire's own destiny. The powerful sense of alienation that suffuses Poe's tales made him a natural inspiration for exotes—and no writer was more profoundly under his weird spell than Lafcadio Hearn.

Hearn was born *heimatlos*, a man without a country. The son of an Irish army surgeon and a Greek woman, he was born on the Ionian island of Lefkada, which gave him his unusual forename. After irregular schooling in France and England, in 1869 he was sent at the age of nineteen to live in the United States. According

to his own, self-romancing account of his early life, Hearn arrived on the streets of Cincinnati, penniless and completely alone after the distant relative charged with his care gave him five dollars and told him not to come back. Although he was blind in one eye and severely myopic in the other, he found work as a printer's devil and then as a reporter. When he was twenty-three, Hearn married a black woman named Alethea "Mattie" Foley, a former slave who was visited by ghosts, but the union was null and void in Ohio, which outlawed interracial marriage. After a year of marriage he left her and moved to New Orleans. He wrote to a friend in Cincinnati that times were hard, but "better to live here in sackcloth and ashes than to own the whole State of Ohio."

Hearn was passionate about Poe and signed his letters "the Raven." The reasons he identified with him ran deep: Poe was orphaned at the age of two, while Hearn's father abandoned him when he was five; both men made unorthodox marriages, Hearn to a black woman and Poe to his thirteen-year-old cousin; both were outcasts who lived in extreme poverty. Hearn is most often read now for his essays and short stories explaining Japan to the English-speaking world, particularly his retelling of traditional ghost stories. Hearn finished his life happily as a family man, becoming as Japanese as any foreigner could ever be, and in 1896 he took Japanese citizenship. Yet Hearn's reporting in America often holds more interest than his quaint recitals of Japanese legends. His fascination with the supernatural was present from the start. One of his first newspaper features in Cincinnati was "The Reminiscences of a Ghost-Seer," a compendium of ghost stories told to him by a "healthy, well-built country girl" with "a strangely thoughtful expression in her large dark eyes, as though she were watching the motions of somebody who cast no shadow and was invisible to all others." The ghost-seer was Mattie, of course, her race evident only in her dark eyes.

In New Orleans, Hearn became fascinated by voodoo, the magic religion of African slaves in Hispaniola, which flourished in the city after an influx of refugees from the Haitian Revolution of 1804. One early story investigated "the withering and wasting power of Voudoo poisons." His anonymous informant,

who sounds suspiciously like Hearn himself, says that these poisons "slowly consume the victims like a taper. He wastes away as though being dried up; he becomes almost mummified; he wanes like a shadow; he turns into a phantom." Published in 1877, Hearn's story in *The Cincinnati Commercial* is one of the earliest accounts of zombie phenomena. Hearn met and interviewed Marie Laveau, the most popular voodoo priestess in New Orleans, but she did not tell him much, or he asked the wrong questions. She said nothing about voodoo per se and confined her remarks to good luck charms, love spells, and curses.

Hearn's break came with a report about St. Malo, a colony of Filipino fishermen and alligator hunters who lived in the swamps of Louisiana in a state near savagery, which was published by *Harper's Magazine*. More assignments from *Harper's* followed, including an obituary titled "The Last of the Voudoos," about Jean Montanet, or Dr. John, who had been Marie Laveau's principal rival for leadership of the New Orleans voodoo community. Hearn grew to hate New Orleans as much as he had adored it when he first arrived, and in 1887 he began a period of vagabondage in the West Indies. He made an extended sojourn in Martinique, which, he wrote to a friend, he "loved as if it were a human being." Gauguin was there at the same time; it is possible or even likely that their paths crossed, but no record survives of a meeting between the obscure itinerant journalist and the unknown painter just beginning his career.

At thirty-nine, Hearn found himself in New York, another city he hated, with a modestly successful career and no place to call home; then *Harper's* offered him a commission for a series of articles in Japan. He sailed to Yokohama and never looked back. Within a year of his arrival he entered into an arranged marriage with a woman eighteen years younger than himself. Sickly and irascible, Hearn needed someone to take care of him. The match was a passionless success, with an issue of four children. It was the precise inverse of Pierre Loti's pretend marriage in Japan to "a little yellow-skinned woman with black hair and cat's eyes . . . not much bigger than a doll," which he chronicled with blunt misogyny in his novel *Madame Chrysanthème*, a major source for David

Lafcadio Hearn, dressed in a kimono with the crest of his wife's family

Belasco's play *Madame Butterfly* and thus Puccini's opera with the same title. Hearn had long professed an admiration for Loti and translated upward of twenty excerpts from his books for newspapers. Yet after reading *Madame Chrysanthème*, he wrote that Loti had been a fine writer in his youth, "then the color and the light faded, and only the worn-out *blasé* nerves remained; and the poet became—a little morbid modern affected Frenchman," a condemnation no more attractive than its target.

True to form, Hearn manufactured a quarrel with *Harper's* as soon as he arrived in Japan, cutting off his main prospect for work, and took a job as a high-school teacher in order to support his family. At least precariously secure for the first time in his life, now he wrote for himself. Following the method of "The Reminiscences of a Ghost-Seer," he transformed his wife's recitals of the odd customs and superstitions of old Japan into polished prose miniatures. His first collection of them, *Glimpses of Unfamiliar Japan*, was published in 1894 by Houghton, Mifflin and was an immediate bestseller, the first of a dozen books about the country, which had made him famous by the time of his death, at the age of fifty-four.

Hearn was not as subtle or profound a writer as Victor Segalen, but they shared an important trait: a lover-like devotion to a dream of ancient empires, theatrical states that had been refined and harmonious in their pristine condition yet were now in decline, which engendered a tragic desire to preserve and restore them. The utter otherness of Japan, his first and last home, enchanted Hearn in a literal sense. Sounding like Segalen's master of ceremonies in *Paintings*, he wrote, "You have entered bodily into Fairyland, into a world that is not and never could be your own. You have been transported out of your own century, over spaces enormous of perished time, into an era forgotten, into a vanished age—back to something as ancient as Egypt or Nineveh. That is the secret of the strangeness and beauty of things, the secret of the thrill they give." Yet with the encroachment of the cold logic and materialism of the Western world, the empire of dreams was descending into cultural chaos. "What is there, after

all," he asked, "to love in Japan, except what is passing away?" For Segalen, however, immersion in the Other was more than a thrill; it was a means of expanding the consciousness, amounting to an aesthetic path to enlightenment.

Segalen devoted much of the year 1911 to medicine: he served bravely on the front lines against a virulent outbreak of pneumonic plague in Manchuria, and after it abated he taught Chinese students at the Imperial Army Medical College in Tientsin, lecturing in English. It was during this period that he became most deeply engaged in the life of China. On September 22, a few months before the fall of the empire, he wrote a long letter to Henry Manceron, a childhood friend with whom he had renewed contact after Manceron too became a naval officer serving in the Far East. After catching him up on the news about his work and confessing that he hoped someday to return to Tahiti, "where I passed nocturnal hours of radiant beauty," Segalen laments the empire's moral decay. Peking, he says, manages to redeem its filthy orgies with blowsy chanteuses only by the weight of its ancient majesty. In stark opposition to Gauguin and the French philosophers who preceded him, Segalen was a passionate advocate of "civilization," that of his own Cathay, which was passing into oblivion. His letter concludes, "The transfer of the Empire of China to the Empire of the self is a constant process."

Just as Gauguin had warred against the Christian missionaries in Polynesia, and Spies before his death was chagrined by the cultural debasement of Bali caused by the tourist economy he had helped to create, so Hearn and Segalen saw the empires they had venerated dissolving into a mist of modernity, leaving them with only regrets. It is the curse of the exote: a passion is conceived for the place as the traveler imagined it to be when he discovered it, and it must never change. Even more embittering than the mutability of the beloved is the realization that it was a phantom manufactured by the lover, a geographic Albertine: a truth that if conceded would admit the pathetic fallibility of the dream and thus make a waste of the dreamer's life.

The end of Victor Segalen's life presents a mystery reminiscent

of *René Leys*. It would put a fine point to the narrative to postulate that he died of chagrin after the fall of the Chinese Empire, the center of his intellectual life, but he had stayed on there for six more years before his final return to France. He himself was mystified by the slow, inexorable decline of his physical powers. A contemporary French doctor, Christian Régnier, has diagnosed Segalen's condition as that most Decadent of ailments, neurasthenia, caused by giving up the use of opium cold turkey and complicated by a case of Spanish influenza he contracted while managing the response to an epidemic of the disease in Brest. Segalen was deeply affected by the death of Debussy, on March 25, 1918, and went into his final decline.

The day after the armistice was signed, Segalen resigned his duties. In February 1919, he and his wife went to Algeria for a rest cure, which did him no good. After his return, he wrote to a friend, "I am being despicably betrayed by my body," and added, "I can assure you that opium is absolutely not responsible." He gives a full report of his near-total abstemiousness and concludes, "So we must look elsewhere. Syphilis: 0. Tuberculosis: 0. Anemia: 0. Malaria: 0. Recently, the very thorough examination by Dr. March'adour and Dr. Delahet gave me a clean bill of health. Thus I do not have any known detectable disease. And yet it is as if I were seriously ill. I do not weigh myself any longer. I do not take any medicines. I simply note that life is slowly abandoning me."

However, the mysterious wasting disease was not the cause of his death. On a visit to Brittany in May, Segalen told his wife one day that he was going for a walk in the forest of Huelgoat, where he had played as a child, and he did not come home. Two days later, she found his body lying under a tree, buzzing with flies. He had suffered a deep wound to his leg from a sharp, cutoff sapling. A healer to the end, he had tried unsuccessfully to bind the wound with his handkerchief and necktie. Segalen probably died of exsanguination from the injury, but no autopsy was performed. Because of his depressed mental state at the time, there have always been suspicions of suicide, yet they are hard to reconcile with the horrible cause of death and his attempt to stanch the flow of blood.

One ornament to the story, which is usually accepted as fact, is that a copy of Shakespeare's plays, bound in blue morocco, was found at his side, open to the tragedy of *Hamlet*—an apt ambiguous gesture from an exote embarking on his voyage to the ultimate Other, the undiscovered country.

Seekers of Oblivion

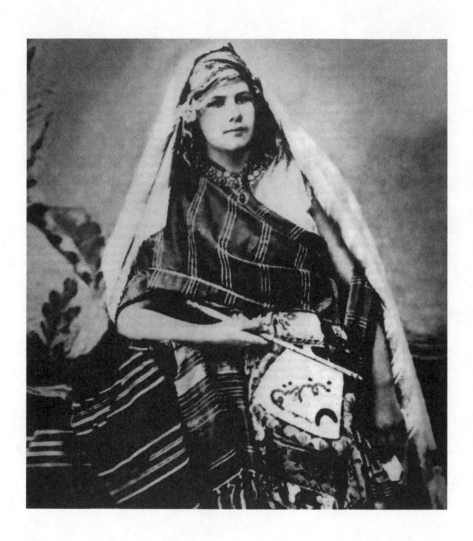

*Il n'y a plus de déserts. Il n'y a plus d'îles. Le besoin pourtant s'en fait
sentir.* ———Albert Camus, *Le Minotaure*

There are no more deserts. There are no more islands. Even so, we feel
the need for them. ———*The Minotaur*

Isabelle Eberhardt never converted to Islam. For her, it would have
been a redundant formality: from her early youth, she was pos-
sessed by an unshakable belief that she had been born a Muslim.
Among the first Western writers to describe the life of Islam from
the inside, as a believer, Eberhardt came from origins tangled in
mysteries that will never be unraveled. She was born in Geneva in
1877, the daughter of Nathalie de Moerder, a Russian noblewoman
who six years before had left her husband, General Pavel de
Moerder, to live abroad, taking their three young children with her.
The move was ostensibly undertaken for her health, but in fact
she went to Geneva to make a new home with her lover, Alexan-
dre Trophimowsky, the children's tutor, a defrocked Orthodox
priest.

When Isabelle was born, Nathalie registered her as *fille na-
turelle* and gave her her own birth surname, to avoid naming the
father. In adulthood, Eberhardt spun fantastic stories about her
parentage, claiming variously that she was the "wretched outcome
of a rape committed by my mother's doctor," a Turk, and that her

father was a Russian Muslim. The most outlandish theory of her begetting, first advanced by the French critic Pierre Arnoult, is that she was the daughter of Arthur Rimbaud, based on a perceived resemblance and a common destiny.

Whether he was her natural father or not, Trophimowsky supervised Isabelle's upbringing and education like a tyrant. He was a fervent anarchist associated with Mikhail Bakunin; the choice of Switzerland as the new home might have been determined by his desire to join the Bakuninist faction in exile there. When Isabelle was two, Trophimowsky bought a walled estate in the countryside near Lake Geneva called Villa Tropicale, shaded by groves of pine trees and lilac, which he renamed Villa Neuve. The principal subject on the curriculum was horticulture, specializing in orchids and cacti. The children worked long hours in the gardens and fields, which covered more than three acres, trying out the latest agricultural fad to capture Trophimowsky's imagination. He did give Isabelle a firm grounding in languages: in addition to Russian and the European languages that all Swiss study, he instructed her in Latin, ancient Greek, and classical Arabic, which she had mastered by the age of nineteen.

From her early childhood Isabelle was raised as a boy, a decision that may have been motivated by a noble intention to liberate her from the inferior role of women in Swiss society, but it might have been simply a freak of Trophimowsky's fancy. She learned to ride and shoot and always dressed in boy's clothes, with her hair cropped. When Isabelle was old enough to venture into the city on her own, Trophimowsky allowed her to do so only if she wore trousers. In adolescence, she delighted in strolling the streets of Geneva dressed as a sailor and drinking beer with real sailors in cafés, the first of many disguises.

Trophimowsky, the renegade priest, was violently antireligious, but he held a more bitter grudge against Christianity than Islam and regarded Jesus Christ as his personal enemy. His ancestry was Armenian and possibly Muslim, and his reading of the Koran in Arabic with Isabelle brought him close to an open embrace of cultural Islam. Effectively a prisoner behind the villa's walls in her childhood, Isabelle sought imaginative escape in books. Swiss

by birth she loved Rousseau, Russian in her soul she venerated Dostoyevsky and Tolstoy, but her favorite books were by Pierre Loti, particularly his *Romance of a Spahi*. A spahi was a native Algerian cavalryman serving in the French army; Loti's novel was a picaresque romance of the soldier's life in the Maghrib (also spelled "Maghreb"), the Arabic name for northwestern Africa.

From these disparate influences, the lonely, unhappy girl, born without a father or a homeland, synthesized a land of dreams in the African desert. Long after she had escaped Trophimowsky's grip, she wrote to her beloved brother Augustin about "this land of the Maghrib, which, you remember, was always the sacred Kaaba for us both," and in her diary described "that extraordinary attraction I felt for [the land of Africa] before I had ever seen it, long ago in the monotonous Villa." After she immigrated to Algeria and traveled through the desert in the character of a young male scholar, Eberhardt's fantasy of the Maghrib merged with her acute observations of the real place in tender, vivid reportage and short fiction.

Villa Neuve was tormented by secrets and forbidden passions, doomed like the House of Usher. Isabelle adored her mother, whom she always referred to as the "White Spirit" in her journals. Throughout Isabelle's childhood and adolescence, Madame de Moerder was an invalid in a state of slow decline from an unspecified chronic illness, increasingly overpowered by Trophimowsky. Of the general's three children who accompanied them to Switzerland, Nicolas, the eldest, joined the French Foreign Legion when he turned twenty-one and promptly jumped ship in Singapore; Nathalie denounced Trophimowsky to the police for making "disreputable and obscene propositions to her" and conspiring to murder General de Moerder, her father, by poisoning; and Vladimir, a delicate, shadowy youth whose principal interest was tending the villa's cactus garden, committed suicide.

Isabelle and her fourth sibling, Augustin, were extraordinarily close in childhood and adolescence, almost to the suspicion of an incestuous love. Their sister Nathalie told the police that Trophimowsky was Augustin's father; if she was telling the truth,

Augustin might have been Isabelle's only full sibling. Isabelle and Augustin dreamed of their escape to the Maghrib, where they could ride together in the desert, free from their autocratic guardian or undeclared father. With Pierre Loti in mind, Isabelle later wrote to Augustin about "certain books which arouse in our two almost identical souls the same feelings, the same anxieties, the same sad calls toward the Unknown, toward an Elsewhere."

Augustin proved to be a disappointing soul mate. He was an indecisive weakling, an alcoholic and habitual smoker of opium and hashish. Time and again he ran away from the villa, only to creep sheepishly home. In what was intended to be a final, irrevocable break with his shadow father, Augustin imitated his elder brother by joining the French Foreign Legion, a last resort for misfits and losers. Isabelle wrote to him in despair,

> Who knows whether the kisses we exchanged on the doorstep at ten o'clock on October the twelfth were not to be our last. We have never been separated for long. What desolation, what heavy sadness, deep and implacable. There is no hope and no faith. No God to whom we might cry out our nameless misery, all the atrocious injustice of our suffering. Heaven is empty and dumb; there is nothing, no one anywhere. The loneliness is absolute. . . . What is to become of our dreams, our hopes, our plans for the future?

Augustin was a failure even at ignominy: after committing an unnamed criminal offense, he was discharged from the Foreign Legion, an almost unheard-of disgrace. Isabelle finally realized that "our dreams, our hopes, our plans for the future" were *her* dreams, *her* hopes, *her* plans.

Trophimowsky impulsively came up with a new plan, possibly at Isabelle's instigation: they would sell Villa Neuve and immigrate as a family to Algeria. The move realized the first of Isabelle's three main goals, to live in the Maghrib, and temporarily accomplished the second, to be quit of the domestic despot. A French-Algerian couple Isabelle was in correspondence with found them a house in the coastal city of Bône (which has since reverted to its Arabic

name, Annaba). Isabelle and her mother would leave for Africa immediately, while Trophimowsky remained in Geneva to oversee the sale of the villa. It was an ideal scheme as far as Isabelle was concerned: she needed someone to bully with love, and with Augustin now beyond her reach, she concentrated her affections on the White Spirit. On May 21, 1897, twenty-year-old Isabelle and her mother embarked at Marseilles, bound for Bône.

Eberhardt's third goal, which she had cherished since childhood, was to make a name for herself as a writer, an ambition she had already begun to fulfill before she left for Algeria. Writing under the name Nicolas Podolinsky, she sold three stories to the prestigious French journal *La Nouvelle Revue Moderne*, which also published Huysmans, Verlaine, and her idol Loti. The first, "Infernalia," is a shocking story about a necrophiliac medical student who violates a corpse in the school's morgue. The outrage is narrated explicitly: "Her dead eyes remained closed, and without joy or pain during this monstrous coitus; she rested more passively than any lover ever will beneath the powerful embrace of the living being." The story is just as repellent as the author intended, yet it was an astonishingly bold debut.

One month later, the review published "Vision of the Maghrib," a longer, more complex story in which Eberhardt predicts her own future with uncanny accuracy. It is a first-person narrative written in the character of a Russian woman traveling in Algeria, who has a series of encounters with a *taleb*, an Islamic scholar and mystic named Halim. In the first scene, the narrator idles by a campfire with two young men, one called Mahmoud and the other "the Beloved," who is tall and svelte, and dressed in a flowing white burnoose. The latter goes to find Halim and brings him back: "His slenderness seemed almost feminine beneath the wrapping of his coarse clothing typical of a man of the people. He sat down near the fire across from me, and in its rekindled glimmer I saw his pale face, almost unreal in its beauty, with dark eyes that seemed illuminated from the interior by a mystical flame, beneath the perfect arch of his black eyebrows."

The second scene takes place five months later, in a crowded café in Algiers, where the narrator, the Beloved, and Mahmoud are

watching a performance by Ouled Naïl women, prostitutes famed for their exuberant belly dancing, "dressed in silks of shimmering colors with jewels in their hair and necklaces of native flowers." Halim arrives and joyfully announces that he has been chosen for martyrdom. The final scene takes place during a battle between Algerian freedom fighters and the French. The narrator watches the destruction of a village loyal to the cause of independence. The mosque is the last building to catch fire. As the flames rise, she hears "the ancient voice of Islam," as Halim sings the call to prayer for the last time from the fiery minaret. "Finally the martyr's voice weakened, little by little becoming a soft and resigned lament, a child's lament invoking the ambiguous Unknown at the supreme hour of death."

The four characters are all emanations of Eberhardt in her new life, before it had even begun: the Russian woman always in the company of Arab men; the Beloved, svelte in his white burnoose; Mahmoud, the name she would adopt for her male alter ego in the Maghrib; and the mystic martyr. It is a youthful work, glowing with zeal, but the distinguishing qualities of her mature writing are already evident. The settings are painted in brilliant colors, musical and perfumed; the story reeks of romance, but the romance is an integral part of the narrative. Despite its title, "Vision of the Maghrib" has a gritty, tactile realism.

Yet it is an honest title: the most remarkable aspect of "Vision of the Maghrib" is that it was the work of an eighteen-year-old self-taught writer who had spent her entire life in Switzerland. Edmonde Charles-Roux, the French novelist who wrote the definitive biography of Isabelle Eberhardt, praises the story for its "perfect authenticity" and points out that an openly pro-native story was very unusual at this time. French colonialism was expanding quickly; Madagascar had been subjugated just one year before, after a long war: scruples about the rightness of the *mission civilisatrice* were not welcomed. Eberhardt insulated herself to some degree by writing under a Russian name and prefixing a quotation from Pierre Loti, but *La Nouvelle Revue Moderne* was a reactionary journal, which Charles-Roux describes as "clerical, chauvinist, nationalistic, and its anti-Semitism was but one of the

numerous forms of its xenophobia." Halim's fiery martyrdom is a powerful statement of the cruel reality of the French conquest of Algeria. Charles-Roux concludes, "I don't believe that it had often been denounced in a text of this era and with such sensitivity."

The third story published in *La Nouvelle Revue Moderne*, "Per fas et nefas," is a story of romantic love between men, told by a Russian doctor, a woman, who is treating an artist dying of consumption in a hospital in Corsica. The Latin title translates, "by legal or illegal [means]." The character of the artist, Mikail Lebedinsky, derives directly from the Gauguin legend: "This giant of Art, this great renegade, both admired and cursed, who was thought to have renounced forever his distant homeland," with the difference that Eberhardt's character possesses a "sovereign male beauty," which has become "excessively refined" in his illness. Lebedinsky's urgent last wish is that the doctor summon to his side a friend in Athens. The dying man cries, "I don't give a damn about the judgment of men, or yours. Oh, how I scorn all Pharisees! Yes, I love him, I love him!"

The beloved, named Stelianos Synodinos, has "a sensual and pale beauty, entirely feminine." When he arrives, the lovers meet in a passionate embrace. The doctor, who describes herself as "detached from feminine sentimentality" and possessed of a high Slavic skepticism, accepts the homosexual relationship "without the least disgust and without revolt in the face of this glaring contradiction to nature." Lebedinsky expires in a rapturous death scene tinted in Gauguinesque colors: "A last ray of the setting sun created a very pale pink reflection on the blue-flowered tapestry, on the immaculate blanket, and on Synodinos's black hair. Outside, very high, small scarlet clouds were swimming in the infinite golden molten pink of the sunset, while the mountains were fading into lilac-colored shades."

Very few fictional depictions of homosexual love, as opposed to pederastic buggery, had been published before 1897. It was an impressively original theme for an apprentice writer with no connections to the literary scene in Europe. In her classical studies with Trophimowsky, she might have encountered stories about men infatuated with adolescent boys, such as Virgil's second

eclogue, which tells of the shepherd Corydon, who burned with love for the fair Alexis. However, the concept of reciprocal love between adult men was something that would not be in the air until the twentieth century. Like Gauguin, she advocated the principle of unhindered self-sovereignty from the beginning of her career.

Most exotes travel the world in search of a new home that will be congenial to their tastes and receptive to their talents; yet others seek nothingness, the absolute freedom of places *hors frontières*, beyond the limits of civilization. Byron had set the paradigm. At the conclusion of *Childe Harold's Pilgrimage*, the poet resolves to abandon humanity, crying, "Oh! that the Desert were my dwelling-place!" Yet, being Byron, he must have "one fair Spirit for my minister, / That I might all forget the human race, / And, hating no one, love but only her!" The fair spirit savors of poetic convention; the poet's adoring female fans demanded a place in his dream. Yet the Byronic hero, of which Harold was the type specimen, was a mirage, alluring in prospect but certain to disappoint: he would have made poor, moody company for a life in the desert. As he continues, Byron reveals the philosophical motive for his flight:

> There is a pleasure in the pathless woods,
> There is a rapture on the lonely shore,
> There is society where none intrudes,
> By the deep Sea, and music in its roar:
> I love not Man the less, but Nature more,
> From these our interviews, in which I steal
> From all I may be, or have been before,
> To mingle with the Universe, and feel
> What I can ne'er express, yet cannot all conceal.

By 1817, when he wrote canto 4 of *Childe Harold*, Byron had fled England to escape debt, divorce proceedings, and the scandal of his passionate attachment to his half sister, Augusta Leigh, not to mention notorious liaisons with actresses and boys. As these verses predicted, he never returned.

Byron's poetical yearning to dwell in desert places was preceded, if only by a few years, by the peregrinations of Lady Hester Stanhope, whose eccentricities have always endeared her to the British. She was the niece of William Pitt the Younger and served the bachelor prime minister as his hostess at 10 Downing Street from the age of twenty-seven, a job that sharpened her waspish wit and strengthened her prodigious sense of independence. After the premature deaths of Pitt, her brother Charles, and her suitor, Sir John Moore, she decided to travel to the Orient with her brother James.

She met Byron in Athens in 1810 under extremely awkward circumstances. His literary career scarcely begun, he was living at a Capuchin monastery, where he mingled not with the universe but with the adolescent students who boarded with the monks. Byron's letters to Cam Hobhouse, his confidant about Greek games, describe orgies that were extraordinarily debauched even by his own standard, with a tally of more than two hundred coitions. After a fourteen-year-old student named Nicolò Giraud suffered a ruptured anus, Byron sent to town for a doctor, who proved to be Lady Hester's personal physician and future biographer, Charles Lewis Meryon.

It is doubtful that word of Nicolò's affliction reached Lady Hester's ears, but she independently formed an unfavorable opinion of Byron. In her memoir, she wrote, "At Athens, I saw nothing in him but a well-bred man, like many others: for as to poetry, it is easy enough to write verses; and as for thoughts, who knows where he got them?" Betraying her suspicions about his character, she added, "He had a great deal of vice in his looks." Byron, for his part, was appalled by Lady Hester. He wrote to Hobhouse, quoting Alexander Pope, "I do not admire 'that dangerous thing, a female wit.'" He said that he had "discovered nothing different from other she-things, except a great disregard of received notions in her conversation as well as conduct."

Further complicating the encounter, Stanhope's current lover, a younger man named Michael Bruce, made a pass at Byron. For once, Byron was nonplussed. "I can't think for the soul of me what possessed Michael," he wrote to Hobhouse. "He is a little

chivalrous & romantic, and is smitten with unimaginable fanta-
sies ever since his connection with Lady H. Stanhope." Like all her
suitors, Bruce soon faded from her life: she was too mad about
herself to carry on a serious love affair.

Sailing for Cairo, Lady Hester's party was shipwrecked off the
south coast of Rhodes, with the loss of everything but their lives.
Her account of the disaster anticipated a famous episode in Byron's
Don Juan, "starving thirty hours on a bare rock, even without
fresh water, being half-naked and drenched with wet, having tra-
versed an almost trackless country over dreadful rocks and moun-
tains." When they reached Rhodes town, the British consul took
them in. Aghast at the notion of wearing a veil as custom de-
manded, Lady Hester adopted the dress of a Turkish pasha: tur-
ban, waistcoat and pelisse, billowing pantaloons, slippers, and a
saber. She never wore female clothing again. "If ever I looked well
in anything," she crowed, "it is in the Asiatic dress." Years later,
when she had actually assumed the powers of a pasha in Lebanon,
she proudly wrote, "The Arabs have never looked upon me in the
light either of a man or of a woman, but as *un être à part* [a being
apart]."

Lady Hester delighted in every success of her cross-dressing de-
ception. She wrote in her memoir, "Once when riding my beau-
tiful Arabian mare Asfoor, near a place called Gezýn, in that
crimson bornôos, with a richly-embroidered dress under it, and on
my crimson velvet saddle, I happened to approach an encampment
of the Pasha's troops." Some prostitutes saw her and took her for
a young Turkish lord. "Every time, just as they got near, I quick-
ened my horse's pace, that they might not see I was a woman: at
last, two fairly came and seized me by the knees, to make me turn
and look at them. But what was their confusion (for such women
are not so hardened as in Europe) when they saw I had no beard
or mustachios, and was one of their own sex." The British histo-
rian Kathryn Tidrick called her "the strange, talented, and ambi-
tious woman who provides us with the first, extraordinary example
of an English person identifying with the Arabs as her own
people."

Stanhope's opinions were more often violent reactions to per-

Lady Hester Stanhope, female pasha, sits astride her Arabian mount.

ceived affronts than considered judgments, yet she made the
ultimate commitment to her new home by renouncing British
citizenship. In 1838, the British consul general in Syria wrote to
inform her that the pension settled on her by Pitt would be stopped
unless she paid her debts in London. Lady Hester replied with an
astonishing letter to Queen Victoria, assuming a tone of equality
with the monarch:

> Your Majesty will allow me to say that few things are more
> disgraceful and inimical to royalty than giving commands
> without examining all their different bearings, and casting
> without reason an aspersion upon the integrity of any branch
> of a family who had faithfully served their country and the
> house of Hanover. . . . I shall not allow the pension given by
> your royal grandfather to be stopped by force, but I shall
> resign it for the payment of my debts, and with it the name
> of English subject, and the slavery that is at present annexed
> to it.

A year later, Lady Hester Stanhope died in seclusion in her castle
on the Levant coast, the butt of ridicule for her quixotic one-
woman rebellion against the Crown.

Isabelle Eberhardt's travels in the character of Mahmoud, the
devout young scholar, were a classic case of self-romancing, a com-
mon characteristic of the artist-exote since Gauguin created the
legend of his life in Tahiti, where, "in the silence of the lovely trop-
ical night, I can listen to the sweet murmuring of the music of
my heart, beating in amorous harmony with the mysterious beings
of my environment. Free at last." Like Byron's Childe Harold,
Eberhardt sought freedom in the purity of the desert, an illimit-
able place where she could roam at will in her new identity as Si
Mahmoud Saadi, a *taleb* on a solitary quest for the infinite.

After her arrival in Bône with her daughter, Madame de
Moerder converted to Islam and died soon afterward, leaving Is-
abelle alone in the world. She and Augustin drifted ever farther
apart and made the final break after his marriage to a dreary, semi-
literate Marseillaise. Isabelle was despondent after the death of

the White Spirit. In his biographical sketch of Eberhardt, Paul Bowles wrote that when Trophimowsky arrived in Bône for the funeral, "he found Isabelle in a state of hysteria, wailing that she too wanted to die. The old Nihilist's reaction was typical: he took out his revolver and offered it to her. She did not accept it." After Vladimir's suicide five months later, Trophimowsky was a broken man, at last bitterly aware of his utter failure as a parent. He himself died a year after Madame de Moerder, of esophageal cancer, severing Isabelle's last connection with Switzerland except legal entanglements over Trophimowsky's bequest of the villa to her and Augustin.

Released from the twisted, toxic environment of her childhood home, Eberhardt exulted in her newfound independence. She began her restless wandering in the Sahara, always dressed as a man and usually traveling alone. She wrote in her diary, "Since I've finally left that house, where everything had died a death even before it conclusively fell into ruins, my life has been nothing but a quick, dreamlike flash through various lands, under different names and different disguises." She delighted in being taken for a man, so she could astonish those she chose to attach herself to by revealing that she was a woman. She was naïve about the success of her deception; her friend Robert Randau wrote that the men she met "knew that this svelte cavalier in an immaculate white burnoose and soft red leather boots was a woman," but "the innate courtesy of the Arabs is such that none of them ever made any allusion, even by so much as a wink," that would have spoiled her fun.

In her desert rambles, Eberhardt realized Lady Hester Stanhope's ideal of living as *un être à part*, female only in bed. In cities, she frequented the roughest dives, where she could meet sailors and working-class men for quick trysts divested of affection, anticipating the sexual outlaws of Jean Genet. On a visit to El Oued, a remote outpost deep in the desert, her scandalous behavior attracted the notice of the Arab Bureau, as the local colonial administration in the Maghrib was called. The bureau chief wrote to his superiors that Eberhardt was a "neurotic and deranged woman" who had come to El Oued "to satisfy her vicious inclinations and taste for the locals." Eberhardt did have her vices: she

drank like a fish and smoked like a chimney, much of it kef, the form of hashish common in Africa. Intoxication palliated the hardships of her circumstances and emboldened her in the aggressive pursuit of sex.

One of Eberhardt's biographers, Françoise d'Eaubonne, advanced the theory that Eberhardt's male disguise was essential to her sexual pathology, suggesting that she presented herself as a boy because she wished to make love like a boy, by taking the passive role in anal intercourse. This scenario of sexual role-playing has a pedigree that dates to comic tales of buggery in *The Arabian Nights* and resurfaces in modern dramas such as David Henry Hwang's play *M. Butterfly* and Neil Jordan's film *The Crying Game*, but for obvious reasons it is an implausible model of habitual sexual behavior. Eberhardt was obsessed by the romantic image of the Arab youth, androgynous and ethereal, first exemplified by Halim in "Vision of the Maghrib." She wanted both to be that man and to be loved by him, not in an exciting daydream but in a real, rapturous physical union.

Isabelle Eberhardt's celebration of the freedom of the life of the Arab brought with it an inherent hypocrisy, resulting from the dissonance between her idealization of the male's independence and the state of subjugation in which most Muslim women lived. The only alternative to being a wife in some form of domestic isolation, if not actually in purdah, was to become a prostitute, like the feral belly dancers of the Ouled Naïl. Eberhardt seized for herself the freedom of the desert by creating a male alter ego, with little thought for the powerless dependency of Arab women. It is not a question of judging her by the standards of a later era: the feminist critique had been articulated long before, dating at least to Flora Tristan's *Peregrinations of a Pariah* in 1838.

In the new century, two events transformed Eberhardt's life. On a return visit to El Oued, she met Slimène Ehnni, a young spahi officer who was posted there. She fell in love with him with a passion that never diminished. Dark and good-looking, almost exactly her age, he was raised in Bône, the son of a police officer.

He was Muslim, of course, but *évolué*, the French term for a Gallicized Algerian committed to French rule, who held French citizenship. He was in the cavalry, so the lovers would ride the dunes together to distant oases for discreet assignations. Slimène was the first man she met with whom she felt secure enough to take the feminine role, a disguise she had not yet tried. He had a sickly constitution and was as irresolute and tractable as Augustin. Isabelle alternated between nursing him, as she had her mother, and making a project of him, as she had done with her brother. Her friends were unanimous in their disapproval, incredulous that she was besotted with a man so obviously her intellectual inferior; yet to the end of her life she persevered in the dream of making a home in the desert with Slimène.

Eberhardt's lifelong conviction that she was born under an evil star, so often validated by events, had made her spiritual life a mystic quest. In Paul Bowles's summary,

> She calmly set out to be initiated into the secret religious cult of the Qadriya, a Sufi brotherhood that wielded enormous political power among the as yet unconquered desert tribes. . . . They were under no misapprehension as to her sex; but if she chose to dress as a man it was her affair. From then on, no matter where she went, every member of the cult was bound by oath to feed her, give her shelter, or risk his life to protect her. She belonged to the Qadriya.

The Qadriya gave Eberhardt the sense of family she had never securely possessed and which was altogether lacking after the death of her mother. Because it is a secret society, no accessible record exists to testify to the extent or details of her involvement, yet there is no doubt that it profoundly changed not only her spiritual life but her earthly life as well, for membership in the Qadriya brought with it certain dangers.

In her diary, she wrote that as she lay in Slimène's arms one night in El Oued, she had "a vague feeling that some enemy forces lurking in the shadows were trying to separate us." The presentiment soon proved to be true. In January 1901, Slimène

was transferred to another posting, an order issued with the explicit intention of breaking up his affair with Eberhardt and ridding the town of them both. Although it was never revealed to her, the shadowy enemy had written an anonymous letter to the Arab Bureau, the first in a series denouncing Eberhardt as a spy working against French interests; for good measure, the letter also accused her of murdering Trophimowsky.

Another, more dangerous calamity occurred a week later. While she was on the way to a funeral with her Qadriya brothers and their spiritual leader, or marabout, known as El Hachemi, an attempt was made to assassinate her. As she sat peaceably in a courtyard in a village called Béhima, translating business letters for a stranger, a member of the Qadriya's fanatical rival sect, the Tidjaniya, burst in wielding a saber and aimed a blow at Eberhardt's head. The blade was deflected by a wire clothesline, saving her life by redirecting the blow to her left arm, which was nearly severed. The attacker escaped into the crowded street, crying that he was going to find a gun and finish the job. The Tidjani sheik of Béhima at first refused to cooperate with the authorities, but he finally handed over the assassin, Abdallah ben Mohammed, who claimed that he was acting on a direct command from Allah.

Who, if not Allah, ordered the attack? Eberhardt suspected the French, who were always making trouble for her, but she never made a direct accusation; for their part, the French, quick to find a romantic intrigue, apparently believed that El Hachemi was Eberhardt's lover and that he had ordered the hit in order to get rid of her and blame the attack on the Tidjaniya. Legal documents relating to the case were made public for the first time in 2001, which multiplied the possible scenarios but did not clarify the motive behind the crime. Eberhardt's theory is more plausible than that of the French; the notion that she was sleeping with her religious instructor while she was in love with Slimène is difficult to accept. Yet the Lone Swordsman theory, that Abdallah ben Mohammed acted on his own volition believing he was under divine orders, is just as likely as any other. Eberhardt pleaded for the court to show mercy, but he was sentenced to hard labor for life. She immediately lodged an appeal on his behalf, even though he

had said repeatedly that if he regained his freedom he would make another attempt to kill her, and his sentence was reduced to ten years in prison.

Meanwhile, the French exiled Eberhardt from the Maghrib, for her own protection, they claimed. After the trial she sailed to Marseilles, where Slimène joined her. They were married in civil and Muslim ceremonies there, which entitled her to claim French citizenship and thus put an end to her perennial immigration woes.

When she was recovering from her wounds at the hospital in El Oued, Eberhardt had a mystical revelation that she was under divine protection, that her life had been spared for a higher purpose, and that in fact she herself was chosen to be a marabout. She wrote in her journal, "God alone knows—I shall not know *who I am*, or what is the reason or the point of my destiny, one of the most incredible there has ever been. Yet it seems to me that I'm not destined to disappear without having some understanding of the whole mystery which has surrounded my life from its strange beginnings to the present day." Eberhardt was well aware that to claim openly that Allah had chosen a European woman as a prophet would invite accusations of insanity, and she never disclosed this epiphany to anyone but her husband.

Surviving the attack also revived her self-confidence as a writer. In her diary she noted, "Before, I had to wait sometimes for months for the right moods to write. Now I can write more or less whenever I want." Eberhardt's bravura performance at the trial was widely publicized and made her a celebrity in the Maghrib, prompting a Parisian writer and editor named Victor Barrucand to take an interest in her. He was one of a growing number of influential men who believed that Eberhardt was in a unique position to aid the French cause in Africa and should be put to a good use rather than persecuted on account of her eccentricities. He was starting a newspaper in Algiers, the *Akhbar*, and invited her to contribute as a correspondent. She leaped at the opportunity.

Barrucand proposed sending her to Aïn Sefra, a western outpost near the frontier with Morocco, where the French were poised to invade, though they did not yet know it. A brilliant officer named Hubert Lyautey, who had previously served as a

colonial administrator in Tonkin and Madagascar, had been put in command in Aïn Sefra. Lyautey loved Africa and admired the Arab way of life; he had studied Arabic and read the Koran. He believed that Islam and French colonialism in the Maghrib could work together, a progressive mutation of the *mission civilisatrice.* They were an unlikely pair, the general and the transvestite hashish addict, but Lyautey and Eberhardt became fast friends. After her death, Lyautey wrote to Barrucand, "We understood each other very well, poor Mahmoud and I, and I shall always cherish exquisite memories of our evening chats. She was what attracts me most in the world: a rebel."

Lyautey met Eberhardt at a propitious moment. He was developing a strategy to bring the city-state of Kenadsa, on the unsettled frontier with Morocco, under French influence. He wrote to his superior that an alliance with the marabout of Kenadsa "would be one of the most important factors in our success," by which he meant the annexation of Morocco. Kenadsa was in theory under the sovereignty of Fez, but in fact the marabout ruled his tiny domain like a prince. The present marabout, Sidi Brahim ould Mohammed, was a mystic who strictly enforced Sufi doctrine and despised the corrupt, extravagant sultan of Fez, who imitated Western ways. The main obstacle to Lyautey's plan was that infidels were barred entrance to Kenadsa under penalty of death. Eberhardt, or rather Si Mahmoud Saadi, was clearly the man for the job as a Qadri brother. She had long wanted to visit Kenadsa, a legendary center of Islamic learning deep in territory that no European had ever penetrated.

Eberhardt's friendship and collaboration with Hubert Lyautey has always raised doubts about the sincerity of her commitment to "the Arab cause," as it was called. It was a bitter irony that she should be accused of working as an agent for French interests in the Maghrib, for the French had kept her under constant surveillance and exiled her after the assassination attempt, which might have been made at their behest. Eberhardt might have thought that she had the advantage of Lyautey by accepting his sponsorship for the mission to Kenadsa. No record exists that she ever reported significant intelligence to him about her sojourn there or elsewhere (but none would).

She was conducted to Kenadsa by a slave named Embarek, lent to her by a religious brother in Béchar, the last outpost in Algeria. After a long journey across golden sands and desolate valleys, "Kenadsa appears on the horizon, clouded in a pink haze: black spots of scattered trees, the bluish line of a large palm grove, and a broken minaret appears reddish brown as it towers above the sand in the still-slanting sun." The town was built of warm-colored clay and surrounded by fine green gardens, clinging to a gentle hillside in a graceful disorder of superimposed terraces. Embarek led her through a maze of alleys to the *zaouia*, the ancient Islamic academy of Kenadsa and the seat of temporal power, where Si Brahim lived. The marabout received her kindly and invited her to stay as long as she liked. In a dispatch to Barrucand, she wrote, "I am a guest of these men. I will live in the silence of their house. Already they have brought me all the calmness of their spirit; a shadow of peace has penetrated the innermost recesses of my soul." Her quest of the absolute seemed finally to have brought her to a place where it was within her grasp. She asked, "Is all my thirst finally going to be quenched?"

Accustomed to the relatively free and easy atmosphere at Algerian *zaouia*, Eberhardt was at first taken aback by the rigorous discipline in Kenadsa. After a few days of quiet contemplation and working on the novel she was always scribbling at, she realized that she was, in effect, being held prisoner: the doors of the *zaouia* were barred and guarded by statuesque slaves. She went to Si Brahim and demanded her freedom. He granted it at once, with the proviso that she exchange her Algerian burnoose for a djellaba, the light muslin gown of the Moroccans. He was perfectly aware of her transvestite charade, but with the usual Arab courtesy participated in the deception and affected to believe in the reality of Si Mahmoud.

Invisible in her djellaba, Eberhardt roamed through the tortuous alleys of the Casbah and into the desert. On a dune above the town, she found a kef den in the hut of a lunatic mystic, where she passed hours in ecstatic oblivion. One hot evening, as she lay in her cell at the *zaouia*, she heard the pounding of drums and the clangor of copper castanets, announcing a Sudanese festival,

"a stranger note from a more distant Africa. Through centuries of Islam, the Sudanese have kept the practices of a forgotten, fetish-laden antiquity, a poetry of noise and gesticulations that had its full meaning in the deep forests haunted by monsters." The dancing became ever more frenzied, "excited to the point of madness," until the celebrants collapsed. The marabout arrived to give his blessing, not forgetting to include Si Mahmoud.

Eberhardt saw the students of the *zaouia* as she wandered through its dim passageways and at the mosque, but she had had little direct contact with them until a slave arrived one day at her cell and, with an air of mystery, invited her to follow him and take tea with a group of students at their private retreat. The students at Moroccan *zaouia* had acquired some notoriety after the publication of *Unknown Morocco* (*Le Maroc inconnu*), a scurrilous book by a French missionary named Auguste Mouliéras, which described depraved orgies in lavish detail, most of it invented. In her report for Barrucand, Eberhardt mentioned the book and wrote that beneath the students' piety there lurked a "raging sensuality that creates the most complicated and most dangerous love affairs and, it must be said, many hidden vices." Yet in her visit to the *bith-es-sohfa*, the students' clubhouse hidden away in the Casbah, she found a scene of chaste refinement verging on effeminacy.

"We enter the tea room through carved double doors that creak on their rusted hinges. A hazy half-light reigns there." Delicate milkstone columns support a lacework frieze of arabesques; overhead, small dormer windows in a cupola filter watery light onto Nile-green pots and chests painted in tarnished gold, piled with books, saddlery, weapons, and musical instruments. An inscription in cinnabar leaves urges eternal health. The students sit on a low platform, covered with carpets from Rabat. The host, a scrawny fellow named Si El-Madani, greets her and without being asked explains his clandestine invitation: "You know, Si Mahmoud, that usage and custom demand that our parents and elders remain unaware of our pleasures or at least be able to pretend to be unaware. We gather here to spend hours rejoicing our hearts through music and the recitation of the sublime works of ancient poets and through cordial discussions. No one must

know what happens here except God and us." The time passes in conversation and classical song, accompanied by a three-string guitar and tambourine. One youth busies himself embroidering a white silk tunic. Eberhardt writes that she is becoming aware of the "strength and tranquility of things that seem to last indefinitely because they are slowly making their way toward nothingness."

At the end of the hot, long summer in Kenadsa, her health failed her. Years of extreme deprivation, hard travel, heavy drinking, and smoking kef had wrecked her. She was scrofulous and had lost all her teeth. She fell ill with malaria and passed many days and nights in shivering deliriums. Si Brahim's mother nursed her back to health. After she had recovered some of her strength, Eberhardt worked on her novel in the courtyard and talked with Si Brahim, who had grown fond of her. When two young Berbers from the far West arrived to return a flock of sheep that had been stolen some time before, and to seek the forgiveness of the marabout, he lodged them with Si Mahmoud. As he expected, they soon became friends.

The Berber lads begged Eberhardt to return with them to their homeland. She agonized over the invitation. She had been drawn to Kenadsa in the first place because it was *hors frontières*; here was a chance to visit a place still more remote, even more distant from "civilization." In her journal she wrote that while she realized that returning to Aïn Sefra to stay at the hospital was the only reasonable course open to her, "nevertheless, I cannot bring myself to do it. I linger in my retreat: I breathe with delight the air that poisoned me." Finally she declined the invitation, the first time she had ever let such an opportunity slip away. Perhaps she remembered that she had a home of her own to return to, with Slimène.

He was now serving as an interpreter in a remote outpost near the coast. As she lay convalescing in the hospital, she wrote asking him to take a leave of absence so they could be reunited. She rented a simple clay house for them to share in Aïn Sefra, at the foot of a ravine by the dry riverbed. Once Slimène was installed there, she could no longer bear the enforced idleness of the hospital, and on

October 20, 1904, she checked out against medical advice and went home. Slimène had laid in a supply of kef for her. For the first time in eight months, they spent a night together, in their own home.

Paul Gauguin died at fifty-four of tertiary syphilis, crippled by bleeding chancres and almost blind; Raden Saleh died of a broken heart after he was insulted and abused by the government in his native land; Walter Spies drowned within sight of land, locked in a cage aboard a sinking ship; Victor Segalen, forty-one, died in a freakish walking accident at a time when he felt life slowly abandoning him; Isabelle Eberhardt died in a flash flood in the Sahara. Slimène gave this testimony:

> We were on the balcony of my room on the first floor. All of a sudden we heard a grumbling sound that sounded like a procession of trucks advancing. The noise grew louder and louder. People passed by, running. They cried out, "The wadi! The wadi!" I did not understand. The weather was clear and there was neither rain nor storm. The mass of water arrived in the bed of the ravine in an instant; it rose up like a wall; it ran like a galloping horse; it was at least two meters high; it was carrying trees and furniture, bodies of animals and men. I saw the danger and we fled. The torrent caught us up. I don't know how I escaped. My wife was carried away.

Isabelle Eberhardt's destiny, one of the most incredible there has ever been, had made its last claim on her.

Hubert Lyautey personally supervised the recovery of her body, which was dressed for burial in the uniform of an Arab cavalry-man. It was a simple Muslim funeral, one of more than twenty that took place that day. Under Lyautey's orders, the soldiers who cleared the debris after the flood picked through it carefully for any scrap of paper than might have belonged to Eberhardt. Page by page they brought their commander the nearly complete text of her last book, a collection of vignettes she had written for Victor Barrucand's newspaper, and the manuscript of the novel she had

been working on throughout the year. The pages were torn and mud stained and falling to pieces. Lyautey put everything in a box and sent it to Barrucand, in Algiers, who appointed himself Eberhardt's literary executor and published them in heavily redacted editions.

Isabelle Eberhardt's life was in a sense *too* fabulously eventful, inviting the pat dismissal of exote artists (often applied to Walter Spies, for example) that the life is more interesting than the work. At the time of her death, she was just coming into her full powers as a writer. Bursting with high ambition, Eberhardt was always hard at work on novels that she hoped would make her name, which she did not finish. Critics have tended to concentrate on these fragmentary novels and paid less attention to her shortest works, with the result that she has been perennially underrated.

Eberhardt's longest complete work published in her lifetime is *Yasmina*, a tragic melodrama of the fallen woman. She began it in 1899 and after many revisions published it in 1902, in a socialist newspaper, *Le Progrès de l'Est*. Yasmina, an Algerian shepherdess, fifteen years old, meets Jacques, a handsome French lieutenant, and they fall in love. After a romantic idyll, he is transferred to a post far away. She pines for him; he soon forgets her. When chance brings Jacques back five years later, with a pretty Parisian wife on his arm, he finds Yasmina a tubercular prostitute, her beauty ruined. He gives her a handful of gold coins, which she throws in the dust with a curse. She dies in the street, lonely and mocked.

Closely patterned on sentimental fiction that was fashionable at the time, such as *Madame Butterfly*, *Yasmina* has frequently been anthologized, but it is far from Eberhardt's best work. Here, the cultural overlay is shallow, perhaps unconscious: the novice writer takes French light fiction as her literary model and populates the familiar story with real Algerians, observed from life. The story's principal interest lies not in the pathetic narrative, which is predictable from the first page, but rather in its dark, gothic vision of the Maghrib. Yasmina lives amid the ancient Roman ruins of Timgad, "where, in the heart of the surrounding desolation,

floated the mysterious souls of abolished millennia." The landscape haunts the story like a Brontëan ghost, as much to blame for Yasmina's wretched end as the stock character Jacques.

The manuscript Eberhardt was working on in Kenadsa and Aïn Sefra was a good start on the big novel she so yearned to write. It opens in St. Petersburg with a narration of the rivalries among a circle of revolutionaries that is heavily influenced by Dostoyevsky, particularly his political thriller *The Possessed* (also translated as *The Devils* and *Demons*). Then the story follows Dmitri, a disaffected anarchist, as he leaves Russia and takes up an itinerant worker's life, culminating in his participation in a socialist revolt on the docks of Marseilles. Dmitri was the working-class hero that Eberhardt wanted Augustin and her husband to be. The fragment, 140 pages long in a published translation, ends soon after Dmitri arrives in Algeria and joins the French Foreign Legion.

Vagabond, as it is called in a new collection of Eberhardt's works, is a book of borrowed ideas, specifically European ideas, which is set in Europe, a place that was becoming alien to her after seven years in Africa. She had never been to Russia; for the first part of the book, she fabricated a literary impression of St. Petersburg based on her reading and what she had heard from her mother and Trophimowsky, a variation on the fictive process behind "Vision of the Maghrib." There is nothing really wrong with this torso of a novel, no shame in borrowing ideas, but it has a dutiful air, as though she were completing an assignment she set herself. Her best stories, all set in the Maghrib, are direct, visceral expressions of her soul, her response to the African landscape and her experience of Islam, with no need of big ideas. Reading Eberhardt's complete works discloses a writer whose natural format is the miniature. At their best, they approach the character of prose poems in the tradition of Baudelaire the flâneur, substituting the loneliness of the desert for that of the streets of Paris.

Eberhardt's most influential advocate in English was Paul Bowles. In 1975, City Lights published a slim collection of his translations of her stories, introduced by the biographical sketch I have quoted. Just eighty-eight pages long, *The Oblivion Seekers* constitutes a fine artistic legacy in itself. Two of the best stories in

the collection are from Kenadsa, among the pages that Lyautey saved from the mud. "The Breath of Night," two pages long, isn't a story at all but rather an intensely observed vignette, which reveals the nocturnal life of the village through shadows, scents, and sounds. After the last notes of music-making die away, "a breath steals across the terraces, disturbing the calm. I know. I imagine. I hear. There are sighs and catchings of breath out there in the cinnamon scented night. The heat of rut under the quiet stars. The hot night's languor drives flesh to seek flesh, and desire is reborn. It is terrible to hear teeth grinding in mortal spasms, and lungs making sounds like death-rattles. Agony! I feel like sinking my teeth into the warm earth." The conventional expectation is that the poet, surrounded by the sounds of lovemaking, would lament the absence of her own beloved, but Eberhardt expresses a deeper regret, at the grossness of the human condition. Her sense of alienation and disgust appears to be irremediable.

"The Oblivion Seekers" is an exquisitely wrought account of a visit to the kef den of Kenadsa, a ruined stone house with smoke-blackened walls "ribbed with lighter-colored cracks that look like open wounds." Every detail of Eberhardt's description contributes to the exotic atmosphere—embroidered leather cushions from Fez, a tiny potted rosebush, a copper kettle boiling on a tripod, a captive falcon on a rude palm perch—but they are presented coolly, as the objects one would expect to find there. She sketches portraits of three kef smokers: a player of the *guinbri*, a two-stringed mandolin with a body made from the carapace of a tortoise; a young Moroccan poet with caressing eyes; and a purveyor of magical medicaments, his skin tanned by years of following caravans from Senegal to Timbuktu. Brought together by chance, they take refuge from the dazzling light of the desert in this smoky hovel, seeking to arrive at the unknown through the disordering of the senses.

> The seekers of oblivion sing and clap their hands lazily; their dream-voices ring out late into the night, in the dim light of the mica-paned lantern. Then little by little the voices fall, grow muffled, the words are slower. Finally the smokers are

quiet and merely stare at the flowers in ecstasy. They are epi-
cureans, voluptuaries; perhaps they are sages. Even in the
darkest purlieu of Morocco's underworld such men can
reach the magic horizon where they are free to build their
dream-palaces of delight.

Sympathetic vibrations between Eberhardt's Moroccan minia-
tures and the stories of Paul Bowles are immediately apparent.
Some of her tropes could have been written by him: the kef den is
"like the antechamber of the room where the crime was commit-
ted"; "as at a disreputable hotel, you spend a few badly advised
nights there and go on." Her approving depiction of drug addicts
anticipates the lavish, incoherent fictions of William S. Burroughs,
who came to Tangier for hashish and the company of boys after
Bowles had established the American beachhead there. They were
following a decadent tradition that was already well established by
the time Oscar Wilde came to Algiers for a sex vacation in 1895
with his beloved Bosie, Lord Alfred Douglas. When André Gide
was twenty-six, on his first visit to Algeria, he met Wilde, who
initiated him into the mysteries of African sex.

In his memoir *Si le grain ne meurt*, translated as *If It Die*,*
Gide narrated his first tryst, a common exote scenario. At a louche
café deep within the Casbah, "a marvelous youth appeared in the
half-open door. He stood there for some time, his elbow raised,
leaning against the doorjamb, silhouetted against the backdrop of
the night." He pulled a rosewood flute from his vest and began to
play, beautifully. Wilde later told Gide that he was "one of Bosie's,"
and his name was Mohammed. "His large black eyes had the lan-
guorous glance that hashish gives; his complexion was olive. I ad-
mired his tapering fingers on the flute, the slenderness of his
child's body, the delicacy of his bare legs poking out of his billow-
ing white breeches." A waiter sat next to Mohammed and accom-
panied him on the *darbuka*, a small drum. Gide and Wilde sat

*The French title may be literally translated, "If the grain does not die," a heavy-footed
reference to Jesus's parable in the Gospel of Saint John: "Except a corn of wheat fall into the
ground and die, it abideth alone: but if it die, it bringeth forth much fruit." King James,
12:24.

quietly listening to them play for a long time, then Wilde took Gide's arm and led him into the alley.

Gide was crestfallen at the abrupt end to his erotic reverie. Wilde dropped a huge paw on Gide's shoulder and said in his deep voice, "Dear, do you want the little musician?" Gide summoned all of his courage to squeak, "Yes." Wilde sent their guide back to the café to collect Mohammed and led Gide to a shabby short-time hotel. Wilde held the key to a tiny two-room apartment there. The guide rejoined them with Mohammed and the *darbuka* player in tow, their burnooses pulled low over their faces. Wilde gave the inner room to Gide and Mohammed and remained in the outer room with the drummer. "Since then," Gide concludes, "every time I have sought pleasure I was chasing after the memory of that night."

Gide had written about the flautist Mohammed and the seedy café in a book published twenty years before *Si le grain ne meurt*, a slim volume of his North African journals titled *Amyntas*. In 1906, the homosexual panic in Europe was at its hysterical height, so the pedophiliac references are discreet, but sex is not his subject. In *Amyntas*, the North African landscape itself is the beloved. At its best, *Amyntas* is a successful experiment in painting gorgeous impressionist landscapes with words, which sometimes sound quite like Isabelle Eberhardt: "Here a redness lingers where the last fervor of the sun's rays is eroded, and here, touching the dunes, level with the ground, far away, a deeper crimson line, a streaming bleeding cloud, a kind of wound in the sky."

Gide makes continual, explicit reference to Virgil, including the title; in *The Eclogues*, Amyntas is the beloved of the shepherd Menalcus, a boy famous for his playing of the pipes. There are also echoes of Roman erotic poetry, such as an elegy by Tibullus, in which the frustrated poet addresses the bolted door of his darling Delia. Gide yearns to enter a walled garden with a grove of apricot trees, which is closed to him: "Earthen walls! detested walls! my endless desire besieges you; a day will come when I shall enter too!" In another piece, he enters a similar garden by stealth: "I made my way into this orchard like Aladdin into the garden of jewels; I walked, staggering, drunk all over again with ecstasy and

delight, letting the stammering alliteration of sun and shadow play within me. Not a sound, not a song, which was not of some bird. Doubtless at sunrise this garden is steeped in mist, I thought, for there remained everywhere something moist, something touching."

Amyntas has many such voluptuous, exquisitely observed vignettes, yet the continuous emphasis on the author's own refined sensibility, presented in contrast with the coarseness of everyone and everything around him, becomes monotonous. In one passage, he records waking in the morning with a "tremendous resentment against this country" because of the cold weather; he seeks relief by humming the entire score of Schumann's Third Symphony and reading Virgil's fourth eclogue, but they are not enough: "This morning I wish I could go to the Louvre and reread some La Fontaine." Gide was beguiled by the erotic glamour of African life and charged the desert landscape with its heady perfume, but he never entered into it spiritually, as Isabelle Eberhardt did. The otherness of little Mohammed was the essence of Gide's desire for him; when the shock of the Diverse wears off, the glamour dissipates. The reader of *Amyntas* feels that Gide will soon be back at the Louvre, and thus precisely fits Bowles's definition of the tourist as opposed to the traveler.

Isabelle Eberhardt's remarkable adaptation to the Maghrib might have been a unique case of a successful culture transplant, or it may simply be that her early death saved her from the inevitable disillusionment. The more ardent the admiration, the more bitter the chagrin; Gauguin and Segalen grieved over the degenerate state of Tahiti and the Chinese Empire as if they were dying lovers. For Arthur Rimbaud, the writer to whom Eberhardt has always, inevitably, been likened, the *neue Heimat* was just as tormenting as the birth home, like an unhappy second marriage he could not escape.

In fact, the lives of Rimbaud and Eberhardt are remarkably similar: a strict childhood, a phantom father, a close attachment to the mother (Rimbaud called his mother the Mouth of Darkness,

chiaroscuro to Isabelle Eberhardt's White Spirit), and a sentimental infatuation with a sibling, for Rimbaud his adored sister Vitalie, who died at seventeen. Rimbaud and Eberhardt shared a passion for vagabondage; both were heavy drinkers and smokers of hashish. If Abdallah ben Mohammed's saber had been sharper, it would have severed Eberhardt's left arm, to match the amputation of Rimbaud's right leg shortly before his death. At times, she almost seems to be trying to outdo him in suffering.

Rimbaud's move to Africa was an escape, in search not of paradise but of hell, a place to do the penance imposed by the curse that lay upon his head. The Rimbaud legend requires damnation as the counterbalance to his charmed youth. His farewell to Europe was accomplished in stuttering fits, beginning with the impulsive flight to the Indies in 1876. It was at this time that some would have him begetting Isabelle Eberhardt. Françoise d'Eaubonne even fixed a date for Isabelle's conception: May 16, 1876. On that day, Rimbaud, twenty-one years old, was en route from Charleville to Flanders, where he would volunteer as a soldier in the Dutch colonial army. Geneva was 250 miles in the wrong direction; in order for d'Eaubonne's scenario to work, Rimbaud would have had to dash to Switzerland, find Nathalie de Moerder and discharge his stud duty, and then be on the first train to Holland to arrive in time for his embarkation for Java, on May 18.

Rimbaud's tropical adventure came to an abrupt end three weeks after his arrival in Java, when he deserted his post and returned to Charleville by stealth. This escapade was followed by a stint as a roustabout with a circus in Scandinavia, then a mysterious sojourn at a monastery in Marseilles, where he was "living by theft and doing something worse with a cynical Capuchin." After he settled on a move to Africa, en route to the Red Sea he worked as the boss of a construction crew in Cyprus. He had to quit the job in a hurry after he killed one of his workers unintentionally (or so he said), when he lost his temper and threw a stone that struck him on the temple. In August 1880, Rimbaud found a stopping place in Aden, with a position at Alfred Bardey's export firm.

A few months after he hired Rimbaud, Bardey returned from

an expedition in Abyssinia with exciting news: he had visited the thousand-year-old walled city of Harar, which had been un-broached by the infidel for centuries until Richard Francis Burton's stealthy visit there in 1855. With his usual flair, Burton called Harar the Timbuktu of East Africa, "the ancient metropolis of a once mighty race," celebrated as "the reported seat of Moslem learning, a walled city of stone houses, possessing its independent chief, its unknown language, and its own coinage." Harar was now under Egyptian control, and Bardey had obtained permission to establish the first foreign trading post there. Rimbaud led the first caravan to Harar, accompanied by a young Greek in Bardey's em-ploy named Constantin Righas, whom Victor Segalen would meet and interview twenty-four years later.

Until his death in 1891, at the age of thirty-seven, Rimbaud worked as a commercial trader in Harar and Aden, with occasional forays to remote places such as Shewa and a remarkable expedition to the Ogaden plateau in the Somali region of Abyssinia, the first ever completed by a foreigner. He reached the Webi Shebele, a sa-cred river known to the Somali as "the place where the elephants go to die"—a source for the legend of the Elephants' Graveyard, memorably romanticized by the film *Tarzan the Ape Man*, starring Johnny Weissmuller. Rimbaud did not find treasure in Abyssinia, only grinding hard work.

The record of Rimbaud's life is speckled with hints that he might have converted to Islam. In Harar, he translated the Koran, as his father, a soldier, had done when he was posted in Algeria. At some point, Rimbaud had a gold signet made with the Arabic in-scription ABDO RINBO, an abbreviation of "Abdallah Rimbaud," meaning "Rimbaud, servant of God"; converts to Islam often take the name Abdallah. In the Pléiade *Album Rimbaud*, Henri Matarasso and Pierre Petitfils, sounding almost confident, assert that he "became, in manners and spirit, Mahometan." If Rimbaud experienced a sincere conversion to Islam, it did not bring him the spiritual clarity and resolve he sought. In a despairing letter to his sister Isabelle, after the amputation of his leg, he uttered this cry *de profundis*: "All these worries are making me crazy. I don't get a moment of sleep. Finally, our lives are misery, a misery without

end. Why, then, do we exist?" It is difficult to conceive of a more un-Muslim question.

Few people anywhere were asking this question in 1891, but it would soon become a preoccupation of European art and literature: Rimbaud's final prophecy. At Kenadsa, a medieval citadel of mystics lost in a wasteland *hors frontières*, Isabelle Eberhardt asked her journal, "Is all my thirst finally going to be quenched?" It was a different question, perhaps, but she got the same answer.

The figure of the lithe young man swathed in billowing white robes that fascinated Isabelle Eberhardt found its living incarnation after her death, in androgynous, enigmatic T. E. Lawrence, who also grew up not knowing who his father was. *Seven Pillars of Wisdom*, Lawrence's memoir of the Arab Revolt, is among the finest works of literature to come out of a war that produced some masterpieces. Epic in scale and lyrical in execution, the narrative is driven by an urgent goal precisely parallel to Byron's mission in Greece, to liberate the Arabs from their Ottoman overlords. On his visits to British command in Cairo, Lawrence proudly wore the white silk robes, golden head rope, and dagger of the elite corps of the Sharif of Mecca, gifts of Emir Feisal, the leader of the revolt. Lawrence entered wholly and imaginatively into the life of the Arabs, a passion that ended for him as it had for Raden Saleh, with a divided heart.

Yet Lawrence was as sterling an English hero as any produced by the empire. In his first chapter, Lawrence articulates with merciless candor the spiritual risks of cultural reassignment:

Pray God that men reading the story will not, for love of the glamour of strangeness, go out to prostitute themselves and their talents in serving another race. A man who gives himself to be the possession of aliens leads a Yahoo life, having bartered his soul to a brute-master. He is not of them. He may stand against them, persuade himself of a mission, batter and twist them into something which they, of their

T. E. Lawrence in the regalia of the Sharif of Mecca, photograph by B. E. Leeson, 1917

own accord, would not have been. Then he is exploiting his old environment to press them out of theirs. Or, after my model, he may imitate them so well that they spuriously imitate him back again. Then he is giving away his own environment: pretending to theirs; and pretences are hollow, worthless things. . . . In my case, the efforts for these years to live in the dress of Arabs, and to imitate their mental foundations, quitted me of my English self and let me look at the West and its conventions with new eyes: they destroyed it all for me.

The overwrought talk about prostituting oneself and bartering the soul to a brute master has provided rich material for critics with a psychoanalytic agenda. Lawrence was well supplied with sexual neuroses, but he also had the gift of self-knowledge. The primordial conflict between East and West, the faithful and the infidel, between civilization and barbarism viewed from both sides of the question, was enacted in one man's soul. Aware that his English self could not coexist with Lawrence of Arabia, he ran away, or tried to. *Seven Pillars of Wisdom* concludes with his final meeting with Edmund Allenby, his supreme commander, two days after the fall of Damascus. Amid the chaos of quarreling Arab chiefs and scheming foreign diplomats, he asked "leave to go away." Allenby granted the request, Lawrence wrote, "and then at once I knew how much I was sorry."

Of course the story did not end there. Lawrence went to the Paris Peace Conference in 1919 as a member of the Arab delegation headed by Emir Feisal. Two years later Winston Churchill, then serving as colonial secretary, recruited Lawrence and Gertrude Bell for the Cairo Conference, which, among other business, drew the political boundaries for the British mandate in the Middle East. The two waged a vigorous, ultimately successful campaign for the creation of Iraq and Transjordan (renamed the Hashemite Kingdom of Jordan in 1946), to be ruled respectively by Feisal and his brother Abdullah as kings.

Meanwhile, Lawrence was transformed into one of the first media icons, thanks to Lowell Thomas, the American broadcaster,

who had filmed him at the front during the war. In 1919, Thomas presented *With Allenby in Palestine and Lawrence in Arabia* at the Royal Opera House, which had a sensational success. Lawrence did not seek celebrity, but he continually abetted it; as Thomas said, he had a genius for backing into the limelight; and when fame came to him, it was on a Byronic scale. The press besieged his home, and he was stopped continually on the streets of London. Lawrence took fright and fled, seeking oblivion. He volunteered first for the Royal Air Force under the name John Hume Ross, and then as T. E. Shaw for the Royal Tank Corps, which he served as a private. He solaced himself with classical studies and published an intensely colorful prose translation of *The Odyssey*.

Yet Arabia was always on his mind. Lawrence urged the Royal Air Force to send one of its new airships, the hydrogen-lifted R100 and R101 dirigibles, to fly over the Rub' al-Khali, the "Empty Quarter," the vast sand plain that occupies most of the southern half of the Arabian Peninsula. At that time no one, including the nomads who lived on its fringes, had crossed it. "It will mark an era of exploration. Nothing but an airship can do it," he wrongly predicted, "and I want it to be one of ours which gets the plum." He also contemplated an expedition to the Empty Quarter in search of the lost city of Ubar (or Wabar), which was identified with Iram, described in the Koran as a city of "lofty pillars, the like of which were not produced in all the land." The city was said to have enjoyed vast wealth from the frankincense trade, until the Lord destroyed it to punish the wickedness of its king. Lawrence called it the "Atlantis of the Sands."

Lawrence after Arabia became a speed addict, with a collection of Brough Superior motorcycles and a Biscayne Baby speedboat, the *Biscuit*. He told the American poet Laura Riding that "speed, and especially the conquest of the air, was the greatest achievement of civilization." In 1931, after he witnessed a seaplane crash in which several airmen drowned before they could be rescued, he persuaded his superiors to develop high-speed rescue boats. Lawrence himself volunteered as a test pilot of the new craft. In March 1932, he made a voyage of 740 miles from Southampton to Fife in a rough sea.

As his enlistment drew to a close, Lawrence attempted to repair his inner cultural rift by a steep downward move in class. When Robert Graves ran into him in London, he reported that Lawrence spoke with an accent "one associates with men who drive lorries" and had a mouthful of gold teeth. "Common-clay vulgarity," sniffed Graves, who had published an early biography of Lawrence and thus had a stake in the legend. Lawrence later wrote to him, "Come off it, R.G.! I live all of every day with real people, and concern myself only in the concrete. The ancient self-seeking and self-devouring T.E.L. is dead." Yet Lawrence the workingman was just another disguise: the authentic Lawrence, if there ever was one, had been swallowed up in the sands of Arabia.

He died in a motorcycle accident in Devon in 1935, near the cottage where he lived in virtual retirement, at the age of forty-six. There was nothing suspicious about his end—he suffered a head injury after he swerved to avoid hitting two boys on bicycles and was thrown over the handlebars—but it was a freakish irony that a soldier who had lived so dangerously should be extinguished on a fine spring day on a country lane in Devonshire.

Possessed by Rhythm

Beware! Beware!
His flashing eyes, his floating hair!
Weave a circle round him thrice,
And close your eyes with holy dread
For he on honey-dew hath fed,
And drunk the milk of Paradise.
—Samuel Taylor Coleridge, "Kubla Khan"

In September 1947, when Maya Deren set off on a voyage she had carefully plotted as a life-changing adventure, she was nursing a broken heart. At thirty the most admired experimental filmmaker of her generation, she had won the top prize for independent film at the Cannes festival and a Guggenheim Fellowship, the first ever awarded for creative work in motion pictures. When she boarded a freighter in New Orleans bound for Haiti, her brain was furiously buzzing with artistic dreams and high hopes for her new film, but her journal of the voyage was mostly devoted to melancholy regrets about the end of her love affair with Gregory Bateson.

The two lovers had planned the trip to Haiti as a creative honeymoon, to immerse themselves in the life of voodoo and film its ecstatic rituals together. Nine months before, Deren had had a formal meeting with Bateson and his wife, Margaret Mead, to request permission to study the film they had shot in Bali with the help of Walter Spies, and perhaps use footage from it for her new

film, which was conceived as a cross-cultural study of ritual. By September, she had divorced her husband, the Czech film director Alexander Hammid, and Bateson's marriage was on the rocks after Mead learned about the affair. Deren and Bateson booked passage to Port-au-Prince, planning to marry just before they sailed. Yet by then the hot passion of their love had cooled, at least for Bateson, and for Deren the relationship had ended in trauma.

So she was traveling alone. "It goes up and down," she writes in a typical passage in her journal. "At first a sense of freedom and that it is right and has to be this way—and then, because in the street the beggars play 'Peg o' my Heart,' and I see in the distance a tall figure in khaki—there is a sense of anguish and loss." Many pages are addressed directly to Bateson: "These past days have been full of you and full of a growing anguish as it has become increasingly clear to me that I have been infinitely destructive in my stupidities"; elsewhere, "Oh Gregory, Gregory, there is a hunger in me for all we had."

On the night train from New York to New Orleans, she has trouble sleeping. "I go to bed at 8—I dream a bit, turn on the light, read nonsense in an old *Reader's Digest* borrowed from a woman who shot herself with cocaine in the ladies room—for migraine, she said. An elderly, respectable woman—and I had suddenly an image of what her life might be internally." Deren steals an ashtray from the ladies' room and smokes in her berth, with the ventilator turned up full blast. "I take out my flask and have a drink from the silver cup and remember that there are two—one for Gregory." After she boards the ship in New Orleans, she writes, "Until the very last minute I expect Gregory to have wired—even perhaps flowers to the boat."

When the ship docks in Havana, Deren observes a game of craps through her porthole. "When I first heard it the voices were so amazingly formalized, and the shouts like the shouts of some religious ceremony. One does not say simply 'I bet,' one says a ritual sentence, always the same or with a highly formalized variation, such as 'A dollar he's wrong.'" She sketches a quick scenario and notes, "Wonderful—magic & money. . . . I must film this at some point." She writes descriptions of the tints of blue in the sky and

sea that are as detailed and delicately shaded as those Lafcadio Hearn wrote about the same sky and sea. On the last night before the ship arrives in Haiti, she throws a champagne party for the friends she has made on the voyage, "partly out of the desire to leave a trail of goodwill behind me—as a seraph might leave its gleaming—and partly out of a desire to buy, with some sort of meaningless extravagance, the good luck that I wish for Haiti."

On her first day in Port-au-Prince, after checking into her hotel, she walks into the city to buy stamps. "I passed a bookstore that had all the old familiar poets of my thesis in the windows (Symbolists)." At the post office, she begins her first romantic intrigue in Haiti: "I was spoken to by a very charming, very young boy." (Deren always referred to young men and women as boys and girls; by "very young boy," she means around eighteen.) She carefully writes down his name, Gerard Cantave, and his four-digit phone number. They leave the post office together and stop for a drink; in the evening they meet again for dinner. "Very nice evening. Talked, intellectual." She stays out too late and must raise the night porter at the hotel to unlock the front door for her.

The next day, Deren goes to her first voodoo ceremony. "I have just washed all the mud from my feet and sandals, and sitting here I can still hear the drums of the ceremony which I just left." She has witnessed the *houngan*, the voodoo priest, being possessed by the god. Possession is an essential element of a voodoo ceremony, when a divinity (properly, the *loa*), summoned by the drums, enters the sacred precinct and takes temporary control of an entranced celebrant. In voodoo parlance, the *loa* mounts the believer as a rider mounts his horse; during the ceremony, the spirit speaks and acts through his mount, who will remember nothing of the experience when the *loa* departs.

Deren writes, "Feeling my way, didn't want to get in the way or be conspicuous, so remained on the outskirts. Wonderful drumming. Felt like dancing." She concludes, "See it is important to get established in a community if not to be forever relegated to the outskirts."

The next day she dines with Gerard Cantave and a man named André. After dinner, they follow the music of the drums and attend

another ceremony. She feels the urge to join the dance but resists it. For the first time, she experiences the beauty of the dance movements, "very smooth and elegant." The disjointed passage breaks off, "Beauty and poetry of it." After Deren's arrival in Haiti, her journal becomes more fragmentary; Gregory Bateson disappears from its pages quickly.

The entry for the following day is enigmatic but appears to describe a development in her blooming relationship with the charming, very young boy Cantave: "Afraid I might have made a mistake—but always hope that geography need not be the only indication of distance." Her entry for September 24, her sixth day in Port-au-Prince, reads, "Argument with Cantave. *Maladie de la beauté*": the disease of beauty. It is the last entry in the notebook; the journal that followed it, if there was one, is missing.

She was born Eleanora Derenkowsky in Kiev, the daughter of a stern psychiatrist father, Solomon Derenkowsky, whom she described as "looking like the Smith Brothers on the cough-drop box," and a sharp-witted, affectionate mother, née Marie Fiedler, whose own mother had been a doctor; Marie's medical studies had been interrupted by the revolution. Socialists and secular Jews, the Derenkowskys immigrated to the United States when Eleanora was six to escape the anti-Jewish pogroms in the newly formed Soviet Union. The family settled in Syracuse, New York, where Solomon Derenkowsky was appointed to a high position at the State School for Mental Defectives.

For three years, from the age of thirteen, Eleanora studied at an elite boarding school in Geneva, the League of Nations International School. Marie accompanied her, as much to escape her domineering husband as to be with her daughter. After their return to America, Eleanora, now a naturalized citizen with her family name shortened to Deren, enrolled at Syracuse University, where she majored in journalism and political science. She wrote for the college newspaper and was a leader of the Young People's Socialist League. In his biographical sketch of Deren, the avant-garde filmmaker Stan Brakhage tells "one of the early legends of

Maya Deren," about her activities as a young socialist. When she was still in her teens, he writes, the league sent her to Oregon to support lumberjacks who were trying to organize a strike. They had buckled under pressure from the bosses, but brave, indefatigable Deren "threw herself into the effort and single-handedly organized a wildcat strike that was successful. There has been a lot of debate whether this is a true story, but anyone who ever met Maya, as I had, or simply seen her films . . . would believe that she was able to do such a thing."

At eighteen, she married her boyfriend, Greg Bardacke, a campus activist who attended the university on a football scholarship. She met him, she later wrote, "at a socialist protest meeting against discrimination against negroes." The newlyweds organized and gave speeches at peace rallies. A year later they moved to New York City, when Deren transferred to New York University, where she graduated with a bachelor's degree. She stayed on in New York to pursue a literary career, which reduced her active participation in political causes, but her commitment to social justice never declined. In 1938, she divorced Bardacke and enrolled in a master's degree program at Smith College, where she wrote a thesis with a Trotskyist edge, about the influence of French Symbolist poetry on T. S. Eliot and Ezra Pound.

Well educated and poor, now on her own in Manhattan, Deren began a search for any sort of editorial work that would keep her out of the typing pool. She translated a novel from the French, *Conquered City*, by the Bolshevik revolutionary Victor Serge, and read new French books under consideration for translation by Simon & Schuster. She started a detective novel in collaboration with her mother. Deren's main source of income was work as a freelance researcher, assisting established authors such as the American radical Max Eastman and the polar explorer Vilhjalmur Stefansson.

The most intriguing entry on her résumé was assisting William Seabrook in his research for a book on witchcraft. Deren met the author of *The White Monk of Timbuctoo* in Martha's Vineyard the summer of 1939 after completing her studies at Smith. He had made his name ten years before with *The Magic Island*, the first popular book about Haiti. It was followed by *Jungle Ways*, a

sensational account of his exploits in West Africa, which described his participation in a cannibal feast in Côte d'Ivoire. Deren helped Seabrook with his research for *Witchcraft: Its Power in the World Today*. At the conclusion of that assignment, he invited her to come to his estate in Rhinebeck, New York, to participate as a subject in experiments he was conducting about extrasensory perception. She took him up on the offer in February 1940, at the rate of twenty-five dollars a week plus room and board. Afterward, Deren wrote a long letter to her friend and lover Herbert Passin, an anthropologist at Columbia University, describing the experience.

The Seabrook estate was deep in the woods of the Hudson Valley. There were two buildings, the main house and, a quarter of a mile away, a converted barn with a formal dining room on the ground floor and Seabrook's studio upstairs. Deren wrote to Passin, "It was a large beamed room filled with the fantastic objects you find in the African room of the museum," wooden masks, tapestries, weapons, jewelry, and "strange leather things hanging from the ceiling." She described Seabrook as "a healthy-looking, slightly florid man with a pug nose," about forty-five, and his wife was "rather good-looking." Marjorie Seabrook never came near her husband's studio, for reasons that soon became obvious.

Seabrook told Deren that he was conducting experiments on the effects of sensory deprivation, for which he had created a head mask perforated only by a narrow slit for breathing. "It was reasonable and interesting," Deren wrote. She thought she would be a good subject for Seabrook's experiment and told him so. However, when he described how the experiment would proceed, she realized that he was a sadist who invited women to his estate to gratify his erotic fantasies. Some of the "experiments" lasted less than a day, such as one that required the subject to stand on tiptoe for six to eight hours, and another in which she was confined in a medieval sensory-deprivation device called the witch's cradle. In longer sessions, the woman was locked in a small wooden cage or made to wear the head mask, with her hands tied, for three to five days. As an afterthought, Seabrook added three conditions that applied to all the procedures: the subject was to be completely nude; if she failed to complete a task, the punishment was whipping ("not too severely, he said"); finally, she was allowed to ex-

press herself only by making animal noises. Any human speech would also be punished by whipping.

Seabrook's true motive was clear, but Deren argued with him as if they were at a graduate seminar at Smith, pointing out the inconsistencies between these sadomasochistic activities and his professed scientific goals. "I wanted to make him say it out loud," she wrote to Passin. "He finally said, 'It is obvious I wouldn't go to all this trouble for materials of dubious value on extrasensory perception unless I got some erotic pleasure from seeing attractive young girls acting like animals.'" He claimed that he had many takers, and some of them did not ask to be paid. Seabrook amiably accepted Deren's refusal and left her to sleep in the studio with its collection of ritual paraphernalia and a lustful tomcat that bothered her all night.

Deren wrote that it was not until the next day on the train back to the city that she realized "the extreme cunning of the man." His prey were transported from the familiar world of twentieth-century New York to a secluded domain of exotic magic, where "he spoke to you about the entire procedure in so casual and usual a tone that it seemed normal." She imagined that some bored suburban girls might find a thrilling, forbidden pleasure in it, but memories of her bizarre trip to Rhinebeck disturbed her sleep for months afterward.

The letter concludes with a poignant gust of youthful candor and hope, interfused with a young person's unease at the obscure prospect of her destiny, just beginning to make itself known: "I am a little surprised at how full life is so constantly, how many adventures it has for me—and I don't quite understand why all these things happen to me. And because I don't quite understand why they do, I am afraid that they may stop happening and I don't quite know how to hang on to the wonder it all has for me." One year later, life surprised her with an adventure that set her on a new course, which would eventually lead to Haiti.

Deren had a gift for writing business letters that got replies. Her association with Katherine Dunham, an anthropologist who founded the first African-American dance group in the United

States, began with a letter in which she shrewdly presents herself as a fan. She tells Miss Dunham that she has seen *Cabin in the Sky*, her long-running Broadway show, seven times; she mentions their mutual friend Herbert Passin and declares that she herself has "a very deep feeling for the dance with some uncultivated talent in that direction." Then she makes a bold proposition. She describes a children's book about dance movement that she wants to write: "The approach would be anthropological but not academic," illustrated with "drawings of the poetry in motion." The letter ends with a coy demurral: "I dare not jump so far ahead as to suggest some sort of collaboration," though that is obviously what she has in mind.

Dunham's answer does not survive, but it must have been encouraging, or perhaps the two women met in person, for three weeks later Deren wrote to Dunham again with impressive news about her progress in finding a publisher for "our editorial labors" and an offer to share her literary agents. The future filmmaker made a prophetic proposal for the children's book: she suggested printing, on the upper corners of the book's recto pages, consecutive stills from a short film Dunham had shot in Haiti of a boy dancing, thereby embedding a mini–flip book. The book was never published, but Dunham hired her as her personal assistant for a national tour of *Cabin in the Sky*, a musical with an all-black cast starring Ethel Waters, staged by George Balanchine.

A petite, voluptuous beauty who exuded a magnetic personal charm, with an unruly shock of auburn hair sometimes hennaed flaming red, Deren made herself indispensable to Dunham. Although many northern and midwestern states had laws prohibiting racial discrimination in hotels and restaurants, they were widely flouted with impunity. Deren's correspondence is filled with urgent pleas to promoters and hoteliers on the tour itinerary, alternately complaining and begging for rooms at the better hotels, at least for Dunham and Ethel Waters. Alexander Hammid, Deren's second husband, told the authors of *The Legend of Maya Deren*, the definitive but incomplete biography of the artist, that Deren herself "looked kind of odd. She was looked on as a black trying to pass for white, so there were problems."

Born in Chicago in 1909, Katherine Dunham was the daughter of a black man descended from African slaves and a French-Canadian mother, who owned a dry-cleaning business in Joliet, Illinois. After she graduated with a degree in anthropology from the University of Chicago, where she studied with Bronislaw Malinowski, Dunham went to the Caribbean to study relicts of African dance performance in the New World. She was one of the first artists of the African diaspora to undertake a search for her heritage. She traveled throughout the Greater Antilles, ending in Haiti in 1936, where, as Joan Dayan writes, "the pride of the Haitian black majority—those peasants who speak Creole and practice vodou—led her to choose the first Black Republic as her spiritual home."

Dunham's dance career gained ascendancy over academic studies after she performed with the Chicago Opera Company in a ballet based on a West Indian tale as told by Lafcadio Hearn, which led an invitation to present her own company at the 92nd Street Y in New York. After appearing in several musical revues on Broadway, the Katherine Dunham Dance Company was hired for *Cabin in the Sky*, with Dunham in the role of the seductress Georgia Brown. She worked closely with Balanchine on the choreography. Vincente Minnelli, in his debut, directed a film of *Cabin in the Sky*, which cast bankable Lena Horne as Georgia Brown, but Dunham eventually found a few good Hollywood roles and worked as a choreographer for movies that sought a lively dose of exoticism.

Dunham was a star, but the color bar in Hollywood was rigidly in place, and despite her fresh, girlish beauty and abundant talent she was never the headliner. She performed in low-budget, high-quality "race movies" with all-black casts, such as *Stormy Weather* (1943), and had a few electrifying cameo roles in films with foreign settings, such as her turn as a nightclub owner in *Casbah* (1948), set in Algiers. The modern-dance stage was more receptive to black performers, but the most inviting venues were overseas. The Katherine Dunham Dance Company toured the world for years, with its headquarters at Habitation Leclerc, a rural estate in a village called Croix-des-Missions, near Port-au-Prince.

Katherine Dunham in costume, 1956

Deren's association with Katherine Dunham gave her her first taste of Haitian dance and music, creating a thirst for the particular Other that would eventually become her all-consuming passion. In an interview in Martina Kudláček's essential documentary *In the Mirror of Maya Deren*, Dunham revealed her affectionate admiration for Deren as well as the difficulties entailed by employing a self-confident, intellectually brilliant woman in a subordinate role. "I had to keep my eye on Maya at times," Dunham remarked. "I had to remind her now and then [who was boss]." At first Dunham was annoyed by Deren's lack of deference, but, she said, "I got over that, because I saw she was a serious person, and because she got on so well with the Haitians."

At the conclusion of the national tour of *Cabin in the Sky*, in Los Angeles, Dunham tried to start a new career in film for her company. She frequently invited producers and studio executives to see them rehearse. "Maya was wonderful at meeting them at the door, making introductions, seating them, and so forth," Dunham said, but after the show started, Deren couldn't sit still. "She was very well-built and robust, you know, and her little simple frocks were quite low-cut in front. After a while she couldn't stand it, she would feel it growing and growing within her—she would turn to the person next to her and say, 'How *can* you sit still?' and start dancing in her seat." Dunham had to have a word with her; she couldn't let her personal assistant upstage the performers by boogieing in her seat. "There was a gleam in her eye when the drummers took their positions and began to play," said Dunham. "The drums really took her over. Maya was possessed by rhythm."

At a cocktail party at the home of Meyer Levin, the film critic for *Esquire*, Deren met the Czech filmmaker Alexander Hackenschmied, who was in the process of changing his surname to Hammid. Sasha, as he was known to his friends, introduced her to film, which she quickly adopted as her own métier. Soon after they met, Deren resigned her job with Katherine Dunham, and she and Hammid set up housekeeping in a bungalow off the Sunset Strip. By the end of the year, they were married.

A gentle, earnest man with passionate political convictions to match Deren's, and ten years older, Hammid was the loving

mentor her father had never been. He had already established a successful career in film and was credited with creating the avant-garde cinema in Czechoslovakia, with a short film called *Aimless Walk* (1930). After shooting a documentary about the Nazi invasion of Czechoslovakia with the leftist American film-maker Herbert Kline, Hammid immigrated to America to avoid reprisals. Settling in Los Angeles, he found a day job shooting for the March of Time, a newsreel production company, but he was keen to return to creative cinema, and saw Deren as the catalyst and screen presence he needed. When she told Hammid that she had never thought of herself as Eleanora and wanted to change her name, he suggested Maya, the Sanskrit word for illusion: a new name for a new career, a new life.

Later Hammid recalled, "She said one day, 'Why don't we make a film?' And so we did." The film was *Meshes of the Afternoon* (1943), which has been called the most widely viewed experimental film after *Un chien andalou*, by Luis Buñuel and Salvador Dalí. Hammid described the dynamic of his collaboration with Deren: "She was writing poetry always. It was one of her main ambitions. She started with poetic images on paper, and I was visualizing them. And so we made *Meshes*, kind of a home movie." Shot on a budget near nothing at their Spanish-style bungalow on North Kings Road, which winds up into the Hollywood Hills, it was an experiment in purely subjective film. "This film is concerned with the interior experiences of an individual," Deren wrote in her program notes. "It does not record an event which could be witnessed by other persons. Rather, it reproduces the way in which the subconscious of an individual will develop, interpret, and elaborate an apparently simple and casual incident into a critical emotional experience."

She continues with a detailed synopsis that begins, "A girl, on her way to the house of another person, finds a flower on the road and carries it with her." The door of the house is locked. She fumbles with the key, which falls down a staircase; she retrieves the key and finally gains access. The house is deserted, but a phonograph is playing, the telephone is off the hook, the bed is unmade. A knife rammed into a loaf of bread falls to the table. The

girl settles in a chair by the window to wait. She falls asleep and has a dream in which the previous events are reenacted with unsettling permutations. Knife, key, flower, and staircase are standard elements of Freudian dream interpretation, but Deren, in a lifelong rebellion against the man on the cough-drop box, rejected any psychological interpretation of her films.

It is doubtful whether any other thirteen minutes of film have been analyzed and written about as much as *Meshes of the Afternoon*. The film fits one conventional definition of great art, that it continues to speak, having new things to say, to everyone who views it. One of the perennial issues is that of authorship: the opening frame states that it is a film by Maya Deren and Alexander Hammid, presumably an alphabetic credit, but it soon became known as her film, though the polished craftsmanship is Hammid's work. Film scholars and critics out for revisionist scalps have sought to minimize Deren's contribution; yet regardless of how one deconstructs the film, its overwhelming impression comes from the screen presence of Deren herself, her expressive movements, her manifest inner energy when at rest, and above all her face. Anaïs Nin wrote this portrait of Deren in her diary immediately after they met: "Under the wealth of curly, wild hair, which she allowed to frame her face in a halo, she had pale blue eyes and a primitive face. The mouth was wide and fleshy, the nose with a touch of South Sea Islander fullness." Alternately serene and animated, sensual and abstract, Maya Deren's face is among the most compelling images of the cinema, an imperishable icon to rival Garbo and Valentino.

A year later, in 1944, Deren completed her first film credited as solo director. *At Land* took an even more radical approach to narrative by interpenetrating several dreamlike visual worlds and presenting them simultaneously. It begins at the beach, with Deren being washed up onto the shore like flotsam. Slowly she climbs a tall, jagged piece of driftwood; when she reaches the top, she raises her head and peeps over the edge of a table in a stately dining room with art deco chandeliers, where a party is about to break up. Well-dressed men and women are smoking and drinking, deep in animated conversation. Again the girl is climbing the driftwood,

but this time she arrives in a dense forest, which scarcely admits her passage. She crawls first through the forest, then down the long dining table, cleared of plates, but none of the guests see her. She is invisible. At the end of the table, a chess game is in progress; as the guests rise from the table and say farewell to each other, the chessmen magically begin to move themselves as the girl watches in wonderment. Then a pawn falls off the table's edge into a tidal pool on the beach.

Such is the action of the first four minutes of *At Land*, which proceeds with the same density of incident and imagery for just under fifteen minutes. P. Adams Sitney, in his history of the American avant-garde cinema, cites it as "the earliest of the pure American trance films." The exterior scenes were filmed on Long Island, after Deren and Hammid had moved back to New York. Deren missed the city, and Hammid had been offered a lucrative job there making propaganda films for the Office of War Information. Before *At Land*, Deren had started and left unfinished a film with Marcel Duchamp as one of the principal performers. Filmed at Peggy Guggenheim's Art of This Century gallery on West Fifty-Seventh Street, the film is now lost. Hammid recalled that Deren once projected a rough cut for friends, but all that survives of the film is a reel of disconnected snippets, most of them under ten seconds long.

The film was called *Witch's Cradle*. A few months before Deren shot the film, William Seabrook published an article in André Breton's *VVV* magazine, in which he described an experiment in bondage that was much tamer than those he had proposed to Deren. The subject sat on an ancient Egyptian throne in his studio while Seabrook wrapped her in "a fragile web of fine silken thread," the central image in *Witch's Cradle*. One of the longer surviving takes shows Duchamp playing a string game with his hands, while a young woman, played by Pajorita Matta, sitting opposite him, envisions the thread coming to life and coiling around his body like a gracile snake.

In New York, Deren and Hammid lived in the top-floor apartment of a brownstone on Morton Street, in Greenwich Village. They entertained constantly. Leo Lerman, the legendary editor at

Vogue, recalled, "They had a wonderful way of living. They had good things to eat all the time. You had a *very* good time, and it was *every* week, week in and week out. It never stopped, and it was everybody you could think of." Dylan and Caitlin Thomas turned up at one party and wreaked havoc. As Anatole Broyard narrated the scene in his memoir, Caitlin was drunkenly destroying Deren's precious collection of ritual objects from Haiti. "Plunging her fingers into her curls, [Deren] cried, like an Ibsen heroine, She's smashing my universe!" Isamu Noguchi recalled that Deren had been "much more demure" when he met her in L.A. "I felt that she blossomed in New York, as she took in more and more territory of her own. She literally took possession of movie-making. She was a very modern person, for that time."

The Morton Street apartment was the archetype of the beatnik crib. A skylight on the north wall of the studio filtered daylight into a large, open room furnished with found objects. Three couches rescued from the streets often served as beds for friends or visitors. The fireplace was crowded with Chianti bottles serving as candleholders. A year-round Christmas tree, an umbrella frame hung with colored glass balls, was suspended from the ceiling. Deren never had enough money to finish her films, or even to pay the rent, but she collected works of art that she deemed necessary to her existence. She owned a watercolor by Paul Klee she had bought for a hundred dollars in Los Angeles and an early abstraction by Adolph Gottlieb that she acquired impulsively, Hammid said, "out of pure love for the painting." The pride of her collection was a glass collage that Duchamp gave her. The apartment was always full of quarrelsome cats.

James Merrill met her in 1945, when he was nineteen, and became a lifelong friend and patron. He immortalized Deren, or rather resurrected her, in *The Changing Light at Sandover*, in which Deren is one of the principal spirit voices. In "The Book of Ephraim," published in 1976, he wrote this sketch to introduce her, at home on Morton Street:

Deren, Eleanora ("Maya"),
1917–61, doyenne of our

American experimental film.
Mistress moreover of a life style not
For twenty years to seem conventional.
Fills her Village flat with sacred objects:
Dolls, drums, baubles that twirl and shimmer,
Stills from work in progress, underfoot
The latest in a lineage of big, black,
Strangely accident-prone Haitian cats.
Dresses her high-waisted, maiden-breasted
Person—russet afro, agate eyes—
In thriftshop finery. Bells on her toes,
Barefoot at parties dances.

After *At Land*, Deren produced two more films quickly. *A Study in Choreography for Camera*, just three minutes long, featured Talley Beatty, a soloist with the Katherine Dunham Dance Company, as the principal performer. The film might be better characterized as a duet between dancer and camera, an experiment that would have a long afterlife in the filming of dance. *Ritual in Transfigured Time* was another experiment, using the simple techniques of altered film speed, freeze-frame, repetition, and negative image to create simultaneous layers of reality. In the first scene, Deren and Rita Christiani, another soloist with the Dunham company, perform a pas de deux in a dreamlike domestic interior that involves winding and unwinding string, as in *Witch's Cradle*. The next scene is a crowded cocktail party at which the guests, including Anaïs Nin and Gore Vidal, continually greet one another, followed by an extended elegiac dance sequence in an Arcadian sculpture garden. At the film's end, Deren runs jubilantly into the sea, from whence she had emerged in the opening of *At Land*.

Just over fourteen minutes long, the film emboldened Deren to write a manifesto, titled *An Anagram of Ideas on Art, Form, and Film*, which was an elaborate expression of her film theory. Deren's central premise was a conception of art as "ritualistic form," an investigation that had begun with her master's thesis at Smith, which analyzed T. S. Eliot's discovery of congruencies between primordial ritual and contemporary urban life in *The Waste Land*.

Anagram is a dense essay that does not lend itself to quotation, but Deren's conclusion is lucid enough. A contemporary expression of ritualistic form, she writes, "would be predicated upon the exercise of consciousness, not as the instrument by which divine will is apprehended but as the human instrument which makes possible a comprehension and a manipulation of the universe in which man must somehow locate himself."

It was not easy to find a publisher for this complex synthesis of global artistic forms. When she sent the manuscript to James Laughlin, he addressed his rejection letter to "Dear Little Maya" and jocularly accused her of being "the beautiful stooge for some crabbed old intellectual wreck hidden in the stacks up at Columbia. It is quite impossible that anyone with your visible charms should also have that much brains. It's against nature." It was a classic iteration of the sexist canard that big breasts make a woman dumb. *Anagram* was finally published in a tiny edition by the Alicat Book Shop Press, which also published Djuna Barnes, D. H. Lawrence, and Anaïs Nin. (Nin, furious at what she regarded as an unflattering close-up in *Ritual in Transfigured Time*, was carrying on a bitter feud with Deren.)

Deren now had a body of work, even if the total projection time was under an hour, and she used it to make herself a public figure. She presented a program called *Three Abandoned Films* at the Provincetown Playhouse on MacDougal Street, on the theater's dark nights. The films were *Meshes*, *At Land*, and *Ritual in Transfigured Time*; her title was suggested by Paul Valéry's comment "A work is never completed but merely abandoned." The canny choice of the Provincetown Playhouse, where Eugene O'Neill had staged some of his best plays, gave the event an instant pedigree. Stan Brakhage wrote, "After the first showing, the place was packed and hundreds had to be turned away. The theater sold out night after night, and it became quite the thing to do in town for six months, to go see *Meshes of the Afternoon* and hear this crazy woman spouting film art." Her mother was a constant presence at these events; Marie was her daughter's toughest critic, and on a few occasions the two of them ended the evening with a vehement argument in the lobby.

Maya Deren's great idea was that film could be, should be a fine art like music or poetry, existing entirely on its own terms beyond the demands of the marketplace. She wanted her films to be viewed the way one reads poetry or listens to chamber music, an experience requiring total concentration, which is deepened by repetition. Her program at the Provincetown Playhouse is usually cited as the first public screening of experimental film in the United States. She repeated the program at college campuses and other venues across the country. The experimental filmmaker Harry Smith described the effect of Deren's first appearance in San Francisco in 1946: "Her movies hit like thunderbolts and sent everybody to the nearest pawn shops to get a Bell & Howell."

In December 1946, Deren attended a lecture by Gregory Bateson, in which he projected selections from the film of dance rituals and domestic life that he and Margaret Mead had shot in Bali. This footage inspired Deren to conceive a film that would be her most ambitious experiment to date, a "cross-cultural fugue" that would integrate scenes of urban American children playing hopscotch and other street games with Bateson and Mead's film from Bali and the film of voodoo rituals she planned to shoot in Haiti. After her meeting with Bateson and Mead, they gave her the Bali film, all of it, stacks of reels of unedited footage, with their permission to do with it what she would. In her notebooks, she described the electric effect it had on her, the excitement surely intensified by the first stirring of her love for Bateson: "The minute I began to put the Balinese film through the viewer, the fever began. . . . Is it because in holding film in one's hand one holds life in one's hand?"

Deren's interest in ritual dance, which culminated in her decision to go to Haiti, had been germinating since the drums took her over on the *Cabin in the Sky* tour. As early as 1942, she had published an essay titled "Religious Possession in Dancing," in a scholarly journal called *Educational Dance*. As voodoo itself became the obsessive focus of Deren's thought, her colleagues in the tight circle of avant-garde film lamented her involvement with it, seeing

it as tantamount to an act of treason. P. Adams Sitney, the film historian, wrote that after Haiti, "her career as a filmmaker was radically deflected." Brakhage, one of Deren's closest friends, was more severe: "She became deeply and personally involved in a religion and, essentially, that religion destroyed her as an artist." Yet it might be more accurate to say that her study of ritual dance was interrupted by her discovery of film.

In 1957, Mike Wallace interviewed her on a television program called *Night Beat*. Wallace's first question was "Maya, if there's one thing that seems to hold true about voodoo it is that nobody seems to entirely agree, from what I've read, just what voodoo is—black magic, a dignified religion, an orgiastic ritual, or what?"*

Deren replied with a careful summary of the standard anthropological line: "Primarily it is African in origin. When the Negroes were imported into Haiti from Africa, they were brought from many different tribes—Ibo, Congo, and others. And when they were brought to Haiti they were separated, even families were broken up," in order to reduce the opportunities for rebellion. In exile, the slaves amalgamated their rites, adopting and adapting their various divinities to create a new, all-embracing religion. Christianity was imposed on them by their colonial masters, so they ransacked that closet too for imagery and stories. They associated the *loa* with Christian saints based on conventional attributes; the classic example is the identification of Damballah, the powerful rainbow-serpent *loa*, with Saint Patrick, who was portrayed with snakes in Catholic posters. Then Deren advanced the original theory that voodoo was forged in the mountains and small offshore islands of Haiti, where fugitive slaves, known as Maroons, encountered native Taíno Indians who had also escaped

*The conflict extends to the spelling of the religion's name. Some readers object to "voodoo," the standard dictionary spelling, on the grounds that it may be perceived to carry a prejudicial charge, and prefer French or Creole equivalents. However, the proponents of orthographic reformation, primarily foreign scholars, have no consensus among themselves: *vaudou, vaudoun, vodon, vodou, vodoun, vodun, voodoun, voudou,* and *voudoun* are all in use. Everyone I met in Haiti, when they were speaking English, used "voodoo." To avoid any appearance of making judgments about the writers I quote, I have respected their decisions (without the genteel sneer of a bracketed *sic*). I myself have used "voodoo," following *Webster's,* in the hope that it will be taken as a neutral common ground, and with apologies to readers who find it objectionable.

bondage, and the two peoples found common cause—a shock of the Diverse that must have been truly incomparable, at this first conjunction of three continents, which took place in 1512, just twenty years after Columbus had landed in Hispaniola.

Throughout most of its history, the practice of voodoo was illegal, which endowed the religion with an outlaw glamour and a sense of continuity with the celebrants' history. Voodoo was more than a religion; it was a portable homeland of the soul for people who had been forcibly extracted from their native lands. Deren's theory was sexy and plausible, but the origins of voodoo are irrecoverable, *immémoriaux*; for voodoo, like ancient Tahitian culture, has no literature of its own. There exists no voodoo Bible, no Haitian Book of the Dead to give voice to the men and women who created it. Their story has been told by outside observers, relegated to the outskirts.

What makes Maya Deren's experience in Haiti invaluable is that to an extent impossible to measure, she became an insider. Deren told Joseph Campbell that there was a Haitian proverb, "When the anthropologist arrives, the gods depart." The attribution is dubious; it sounds more like a witty comment by one of her worldly Haitian friends in the capital, or perhaps a little joke of Bateson's. Yet the point is not only valid but essential: any attempt to explain the mysteries of the cult will be false to its essential nature, for voodoo is not a system of thought that can be explained.

In this sense, voodoo might be more profitably thought of as a dance tradition than a systematized religion. *Island Possessed*, the Haiti memoir by Katherine Dunham, anthropologist and dancer, takes as its central theme the conflict created in the rational Western mind when it experiences voodoo. The book's vivid narrative of her initiation and ritual marriage to Damballah occupies nearly one-third of the book. "In none of my affections have I been so punished for infidelity as by my Haitian serpent god," she writes, with just a trace of irony. Elsewhere in the book, she admits to simulating possession in voodoo ceremonies for the sake of gathering anthropological data. She suspects that there must have been "drugs of some mild kind administered, incense and herbs burnt

that added to the trance feeling." Once it made itself felt, she writes, "the sensation would leave me, and instead of feeling the god in possession of me the calculating scientist would take over, and I would be making mental notes."

Compare Dunham's account with this description of celebrants dancing at a voodoo ritual, in *Divine Horsemen: The Living Gods of Haiti*, Maya Deren's comprehensive study of voodoo:

> What secret source of power flows to them, rocks them and revolves them, as on a roundabout the bright steeds prance and pursue, eternally absolved of fatigue, failure, and fall? I have but to rise, to step forward, become part of this glorious movement, flowing with it, its motion becoming mine, as the roll of the sea might become the undulation of my own body. At such moments one does not move *to* the sound, one *is* the movement of the sound, created and borne by it; hence nothing is difficult.

Yet Dunham, to put it simply, can never quite decide if she believes in voodoo. The conflict between the anthropologist from the University of Chicago and the exuberant dancer whose ancestors lived in the West African forest cannot be fully resolved. Dunham *wanted* to believe, but that was not enough. Maya Deren was a believer from the start, almost, it seemed, before she arrived in Haiti. In the last paragraph of *Divine Horsemen*, Deren writes simply, "As a metaphysical and ritualistic structure Voudoun *is a fact*."

In *Island Possessed*, Dunham laments that William Seabrook was "first on the scene" in Haiti, because his sensational narratives of violent rites in *The Magic Island* had offended the elite and poisoned the well for those who followed him. Seabrook's book was sensational in every sense, including its sales, and sealed his reputation as "the Richard Halliburton of the occult." For better or worse, he created the matrix of the popular understanding of voodoo. Published in 1929, when the United States was running the country like a colony, ruthlessly administered by the Marine Corps,

The Magic Island is hopelessly compromised by shallow patriotic shibboleths and mired in racist stereotypes, but at least Seabrook is candid about his intentions, chief among them simply to tell good stories.

One of his best is the chapter called "The White King of La Gonave," about a marine gunnery sergeant whose career closely paralleled that of Kipling's Daniel Dravot in *The Man Who Would Be King* and Conrad's Kurtz. La Gonave is a dry, barren island fifty miles off the coast of Port-au-Prince, inhabited by the descendants of Maroons. In 1925, Faustin Wirkus, a farm boy from Pennsylvania, volunteered to take command of La Gonave for the gendarmerie, Haiti's police force under the Marine Corps' control. Wirkus was enormously popular with the island's inhabitants, in part because he had the same first name as Faustin Soulouque, who was crowned emperor of Haiti in 1849 as Faustin I. When the strapping, lantern-jawed soldier appeared from the sky, the native people, who seldom had contact with the mainland, believed him to be their emperor, whose return had been prophesied.

La Gonave already had a queen, Ti Memenne, who endorsed the people's choice of Wirkus to be their king. According to the brief biography of him posted by the Marine Corps Association,

> On the evening of 18 July 1926, Master Sergeant Faustin Wirkus was crowned king of La Gonave in a voodoo ceremony. As the drums beat the "Call of the King," a rhythm designed specifically for Wirkus, he was carried from the *houmfort*, or voodoo temple. In the firelight, the blood of a sacrificed rooster was evident on his forehead and wrists. He wore the crown of Faustin I. Behind him walked Ti Memenne. The crowd shouted, "Le Roi! Vive le Roi Faustin!"

Seabrook published his photograph of Wirkus enthroned, scowling majestically, surrounded by his jubilant subjects waving flags. The reign of Faustin II ended soon after Seabrook's visit, when the president of Haiti came to La Gonave and decided that his country had no need of a white king, particularly not a U.S. marine, and Wirkus was sent back to his garrison on the mainland.

Taken at face value, the story of Faustin Wirkus is a fine example of exoticism inverted, in which the visitor exerts the glamorous attraction on the local people. However, one contemporary scholar dismisses Seabrook's narrative as a "typical neocolonial version of the Great White Hunter, adopted by native peoples awed by his technological prowess while he is attracted to their 'simple' customs and affections," yet he does not cite any inaccuracies in Seabrook's narrative. It is another instance of the postcolonial narrative, which begins with the censorious conclusion and works its way awkwardly back to events. That Seabrook embroiders his tales and pushes atmosphere beyond the lurid limit is obvious; his facts are often proximate, as he himself happily admits, and he tells secondhand stories as if he were an eyewitness; but as far as I know, no one has accused him of outright fabrication.

Yet there is no doubt that Seabrook is striving for maximum shock value in *The Magic Island*. In addition to many detailed descriptions of voodoo rituals, which are written in an irritating flippant tone but generally harmonize factually with later testimony, he explores far beyond the fringe. He sought out the *culte des morts*, an outlaw sect that used human corpses for magical purposes. Seabrook reports that they rubbed grease from rotting brains into their machetes to make them "intelligent," that is, true in aim; cultists who lacked courage ate morsels of dead men's hearts. He saw an altar piled with human skulls and bones, which he correctly states were not used in any voodoo rite. His narrative transports the reader into the scene with cinematic immediacy. "Huddled upon the floor," he writes, "were a score or more of black men and women, swaying, writhing, moaning. Before the altar of skulls, facing us, stood three human figures, grotesque, yet indescribably sinister."

If there is a sinister element of violence in Haitian life, its roots may be not in Africa but in France. In *Island Possessed*, Katherine Dunham describes her restoration of Habitation Leclerc, the estate in Croix-des-Missions that she bought in 1949 as a home for her dance company. It was built at the end of the eighteenth century by Charles Leclerc, the commander of the French expeditionary force sent to suppress the revolution against French rule led by

Toussaint-Louverture, as a gift for his wife, Pauline Bonaparte, Napoleon's sister. Sited on forty-five acres of tropical forest, the estate was in ruins when Dunham took it over and rebuilt it as an arts center.

The construction site became an archaeological dig, as artifacts of the original estate were unearthed. French carriage lamps, excavated beneath a collapsed staircase, were fitted with electric lights and installed in the new driveway. The main pavilion, which Leclerc had lined with seventeenth-century Venetian sculptures of blackamoors, became a rehearsal space. A bas-relief in the style of Canova, depicting Pauline Bonaparte seated on an Empire sofa, receiving the gifts of the country from kneeling slaves, was restored on a terrace beside a new swimming pool. Several feet under the floor of Dunham's bedroom, workers found Charles Leclerc's sword, which they promptly repurposed as a ritual saber for voodoo ceremonies.

He might have had a talent for building an elegant country retreat, but Leclerc bungled his military mission. One of its principal aims was the reinstitution of slavery, previously abolished by the republic under Robespierre. In 1802, Leclerc wrote to Napoleon about his "opinion on this country": "We must destroy all the Negroes in the mountains, men and women, keeping only infants less than twelve years old; we must also destroy half those of the plain, and leave in the colony not a single man of color who has worn an epaulette. Without this the colony will never be quiet." Clearly, the ideals of the Enlightenment, or at least the concept of *fraternité*, did not extend to the Caribbean. The contrast between this mission of murderous barbarism and the tender paternalism the French showed for the Tahitians at the century's end presents an astonishing reversal.

Leclerc came to an ignominious end before he could institute this policy of genocide. After a major setback in the war, when his forces were besieged by revolutionaries, the cowardly general planned an escape, sending his silver plate and other valuables to the ship of the French admiral in the harbor. The admiral, Latouche-Tréville, replied that he "would fire with more pleasure on those who abandoned the town than on those who attacked

it." Disgraced and despised, Leclerc went into seclusion and died three days later of yellow fever, which plagued the country.

His successor, Donatien Rochambeau, who presided over the final disastrous defeat of the French, proved to be even more depraved. Dunham (who herself found a silver fork at Habitation Leclerc with a hallmark identifying it as a part of Rochambeau's service) wrote a sketch of his command closely based on contemporary accounts: "[Rochambeau] drowned, asphyxiated, hanged, fed to man-killing dogs, starved to death, and buried alive as many Negroes and mulattos, officers and slaves alike, as time from other pastimes and duties permitted." Some of these murders were performed as the entertainments at lavish balls and midnight suppers, while in the streets of the capital yellow fever claimed thirty to fifty French lives daily: Poe's "Masque of the Red Death" brought horribly to life.

Joan Dayan recounts one of the most macabre of these spectacles in *Haiti, History, and the Gods,* her brilliant study of the literature of the Haitian Revolution. Dogs imported from Cuba, trained to eat human flesh,

> ripped into blacks in the arena Rochambeau set up in the courtyard of the old Jesuit monastery. Yet sometimes these dogs refused to attack, and had to be driven to frenzy by the French. Once, the elegant General Jacques Boyer, called *le cruel* by French soldiers, leapt into the arena, slit open the stomach of his faithful servant, and pulled out the guts in order to incite the dogs. The victim was devoured to the sound of applause, cheers, and military music.

In keeping with the festivity of the occasion, the dogs were adorned with silk ribbons and feather headdresses. In another hellish spectacle, Rochambeau constructed a living pyramid of Haitians and suffocated them with sulfur smoke.

Dunham sensed the evil that possessed the estate from the day she moved in and decided that it must be exorcised to make the place habitable. She invited a powerful *mambo,* a voodoo priestess from the mountains named Kam, to perform the ritual. Dunham's

mother, Annette, was visiting at the time. Soon after Kam's arrival at Habitation Leclerc, Annette saw a ghost on the balcony of her cottage, a black man "bare to the waist, hands tied behind his back," kneeling and begging for help. Dunham and the major-domo of the estate came running when they heard Annette's screams and saw "the ragged figure go running through the euphorbia bushes and bougainvillea vine, making for the torture chamber," a small slave house where Rochambeau had carried out his horrors. Kam moved in there and spent several days chanting and burning incense, herbs, and papers covered in charms. Years later, when Dunham rebuilt the slave house, workmen digging beneath the floor found iron rings with bits of chain attached, relics of the civilized demons who had built the place.

From her first experience at a voodoo ceremony in Haiti, Deren understood the importance of being established in a community, so as "not to be forever relegated to the outskirts." A few weeks later, she rented a *caille*, virtually a shanty, near Habitation Leclerc in Croix-des-Missions, from a well-known *mambo* named Madame Île de Vert. Deren attended ceremonies daily and began shooting film and making sound recordings of them, the ostensible purpose of her trip. In the beginning, she was conflicted about her motives in much the same way that Katherine Dunham had been, unsure whether she was immersing herself in the culture to gather information or falling in love with the place. Gradually, she realized that what she had called her "courtship of the country" when she arrived had ended with the country taking possession of her.

Deren's uninhibited pursuit of love in Haiti, an instinctive rather than ideological assertion of her right to take as many lovers as she liked, was a bold course in 1947, which required the bravery of an Isabelle Eberhardt; and as it had been for Eberhardt, sex with the men of the country was an instrument (Deren's term) of union with its genius of place. She had no trouble attracting lovers. Apparently, she found a new man soon after or even before her breakup with Cantave, the passionate adolescent. Deren took many lovers in Haiti, including serious affairs with men of substance; some of

them requested anonymity when the authors of *The Legend of Maya Deren* interviewed them.

She was also, like Eberhardt, a demanding, intensely romantic lover. A draft of a letter to a Creole man named Denizé reveals an extraordinary level of need. She writes, "I expect you even when we have no arrangements." She describes a typical evening at her cottage: she bathes and changes her clothes and waits until seven to have a drink, "thinking perhaps, by some miracle, it will be earlier tonight." She puts food on the table at half past eight and waits for him, whether they have a date or not. "At about ten I stretch out on the little porch and look at the stars and listen for you. And I say to myself, surely, surely tonight he can manage one hour." At eleven "I nibble at the chicken I have been keeping for you, and at about twelve I go to bed but leave a light burning." She dozes off and then wakes up at two, nursing the hope that her sudden awaking will bring her beloved. She goes back to sleep, and again she awakes, but when she hears women going to market, she finally accepts that he will not come. "And if one were to ask me what I wanted of you, I should not be able to answer." There is no way of knowing if she sent the letter to Denizé.

In one long entry in her journal, Deren reveals the irrational edge to both her intensifying sexual desire and the need to identify in some ultimate way with voodoo: "To whom shall I confess that I was almost ready to take the houngan as a lover—syph or no syph—so that with my very body I could protest: This man I really hold dear for himself and not for his informations [*sic*]."

On November 21, she records an extraordinary event that occurred at a ceremony dominated by Ghede, a supreme *loa*. Ghede is the god of death, writes Deren, "the master of that abyss into which the sun descends" and thus "the night sun, the life which is eternally present, even in darkness." He is a jaunty dude, frankly lascivious, who wears dark sunglasses and a top hat. At this ceremony, a *mambo* (who could well have been Madame Île de Vert) was treating a sick child. The *mambo* "makes a terrific effort—masturbates under dress, passes water as if ejaculation, and gathering it into her hand washes the very sick child with it. Terribly impressive and true feeling." Then Ghede, speaking through his

mount, "asks for movies." In the evening, Deren obediently projects Bateson's film of a cremation ceremony in Bali for the people of the village, "which they understand."

On the next day, Deren writes for the first time in her journal about being possessed herself, by a minor *loa* called Jaco (derived from Saint Jacques). In *Divine Horsemen*, Deren writes that Jaco's "characteristic activity is the sly creation of disorder, ill-temper, and misunderstandings between people." The journal entry, written soon after the *loa* left her, is disjointed, but it appears to record the beginning of a new love affair immediately after the end of another:

> Evening—definitive break with Denizé.
> Possession by Jaco . . . began with one leg and lassitude.
> Fito . . . Ghede cross . . . "*Es[t]-ce que je ne serais jamais chez moi?*" "*Jamais?*" "*Jamais?*" "*Jamais?*" "*Nul part?*" "*Nul part?*" Kissed Ghede cross.
> Sudden lucidity after possession.
> Fito at night.*

In his interview, Mike Wallace asks Deren, "Do you consider yourself a convert to voodoo, or are you simply a student of it?" She replies by making the crucial distinction between belief and servitude: "The Haitians never ask, Do you believe in Voudoun? They ask, Do you serve?" Wallace then asks her if she serves. Her answer is carefully phrased: "Well, I did. I participated in it." Pressing his point, he asks her if she practices voodoo at home in New York. She answers with a lie: "No, not out of context. I think about the *loa* often, though." In fact, she brought the context home with her, making the apartment on Morton Street an overseas outpost of Haiti, where voodoo rituals were often celebrated. It was a Haitian white lie: in public, sophisticated Creoles maintained a disdainful attitude toward voodoo, which was associated with ignorant

*Ghede's French is substandard and nonsensical. His phrases might be translated literally, "So, should I never be in my place? Never? Nowhere?" *Chez moi* ("my place") may mean Deren's body, which was occupied at the ceremony by Jaco. *Nul* should take the feminine form, *nulle*. The ellipses are Deren's. Fito is unidentified.

country folk—even if they were dedicated servitors of the *loa* in private.

After voodoo claimed her soul, Maya Deren never really came home again. Her heart was divided between America, the place that made her, and her new homeland, a spiritual nation of the dispossessed.

When I decided to visit Port-au-Prince in 2014, I asked friends who knew the place what to expect: Was it really as terrible as everyone said? They replied with a melancholy sigh and downcast eyes; people who become attached to awful places can never bring themselves to say a word against them. Yet the city lived up to its reputation: Haiti's capital in the twenty-first century is a hopeless wreck. The grievous damage wrought by an earthquake four years before was in evidence everywhere, reconstruction less so. Electrical power is sporadic, the public water supply is not only unpotable but poisonous, and violence is visibly rampant in the streets, where young men who have never had a job get drunk at midmorning on white lightning dipped from a garbage pail.

My first stop is the Hotel Oloffson, one of the few places where visitors can escape the chaos. The Oloffson itself is a bit of a wreck, a genteel, gingerbread-encrusted mansion on a hill surrounded by aromatic pines, in the midst of the city. Graham Greene set his novel *The Comedians* here, calling it the Hotel Trianon. "With its towers and balconies and wooden fretwork decorations it had the air at night of a Charles Addams house," Greene wrote. "You expected a witch to open the door to you or a maniac butler, with a bat dangling from the chandelier behind him. But in the sunlight . . . it seemed fragile and period and pretty and absurd, an illustration from a book of fairy tales." At the top of a double staircase, I am welcomed by the hotel's proprietor, who shakes my hand and says cheerfully, "Welcome to Hell."

He is Richard Morse, a tall, robust American with a profile like a Roman medallion, who wears his long gray hair in a braid down his back. We order coffee on the veranda, which displays sequined voodoo flags and paintings of the hotel that look as if they were

given in lieu of paying the bill. We talk about the hotel, Haiti's history, and his cousin Michel Martelly, a former singing star who is now the country's president. When I explain why I am here, Morse says, "You should go see my mom. She's in the life," by which he means that she practices voodoo. "She knew everybody." He gives me her address and recommends a driver who can find the place. I promise to return to the hotel on Thursday night, when Morse's band will perform his brand of voodoo rock, a promise I will not keep.

Emerante de Pradines lives on a narrow hairpin road carved in the side of a steep, wooded gorge in Pétionville, a suburban municipality in Maya Deren's day, now engulfed by the sprawl of Port-au-Prince. Her domain occupies four terraces rising in a stack against the hillside, which commands a distant view of the sea. The superb situation reminds me of houses I have visited in the Berkeley Hills. A gardener listlessly swishes a broom on the lowest terrace, which is dominated by a cement shrine sheltering a half-molten statue of the Virgin Mary.

Madame Emy greets me at the door dressed in black tights, a bulky blue sweater, and a knotted turquoise necklace that sets off her ice-blue eyes. With a flirty smile, she leads me into a high-ceilinged room overlooking the valley. Her frame is slightly bent, which she corrects by squaring her shoulders, and her gait is lively and delicate: you would never take her for ninety-five.

"Of course I knew Maya Deren," she says airily. "I met her through Katherine Dunham." She points to a good oil portrait of Dunham in profile, wearing a stage necklace of gold stars. "I met Maya at a party in New York, when I was teaching at the Katherine Dunham school there." She diverts the conversation momentarily to reminisce about her years as a dancer in Dunham's company, after Maya's time. Madame Emy was Dunham's stage double. "We wore the same size, and we looked enough alike"— which is true; when I first saw the painting, I took it to be a portrait of Madame Emy. "Then one day I told her, 'I am not that person. I am Emerante, and I want to be Emerante onstage.' Miss Dunham said, 'It's all right. You can be yourself.' So after two years of being Katherine Dunham, I was myself again." A dreamy

look softens her face as she talks about performing with Paul Robeson and Harry Belafonte.

I ask Madame Emy what she knew about Maya's life in voodoo. "If you knew voodoo," she said, "you could see that she was chosen by the gods. You could never tell exactly when Maya was possessed and when she wasn't. She might have been possessed all the time." Behind her, the gardener presses his face against the window, staring at me intently. She follows my gaze and shoos him away with an elegant wave of her hand. "That boy is new, and I don't like him," she declares.

She returns to her subject: "Maya was attracted to Erzulie, the woman's goddess. Erzulie possessed her body and soul. Maya was an outspoken person. Maybe she needed to be possessed to show what she was, to say what she wanted to say. She was always fighting to get out the truth about voodoo, that it's not some devilish thing." She shudders theatrically. "There are many different ways to see voodoo, but if you see it, there's no way you can't accept it."

She gives me the tour, pointing out Erzulie's flag, emblazoned with a glittering crimson heart, and a cut-crystal pitcher with a silver lip that once belonged to Samuel F. B. Morse, an ancestor of her husband's. Richard McGee Morse was a noted historian of Latin America who died in this house in 2001. She shows me a portrait of him when he was a Princeton undergraduate, glowing with a golden beauty that distinctly evokes F. Scott Fitzgerald at that age. As I take my leave, Madame Emy exacts a promise that I will come visit her at the school she runs at the bottom of the hill, a promise I will keep. As I drive away, I see her giving the gardener hell.

A few days later, I go to Croix-des-Missions. In Deren's film footage it is a rustic village set amid cane fields; today it is a shattered, overpopulated slum, with garbage baking in fetid sewers. After much asking around, my driver finds someone who says he has heard of Madame Île de Vert. The man leads us into a cul-de-sac of small cinder-block houses painted pink, the white of Port-au-Prince. The place is weedy and full of litter, but situated fifty feet off the main road it is pleasant enough. A man emerges from one of the cottages, beautifully groomed and dressed all in black,

wearing opaque black sunglasses. His name is Champagne. He tells me to return in the afternoon, when the owner will be there.

To kill time, I cruise by Habitation Leclerc, which is nearby. The estate is completely deserted and running wild. A tall, stout iron fence with menacing spikes at the top has been built around the perimeter, which goes on for miles. At what must have been the main entrance, I can just make out, a hundred feet into the jungle, a plaza with a checkerboard pavement, enclosed by an Italianate balustrade with gaps, like the grin of someone missing a few teeth. Creepers and vines have blanketed the terrain; occasional humps and heaps of green suggest the location of collapsed buildings. When Katherine Dunham lived here, she kept pythons; I wonder if their progeny lurk in the humid gloom.

When I return to Croix-des-Missions, Champagne is waiting for me with a portly man whose shirt is almost completely unbuttoned to reveal gold chains draped across his soft, sweaty chest. His name is Jean-Yves, and he is the owner of these cottages. He says that Madame Île de Vert owned the land until 1994, when she was poisoned by her lover, a younger man named Rodrigue. Jean-Yves bought the property from him. "She was a popular *mambo*," he says, "*très géniale*." Jean-Yves too wears opaque black sunglasses; he removes them for a moment to mop the sweat from his jowly, heavy-lidded face.

In rapid Creole, he tells my driver, "Madame Île de Vert's specialty was zombies. She kept thirty or forty of them here. After she died, they were wandering around the neighborhood, lost without their mistress to tell them what to do." He says that some of the zombies' families tried to reclaim them, to cremate them under a calabash tree so their souls might find rest, but they had melted into the landscape, as zombies do. After two minutes of standing in the sun talking to a curious foreigner, Jean-Yves abruptly gets into his long black car, its windows as impenetrably dark as his glasses, and takes his leave.

When Deren returned to New York from her first trip to Haiti, she tried to pick up the threads of her old life, struggling to make

enough money to pay the bills by writing and lecturing, and searching out financial support for her films. She made valiant efforts to edit her footage from Haiti, which came to naught. On the first page of *Divine Horsemen*, she confesses to the reader, "As I write these last few pages of the book, the filmed footage (containing more ceremonies than dances) lies in virtually its original condition in a fireproof box in the closet; the recordings are still on their original wire spools; the stack of still photographs is tucked away in a drawer labeled TO BE PRINTED, and the elaborate design for the montaged film is somewhere in my files, I forget where."

Joseph Campbell assumed a crucial role as Deren's mentor. He was editing books with anthropological subjects for Thames & Hudson, and secured a contract for her to write *Divine Horsemen*, both as a productive way to cope with the sea change in her life and to alleviate her perpetual state of destitution. She was approaching the limit of her ability to wheedle extensions from her creditors and borrow money from her friends, particularly Sasha Hammid and James Merrill. Her mother was always ready to give what she could, but there was never enough money.

When Deren got the book advance, rather than paying even her most pressing bills, she went straight back to Haiti. After she got home from that trip, Campbell wrote, "I had to plead for the second installment of her advance to make it possible for her to live here. All right, they gave her another advance, and she went back to Haiti again!" Deren supplemented her income with freelance assignments to write travel stories for *Mademoiselle* and *Flair*, a lavish new magazine published by Fleur Cowles, which paid a thousand dollars for a feature article, good money. Even more prestigious, the government of Haiti commissioned her to photograph the Bicentennial Exposition in 1950. The first world's fair mounted in the Caribbean, it was ostensibly intended to celebrate the two hundredth anniversary of the founding of Port-au-Prince as the nation's capital, but its real purpose was to showcase the modernizing policies of President Dumarsais Estimé. It was a lucrative assignment, but Estimé's government fell before Deren got paid, and the new regime did not honor the debt.

She returned to New York abruptly, deep in debt and demoralized. Her problems were exacerbated by her habitual use of amphetamines. She was a patient of Max Jacobson, the notorious "Dr. Feelgood," whose injections of amphetamines compounded with vitamins, hormones, steroids, animal placenta, and a trace of novocaine were used by some of the most famous Americans in the arts during the 1950s and early 1960s, including Cecil B. De-Mille, Marilyn Monroe, Elvis Presley, and Tennessee Williams. Jacobson later recalled that Deren needed frequent treatment for migraines and depression brought on by loneliness and a dread that her inspiration was drying up. In *Divine Horsemen*, Deren thanked Jacobson for "creative medicine involved in helping me to accomplish an appallingly demanding program of work." According to Deren legend, he treated her gratis, because her father had been a doctor.

In 1950, Deren met the man (for such he became) who would be her companion for the rest of her life and her third husband. As Stan Brakhage tells the story, one night after she had gone to the movies, she realized that she had left her purse behind and went back to look for it. In the empty theater, she found a fifteen-year-old Japanese boy sleeping under the seats. His name was Teiji Ito, and he told Deren that he had run away from home. He said that he went to the cinema to sleep every evening after it closed and left in the morning to panhandle and roam the streets. He was a musician in desperate need of protection, so tender-hearted Deren took him under her wing.

He was seventeen when he moved into the apartment on Morton Street in 1952; Deren was thirty-five. They were very much in love. At first the Greenwich Village crowd was amazed that she could attract and hold on to an adolescent lover, and within a few years they credited him as a steadying influence on their increasingly erratic friend. With each of her four trips to Haiti, between 1947 and 1955, her involvement in voodoo deepened. The Surrealist poet Philip Lamantia, who had appeared in *At Land*, recalled an all-nighter at Morton Street after one of her trips to Haiti, when Deren played him the recordings she had just made, accompanied by a running commentary on the

ceremonies, which lasted fifteen hours. "What impressed me most," he said, "was her extraordinarily passionate relationship to the experience." Her apartment was the first destination in America for many visiting Haitian artists and intellectuals, who were now her friends and colleagues as much as the old gang in New York.

The conventional narrative is that Deren was paralyzed by the fear that her close personal identification with voodoo impeded her ability to write the book and craft the film that she hoped would be the definitive works on the subject, that her sense of responsibility to her subject rendered her incapable of setting her mind to the task of writing sentences and splicing film. Catrina Neiman, Deren's biographer, advances the intriguing hypothesis that her hesitation was due not to her closeness to the subject but, on the contrary, to her fear that her knowledge was inadequate. Joseph Campbell proposed that he and Deren work together on the book in a series of recorded conversations, a process that would enable her to get her thoughts down in a usable form without the forbidding glare of the blank page. By the end of 1952, with Teiji Ito's assistance, the manuscript was ready for publication.

Divine Horsemen occupies a privileged position among the major studies of voodoo, staking a middle ground between anthropology and literature. Deren takes pains to be lucid in her presentation of the conceptual architecture of the religion and precise in her diction as she draws distinctions among its constituent traditions, yet she wastes no words defending its legitimacy. *Divine Horsemen* continues to be cited by scholars; more significantly, it has been accepted by Haitian readers. The depth of Deren's penetration into the baffling world of voodoo continues to astonish. The Haitian choreographer Jean-Léon Destiné called *Divine Horsemen* one of the best books written on voodoo and remarked, "I myself, being Haitian, when I read the book I wonder: How did she accumulate all that knowledge? How could people have opened up so easily to a foreigner?"

The intellectual discipline of Deren's model of voodoo is impressive, but there is a sense that something is lacking until the final pages. The reader constantly feels that the author's passion

propels the book, but Deren alludes to her personal commitment to voodoo only obliquely and in passing until the final chapter, "The White Darkness," in which she describes the experience of possession:

> The white darkness moves up the veins of my leg like a swift tide rising, rising; it is a great force which I cannot sustain or contain, which, surely, will burst my skin. It is too much, too bright, too white for me; this is its darkness. "Mercy!" I scream within me. I hear it echoed by the voices, shrill and unearthly: "*Erzulie!*" The bright darkness floods up through my body, reaches my head, engulfs me. I am sucked down and exploded upward at once. That is all.

In this fragment of spiritual memoir, Deren integrates precise observation and ecstatic revelation in delicately shaded prose, charged with the oracular power of poetry, which has few analogues, and none more striking than Isabelle Eberhardt's miniatures from Kenadsa.

Stan Brakhage's gloomy assessment that Deren's devotion to voodoo "destroyed her as an artist" was accurate, if you take the production of finished films as the only measure. After her second trip to Haiti, in 1949, until her death in 1961, she completed just one film, *The Very Eye of Night*, a fifteen-minute collaboration with the British choreographer Antony Tudor, which was completed in 1954 but not released until four years later. The film extends Deren's previous exploration of filmed dance into a cosmic setting, with negative images of dancers from the Metropolitan Opera Ballet School rising and falling through a starry night sky, accompanied by Teiji Ito's elegant, elemental score.

The film suffered from the long delay in its release, which gave the appearance that it had been ten years in the making. It got a cool reaction, at best, from the avant-garde film community. P. Adams Sitney wrote that it suffered "from excessive stylization, both intellectual and graphical." It was faulted by others for

being amateurish, falling below the level of her early works, the "three abandoned films" that had attained the status of classics. Stan Brakhage, for one, was a stout defender of *The Very Eye of Night.* "Nobody understood it," he said in an interview. "People said, 'Oh, you can see that the stars are just sequins on a scrim that's being shakily moved along, like in a child's theater.' That is exactly the point. Maya would not make a fakery like Hollywood. She *wanted* it to be like a child's vision."

Deren's last years were haunted by her failure to complete the Haiti film, the masterwork that would unite her two great passions. It was a hopeless undertaking: her initial attraction to voodoo had been aesthetic, but her deepening immersion in the rituals of voodoo brought her to the realization that their meaning lay in the experience, which was enacted in a realm where art, life, and spirituality converged. Many years after her death, Teiji Ito and his fourth wife, Cherel Ito, produced a tight, fifty-minute edit of the Haiti footage, with a voice-over narration based on *Divine Horsemen,* also the title of the film. It perfectly illustrates the conceptual dilemma that Deren had faced. The scenes of voodoo ceremonies, shot in Croix-des-Missions when it was an idyllic agricultural community, radiate a rapt, sympathetic intimacy, seeming to peer into the souls of the celebrants during states of possession, which establishes a near kinship to her early dream-quest films; yet the narration has the dry, didactic tone of vintage ethnographic documentaries, such as those by Margaret Mead. In Deren's book, the ecstatic and the anthropological blended in a synergism, but in the Itos' film (for that's what it is) they are perpetually at war with each other.

One of the strongest passages in *Divine Horsemen,* the film, is Deren's astonishing footage of a rare ceremony that "celebrates the wedding of Agwé, sovereign of the sea, to the goddess of love," meaning Erzulie, which Deren calls "perhaps the most elaborate of all ritual undertakings." The celebrants fill a small sailing ship with a banquet for the *loa* Agwé, an offering of many cooked dishes, live chickens and a ram to be sacrificed at sea, champagne and liqueurs, and a seven-tiered wedding cake. When the ship reaches the domain of Agwé, the feast is loaded

onto a painted raft and set adrift in open water. "It seemed to hesitate to a stop," Deren wrote, "and then, as if a great hand had reached up from below and grasped it, it disappeared abruptly into the quiet water," where Agwé will dine on it, in his mansion on the seafloor.

Deren continued to lecture and publish essays on film theory, but as an artist she was stymied. She wrote poetry that was never published and film scenarios that were never produced. With Teiji Ito, she prepared a six-album set of her recordings of Haitian music for the Cadence label, which was never released. With start-up funding from James Merrill, she organized the Creative Film Foundation, with a mission to foster the careers of young independent filmmakers, but she could not raise enough money to endow a cash prize for the awards—another defeat.

The most spectacular of the Maya Deren legends is also the grimmest, that of her violent possession at Geoffrey Holder's wedding, in 1955. Holder was a Caribbean dancer who was then appearing on Broadway in *House of Flowers*, a Harold Arlen musical with voodoo elements, based on a novella by Truman Capote. When Holder married Carmen de Lavallade, another dancer in the show, he asked Deren, his friend, to take charge and make it a voodoo wedding. The ceremony was held at the estate of the theatrical producer Lucille Lortel, in Westport, Connecticut. Deren asked Stan Brakhage, who was staying with her at the time, to photograph the event. When he arrived, he found Deren in a fury because the wedding's professional organizers had thwarted her plans for a voodoo ceremony and were, she thought, treating her with contempt. Brakhage wrote, "She did look like the wildest woman on earth to those professional Broadway people, who work so hard at being strange that when they encounter any genuine human strangeness, it gets their backs up."

While the wedding guests were drinking and eating hors d'oeuvres, bloodcurdling screams emanated from the kitchen. "I got to the kitchen in time to see Maya Deren, growling and possessed and in a terrific rage, pick up a refrigerator and hurl it from one corner of the kitchen to another. This wasn't a little luncheon icebox—it was a standard-sized kitchen refrigerator.

Some people don't believe this, but I saw it with my eyes." Soon, "everything else in the kitchen started flying. Watermelons went careening out the door, pots and pans, china—she was throwing everything." Holder arrived on the scene and surrounded her with sympathetic friends. He asked that no one call the police; they would handle it themselves. After Deren had calmed down, they led her upstairs to a bedroom.

"Some time later," wrote Brakhage, "I was called to the upstairs room. One of the Haitians came and said, 'Maya wants you.' I was, frankly, terrified. But I went upstairs, and as I stepped inside the room, two men grabbed me by the arms and held me. Maya was sitting on the bed with her hair standing completely on end" and growling incomprehensibly. Then "someone came up with a bowl of blue burning liquid and spooned it out all over the front of my suit. All I could do was to look down and see my suit burning from lapel to cuff, and all I could think was that this was my only suit and it was on fire." Deren was chanting in a voice that sounded nothing like her own. Afterward, the Haitians informed Brakhage that because of his loyalty he had been blessed by Papa Loco, the *loa* governing rituals. Brakhage concluded, "After that experience, I wasn't so inclined to doubt the power of Voodoun, or Maya's status in it." As he himself conceded, the story has always invited skepticism; yet he was among Deren's closest friends, even her disciple, and had no discernible motive to invent a story that portrayed her in a bad light.

In 1961, in the final months of her life, Deren worked on a low-budget film called *Maeva*, a trite melodrama about the degradation and redemption of a simple Tahitian girl. Directed by an Italian-American director named Umberto Bonsignori, in his only film, it was shot on location in Tahiti in black and white, without sync sound. Deren wrote a voice-over narration, complemented by a musical soundtrack by Teiji Ito, which work well together in a creditable attempt to overcome the film's weak scenario. A beautiful girl in a fishing village, Maeva dreams of a better life. One day she is raped by a sailor and soon afterward she leaves her village for the port, where she becomes a European painter's model: a late, faint echo of the Gauguin legend. Maeva commences a series of

Publicity still from Umberto Bonsignori's *Maeva*, the last film Maya Deren worked on.
Tumata Teuiau, the amateur Tahitian actress who played the title role, dances at center.

reckless love affairs with loutish white men; in the denouement she reforms and moves back to her village, where she marries her childhood sweetheart.

As Murnau had done in *Tabu*, a much better film in every way, Bonsignori lifts his story from Western melodrama, with the result that it poorly reflects the realities of Polynesian life. Maeva is motivated by violent jealousy; there are two scenes of her attacking Tahitian women who are her rivals for the affections of transient European men she has attached herself to. (When the film failed to find a distributor, Bonsignori tried to market it as a sexploitation film under the title *Pagan Hellcat*.) Maeva's age is never established, but Tumata Teuiau, the amateur actress who plays her, looks at least thirty; yet when the story begins she is supposed to be a virgin who knows nothing about sex or love, which pushes beyond the limits of credulity.

Deren's script is a polished attempt to make sense of the material, with some moving passages evoking Maeva's inner life. Deren does a fine job of imagining life in Tahiti, a place she had never seen, from the perspective of an islander. The narration, written in Maeva's voice, begins,

> Sometimes it seems to me as if this is the edge of the world, and that there is nothing real beyond these lagoons. . . . But they *are* real, the ships and their cargoes of men who come and look and go away. Why do they come? Tahiti is so small. There is no place to go except around and around, or away. One would travel so far only to find something very precious, or to see something very strange.

The film, technically primitive by the industry standards of its day, never got a commercial release. Bonsignori, who was Venetian by birth, screened it *hors-concours* at the Venice Film Festival, which got it a good review in *Variety*. Gene Moskowitz, the newspaper's European correspondent, singled out Deren's narration for particular praise, writing that it "points up the revelations and inner feelings and moods of the girl" and creates "a stream of consciousness effect which blends with the imagery."

A month later, Maya Deren died of a brain hemorrhage, at the age of forty-four. Like Raden Saleh, she was torn between two worlds that waged a war in her soul, with the same result: her homeland became alien to her. Postwar American society may have been less moralistic and censorious than that of the Dutch East Indies, but it was not necessarily more sympathetic to the artist's place in society. Teiji Ito said that Deren felt at home in Haiti because for the first time she was living in a community of people who thought as she did, in which art was a necessary activity. Herbert Passin put it in terms that closely parallel Walter Spies's experiment in Bali: "Haiti was important, in that she found a situation in which the artist had a natural place. . . . This is what she was groping for: where art is part of the rhythm of life."

The logical explanation of Maya Deren's premature death is that her stroke was brought on by malnutrition caused by borderline poverty and regular amphetamine use. Stan Brakhage and other friends who had seen her in exalted states of possession believed that she died as the result of a voodoo curse. Teiji Ito thought she died of anger.

In 1980, James Merrill caught her up on the news, in *Scripts for the Pageant*:

> Maya! In New York
> Last week I saw some friends of yours; saw Teiji.
> He and his young wife are salvaging
> Your Haitian film. At last it's out of storage,
> Cut, spliced, synchronized with the drum-tapes—
> Reel upon reel of ritual possession—
> And can be shown soon. We're all thrilled except
> (Wouldn't you know) your mother: "Maya made
> High class, avant garde stuff—documentaries
> Never." Whereupon Joe Campbell spoke
> Authoritatively of your amazement
> At being overwhelmed quite simply by
> Gusts of material so violent
> As to put out the candle held to them
> By mere imagination.

The Last Age of Exoticism

Pour l'enfant, amoureux de cartes et d'estampes,
L'univers est égal à son vaste appétit.
Ah! que le monde est grand à la clarté des lampes!
Aux yeux du souvenir que le monde est petit!

— Charles Baudelaire, "Le voyage"

For the child enamored of maps and prints,
The universe is equal to his vast appetite.
Ah! how wide the world is by lamplight!
Yet how small in the eyes of memory.

—"The Voyage"

When we moved into our apartment on Jalan Petitenget, the beach
road in Seminyak, Bali, I promised I would stay as long as the cows
did. The most attractive feature of the place was the rear terrace,
which looked out on a broad pasture where twenty or so cows
spent their days moseying around, munching on the grass. Our
front windows commanded a fine view of rice fields across the
street, a glittering expanse of emerald green that stretched into the
distance. On a clear day we could see Gunung Agung, Bali's sacred
volcano, with a perfect plume of smoke curling up from the crater
lip. I knew it couldn't last.

In those days, the village of Seminyak was quiet, with a few
hotels and tourist restaurants here and there amid the pasturage

and paddy fields and coconut groves. It lay just beyond the northern limit of Kuta, the beach resort on the island's west coast that rivaled Ubud as a tourist destination after Australian surfers discovered it in the early 1960s. The combination of gnarly waves, magic-mushroom omelets, and hospitable locals transformed Kuta into a thriving budget resort, packed solid with cheap hotels and honky-tonks. Seminyak, a couple of miles up the coast, was still a semirural backwater. Its principal claim to the attention of outsiders was its ancient temple, Pura Petitenget, where the Balinese come from miles around on major holidays to bathe and bless their idols in the sea.

Rendy, my partner and the business brains of the family, saw a boom coming and opened his first restaurant on Jalan Petitenget. It was an ideal situation for me: I wrote in a silence broken only by the chirping of birds and crickets. At lunchtime, I pedaled my bicycle down to our café for fried rice and papaya juice in a shady corner of the garden, and at day's end I went for a swim.

The boom, when it came, shocked even visionaries like Rendy. First to go was the volcano view, blocked by the sign of a Circle K convenience store that was built in the rice field opposite us. Soon a nightclub opened up next to it, which murdered the silence of the tropical night with electronic dance music; then the W chain built a four-story luxury hotel across the street from our café. Ten years after we moved to Seminyak, there wasn't an inch of paddy left, all cleared to make way for hotels, restaurants, and walled holiday villas, thousands of them, occupying the countryside like the encampment of an invading army.

It was great for business. Guests at the W discovered that they could have a steak dinner at our place for the price of a beer at the hotel. The tourists wandering up and down the street sometimes walked in for a meal, and many of them came back. Our café prospered and became a neighborhood landmark. The owner of the land has a gambling problem, and every time he has a big debt to pay, he offers us another extension on the lease, which now reaches into the distant future. As for me, I was living in the midst of one of the hottest travel stories in the world. For years, I was busily employed dispensing analysis and advice to the millions of travelers who discovered a desire to visit Bali.

I tried not to complain about the changes, because the boom was paying the bills, but life in Seminyak became mildly hellish. On the other side of the Circle K, a budget spa opened, where giddy adolescent girls sat on the roadside yelling, "Hey, mister, massage!" at every unattached foreign male who passed by. Traffic was slowed to a crawl by the lumbering behemoths of cement mixers and tourist buses; bicycling became a filthy, dangerous proposition. The transformation of the west coast of Bali has happened so quickly that no one has yet had a chance to take it in.

As the end of our ten-year lease on the apartment approached, a backhoe turned up in the pasture to dig the foundations of a villa complex. The cows were finally being turfed out, and I was ready to follow them. Rendy was opening a hotel on Gili Trawangan, a tiny island off the coast of Lombok, Bali's near neighbor to the east. Gili T was enjoying a sudden international notoriety for its outrageous full-moon parties: another boom. So in 2013 we moved to Lombok, setting up in a house with a garden on the mainland, overlooking the strait. On a clear day, we have a good view of Gunung Agung, looming impossibly large across the water. At dawn, competing choirs of songbirds raise a glorious rumpus, and at day's end the farmer who lives at the end of our street drives his cattle home, raising fine red dust in the slanting shafts of sunlight.

As you might expect, while I was writing this book in Bali and Lombok, I sometimes wondered if I was writing the story of my own life. Early on, I read *The Marsh Arabs*, by Wilfred Thesiger, a model travel memoir published in 1964—though, as Thesiger points out, it isn't really a travel book, because he stayed put once he found a place that suited him. For eight years, Thesiger lived in the wetlands between the Tigris and the Euphrates Rivers with a people who lacked almost every element of civilization except language, who indeed scarcely clothed and sheltered themselves. To explain his decision, Thesiger wrote, "I had spent many years in exploration, but now there were no untouched places left to explore, at least in the countries that attracted me. I therefore felt inclined to settle down among a people of my own choosing."

It occurred to me that that was more or less what I had done.

Like Thesiger, I had shopped around for a good landing place before I chose Indonesia. I was definitely not an explorer like him, but I too was beginning to feel a diminished interest in finding new worlds to conquer with my eyes. The analogy is flawed. Thesiger wrote that he was "always happy, in Iraq or elsewhere, to share a smoke-filled hovel with a shepherd, his family, and beasts. In such a household, everything was strange and different, their self-reliance put me at ease, and I was fascinated by the feeling of continuity with the past." I can do a smoky hovel for a night or two, if there's nothing more comfortable available, but I have always rejoiced in hot water and air-conditioning, and prefer to take in the strangeness and continuity with the past during waking hours.

As I researched and thought about the lives of the artists who populate this book, a list of the traits they shared began to form. From the start, I was wary of articulating a grand unified theory of exoticism and those who pursue it; the larger the sample, the more difficult it is to subordinate the individuals to the theory without making it vaporously vague. Yet the correspondences among these artists and writers are striking: the list created itself.

My principal subjects all had a cosmopolitan ancestry and childhood (if you admit Breton as an identity distinct from French, as Victor Segalen, like most Bretons, did), which resulted in a confusion about cultural identity that was sometimes exaggerated in adulthood, as in the case of Gauguin, the Peruvian. Isabelle Eberhardt requires so many hyphens to label her nationality it only proves that she lacked one.

Many of the exotes complicated their identity by using aliases or altering their names; even Segalen took the accent off his surname (on the first *e*), to make it Breton.

They cultivated an eccentric style of dress, often a version of what the locals wore but sometimes invented, like Raden Saleh's "fantasy uniform." Maya Deren made her own clothes, in a European peasant style, dirndl skirts and low-cut blouses, ruffled and ruched, that anticipated a popular look of the 1960s.

Several subjects were prodigious linguists, particularly Segalen and Walter Spies, who was one of the first foreigners to master the complexities of the Balinese language. (Raden Saleh's German was

fluent but comical, and Gauguin's inability to learn rudimentary Tahitian is a commonplace: I excuse myself from noting all the exceptions, the devils in any theory that has something interesting to offer.)

As artists they were versatile, working in many media, and some extended their interests into completely different fields, including science: the paleontologist Raden Saleh; Spies the pianist, choreographer, and naturalist; Segalen, a medical doctor who published learned articles about musicology.

In part because of their versatility and in part because of their ambiguous national identity, they were often undervalued as artists, neglected or even forgotten by the end of their lives.

In different ways they were all brave people, from Raden Saleh embarking on an overseas voyage by himself at the age of eighteen (or perhaps sixteen) to Victor Segalen serving as a doctor in places ravaged by contagious epidemics to Maya Deren steadfastly persevering in her dream of film art, although she never made a decent living from her work.

One salient similarity for which no exception need be made is the exotes' unconventional private lives. Spies was the only homosexual among my principal subjects (though Segalen appeared to take an interest in the subject, and Gauguin claimed to), yet none of them adhered to social norms. All these men and women experienced a powerful erotic attraction to the people of the new homeland. The body of the beloved Other inspired a state approaching carnal adoration in Gauguin and Spies; for Deren, it became a political symbol as well. All of them except Spies and Segalen married foreigners; Deren married two. As we have seen, there was a compelling reason that so many exotes were gay or interested in adolescents of either sex or lovers of a different race: they could only satisfy these appetites by leaving the country of their birth, where such preferences were socially unacceptable, if not illegal. A sense of injustice arising from this dilemma often intensified their discontent with the native homeland.

Finally, the lives of the exotes ended in tragic, premature deaths, which in several cases had the appearance of a shocking blow of destiny. There is no persuasive evidence that any of them commit-

ted suicide. A few scholars have suggested that Isabelle Eberhardt might have seen in the flash flood at Aïn Sefra a chance to put an end to her suffering, but it is only a conjecture. If true, it would be a unique instance of impulsively seizing an opportunity thrown her way by fate.

To harmonize these recurring themes into a comprehensive profile of the exote, we might discern in these disparate lives a proof that cultural identity can be a personal choice, made in defiance of the accident of nationality assigned by birth. The conventional sorting of artists into national schools, the British Romantics and the French impressionists, is an artificial scheme that does little to illuminate the individuals being grouped together. I propose that these exotes, who declared their personal independence from their native lands, constitute their own school of art: the school of no nation, or all nations. These artists share more traits with each other than they do with most of their contemporary compatriots; thus it might be worthwhile to seek affinities among their works.

It's always risky to assert influences and resemblances in a group of artists, and when the sample is global, comprising works in different media that span two centuries, it becomes something closer to a thought experiment. Yet it makes as much sense to discover sympathetic vibrations between Spies's paintings of the tropical jungle and Raden Saleh's wilderness landscapes painted in Europe as it does to slot Spies into the magic realism subfolder of German expressionism, and it makes no sense at all to regard Raden Saleh's hunt paintings as authentic examples of European art. The congruency is not only a superficial one of subject and detailed observation; both artists invest the image with a protean yet powerful quality of nature worship. It is important for an art historian to know that Raden Saleh's Orientalist paintings were strongly influenced by Eugène Delacroix and Horace Vernet, but that's the answer to a multiple-choice question, not an enlightening analysis. A Javanese feeling is immanent in Raden Saleh's paintings in Europe, even if the viewer cannot point to passages in the work that manifest it.

Affinities across generic lines also invite our notice. The exqui-

site miniatures of desert life that Eberhardt wrote at Kenadsa for all their fairy lightness possess a vivacity and freshness of vision that might usefully be compared to the flesh-and-blood presence of Gauguin's nudes in Tahiti. Norman Douglas, the author of *South Wind*, the classic novel about eccentric expatriates in Capri (which possesses a good measure of fairy lightness itself), was an early champion of Eberhardt's work. In an essay about her published in 1911, he wrote, "In this land of menacing monotony the artistic mind dwells lovingly upon the minutiae of human affairs, the result being a magnified visualization. The Arabs of Isabelle are so vital and palpitating that your ordinary ones [in the works of other travel writers] melt away in their presence like misty phantoms." Gauguin's robust adolescent girls, with their ingenuous poise and frank stares, likewise make the figures in paintings by the foreign artists who followed him to Polynesia seem insubstantial.

Admittedly, this is diaphanous logic and cannot be pushed very far. "Freshness of vision" is a subjective quality that describes many artists who never left home. Gauguin was a wholly original genius whose dream quest in Polynesia had an impact on world art that still resonates; whereas Isabelle Eberhardt was a talented writer who died in obscurity at the age of twenty-seven, before she could create a substantial body of work. Again, it may be necessary for a student of Eberhardt's work to know that she was inspired by Pierre Loti and Eugène Fromentin, the popular travel writer and novelist who visited Algeria in the mid-nineteenth century, but it is more interesting to feel the kinship between Eberhardt's lissome Arab youths and Gauguin's fleshy adolescent girls, both emanations of their creators' erotic reveries.

The most distinctive quality that these artists share is not thematic or stylistic but conceptual: the overlay of cultures across national and continental boundaries. French Romantic painting seen through Javanese eyes, Confucian ideals of cosmic order expressed with a French Decadent sensibility, the harmonious way of life in Bali embraced by a German aesthete who grew up in Moscow, West African magic in Haiti focused in the sympathetic lens of Beat-era Greenwich Village: the rapport that exists among these artists is invisible yet palpable. They were unique in the same way,

a paradox embodied by their lives. The cosmopolitan feeling in their work was not a calculated effect that the artists nurtured. It might never have occurred to Victor Segalen that he was writing about Polynesia and China with a French sensibility, and if it did, it might not have seemed to him a particularly interesting observation: he was simply looking at the world through the only window that was open to him. Finally, this quality of cultural overlay gives the works of exote artists a contemporary feeling, in their anticipation of a world in which commerce and communications and culture flow easily across national boundaries.

The exote experience typically describes an arc that rises in rapture and gradually decays into disillusionment. The new home is never as ideally compatible as it seemed in prospect: How could it be? It was a dream, like a new love. Flaws in the object of desire, potential sources of conflict that were easily brushed away in the first bloom of infatuation, become, with familiarity, disagreeable impediments. In the early days of my life in Asia, the naïveté of my new friends continually charmed me: the ridiculous questions they would ask! Yet over time that innocence about the world began to feel like nothing more than tiresome ignorance. (It's not a failure of the individual: since the colonial era, Indonesia has lacked a decent public-education system; basic reforms did not begin until the twenty-first century. As a result, the gaps in basic knowledge among most Indonesians, even about their own country, are sometimes astonishing.)

Inevitably, expatriates turn to the company of their fellow exiles, compatriots and other foreigners, anyone who speaks their language literally and figuratively; and when expats get together, the conversation at some point always turns to the corruption of their shared mistress, the new homeland. Contemporary exotes in Bali have suffered keenly from the transformation of the island over the past twenty years. Most long-term foreign residents want the island to remain forever as it was the day they arrived and fell in love with it, and they bitterly regret the decline of tradition. In *Arabian Sands*, Wilfred Thesiger precisely formulated the exote's

predicament when he described his response to modernization in the Sudan, where he had been posted as a young man: "I craved for the past, resented the present, and dreaded the future."

When a rather undistinguished pavilion on the palace grounds in Ubud, where the royal gamelan practiced, was torn down and a Starbucks built in its place, the social media were crowded with laments from anguished foreign residents. I regretted it too. It always gave a little thrill to wander through the village at dusk and suddenly hear the sonorous boom and brassy clangor of the gamelan waft over the brick walls. We've lost that. Longtime residents blame such changes on the great wave of tourism in the twenty-first century, the invasion of the barbarians, foreigners who come to Bali for the pink cocktails and easy sex and take no interest in the life of the island. Yet every time I pass by the new Starbucks in Ubud, most of the customers are Indonesians or regional tourists, who have come for a taste of the exotic in the form of a caramel latte.

Disillusioned expatriates tend to forget that their paradise is being paved with the active, enthusiastic participation of the Balinese, who own the land. The Balinese take pride in their unique culture, but they have no interest in preserving the island as it was when the foreign guests arrived. They are beguiled by the glamour of their visitors as much as we are by them. Most of the urban blight creeping across Bali and Indonesia and Asia is being created to cater to local consumers, who see the glowing logo of an American franchise not as an alien disfigurement but rather as a proof that their country is becoming modern and cosmopolitan.

In *The Sheltering Sky*, Kit Moresby, Bowles's weary world traveler, complains, "The people of each country get more like the people of every other country. They have no character, no beauty, no ideals, no culture—nothing, nothing." *The Sheltering Sky* was published in 1949, when exoticism would seem to have been in a state of relatively robust health. The world is wide but it is finite, and so is its store of mystery. With Starbucks on the palace grounds in Ubud and splendid shopping malls peddling Western luxury brands in Beijing, where would you go for an experience that's unlike anything you've ever seen before?

As I said, I no longer feel a yen to travel the world in search of the fountain of perpetual glamour; but if I did, if I could go anywhere I've never been, it would not be Spain or Russia, the conspicuous gaps in my travels in Europe, nor Hawaii or Cuba; it would be the Hermit Kingdom of North Korea, an enigmatic anachronism as exotic today as the Chinese Empire was in 1909, when Victor Segalen arrived. Yet even if the Dear Leader offered me a great job and a house on the grounds of his palace, as first the sultan of Yogyakarta and then the Tjokorde of Ubud did to Walter Spies, I couldn't consider it. After all, Spies settled on Indonesia as the *neue Heimat* not solely because it offered him an immersion in otherness but also because the culture was "unbelievably high and fabulous." He couldn't understand "how anything so divine can exist on earth." In the twenty-first century, it is all too easy to understand how the cult of dead dictators can exist, and there is nothing high or fabulous about it.

As Kit Moresby predicted, the cultural homogenization that has accompanied the global economy and information technology has debased the most basic condition required for exoticism to exist. Segalen's "perception of Diversity" is now in decline everywhere. How can you find something that's unlike anything you've ever seen before when the visual vocabulary of all cultures everywhere is readily available online? The world is too much with us in a way that Wordsworth, the walker, could never have envisioned. He hiked through fells and valleys for days to call on his friends, yet he saw enough of the world to write poetry that still moves readers. Now we can glide across the globe for a bird's-eye view of anywhere at all and read posts by travelers who were there last week.

In many ways, life in Lombok still resembles Diderot's paradisal dream of Tahiti. The people have manufactured few wants for themselves; here, ice cubes and cloth napkins pass for luxuries. Our most conspicuous superfluity is one of fruit, which grows in shocking abundance. My street is lined with mango, papaya, and jackfruit trees, which bear more gorgeous fruit than we and our neighbors can possibly eat. At the height of the season, mangoes litter the roads, and the thunder of twenty-pound jackfruit falling

on the roof of the shed where I park my car makes you leap out of your chair. My garden flourishes with ginger, bird-of-paradise, bougainvillea, and other ornamental shrubs I only know the Indonesian names for; most likely they don't have English names. You can't stop anything from growing in the rain-soaked volcanic soil: the gardener's main job is to reduce the volume of vegetation.

On my first visit to New York after I had come to Indonesia to live full-time, when my friends asked me what it was like, I answered, "It doesn't make as much difference where you live as you might think." It was a glib remark, but I haven't changed my opinion. Like anywhere you might settle down, Lombok has its unique beauties, which become familiar, and its particular problems, which eventually cease to annoy. I consider myself fortunate to have made my own discovery of the exotic when I did, but that's just smugness, like Vicki Baum congratulating herself in 1935 for the privilege of "seeing the real and unspoilt Bali instead of merely the modernized and tawdry fringes which tourists skirt in comfort." My experiences are but a faint impression of hers, or those of Walter Spies on the morning that the sultan's courtiers, appareled in gold, came to escort him to the *kraton*.

Lombok is my home not because its culture and way of life give me a sense of belonging that I never felt in the United States, though I admit I've become attached to the landscape; now when I visit temperate climes, I find even the prettiest scenes somehow too tame and tidy, and I long for the tropical sky almost with desperation. Lombok is my home because I have made it so.

Notes and Bibliography

Acknowledgments

Index

Notes and Bibliography

This book is not scholarly, in the current usage of the word, but my intention has been to adhere to the standards followed by the best academic scholars. In addition to citing the sources of quotations, these notes incorporate the bibliography of my research, with occasional brief comments about the works I consulted, and grateful acknowledgment of assistance and suggestions from colleagues and friends.

These notes reflect the realities of research in our times: I live in Indonesia, a country that lacks research libraries and well-stocked bookstores, so I have often had recourse to electronic books. Therefore I provide page numbers only for the books I consulted that actually have pages. For electronic books, I cite chapters or other markers where possible; of course, one advantage of electronic books is that a passage may be easily located by a global search. To those who complain that electronic books are unreliable texts, I would answer that typos and dropped copy have plagued writers and readers since Gutenberg, and the situation was considerably worse before him.

Where the text has enough bibliographical information to facilitate a successful search, I have made no annotation; one edition of *The Moon and Sixpence* is as good as another for my purposes. In quotations, I have followed the spellings of the original, in the belief that archaic forms and competing scholarly notions of correct usage hold some interest, but I have freely edited punctuation in the belief that it does not (and often doesn't reflect the writer's intentions at all but is rather imposed by the publisher). In other words, all quotations are verbatim and faithful to their sources, with omissions noted by ellipses, but I groom them as it suits me.

Unless otherwise noted, translations are my own.

TO THE READER

xi *"Whereas the tourist"*: Paul Bowles, *The Sheltering Sky* (London: Penguin, 2000), 10.

AN INVITATION

3 *The first nonfiction book*: Richard Halliburton, *Richard Halliburton's Complete Book of Marvels* (New York: Bobbs-Merrill, 1941).

4 *"I quit the Church"*: William Seabrook, *The White Monk of Timbuctoo* (New York: Harcourt, Brace, 1934), 116.

4 *"the Richard Halliburton of the occult"*: *Time*, Sept. 9, 1940.

4 *"magnificently strong"*: Seabrook, *White Monk of Timbuctoo*, 119.

6 *my first book*: David Soren and Jamie James, *Kourion: The Search for a Lost Roman City* (New York: Anchor Press, 1988).

7 *my book was published*: Russell Ciochon, John Olsen, and Jamie James, *Other Origins* (New York: Bantam Books, 1990).

7 *memoir of an Angkor pilgrimage*: Pierre Loti, *Un pèlerin d'Angkor* (Paris: Calmann-Lévy, 1912).

8 *"grander than anything left"*: Osbert Sitwell, *Escape with Me* (London: Macmillan, 1939).

8 *guidebook by the archaeologist*: Henri Marchal, *Guide archéologique aux temples d'Angkor* (Paris: G. van Oest, 1928).

13 *"Argument: Parallelism"*: Victor Segalen, *Essay on Exoticism: An Aesthetics of Diversity*, trans. and ed. Yaël Rachel Schlick (Durham, N.C.: Duke University Press, 2001), "October 1904."

13 *"throw overboard everything"*: Ibid., "11 December 1908."

17 *"Let no man go"*: Santo Brasca, *Viaggio in Terrasanta, 1480*, ed. A. L. Momigliano Lepschy (Milan: Longanesi, 1966), 128.

THE STUDIO OF THE TROPICS

23 *"I hardly know"*: Rimbaud to Izambard, May 13, 1871, in Arthur Rimbaud, *Oeuvres complètes*, ed. Antoine Adam (Paris: Gallimard, 1972), 249.

24 *"My day is done"*: Ibid., 95–96.

24 *"I am going to Panama"*: Paul Sweetman, *Gauguin: A Life* (New York: Simon & Schuster, 1995), 153.

25 *"Born under the most beautiful"*: Anne Salmond, *Aphrodite's Island* (Berkeley: University of California Press, 2009), 20. A definitive, beautifully written history of the European discovery of Tahiti.

26 *"I want to go to Tahiti"*: *Lettres de Gauguin, Gide* [etc.] à *Odilon Redon*, ed. Roseline Bacou and Ari Redon (Paris: J. Corti, 1960), 193.

26 *"feels the need"*: Sweetman, *Gauguin*, 256.

27 *Held at the Théâtre d'Art*: Alain de Leiris, "Charles Morice and His Times," *Comparative Literature Studies* 4, no. 4 (1967).

27–28 *"get himself elected"*: Sweetman, *Gauguin*, 258.

29 *"Stéphane Mallarmé presides"*: *Intimate Journals of Paul Gauguin*, trans. Van Wyck Brooks (London: Routledge, 1985), 17.

29 *"There, in Tahiti"*: *Paul Gauguin: Letters to His Wife and Friends*, ed. Maurice Malingue (Cleveland: World, 1949), 137.

29 *These naïve rhapsodies*: John Gould Fletcher, *Paul Gauguin: His Life and Art* (London: Nicholas L. Brown, 1921), III.5.

30 *"and now that I can hope"*: John Gould Fletcher, *Paul Gauguin,* III.5.

31 *"Marco Polo, citizen of Venice"*: Victor Segalen, *René Leys,* trans. J. A. Underwood (Chicago: O'Hara, 1974), 132.

32 *"a funny sort of Frenchman"*: Sweetman, *Gauguin,* 69.

32 *"I am a savage"*: Fletcher, *Paul Gauguin,* V.3.

33 *"a good, dull, honest"*: W. Somerset Maugham, *The Moon and Sixpence,* chap. 6.

33 *"From floor to ceiling"*: Ibid., chap. 56.

34 *"Between me and the sky"*: Paul Gauguin, *Noa Noa,* trans. O. F. Theis (New York: Dover, 1985), 10.

35 *" 'What! You bring back' "*: Ibid., 30.

35 *"Yacouba le décivilisé"*: White Owen, "The Decivilizing Mission: Auguste Dupuis-Yakouba and French Timbuktu," *French Historical Studies* 27, no. 3 (Summer 2004): 541.

35 *Montaigne begins by telling*: Darlene J. Sadlier, *Brazil Imagined: 1500 to the Present* (Austin: University of Texas Press, 2008), chap. 1.

36 *"all the pictures"*: Michel de Montaigne, *Essays,* vol. 6, trans. Charles Cotton, chap. 30, "Of Cannibals."

36 *"I looked at their happy"*: Gauguin, *Noa Noa,* 11.

36 *"And you, chief of the brigands"*: Denis Diderot, "Les adieux du vieillard," in *Oeuvres complètes de Diderot,* vol. 2, ed. J. Assézat (Paris: Garnier Frères, 1875), 214.

38 *"It is no wonder"*: Georg Forster, *A Voyage Round the World,* ed. Nicholas Thomas and Oliver Berghof (Honolulu: University of Hawaii Press, 2000), 1:351.

38 *"I am beginning to think"*: Stephen F. Eisenman, *Gauguin's Skirt* (London: Thames & Hudson, 1997), 61.

39 *"Good heavens"*: Sweetman, *Gauguin,* 337.

39 *"Everyone knows something about Gauguin"*: Quoted by Elizabeth C. Childs, "The French Connections," *New York Times,* March 31, 1996, among other periodicals; the primary source remains elusive.

39 *An influential essay*: Abigail Solomon-Godeau, "Going Native: Paul Gauguin and the Invention of Primitivist Modernism," in *The Expanding Discourse: Feminism and Art History,* ed. Norma Broude and Mary D. Garrard (New York: HarperCollins, 1992).

40 *"wish to be 'taken' "*: Gauguin, *Noa Noa,* 14.

40 *"the equivalent of eighteen"*: Ibid., 28.

41 *"Slavery is abolished"*: Flora Tristan, *Pérégrinations d'une paria* (Paris: Arthus Bertrand, 1838), xxiv.

41 *"an apprentice savage"*: Mario Vargas Llosa, *The Way to Paradise,* trans. Natasha Wimmer (New York: Farrar, Straus and Giroux, 2011), chap. 4.

41 *"A person's birthplace"*: Ibid., chap. 8.

42 *He published a vicious*: Sweetman, *Gauguin,* 471.

42 *"Tahiti for the French"*: Ibid., 486.

43 *"the Chinese merchants of Papeete"*: Pierre Loti, *Le mariage de Loti* (Paris: Calmann-Lévy, 1898), I.25.

43 *"Marriages made by the missionaries"*: Eisenman, *Gauguin's Skirt*, 167.

43 *An American scholar*: Ibid.

44 *Robert Louis Stevenson had visited*: Ibid., 165.

44 *A secret police dossier*: Ibid., 169.

45 *Gauguin wrote an obituary*: *Les Guêpes*, June 12, 1899, reprinted in *Gauguin: Journaliste à Tahiti*, ed. Bengt Danielsson and Fr. P. O'Reilly (Paris: Société des Océanistes, 1966), 24–25.

46 *"It will be said"*: *The Letters of Paul Gauguin to Georges-Daniel de Monfreid*, trans. Ruth Pielkovo (New York: Dodd, Mead, 1922), 170–71.

47 *"Reddish-brown, braided with foliage"*: I am grateful to Iain Bamforth for permission to quote from his unpublished translation of "Gauguin in His Final Décor."

48 *"Living so far from us"*: Quoted in Graham Robb, *Rimbaud* (New York: Norton, 2000), 399.

49 *"nature's plenitude reflected"*: Solomon-Godeau, "Going Native," 319.

49 *"wished to suggest by means of"*: Annie Joly-Segalen, ed., *Lettres de Paul Gauguin à Daniel de Monfreid* (Paris: Georges Falaize, 1950), no. xxix, 101.

50 *"A tall, thin man"*: Victor Segalen, "Le double Rimbaud," *Mercure de France*, April 15, 1906, 491–92.

51 *"Between the author of the* Illuminations*"*: Ibid., 495.

52 *"forgetful of their customs"*: Victor Segalen, *Oeuvres complètes*, ed. Henry Bouillier (Paris: Robert Laffont, 1995), 1:104.

53 *"the unremitting repetition"*: Ibid., 107.

53 *"The sons of Iakoba"*: Ibid., 182.

54 *"a Julian the Apostate"*: Ibid., 105.

54 *"I have tried to 'write'"*: Ibid., 103.

54 *"As for the influence"*: Ibid., 102.

55 *brilliantly collected*: *Flaubert in Egypt*, trans. and ed. Francis Steegmuller (London: Penguin, 1996), 41.

55 *The singular exception is* Vathek: Jamie James, *Rimbaud in Java* (Singapore: EDM, 2011), 102–103.

57 *"The fifty boys"*: William Beckford, *Vathek*, trans. Herbert B. Grimsditch (London: Nonesuch, 1929), 44. This elegant, straightforward translation of *Vathek* is superior in every way to the alternative, by Beckford's tutor, Samuel Henley, published in 1786 and reprinted many times.

58 *"The two clasps of her tunic"*: Gustave Flaubert, *Salammbô*, chap. 11.

58 *"Sweat flowed down his chest"*: Ibid.

58 *"During the two years"*: Segalen, *Oeuvres complètes*, 104.

PRINCE OF JAVA

My description of the life and work of Raden Saleh has benefited greatly from the generous assistance of Werner Kraus, whose painstaking research and brilliant analysis have set the standard for all future studies of the artist. His monograph *Raden Saleh: The Beginning of Modern Indonesian Painting* (Jakarta:

Goethe Institut, 2012), the catalog of a landmark exhibition at Indonesia's National Gallery, is the principal source. I have drawn on other sources wherever possible, notably the fine series of biographical articles published by the journal *Archipel*.

63 *Raden Saleh's principal obligation*: Jean Gelman Taylor, *Indonesia: Peoples and Histories* (New Haven, Conn.: Yale University Press, 2003), 277.

66 *"Two poles diametrically opposed"*: Kraus, *Raden Saleh* (2012), 25 (trans. Chris Cave).

66 *"far superior to all [his] countrymen"*: Ibid., 31.

67 *I have said that Raden Saleh*: Ibid., 29–30.

67 *"He had his lunch brought"*: Ibid., 37.

69 *Pangeran Diponegoro*: Peter B. R. Carey, "Dipanagara and the Painting of the Capture of Dipanagara at Magelang (28 March 1830)," *Journal of the Malaysian Branch of the Royal Asiatic Society* 55, no. 1 (1982).

69 *"Kyai means lord"*: Kraus, *Raden Saleh* (2012), 36–37.

72 *"the greatest care"*: Albert van Dantzig, "The Dutch Military Recruitment Agency in Kumasi," *Ghana Notes and Queries* 8 (1966).

73 *"abomination and horror"*: Larry W. Yarak, "Kwasi Boakye and Kwame Poku: Dutch-Educated Asante 'Princes,'" in *The Golden Stool*, ed. Enid Schildkraut, Anthropological Papers of the American Museum of Natural History, vol. 65, part I, pp. 131–45 (New York, 1987), 138.

75 *in Salammbô, Flaubert*: Flaubert, *Salammbô*, chap. 4.

76 *"Oh that I had the art"*: Byron, *Beppo*, LI.5–8.

76 *The spectacular Orientalist operas*: Frederick Penzel, *Theatre Lighting Before Electricity* (Middletown, Conn.: Wesleyan University Press, 1978), 69.

77 *Henri Martin, an animal trainer*: Patrick Berthier, "Animal de théâtre ou bête de scène?," *Actes du colloque international 2008*, "Littérature et civilisation du XIXe siècle," Équipe 19, Université Paris-Diderot.

78 *"Raden Saleh, the chieftain's son"*: Kraus, *Raden Saleh* (2012), 42.

79 *Raden Saleh moved from*: Werner Kraus, *Raden Saleh: Ein Malerleben zwischen zwei Welten* (Maxen: Niggemann & Simon, 2004).

79 *Ernst Ferdinand Oehme*: David Bakan, *Sigmund Freud and the Jewish Mystical Tradition* (New York: Schocken, 1965), 7.

81 *"Certainly Your Excellency"*: Kraus, *Raden Saleh* (2012), 42.

81 *"Feelings are so Oriental"*: Ibid., 45.

85 *In the spring of 1844*: *Memoirs of Ernest II* (London: Remington, 1888).

86 *One of Raden Saleh's most*: Permanent exhibition at Ehrenburg Castle, Coburg.

86 *His name was Maximilian Wilhelm Phillips*: Werner Kraus, personal communication.

86 *"When in the first years"*: Kraus, *Raden Saleh* (2012), 114.

87 *"In the Grand Duke of Baden's room"*: Virginia Surtees, *Charlotte Canning, Lady-in-Waiting to Queen Victoria and Wife of the First Viceroy of India* (London: John Murray, 1975), 158.

87 *His opera Diana von Solange*: Irving Kolodin, *The Story of the Metropolitan Opera, 1883–1950* (New York: Knopf, 1953), 112–13.

88 *In 1862, he led*: *Gerstäcker's Travels* (London: Nelson and Sons, 1865).
88 *"Dear Uncle Ernest"*: Charlotte Zeepvat, "The Queen and Uncle E," *Royalty Digest*, July 2000, 5. For information about Raden Saleh's life in Paris, I consulted Claude Guillot and Pierre Labrousse, "Raden Saleh, un artiste-prince à Paris," *Archipel* 54 (1997): 123–52.
88 *"Upon my arrival"*: Kraus, *Raden Saleh* (2012), 58.
88 *"one of the greatest artworks"*: *Wiener Zeitschrift für Kunst, Literatur, Theater und Mode*, Aug. 19, 1847, 650.
88 *"to be entirely successful"*: Kraus, *Raden Saleh* (2012) (manuscript).
89 *"All eyes were on a handsome"*: *Petit courrier des dames*, March 5, 1845, 100–101, reprinted in Guillot and Labrousse, "Raden Saleh," 133.
90 *"The servant Cobellie"*: Kraus, *Raden Saleh* (2012), 59.
90 *after his dismissal in Paris*: Werner Kraus, personal communication.
91 *"well-built, like an Ethiopian Antinous"*: Charles de Spoelberch de Lovenjoul, *Histoire des oeuvres de Théophile Gautier* (Paris: Charpentier, 1887), 331.
92 *The gulf between Dutch*: Taylor, *Indonesia*, 249.
93 *"All Malays who undergo"*: Kraus, *Raden Saleh* (2012), 69.
93 *He wrote a passionate letter*: Ibid., quoted in full on 84–85.
96 *"We alighted at the house"*: [Ludovic] comte de Beauvoir, *A Voyage Round the World* (London: John Murray, 1870), 2:173.
96 *"the most magnificent residence"*: Kraus, *Raden Saleh* (2012), 81.
98 *What learned inquiry*: Huib J. Zuidervaart and Rob H. van Gent, "A Bare Outpost of Learned Culture on the Edge of the Jungles of Java," *Isis* 95, no. 1 (March 2004).
99 *In his report to the Batavian Society*: Kraus, *Raden Saleh* (2012), 88–89.
99 "Burial at Ornans": Gerstle Mack, *Gustave Courbet* (Cambridge, Mass.: Da Capo, 1989), 89.
100 *Werner Kraus makes an ingenious argument*: Kraus, *Raden Saleh* (2012), 65–67.
100 *"It is a joy"*: Jamie James, *The Music of the Spheres* (New York: Grove Press, 1993), 13.
101 *A painting of 1863*, Drinking Tiger: Permanent exhibition, Presidential Palace, Jakarta.
102 *A portrait of Raden Ayu Muning Kasari*: Collection of Oei Hong Djien, Magelang.
102 *A portrait of Hamengkubuwono VI*: See Kraus, *Raden Saleh* (2012), 92.
104 *"I yearn terribly"*: Ibid., 115.
105 *"He had become an old man"*: Ibid., 117.
106 *" 'Think no more, Raden Saleh' "*: Ibid., 121.

INSANELY GORGEOUS

109 *"It's only when you're really clear"*: Hans Rhodius, *Schönheit und Reichtum des Lebens: Walter Spies (Maler und Musiker auf Bali, 1895–1942)*

[The beauty and riches of life: Walter Spies (artist and musician in Bali, 1895–1942)] (The Hague: L. J. C. Boucher, 1964), 128.

111 *His paternal grandfather*: For information about Spies's early life, I consulted John Stowell, *Walter Spies: A Life in Art* (Jakarta: Afterhours Books, 2012).

112 *"a dancing tea"*: Rhodius, *Walter Spies*, 68.

112 *"One thing I've got"*: Ibid., 72.

113 *Lucky as he would always*: Marco De Michelis, "Modernity and Reform: Heinrich Tessenow and the Institut Dalcroze at Hellerau," *Perspecta* 26 (1990): 143–70.

113 *"everything is new"*: Ibid., 145.

114 *"I was totally carried away!"*: Stowell, *Walter Spies*, 5.

114 *"perhaps the most future-looking"*: Steffen Schleiermacher, notes to *Hommage à Walter Spies*, sound recording MDG 6131171-2, 2003, 6.

114 *"Futurist wild child"*: Rhodius, *Walter Spies*, 86.

115 *"The family has a language"*: Stowell, *Walter Spies*, 44.

115 *"hair the color of ripe corn"*: Ibid., 40.

117 *"narrow Gothic chamber"*: Johann Wolfgang von Goethe, *Faust Part I*, trans. Bayard Taylor (Boston: Houghton Mifflin, 1898).

117 *"Then he passes me a photo"*: Rhodius, *Walter Spies*, 85.

119 *Precisely when they met*: David Sandberg, personal communication.

119 *In 1921, Murnau invited Spies*: Gary L. Atkins, *Imagining Gay Paradise* (Hong Kong: Hong Kong University Press, 2012), 51.

121 *"I'm off to God knows where"*: Rhodius, *Walter Spies*, 93.

122 *A critic named Franz Roh*: Atkins, *Imagining Gay Paradise*, 69–71.

123 *"He always seemed"*: Rhodius, *Walter Spies*, 122.

123 *She also expressed concern*: David Sandberg, personal communication.

123 *"I tried to get him to see"*: Rhodius, *Walter Spies*, 122.

124 *"Murnau sailed off"*: Ibid., 267.

126 *"Murnau offers us an apotheosis"*: Lotte H. Eisner, *Murnau* (Berkeley: University of California Press, 1973), 202–203.

127 *"There is but one way"*: Johann Joachim Winckelmann, *Reflections on the Painting and Sculpture of the Greeks*, trans. Henry Fuseli (London: A. Millar, 1765), 2.

127 *"The young Spartans"*: Winckelmann, *Reflections*, 6.

127 *"The forms of the Greeks"*: Ibid., 4–5.

128 *"Mehao had more grace"*: Eisner, *Murnau*, 211.

128 *"With the suppleness"*: Gauguin, *Noa Noa*, 19.

129 *"deep gold tumbler"*: Paule Laudon, *Matisse in Tahiti* (Paris: Adam Biro, 2001).

129 *"In Greece"*: Winckelmann, *Reflections*, 9.

129 *"there is no work"*: Eisner, *Murnau*, 213.

130 *"the only person in the world"*: Stowell, *Walter Spies*, 133.

130 *His rich friends did not come*: In addition to Rhodius's commentary, information about the life of Heinrich Hauser comes from Uwe Schultz's article in *Neue deutsche Biographie* (Berlin: Duncker & Humblot, 1969), 117–18.

131 *"It's odd"*: Rhodius, *Walter Spies*, 137–39.
133 *"It is impossible"*: Heinrich Hauser, *Bitter Water*, trans. Patrick Kirwan (London: Wishart, 1930), 128. Translation of *Brackwasser*.
133 *"Dead tired"*: Rhodius, *Walter Spies*, 146.
134 *"The people, the Sundanese"*: Ibid., 149.
135 *"Luck and good fortune"*: Ibid., 148.
136 *when the book was ready*: David Sandberg, personal communication.
136 *A letter dated November 26, 1923*: Rhodius, *Walter Spies*, 149–56. Rhodius cut this letter, as always failing to note his elisions. David Sandberg kindly provided me with a typescript of the integral letter, but after some agonizing I decided to use the Rhodius version. None of the passages Rhodius deleted are as interesting as those he published, and the entire letter is too long to publish here, as it was for Rhodius. For better or worse, Rhodius's book has acquired a de facto legitimacy.
141 *In letter 126*: Samuel Richardson, *Clarissa* (London: Penguin, 1985), 467.
142 *Spies might even have seen Elsheimer's*: Peter Weidhaas, *A History of the Frankfurt Book Fair*, trans. and ed. C. M. Gossage and W. A. Wright (Toronto: Dundurn, 2007), 50.
142 *"I've seen and experienced"*: Rhodius, *Walter Spies*, 165.
142 *"Is it possible"*: Ibid., 168.

GOONA-GOONA IN BALI

148 *"He now has complete scores"*: Hans Rhodius and John Darling, *Walter Spies and Balinese Art* (Amsterdam: Tropical Museum, 1980), 29.
148 *"Time and again"*: Rhodius, *Walter Spies*, 310.
149 *"I am still here"*: Ibid., 219.
149 *"The scene-drops"*: Stowell, *Walter Spies*, 102.
149 *"I'm going to go to Bali"*: Rhodius, *Walter Spies*, 226.
151 *The loss of the king*: See Clifford Geertz, *Negara* (Princeton, N. J.: Princeton University Press, 1980).
152 *"a really great artist"*: Stowell, *Walter Spies*, 285.
153 *In Bali, Spies continued*: Edward Herbst, liner notes for *The Roots of Gamelan*, ArkivMusic cat. 2001 (New York, 1999).
154 *"Gamelans, dances, games"*: Rhodius, *Walter Spies*, 345.
155 *"It is true"*: Walter Spies and Beryl de Zoete, *Dance and Drama in Bali* (London: Faber, 1938), 83.
155 *"What else"*: Rhodius, *Walter Spies*, 264.
155 *slang in America for "sex appeal"*: Miguel Covarrubias wrote that *goona-goona* was "Newyorkese for sex allure," in Miguel Covarrubias, *Island of Bali* (New York: Knopf, 1936), 391.
156 *"The whole thing"*: Rhodius, *Walter Spies*, 298.
157 *These early films*: The only authoritative source for the life of Devi Dja is the chapter that the American anthropologist Matthew Isaac Cohen devotes to her in his imaginative, well-researched book *Performing Otherness: Java and Bali on International Stages, 1905–1952* (London: Palgrave

Macmillan, 2010), which I have relied on here. There is also an amusing, totally unreliable faux memoir by a Hollywood publicist named Leona Mayer Merrin: *Standing Ovations* (Santa Monica, Calif.: Lee and Lee, 1989).

159 *"sarong-girl numbers"*: Cohen, *Performing Otherness*, 192.

159 *"Here is an exciting"*: Cornelius Conyn and Jon C. Marten, *The Bali Ballet Murder* (London: Harrap, 1961), 1.

161 *Moreover, the comic actor*: Stowell, *Walter Spies*, 178.

162 *After their wedding in Singapore*: Margaret Mead, *Blackberry Winter: My Earlier Years* (New York: Kodansha Globe, 1995).

163 *The depth of research*: Adriana Williams, *Covarrubias in Bali* (Singapore: EDM, 2005).

163 *"In his charming devil-may-care way"*: Covarrubias, *Island of Bali*, xxii.

164 *"He's an incredibly sensitive"*: Rhodius, *Walter Spies*, 306–307.

164 *The Chaplin archive*: I am grateful to Kate Guyonvarch at the Charles Chaplin Archive in Paris for providing me with extracts from this document.

166 *"I found an interesting German artist"*: *The Letters of Ruth Draper*, ed. Dorothy Warren (Carbondale: Southern Illinois University Press, 1999), 204.

167 *Her first bestseller*: *Menschen im Hotel* was translated into English in 1931 by Basil Creighton with the title *Grand Hotel*.

167 *"an eccentric with an unrivaled knowledge"*: Vicki Baum, *A Tale from Bali*, trans. Basil Creighton (Oxford: Oxford University Press, 1973), vii.

167 *Spies's most glamorous visitor*: C. David Heymann, *Poor Little Rich Girl* (London: Hutchinson, 1985).

168 *"In the village of Ubud"*: Ibid., 79.

168 *"The palace and Buddhist temples"*: Rhodius, *Walter Spies*, 330.

169 *"of tall, strange towers"*: Loti, *Un pèlerin d'Angkor*, chap. 1.

169 *"I got up terribly early"*: Typescript of original letter (Rhodius No. 87) kindly provided by David Sandberg.

169 *It had recently completed*: Louis Finot, Victor Goloubew, and George Coedès, *Le Temple d'Angkor Vat* (Paris: EFEO, 1929–32).

170 *"the immoral lifestyle"*: Atkins, *Imagining Gay Paradise*, 112.

170 *"a series of suicides"*: Rhodius and Darling, *Walter Spies and Balinese Art*, 45.

171 *"the whole European population"*: Stowell, *Walter Spies*, 230.

171 *"Dear Stroppiproppity"*: Atkins, *Imagining Gay Paradise*, 102.

172 *"a homosexual who is a man-loving man"*: Ibid., 124.

172 *"Walter Spies has been able"*: Ibid., 126.

172 *"It is dreadfully nice"*: Stowell, *Walter Spies*, 237.

172 *Baron von Plessen told Rhodius*: Rhodius, *Walter Spies*, 274.

173 *"Walter sat on his own"*: Ibid., 434.

175 *In 1933, he published*: Walter Spies, "Das grosse Fest im Dorfe Trunyan (Insel Bali)," *Tijdschrift voor Indische taal-, land- en volkenkunde* 73 (1933): 220–56.

175 *"Walter loves to collect"*: Covarrubias, *Island of Bali*, xxii.

175 *"With inexhaustible energy"*: Ruud Spruit, *Artists on Bali* (Amsterdam: Pepin Press, 1995), 65.
175 *"I have started collecting"*: Rhodius, *Walter Spies*, 423.
176 *"The degree of Spies' influence"*: Rhodius and Darling, *Walter Spies and Balinese Art*, 75.
177 *The story is well attested*: H. I. R. Hinzler, "Sources of Inspiration," in *Lempad of Bali*, ed. Bruce Carpenter (Singapore: EDM, 2014), 27.
177 *"The debt to Spies"*: Rhodius and Darling, *Walter Spies and Balinese Art*, 75.
178 *"The assumptions were always paternalistic"*: Adrian Vickers, *Bali: A Paradise Created* (Tokyo: Tuttle, 2012), 162. If I seem to deal harshly with Vickers's book, it's because it has established itself as the definitive work on its main subject and its sketch of the life of Walter Spies is widely read; however, the latter is careless in its research and tendentious in its conclusions. In addition to his cavalier, unjustified dismissal of Spies's talent, Vickers takes a flippant approach to the highly prejudicial investigation that led to his arrest and conviction. Vickers appears to accept Resident Moll's accusation at face value and does not mention any of the exonerative evidence in the record, such as Margaret Mead's affidavit.
178 *"I hope all will go well"*: Rhodius, *Walter Spies*, 375.
179 *"did not after all"*: Bruce Granquist, *Inventing Art: The Paintings of Batuan Bali* (Bali: Satumata Press, 2012), 40.
180 *"He paints dreamlike landscapes"*: Covarrubias, *Island of Bali*, xxii–xxiii.
181 *"He multiplied his intellectual force"*: Walter Pater, "Winckelmann," in *The Renaissance* (London: Macmillan, 1888), 190.

THE EMPIRE OF THE SELF

My principal sources for the life of Victor Segalen are the only book-length biography of the writer, Henry Bouillier's *Victor Segalen* (Paris: Mercure de France, 1961), and Bouillier's detailed chronology in his edition of the complete works (*Oeuvres complètes*, cited above), supplemented by the author's letters, published in various journals, as noted. I adhere to the Wade-Giles system of romanization, which was in universal use until the late twentieth century, to harmonize with the works of Segalen and the other authors quoted.

185 *"a certain anxiety"*: Segalen, *Oeuvres complètes*, 1:lx.
186 *"symbolic incarnation"*: J.-K. Huysmans, *Against Nature (À Rebours)*, trans. Robert Baldrick (London: Penguin, 1959), 66.
186 *"the sins of the world"*: Oscar Wilde, *The Picture of Dorian Gray*, chap. 10.
187 *"capable of penetrating"*: Rollo Myers, "The Opera That Never Was," *Musical Quarterly* 64, no. 4 (Oct. 1978): 497–98.
187 *"I am a lazy composer"*: Anthony Tommasini, "Debussy's Homage to Poe," *New York Times*, Nov. 25, 2009.
188 *As his daughter later observed*: Annie Joly-Segalen, "Vie de Victor Segalen," *Cahiers du Sud*, no. 288 (1948), 180.
188 *"a little Jewess"*: Segalen, *Oeuvres complètes*, 1:liv.

188 *"twenty-six thousand industrious"*: Bouillier, *Victor Segalen*, 73.

189 *"a perpetual image"*: Ibid., 192.

189 *"I am fortunate"*: "Lettres de Chine, écrites par Victor Segalen à sa femme," *La Revue de Paris*, April 1967, 37.

189 *Paul Claudel*: Paul Claudel, *Knowing the East*, trans. James Lawler (Princeton, N.J.: Princeton University Press, 2004).

191 Son of Heaven: *Le fils du ciel* has not been published in English translation.

191 *"a witness to the secret"*: Bouillier, *Victor Segalen*, 446.

192 *"Then how?"*: Segalen, *Oeuvres complètes*, 2:577.

193 *"The hateful character"*: Ibid., 2:590.

194 *"Je est un autre"*: Rimbaud, *Oeuvres complètes*, 249.

195 René Leys *inverts the detective genre*: I profited by reading Yvonne Y. Hsieh, "Roman policier / roman exotique: *René Leys* de Victor Segalen," *Tangence* 38 (Dec. 1992).

196 *"I must close"*: Segalen, *René Leys*, 17.

196 *"I tell myself"*: Ibid., 199.

197 *"Don't they know"*: Victor Segalen, *Paintings*, trans. and ed. Andrew Harvey and Iain Watson (London: Quartet, 1991), vii. In their introduction, the translators quote Borges's comment and attribute it to "a French poet friend of ours," whose identity they do not reveal. No one is grateful to them for their discretion, which only raises doubts about the authenticity of a quotation that otherwise rings true.

197 *Among many puzzles*: All quotations are from the electronic edition of Edmund Backhouse, *Décadence Mandchoue*, ed. Derek Sandhaus (Chicago: Earnshaw Books, 2011). Biographical information about Backhouse comes from Derek Sandhaus's introduction and Robert Bickers, "Backhouse, Sir Edmund Trelawny, Second Baronet (1873–1944)," in *Oxford Dictionary of National Biography* (Oxford: Oxford University Press, 2004).

203 *"In naïve, or pure, Camp"*: Susan Sontag, *Against Interpretation* (New York: Farrar, Straus and Giroux, 1988).

204 *On the way back to the hotel*: "Letter from Beijing: Bad Boy," *New Yorker*, April 21, 1997.

206 *"a great deal of luck"*: George N. Kates, *The Years That Were Fat* (Oxford: Oxford University Press, 1988), 108.

207 *"an upright stone tablet"*: Victor Segalen, *Stèles*, trans. and ed. Timothy Billings and Christopher Bush (Middletown, Conn.: Wesleyan University Press, 2007), 53. Billings and Bush pair legible half-tone facsimiles of the pages of the first edition with facing translations of a high literary quality, accompanied by a nearly book-length introduction and exhaustive notes.

209 *"What paper!"*: Bouillier, *Victor Segalen*, 246.

209 *the first French translation*: Robert Irwin, introduction to *The Arabian Nights*, trans. Malcolm C. Lyons with Ursula Lyons, vol. 1 (London: Penguin Classics, 2008).

210 *"vast imaginary China"*: Bouillier, *Victor Segalen*, 205.

210 *"can be exactly determined"*: Victor Segalen, "Recent Discoveries in An-
cient Chinese Sculpture," *Journal of the North China Branch of the Royal
Asiatic Society* (1917): 153.

211 *Escapade*: *Équipée: Voyage au pays du réel* has not been published in En-
glish translation.

211 *"The journey has decidedly"*: Segalen to Jules de Gaultier, Jan. 11, 1914.

211 *"One must look deeply"*: Segalen, *Oeuvres complètes*, 2:301.

212 *"Though adjoining states"*: Lao-tzu, *Tao Te Ching*, trans. D. C. Lau (Lon-
don: Penguin, 1963), 87.

212 *"They will know"*: Segalen, *Oeuvres complètes*, 2:305.

213 *"austere houses"*: *Classical Chinese Poetry: An Anthology*, trans. and ed. Da-
vid Hinton (New York: Farrar, Straus and Giroux, 2008), 122.

214 *A similar story*: Friedrich Gerstäcker, trans. George C. Harrup, reprinted
in *Zoetrope* 6, no. 1 (Spring 2002).

215 *The affinities are even more*: Gene Lees, *The Musical Worlds of Lerner and
Loewe* (Lincoln: University of Nebraska Press, 1990), 47–51.

217 *"You are there"*: Segalen, *Oeuvres complètes*, 2:155. Andrew Harvey and
Iain Watson's translation of *Peintures*, cited above, is a fine one; here, I
offer my own versions.

217 *"and he becomes small"*: Ibid., 189.

217 *"in feasts, music"*: Ibid., 214.

218 *"participate in the life of sap"*: Ibid., 180.

219 *"better to live here in sackcloth"*: Jamie James, "A Traveler's Way with
Words," *Wall Street Journal*, March 20, 2009. My principal source for
information about the life of Lafcadio Hearn is Jonathan Cott's engag-
ing biography cum anthology, *Wandering Ghost* (New York: Knopf,
1991).

219 *"The Reminiscences of a Ghost-Seer"*: Lafcadio Hearn, *American Writings*,
ed. Christopher Benfet (New York: Library of America, 2009), 615.

219 *"the withering and wasting power"*: Ibid., 699.

220 *"loved as if it were"*: Ibid., 822.

220 *"a little yellow-skinned woman"*: Pierre Loti, *Madame Chrysanthème*,
trans. Laura Ensor (New York: Modern Library, 1921).

222 *"then the color and the light"*: Cott, *Wandering Ghost*, 284–85.

222 *"You have entered"*: Nina H. Kennard, *Lafcadio Hearn* (New York: Ap-
pleton, 1912), chap. 15.

222 *"What is there"*: Cott, *Wandering Ghost*, 330.

223 *On September 22*: "Lettres à Henry Manceron," *Mercure de France*, June
1962, 249–52.

224 *A contemporary French doctor*: Christian Régnier, in *Medicographia* 27,
no. 2 (2005): 188–99.

224 *"I am being despicably betrayed"*: Bouillier, *Victor Segalen*, 533–34.

SEEKERS OF OBLIVION

My narrative of the life of Isabelle Eberhardt is based on Cecily Mackworth,
The Destiny of Isabelle Eberhardt (New York: Ecco, 1975); Annette Kobak, *Is-*

abelle (New York: Knopf, 1989); and selective reading in Edmonde Charles-Roux's definitive two-volume biography, *Un désir d'Orient* (Paris: Grasset, 1988) and *Nomade j'étais* (Paris: Grasset, 1995), with frequent recourse to Paul Bowles's introduction to his translations of Eberhardt's stories, *The Oblivion Seekers* (San Francisco: City Lights, 1975). None of the English-language works is annotated, thus all their quotations from Eberhardt's journals and correspondence must be taken on faith. Except as noted, quotations from the works of Isabelle Eberhardt are from the two-volume *Collected Works of Isabelle Eberhardt*, ed. Marie-Odile Delacour and Jean-René Huleu, trans. Melissa Marcus (Lincoln: University of Nebraska Press, 2012 and 2014), with minor, silent emendations.

230 *He was a fervent anarchist*: Kobak, *Isabelle*, 9.
231 *"this land of the Maghrib"*: Ibid., 27.
232 *"Who knows whether"*: Mackworth, *Destiny of Isabelle Eberhardt*, 32.
233 *"Her dead eyes remained"*: Delacour and Huleu, *Collected Works*, 2:5–8.
233 *"His slenderness seemed"*: Ibid., 11–21.
234 *"perfect authenticity"*: Charles-Roux, *Un désir d'Orient*, 320.
234 *"clerical, chauvinist, nationalistic"*: Ibid., 317.
235 *"I don't believe"*: Ibid., 323.
235 *"This giant of Art"*: Delacour and Huleu, *Collected Works*, 2:32–42.
236 *"Oh! that the Desert"*: Byron, *Childe Harold's Pilgrimage*, IV.177.
237 *Byron's poetical yearning*: My principal sources are *Memoirs of the Lady Hester Stanhope*, as told to her physician, Charles Lewis Meryon, 3 vols. (London: Henry Colborn, 1846), and Frank Hamel, *Lady Hester Lucy Stanhope: A New Light on Her Life and Love Affairs* (London: Cassell, 1913).
237 *His literary career*: For Byron in Athens, I consulted Fiona McCarthy, *Byron: Life and Legend* (New York: Farrar, Straus and Giroux, 2002), 127–31.
237 *"At Athens, I saw"*: Stanhope, *Memoirs*, 3:194.
237 *"I do not admire"*: Hamel, *Lady Hester Lucy Stanhope*, 94.
237 *"I can't think"*: McCarthy, *Byron*, 130–31.
238 *"starving thirty hours"*: Hamel, *Lady Hester Lucy Stanhope*, 121–22.
238 *"The Arabs have never"*: Ibid., 56.
238 *"Once when riding"*: Stanhope, *Memoirs*, 2:131.
238 *"the strange, talented"*: Kathryn Tidrick, *Heart-Beguiling Araby* (London: Tauris, 1990), 38.
240 *"Your Majesty will allow"*: Hamel, *Lady Hester Lucy Stanhope*, 293–94.
240 *"in the silence"*: Malingue, *Paul Gauguin*, 137.
241 *"he found Isabelle in a state"*: Bowles, *Oblivion Seekers*, 8–9.
241 *"Since I've finally left"*: Kobak, *Isabelle*, 107.
241 *"knew that this svelte cavalier"*: Ibid., 197.
241 *"neurotic and deranged woman"*: Ibid., 130.
242 *One of Eberhardt's biographers*: Ibid., 98–99.
243 *"She calmly set out"*: Bowles, *Oblivion Seekers*, 11.
243 *"a vague feeling"*: Charles-Roux, *Nomade j'étais*, 313.

245 *"God alone knows"*: Kobak, *Isabelle*, 157.

245 *"Before, I had to wait"*: Ibid., 177.

246 *"We understood each other"*: Ibid., 212.

246 *"would be one"*: Mackworth, *Destiny of Isabelle Eberhardt*, 203.

246 *"Kenadsa appears"*: Delacour and Huleu, *Collected Works*, 1:276.

247 *"I am a guest"*: Ibid., 280.

248 *"a stranger note"*: Ibid., 316.

248 *a scurrilous book*: *Le Maroc inconnu* has not been published in English translation.

248 *"raging sensuality"*: Ibid., 320.

248 *"We enter the tea room"*: Ibid., 319–21.

249 *"nevertheless, I cannot"*: Charles-Roux, *Nomade j'étais*, 487.

250 *"We were on the balcony"*: Mackworth, *Destiny of Isabelle Eberhardt*, 222.

251 *"where, in the heart"*: Delacour and Huleu, *Collected Works*, 2:88.

253 *"a breath steals"*: Ibid., 76.

253 *"The seekers of oblivion"*: Ibid., 74.

254 *"a marvelous youth"*: André Gide, *Si le grain ne meurt* (Paris: Éditions du groupe, 1926), 297.

255 *"Here a redness lingers"*: André Gide, *Amyntas*, trans. Richard Howard (New York: Ecco, 1999), 136.

255 *"Earthen walls!"*: Ibid., 9.

255 *"I made my way"*: Ibid., 144.

257 *"living by theft"*: Robb, *Rimbaud*, 292.

257 *He had to quit*: The most probable of several different versions of events told by Rimbaud.

258 *"the ancient metropolis"*: Richard Francis Burton, preface to *First Footsteps in East Africa* (London: Longman, 1856).

258 *"became, in manners"*: Henri Matarasso and Pierre Petitfils, *Album Rimbaud* (Paris: Pléiade, 1967), 254.

258 *"All these worries"*: Rimbaud, *Oeuvres complètes*, 672.

259 *"Pray God that men"*: T. E. Lawrence, *Seven Pillars of Wisdom* (London: Penguin, 2000), 29–30.

261 *"leave to go away"*: Ibid., 683.

261 *Lawrence went to the Paris Peace Conference*: David Murphy, *Lawrence of Arabia* (Oxford: Osprey, 2011), 55.

262 *"It will mark an era"*: Harold Orlans, *T. E. Lawrence: Biography of a Broken Hero* (Jefferson, N.C.: McFarland, 2002), 89.

262 *"speed, and especially the conquest"*: Ibid., 94.

POSSESSED BY RHYTHM

The study of the life and work of Maya Deren has been both blessed and cursed by one of the most extraordinary biographical undertakings in the history of cinema studies. *The Legend of Maya Deren* (hereafter cited as *LMD*), by Vèvè Clark, Millicent Hodson, and Catrina Neiman (New York: Anthology Film Archives, 1985 and 1988), was conceived as a documentary biography, incorporating extensive selections from her journals and correspondence, often fac-

similes of the original documents. It was organized in three volumes: Volume 1, covering the years from Deren's birth to 1947, when she went on her first trip to Haiti, has been published in two parts, in 1985 and 1988, which together come to nearly one thousand pages. The second volume, which brings her life up to 1954, is to be published in three parts. It was completed at the same time, and much of it has been set up in type. The third part is unfinished, owing to the death of its principal author, Vèvè Clark, in 2007. The apparently permanent state of limbo of this grand project has effectively suppressed the undertaking of any new biographical investigations. I am grateful to Catrina Neiman, one of the principal authors, and to the publishers, Anthology Film Archives and McPherson, for sharing with me the page proofs of volume 2, which have been of inestimable value. Everyone with an interest in American experimental film eagerly awaits the book's publication, for so long postponed.

268 *"It goes up"*: All quotations from Maya Deren's Haiti journals, archived in the Maya Deren Collection (MDC), Howard Gotlieb Research Center, Boston University, box 1, folder 15. Hereafter, references to the Maya Deren Collection are abbreviated in this style: MDC 1/15.

270 *"one of the early legends"*: Stan Brakhage, *Film at Wit's End: Eight Avant-Garde Filmmakers* (Kingston, N.Y.: Documentext, 1989), 91–92.

271 *"at a socialist protest"*: John David Rhodes, *Meshes of the Afternoon* (London: Palgrave Macmillan, 2011), 20.

272 *"It was a large beamed room"*: LMD, vol. 1, pt. 1, pp. 411–16.

274 *"a very deep feeling"*: Ibid., 431.

274 *"She herself looked"*: Ibid., vol. 1, pt. 2, p. 27.

275 *Born in Chicago*: Biographical information for Katherine Dunham comes primarily from her memoir *Island Possessed* (Chicago: University of Chicago Press, 1994). The book has factual lapses, so I have tried wherever possible to find corroboration, as noted.

275 *"the pride of the Haitian"*: Joan Dayan, "Haiti's Unquiet Past," *Transition*, no. 67 (1995): 152.

275 *After appearing in several*: Vèvè Clark, "Katherine Dunham's Tropical Revue," *Black American Literature Forum* 16, no. 4 (Winter 1982).

278 *"She said one day"*: LMD, vol. 1, pt. 2, p. 77.

278 *"This film is concerned"*: P. Adams Sitney, *Visionary Film: The American Avant-Garde, 1943–2000* (Oxford: Oxford University Press, 2001), 9.

279 *"Under the wealth of curly"*: LMD, vol. 1, pt. 2, p. 123.

280 *"the earliest of the pure"*: Sitney, *Visionary Film*, 18.

280 *"a fragile web"*: LMD, vol. 1, pt. 2, p. 153.

281 *"They had a wonderful way"*: Ibid., 122.

281 *"Plunging her fingers"*: Anatole Broyard, *Kafka Was the Rage* (New York: Vintage, 1993), 124.

281 *"much more demure"*: LMD, vol. 1, pt. 2, p. 125.

281 *"Deren, Eleanora ('Maya')"*: James Merrill, *The Changing Light at Sandover* (New York: Knopf, 2001), 11.

283 *"would be predicated"*: Maya Deren, *An Anagram of Ideas on Art, Form, and Film* (Yonkers, N.Y.: Alicat Book Shop Press, 1946), 20.

283 *"Dear Little Maya"*: *LMD*, vol. 1, pt. 2, p. 545.

283 *"After the first showing"*: Brakhage, *Film at Wit's End*, 94.

284 *"Her movies hit like thunderbolts"*: *LMD*, vol. 2, intro, pp. 20–21. Page numbers for the unpublished volume 2 of *LMD* refer to draft page proofs, quoted courtesy of Catrina Neiman and Bruce McPherson.

284 *"cross-cultural fugue"*: "An Exchange of Letters Between Maya Deren and Gregory Bateson," in "From the Notebooks of Maya Deren, 1947," *October* 14 (Fall 1980): 18.

284 *"The minute I began"*: "From the Notebooks of Maya Deren," 21.

285 *"her career as a filmmaker"*: Sitney, *Visionary Film*, 34.

285 *"She became deeply"*: Brakhage, *Film at Wit's End*, 111.

285 *her study of ritual*: Catrina Neiman, "Art and Anthropology: The Crossroads," *October* 14 (Fall 1980): 4.

285 *"Maya, if there's one thing"*: Transcript of interview by Mike Wallace, *Night Beat*, May 30, 1957, MDC, kindly supplied by librarian, Howard Gotlieb Center.

286 *"When the anthropologist"*: Maya Deren, *Divine Horsemen* (London: Thames & Hudson, 1953), xiv.

286 *"In none of my"*: Dunham, *Island Possessed*, 111.

286 *"drugs of some mild kind"*: Ibid., 105.

287 *"What secret source"*: Deren, *Divine Horsemen*, 252–53.

287 *"As a metaphysical"*: Ibid., 323.

287 *"first on the scene"*: Dunham, *Island Possessed*, 3.

288 *"On the evening of 18 July 1926"*: www.mca-marines.org, retrieved January 27, 2016.

289 *"typical neocolonial"*: John Carlos Rowe, *Literary Culture and U.S. Imperialism* (Oxford: Oxford University Press, 2000), 285.

289 *"Huddled upon the floor"*: W. B. Seabrook, *The Magic Island* (New York: Harcourt, Brace, 1929), 84.

289 *Habitation Leclerc*: Information about the history and restoration of the estate from Dunham, *Island Possessed*.

290 *"We must destroy"*: Leclerc to Napoleon, Oct. 7, 1802, quoted in English translation by Henry Adams, *History of the United States of America During the Administrations of Thomas Jefferson* (New York: Library of America, 1986), 280.

290 *"would fire with more pleasure"*: Mary Hassal, *Secret History; or, The Horrors of St. Domingo* (Philadelphia: Bradford & Innskeep, 1808), 16.

291 *"drowned, asphyxiated, hanged"*: Dunham, *Island Possessed*, 242.

291 *"ripped into blacks"*: Joan Dayan, *Haiti, History, and the Gods* (Berkeley: University of California Press, 1995).

292 *"bare to the waist"*: Dunham, *Island Possessed*, 254.

293 *"I expect you"*: MDC 1/15.

293 *"To whom shall I confess"*: Ibid.

293 *"the master of that abyss"*: Deren, *Divine Horsemen*, 102.

293 *"makes a terrific effort"*: MDC 1/15.

294 *"characteristic activity"*: Deren, *Divine Horsemen*, 134.

294 *"Evening—definitive break"*: MDC 1/15.

294 *"Do you consider"*: Wallace interview.
295 *"With its towers"*: Graham Greene, *The Comedians* (London: Penguin, 1967), 43.
299 *"As I write these last"*: Deren, *Divine Horsemen*, 5.
299 *"I had to plead"*: LMD, vol. 2, intro, p. 9.
300 *"creative medicine"*: Deren, *Divine Horsemen*, 13.
300 *As Stan Brakhage tells*: Brakhage, *Film at Wit's End*, 106.
301 *"What impressed me most"*: LMD, vol. 2, intro, p. 14.
301 *Catrina Neiman, Deren's biographer*: Ibid.
301 *"I myself, being Haitian"*: In the Mirror of Maya Deren, film by Martina Kudláček (Navigator Film, Dschoint Ventschr, Tag/Traum, 2001).
302 *"The white darkness"*: Deren, *Divine Horsemen*, 260.
302 *"from excessive stylization"*: Sitney, *Visionary Film*, 25.
303 *"Nobody understood it"*: In the Mirror of Maya Deren.
304 *"It seemed to hesitate"*: Deren, *Divine Horsemen*, 130.
304 *"She did look like the wildest"*: Brakhage, *Film at Wit's End*, 104–5.
307 *market it as a sexploitation film*: Anonymous, *Cinema Nuova*, no. 169, June 1964.
307 *"points up the revelations"*: Gene Moskowitz (writing as "Mosk"), *Variety*, Sept. 6, 1961, 18.
308 *Teiji Ito said*: LMD, vol. 2, essay, p. 3.
308 *"Haiti was important"*: Ibid., vol. 1, pt. 2, p. 237.
308 *"Maya! In New York"*: Merrill, *Changing Light at Sandover*, 304–5.

THE LAST AGE OF EXOTICISM

313 *"I had spent many years"*: Wilfred Thesiger, *The Marsh Arabs* (London: Longmans, 1964), 51.
317 *"In this land of menacing"*: Norman Douglas, "Intellectual Nomadism," *North American Review* 193, no. 665 (April 1911): 531.
319 *"I craved"*: Wilfred Thesiger, *Arabian Sands* (London: Penguin, 2007), 32.
319 *"The people of each country"*: Bowles, *Sheltering Sky*, 12.

Acknowledgments

In the ledger of this book's accounts, first among creditors, his name written in scarlet majuscule, is Nigel Barley. The book came to life in the living room of the house in Islington he shares with Sallehuddin bin Abdullah Sani, where we sat side by side on a sofa one fine summer's day as he extemporaneously translated some fifty pages of Walter Spies's letters for me, until the sunlight and his voice gave out. His superb literary translations of Spies's letters, as charming as they are faithful, are the heart of this book. Its conception may be traced to my visit to the National Gallery of Indonesia in 2012, when Werner Kraus took me on a tour of his brilliant Raden Saleh exhibition. His detailed commentaries on the chapters devoted to Raden Saleh and Walter Spies made an essential contribution to whatever claim this book may have to being authoritative.

I am grateful to other scholars and colleagues who generously offered their expertise to make corrections and valuable suggestions, particularly Iain Bamforth, on Victor Segalen (one medical doctor and peripatetic poet making learned commentary on another); Lynda Chouiten, on the life of Isabelle Eberhardt; and Catrina Neiman, Maya Deren's biographer, who not only made vital factual corrections but also engaged in a stimulating dialogue as my understanding of Deren's work evolved. Henri Chambert-Loir suggested fine improvements in my translations. John Finlay and Mark Livingston kindly assisted their far-flung friend in key aspects of research. Early on, Edmund White made some excellent suggestions that bore fruit.

344 ACKNOWLEDGMENTS

I am indebted to David Sandberg, Walter Spies's grandnephew, for his generosity in sharing documents and photographs from the family archive and for his keen insights into every aspect of the artist's life and work; and to Horst Jordt, for access to his collection of Spies documents and for inspiring enthusiasm. Many thanks to Cindy Bonsignori, granddaughter of Umberto Bonsignori, for making an extraordinary effort to locate the director's own copy of his film *Maeva* for my use.

I am enormously grateful to the John Simon Guggenheim Memorial Foundation for the fellowship that made possible the completion of my research and the illustration of the book, with special thanks to Edward Hirsch and André Bernard, president and secretary of the Foundation.

I owe a great debt to my editors at Farrar, Straus and Giroux: Jonathan Galassi, who encouraged me to expand my conception of the book in the beginning, and Ileene Smith, who emboldened me to do what needed to be done at the end. John Knight was a sensitive and reliable guide in the labyrinthine process of transforming the manuscript into the book you hold in your hands. I am grateful to Ingrid Sterner for making many vital corrections.

I also wish to express my appreciation and affection for two brilliant writers and editors who have been sympathetic colleagues and good friends since my apprenticeship days, Anne Fadiman and Will Schwalbe. Herb Leibowitz, a great editor whom I only wish I had met sooner, has also been a valuable counselor.

I am grateful to my agent Katinka Matson and my attorney and dear friend Daniel Schwartzman for their loyal support.

For their generous assistance in providing illustrations, my sincere thanks to Nora Bateson, Lans Brahmantyo, Tom Cohen, Kurt De Belder, Kate Guyonvarch, Julia Hammid, Wayne G. Hammond, Maartje van den Heuvel, Annette Kobak, Martina Kudláček, Susan Legène, Zane Lūse, Ans Molenkamp, Oei Hong Djien, Aude Pessey-Lux, Jutta Tronicke, and Martin Westlake.

For good books and good ideas, many thanks to Franz Xaver Augustin, Janet Byrne, Carroll Dunham, Anne-Sylvie Homassel, Dean Tolhurst, Made Wijaya, and Lois Wilcken.

For warm hospitality and stimulating conversation I am grateful

to Patrick Kavanagh and Sarah Taylor, on my visit to Beijing; to John McGlynn, in Jakarta; to Hamish McColl and Emily Woof, in London; to Henry Rector, Jr., in Port-au-Prince; to Dick and Erica Hiersteiner, in Boston; and in New York to Deborah Baker and Amitav Ghosh, Lucy Littlefield, and Anne Stuhler.

Finally, as ever I offer deepest gratitude to my partner and best friend, Rendy, the beautiful and bountiful Bonita.

Index

Page numbers in *italics* refer to illustrations.

Rhodius, Hans, 117, 122, 136,
332*n; The Beauty and Riches of
Life*, 117, 136; *Walter Spies and
Balinese Art*, 170, 171, 172
rice, 92
Richardson, Samuel, 141; *Clarissa*,
141
Riding, Laura, 262
Righas, Athanase, 50
Righas, Constantin, 50, 258
Rilke, Rainer Maria, 113
Rimbaud, Arthur, 22–24, 45, 48,
64, 66, 94, 109, 110, 114–15,
131, 186, 189, 194, 217, 230,
256–59; in Africa, 24, 31, 45, 48,
50–52, 257–59; *The Drunken
Boat*, 48–49; early life, 256–57;
exoticism and, 22–24, 32, 50–52,
256–59; *Illuminations*, 217;
legend, 48, 50–52, 257–59;
Lettres du voyant, 23; *A Season in
Hell*, 24; sexuality of, 23, 52
Rimbaud, Isabelle, 186, 258
Rimbaud, Vitalie, 257
Road to Bali (film), 160
Road to Singapore (film), 159
Robeson, Paul, 297
Robespierre, Maximilien, 290
Rochambeau, Donatien, 291, 292
Roh, Franz, 122, 149
Rolling Stone, 5
Romanticism, 75–81, 99–101, 104,
316, 317; decline of, 99, 104
Rome, 5, 6
Roosevelt, André, 155, 163
Roosevelt, Theodore, 155
Rousseau, Henri, *le Douanier*, 110,
114, 153, 182; *The Social
Contract*, 25–26
Rousseau, Jean-Jacques, 25, 35, 36,
68, 231
Roy, Maurice, 191–97, 203, 206
Royal Air Force, 262
Royal Asiatic Society, 210
Royal Opera House, 262
Royal Society, 98
Rubens, Peter Paul, 77

Russell, Rosalind, 160
Russia, 111, 135, 137, 173, 230,
231, 252, 270; World War I, 111

St. Malo, 220
St. Petersburg, 252
Sahara, 4, 241, 250
Saint-Saëns, Camille, 76
Saleh, Raden, *62*, 63–106, 134,
141, 144, 157, 180, 182, 259,
308, 315; Bekasi uprising and,
103–104; *The Capture of
Diponegoro*, 69; in Coburg,
85–88; death of, 106, 250; in
Dresden, 74–85; *Drinking Tiger*,
101–2; early life, 64–67; exoticism
and, 61–106; house in Batavia,
95–96, *97*; painting style, 65,
71–72, 75, 77–78, 86–89, 91,
98–102, 104–106, 316; in Paris,
87–92, 104–105; physical
appearance of, 65, 67, 68, 89–90,
93–94, 314; prince of Java persona
and fame, 65, 68–92, 93, 105–106;
return to Java, 91–106; scientific
interests, 96–100
Sanchi, 14
Sanders, George, 159
San Francisco, 188
Santiago de Chile, 5
Sanur, 151
Scemla, Jean-Jo, 59
Schelfhout, Andries, 65
Schönberg, Arnold, 114, 117
Schoonderbeek, Georgette, 122,
123, 133, 135, 149, 150
Schumann, Clara, 79, 83
Schumann, Robert, 79, 83, 84,
256
science, 79, 88, 96–100, 174, 315;
Walter Spies and, 174–76
Scientific Humanitarian Committee,
117
Scott, Walter, 86
sculpture: African, 180; ancient
Greek, 126–29; Chinese, 210–11